MODERN ENGLISH PAINTERS

Volume One Sickert to Lowry

MODERN ENGLISH PAINTERS
JOHN ROTHENSTEIN
Volume One Sickert to Lowry

MACDONALD & CO

London & Sydney

A MACDONALD BOOK

© John Rothenstein 1952, 1976, 1984

First published in Great Britain in 1952.
First revised edition 1976.
This edition published in 1984
by Macdonald & Co (Publishers) Ltd
London & Sydney

A member of BPCC plc

British Library Cataloguing in Publication Data

Rothenstein, *Sir* John
 Modern English painters.
 Vol. 1: Sickert to Lowry
 1. Painting, Modern—19th century
 2. Painting, Modern—20th century
 3. Painting, English
 I. Title
 759.2 ND467

ISBN 0-356-10353-6

Typeset, printed and bound in Great Britain by
Hazell Watson & Viney Limited
Member of the BPCC Group
Aylesbury, Bucks

Macdonald & Co (Publishers) Ltd
Maxwell House
74 Worship Street
London EC2A 2EN

CONTENTS

CONTENTS

LIST OF ILLUSTRATIONS

ACKNOWLEDGMENTS

For information, for permission to reproduce pictures and to quote from letters, for assistance in collecting the necessary photographs, and for help of many kinds, I am so deeply in dept that no full list of my obligations is possible. By gracious permission of Her Majesty Queen Elizabeth the Queen Mother, I have been able to reproduce Paul Nash's *Landscape of the Vernal Equinox*. For exceptional help I am indebted to Esther Pissarro, Rachel Fourmaintraux-Winslow, Olivia Walker, Grace Gilman, E. M. O'R. Dickey, H. L. Wellington, Augustus and Dorelia John, Edwin John, Mary Gore, Frederick Turner, Matthew and Gwendolin Smith, Father Vincent Turner, Grace English, Silvia Hay, Derek Hudson, Eric Westbrook, the Matthiesen and Mayor Galleries and Messrs Arthur Tooth, Rex Nan Kivell, George Barker, John Malkin, Prunella Clough, Michael Ayrton, Robert Frame, Keith Vaughan, Sebastian Barker, Benny Creme, the Hon. Anne Ritchie, Barbara Ker-Seymer, William Chappell, Beatrice Dawson, Annette Armstrong, Catharine Chaloner, Kathleen Freedman, Tim Biggs, Anne Spalding, Ian Rogerson, Richard Macleod, Sir James Richards, Anne Williams, James and John Ravilious, Noel Carrington, Thomas Balston, Kathleen Nevinson, Kathleen Wadsworth, Kate Lechmere, Edward Bawden, Mrs Grove and Count Vanden Heuvel. Also to the members of the staff of the Tate Gallery, in particular Corinne Bellow, Elizabeth Bell and the Librarians. To the artists themselves of whom I treat and almost all of whom I was able to approach directly I owe much gratitude for their ready and kindly response to my queries and requests, also to Victoria Funk of Macdonalds.

The publishers wish to express their regret that, due to technical considerations, they have been unable to reproduce work by all of the artists treated in this volume.

PREFACE TO NEW EDITION

When the publication of the new edition of this book was under discussion with a friend he asked me how I made the choice of the artists to be included. I replied that it was done purely on the basis of personal conviction. But after the friend had left the relevance of the question remained.

The difference between writing about contemporary artists, even those of a century ago, and about those of a remote past is surely radical. To omit Turner and Constable from a book on early nineteenth-century British painters would be an unthinkable absurdity. With works of today and the recent past, however, there are no such certainties; it now takes time for certainties to emerge. A few decades ago, for instance, Victorian paintings were regarded widely as pretentious jokes 'only fit for provincial galleries'. Today those jokes – the best of them – are sold regularly at auctions for formidable prices. Until recently even the Pre-Raphaelites, although highly regarded by a few collectors and scholars as radical exceptions, were generally despised. 'Young women who will prattle with assurance of Pruna or Poussin' – I quote from Evelyn Waugh's *PRB: An Essay on the Pre-Raphaelite Brotherhood 1847–1854* – 'will say, should the topic ever arise, "The Pre-Raphaelites – Burne-Jones and people like that – my dear, you can't admire them" '.

The reputation of contemporaries will prove still more elusive. We regard Picasso and Moore as great masters, all but beyond criticism, but we cannot know with any precision how they will be regarded by collectors and scholars a century hence, or who, among their innumerable contemporaries, will be 'discovered' and acclaimed as masters. For example, only a few years have passed since Henry Moore was discovered and acclaimed. I remember that in 1939 The Contemporary Art Society, which acquired his *Recumbent Figure* – carved the previous year – offered it as a gift to the Tate. Both Kenneth Clark, responsible for its acquisition by the Society, and I were determined that the offer should be accepted, and both had reason to doubt the response of certain of the Gallery's Trustees, even though they showed, in the main, exceptional discernment. ('Discernment', future readers may sneer, because our opinions often coincided.) We

9

accordingly found occasion to express our ardent admiration for Moore, and for the *Recumbent Figure* in particular, to every Trustee. We had neither of us ever so acted before. Whether owing to our words or not I now have no idea, but to our delight the work was accepted. It today seems very strange to reflect that there was reason to doubt the acceptance – and as a gift from a Society of notable discernment – of a work which would receive unquestioning acclaim and which would cost hundreds of thousands of pounds. Yet some years hence we may be judged to have shown an enthusiasm, if not altogether misplaced, at least excessive.

I recall this event as a reminder of the fact that, while in earlier ages, such as those of ancient Greece and Rome, the Renaissance and many others, there were certain accepted qualities which enabled the public to judge works of art. The masters were accordingly afforded full recognition that has remained virtually constant: Egyptians, Greeks, Giotto, Michelangelo, Raphael, Rembrandt, Dürer, Turner, to name a few among a great number. During the last two centuries, however, reputations have been subject to radical change.

In our times – the last century or so – the qualities earlier referred to by which all works of art were authoritatively judged no longer universally apply: those of a wide-ranging variety are universally accepted. Outstanding public collections are almost all wide-ranging, their differing, often radically contrasting possessions having been acquired by the exercise of diverse concepts of quality. But where contemporary art is concerned there are no such concepts: collectors who acquire fine works by Blake, Rossetti, Rouault, Picasso, Stanley Spencer or Moore would be unlikely to be accused of inconsistency, but rather praised for the wide range of their perception.

In writing about one's contemporaries, unlike those of earlier ages, one has no incontrovertible standards by which to judge their work. The writer must form his own judgments, well aware that in the future the qualities and shortcomings of his subjects are likely to be assessed quite differently. He must also be aware of his own shortcomings.

When the question of how to organize my material arose I decided that the artists should be introduced strictly in the order of their appearance in the world. To insist upon an artist's identity with a group is to compromise his individuality; groups have a way of dissolving under scrutiny, of proving to be more fortuitous in their composition and more ephemeral than they at first appeared. Unlike the individuals who compose them, they have no hard core. In earlier, less disintegrated periods, there was some meaning in the classification of artists according to the tradition to which they belonged, but in our time the general enfeeblement and even collapse of

tradition has made the classification of original artists almost impossible: they exist by virtue of their individual selves alone. The chronological arrangement of the chapters that follow is intended to emphasize the individuality of their subjects by cutting them off from all fortuitous and ephemeral groupings.

My treatment of my various subjects has been deliberately varied. In the cases of painters who are the subjects of adequate biographies either already available or in preparation, it has been primarily critical, or else directed towards the elucidation of lesser-known aspects of their work, lives and personalities. But when my subjects are artists apt to be neglected or almost forgotten, such as Ethel Walker or Gwen John, in such cases I have tried to evoke a degree of recognition of value of their art and interest in their lives and personalities. Those artists who are included for the first time in this edition were added because they seemed to me to be inadequately served by recent scholarship.

I have called the subjects of this book English rather than British because there are notable Scottish painters whose works I have had no opportunity to study. Also because, with the exception of Gwen John, England is or was their home, and it was primarily by the intellectual, emotional, social and physical climate of England that they were all predominantly formed. Several of them were not English-born, and I have in fact dwelt in certain cases upon the effects of their country of birth and early environment: Irish in that of Orpen, Dutch in that of Houthuesen, and Scottish in that of Pryde.

The artists treated in this book are those whose work makes a strong personal appeal – in one or two cases a little less ardent than when I first put pen to paper, but only a little. There is nothing in the pages that follow, I trust, to suggest that I believe that those included are the only serious English painters of our time. I have in fact paid tribute to a number of others in a variety of publications. The volume of talent in Britain in the present century has been formidable, and I would not for a moment doubt that there is much of which I am not fully aware or else entirely ignorant.

INTRODUCTION

It is unlikely, it is hardly indeed imaginable, that the twentieth century will be accounted one of the great periods of painting. Yet painting in our time shows certain characteristics of surpassing interest. The waning of traditional authorities has encouraged an unequalled diversity in all the arts – a diversity which has been stimulated by the accessibility of a variety of examples of the arts of every time and place inconceivable in any previous age.

An artist working today has to accommodate himself to circumstances unlike any which have existed previously. A few prints of paintings by Michelangelo were sufficient to produce an intense and lasting impression upon Blake's imagination; and I remember hearing someone describe the delighted agitation of Morris and Burne-Jones when, as undergraduates at Oxford, they happened to see a small coloured reproduction of a painting by Botticelli. How almost infinitely greater are the opportunities of the artist today for acquiring knowledge! With what little effort can a provincial art student gather an impression of the sculpture of, say, the Etruscans or the Minoans, or of the present wall painting of the Mexicans! I am far from being persuaded that the advantage of easy access to the art of other ages and peoples – it can give to the student an unprecedented breadth of critical experience and to the lonely original artist precisely the examples he needs to justify and enrich his own vision – outweighs its disadvantages. Reproductions which in time past would have germinated new movements are now apt to be accepted as a matter of course and regarded with listless eyes. Even the most sensitive cannot respond to more than a relatively few reproductions any more than the most compassionate to more than a relatively few of the atrocious crimes against humanity of the prevalence of which we are aware. Indeed the vast multiplicity of the art forms by which the painter of today can hardly avoid being aware disinclines him from the intensive and therefore fruitful exploitation of the possibilities of a limited range of art forms, and tends to overwhelm his imagination and to prevent his opinions from becoming dynamic convictions.

The manner, nevertheless, in which gifted and resourceful painters have responded to a complex of circumstances that is in this and in

13

certain other respects unique in the history of art, and, perhaps, uniquely unpropitious to the creation of great works, provides a subject which one would suppose to be of absorbing interest. In England, at all events, this has not proved to be the case. When we consider the serious character of more than a few of the English painters of our time, the numbers of perceptive writers interested in painting, and the avid and increasing interest of the public in the fine arts, the paucity of substantial writings devoted to the work of these painters is astonishing. Not long ago there appeared a review by one of the best-known British art critics of a collection of reproductions of paintings and drawings by Augustus John prefaced by a longish essay by myself. The review ended with the observation that the various points I had made had been more extensively developed in previous books on the same artist. In preparation for writing my own essay I must have read most of what had been written about Augustus John, and was in a position to know that not only had no book upon this artist ever appeared, but how surprisingly little had been written about him. Two or three brief prefaces to slight volumes of reproductions, a handful of articles, none of them exhaustive, scattered references in books of memoirs, an informative entry in a foreign dictionary of artists, these represent approximately the extent – apart, of course, from innumerable reviews of exhibitions – of the critical writings on Augustus John.

The relative critical neglect of one of the most celebrated English artists – a painter whose work carried a strong popular appeal, who was also an eloquent writer and a dramatic personality – gives some measure of the neglect suffered by lesser-known painters, indeed by English painting in general. Of recent years there have been signs of awakening literary interest in this subject. Biographies as readable as they are authoritative have been published on Steer, Sickert and Tonks, and the Penguin *Modern Painters* made widely known a number of our most gifted contemporaries.

Year by year, however, I have been expectantly awaiting some treatment of British painting of somewhat wider scope – some work in which the principal figures would be placed in relation to one another, their works compared and subjected to critical investigation. I have waited, so far, in vain, and in the meantime the notion of making some slight attempt at something of this kind gradually took hold of me, but it was a notion to which I yielded with reluctance, for I am very conscious of my manifold disqualifications. I lack, first of all, a clear-cut view of the subject. The view of Post-Impressionism adumbrated by Sickert and belligerently developed by Dr Thomas Bodkin is not one which I find credible. 'The modern cult of Post-Impressionism', Sickert wrote in *The English Review*, 1912, 'is localized

mainly in the pockets of one or two dealers holding large remainders of incompetent work. They have conceived the genial idea that if the values of criticism could only be reversed – if efficiency could only be considered a fault, and incompetence alone sublime – a roaring and easy trade could be driven. Sweating would certainly become easier with a Post-Impressionist personnel than with competent hands, since efficient artists are limited in number, whereas Picassos and Matisses would be painted by all the coachmen that the rise of motor traffic has thrown out of employment.'

However effective the machinations of dealers and other interested persons – if they have succeeded, that is to say, in suborning this or that influential critic, in securing the acceptance, or indeed the apotheosis, of this or that spurious artist – there still remains, in the Post-Impressionist movement and in its derivatives, a consistency of vision and a logical coherence of doctrine which, even were I unimpressed by the painting and sculpture in which they are actually made manifest, would preclude my regarding them as other than spontaneous, even, perhaps, as historically inevitable developments.

Nor, on the other hand, can I fully accept the contrary view implicit in the critical works of Sir Herbert Read. This writer, more interested, perhaps, in the philosophical ideas which may be supposed to underlie works of art than in the aesthetic or representational content of works of art themselves, has treated the principal revolutionary artistic movements of our time with a serious objectivity. But Read's pages, judicious though they are, unmistakably convey the impression that there is an inherent superiority in revolutionary art and that representational art is a curious survival, condemned by its very nature to sterility and hardly worthy therefore of the attention of the critic. For me, a canon of criticism according to which, say, Hans Arp is accounted a figure of greater significance than, say, Stanley Spencer, is one which takes inadequate account of the evidence of one's eyes.

For Sickert the more 'advanced' schools of art were 'the biggest racket of the century', for Read they are the whole of art now. For me, as for Sickert, the ramp is a reality: I have seen it in action at close quarters, but it does not seem to me nearly so influential as it did to him. For me, as for Read, the advanced movements are the chief focus of interest, and they have in general resulted from the activities of the most vigorous and original personalities; but the wind bloweth where it listeth, and genius shows itself in representational as well as abstract form.

I cannot therefore envisage the twentieth century either as a period of retrogression or of progress, still less of stability. I am mainly conscious of a complex interplay of innumerable personalities; of the action upon these personalities of numerous and various forces –

economic necessity, fashion, the momentum of traditional aesthetic movements, social change, patronage, psychological and archeological discovery and so forth – forces which often neutralize each other and are, for the time being, incalculable in their effects. With the passage of time much of what presents itself to our eyes as confused will insensibly assume a settled pattern; then there will be written a history of this period which is accurate in its perspective and secure in its critical judgments. But I am not at all certain the historian of that distant time, who looks back with justified condescension upon ours, may not perhaps envy a little the historian, however ludicrous his errors, to whom the artists who are the common objects of his study were familiar figures, known either directly or through their friends. Therefore it seems to me that there is an obligation upon those with the privilege of knowing artists to place on record something about their personalities and their opinions. (Even if, at certain points, the portraits, like those in *Modern Painters,* as Ruskin noted in the margin of his own copy, are 'drawn mild because . . . men are living'.) For the memory of these fades with pathetic swiftness. Some time ago an acquaintance told me she was engaged upon a study of Innes. This painter died only seventy years ago, yet with what labour will the materials for her study be assembled!

But of what use is the study of an artist's personality? There are many critics who answer this question with an emphatic 'None whatever. The work of art transcends the artist; all that need to be known of him can be learnt from the study of his work.'

It is a truism that we can be deeply moved by a work of art of whose creator we are entirely ignorant, as also, indeed, by works of art produced by societies that have vanished without trace. But are we not moved more deeply by the works of art which we are able to see in relation to the personalities of the artists who made them, or against the background of the society from which they came? It is my conviction that we are, and that the more we know about both the artist and his subject the fuller our comprehension of the work of art is likely to be. It is difficult to think of any fact about an artist, any circumstance of his life, that may not have its effect upon his work. The idea that a painting or any other work of art can in fact transcend its creator is one which is tenable only on the assumption that the creative capacity of the artist is enhanced by a form of 'inspiration' derived from some source outside himself. Until we have some knowledge of the nature of such extraneous assistance it is reasonable to assume that the artist possesses within himself the power of giving visible form to his conceptions. If this assumption is well founded, in what sense can a work of art, which is the expression of a part of a human personality, be said to transcend the whole? For me, therefore,

the artist is, in a sense, more not less important than anything he creates, which is not to say that the work of art may not be more comprehensible and more attractive than the man. (I remember, years ago, someone saying to my father, after meeting A. E. Housman, 'so far from writing "A Shropshire Lad" I shouldn't have thought him capable of reading it'.) Nor do I overlook the possibility of an artist's having an imaginative comprehension of certain qualities, magnanimity, for example, or singleness of purpose, which may enable him to realize them in his art but not in his conduct; yet comprehension forms, nevertheless, an element in his own personality. In any case, the greater our knowledge of a personality, the better able we are to understand how apparently inconsistent and even irreconcilable elements form parts of a whole which can, roughly speaking, be considered one whole. And so it comes about that, with my doubts upon fundamental aesthetic problems unresolved (doubting, even, whether aesthetics, in the sense of a comprehensive system by which the value of a work of art may be judged, has any validity) and my ignorance of many important and relevant matters, I am decided to try to give some impression of certain of the painters who have been at work in England during my lifetime. It has come suddenly upon me, with a sense of shock, that time's winged chariot is indeed hurrying near. Many years ago I had occasion to reply to a girl who said that she believed I knew her parents, that this was the case, and that I knew her great-grandmother. This great-grandmother was Lady Burne-Jones, but my artistic memories extend – tenuously it is true – still farther back than this, for I can remember, as a child, spending an afternoon with an original member of the Pre-Raphaelite Brotherhood, William Michael Rossetti. I still plainly see the darkened room, with blinds half-drawn, and, reclining upon a couch, an old man with a long grey beard and a sallow complexion, wearing a black alpaca cap, whose owl-like eyes, with dark pouches beneath, looked momentarily startled at our entrance. And I still see his relatives grouped solicitously about him and I hear my mother's voice saying: 'Dear Mr Rossetti, pray don't get up.' The couch, which was large and of uncommon design, made an impression on me which I was unaware of having received. One morning during a bomb attack on London, Mrs William Michael Rossetti's daughter telephoned me at the Tate to tell me that the Rossetti's house had been badly damaged, and the family possessions, including Pre-Raphaelite pictures, were exposed to looters and the elements, and to ask whether I would take charge of them. 'And I'd be so grateful', she added, 'if you would take into your care also the couch on which Shelley's body was placed when it was taken from the sea.' Within a few hours the precious pictures arrived; also the couch. I instantly recognized it as that upon

which, nearly forty years before, I had seen Dante Gabriel Rossetti's brother reclining. And I have had opportunities of coming in contact with a number of English painters who have been active during my lifetime, or of hearing first-hand accounts of their characters and ideas and aspects of their lives.

The exceptional complexity, if not the confusion, of the painting of our age, as it offers itself to my contemplation, will be, in one respect at least, radically simplified in the pages which follow. There are at least twenty thousand artists practising in Great Britain today. Of these the merest handful will be noticed at length. It is relevant, perhaps, to say a few words about the principle upon which the choice will be made. There exist critics who claim to base their judgments upon consciously held critical canons. They may, for all I know, in fact so form their judgments, but I myself can hardly conceive of a mental process of such a nature. Indeed, there is only one way in which I can conceive of judging a work of art, and that is the same as that which the greater part of mankind employs in judging its fellow men: namely, instinct refined and sharpened and deepened not by personal experience alone but by those standards, created for us by experience through successive generations, which guide us even when we are hardly conscious of our inevitable appeal to their authority. We respond spontaneously to a fine work of art in the same way as we respond to a fine character, and it is only afterwards that we begin the process of analysis in order to try to account for our response. (Equally, of course, we are liable to be deceived by spurious work, as we are by a plausible but meretricious person.) And by the same means – although the process is inevitably more complex and protracted – do we judge the totality of an artist's work, that is to say, the artist himself.

The artists noticed in the chapters which follow have been chosen on account of a series of just such intuitive preferences – preferences founded, that is to say, chiefly upon personal response tempered by inherited canons of judgment. These painters, however, who appear to me to have distilled to its finest essence the response of our times to the world which the eye sees – by which I include both the outward and the inward eye – have few pronounced characteristics in common. A critic with a conservative bias might well object that they were almost all associated, at one time or another, with some innovating movement. That is true, for there does seem to exist some correspondence between inspired art and revolutionary art. Indeed the assumption that there is some such correspondence underlies so much current discussion about painting that it might well be suspect. But so far as Post-Renaissance art is concerned, it appears to be well founded. All the modern masters to a more or less marked degree

were innovators, and all of them suffered a measure of contumely and neglect on that account. From Delacroix to Cézanne every great painter made his contribution to a revolutionary process, and the more closely we study the period the more completely is the assumption justified, and the more intimately are important painters, formerly regarded as conservative or even reactionary, understood to be implicated with change. The Surrealists, for example, directed attention to the revolutionary elements in the early work of the Pre-Raphaelites, and Picasso to those in that of David and Ingres. In our own age, indeed, it is an unconscious assumption that the great artist is a man who innovates, who is original. Originality has become a part of the meaning that we assign to the word 'greatness'. It has not always been so. The outlook of Aristotle, for example, was rather that by 'experience' men discover the right proportion, say, or the 'right' way of doing something, or form and harmony that satisfy; and when it is discovered, it is there once and for all. An artist will be himself, no doubt, but only in abiding by 'the laws'. Is not this the assumption behind the practice, too, of classical Greek art – as it is also of, say, Sienese Quattrocento painting? In Post-Renaissance times, however, if not earlier, there has occurred a radical change in this respect. So that now it is a sign of an inferior gift if a man continues to do, however well, what has been done before. That there should seem to be some correspondence between greatness and innovation among the painters of modern Europe – in which change as radical as it is continuous has come to be accepted as an inexorable law of existence – is hardly surprising. The possessor of superior gifts is likely, in our change-loving age, to be indifferent towards continuing, with whatever distinction or success, procedures already current: his powers will predispose him to attempt what has not been attempted before. But this correspondence arises, I believe, from an impulse deeper than this. The great artist demands of his art that it should express the whole man. Therefore, more sensitive than his contemporaries, he is aware of the particular bias to which the art of his own time is subject, which incites him to a discontent – although sometimes a deeply respectful discontent – with the prevailing modes of seeing and which impels him to a conscious and radical reorientation.

Consider, for example, the origin of the discontent which brought about the new and unforeseen changes which may conveniently be taken as the beginnings of the chief contemporary movements, at the very moment when Impressionism appeared to have imposed itself as a great central tradition of Western painting, and to have established a kind of 'norm' of vision. The doctrines which crystallized around Impressionism were at least as lucid and compelling as those associated with Neo-Classical art, which had dominated the acad-

emies of Europe since the Renaissance. The aims which it proposed were aims which represented the culmination of centuries of sustained effort on the part of a broad succession of European painters to represent the material world in the closest accord which the facts of vision; its exponents could hardly have been a more brilliant company, indeed they included the most considerable painters of their age.

These considerations were such as to attract any young painter into the Impressionist movement, which did in fact attract a mass following, and it ultimately became the acknowledged academic tradition. It was challenged only by a few of the most sensitive and independent painters of a younger generation, who, although they looked upon the great Impressionists with reverence and affection, were intuitively conscious of a certain incompleteness in their enchanted vision of the world.

The major aim of the Impressionists may be said to have been the representation, on the spot, and with the utmost truth, of a casually selected fragment of visible reality. Impressionist truth was different from that older conception of truth which expressed itself in the accumulation of meticulously rendered detail; it was on the contrary broad and comprehensive. Impressionist painters were not at all concerned with what Sickert used to call 'the august site'. Almost any fragment of the visible world, was, they held, a worthy subject for a picture, but such fragments, arbitrarily come upon, are inevitably without the elaborate balance of subjects either carefully selected or deliberately composed. The Impressionists, therefore, imposed upon their subjects a comprehensive unity of *tone* in the same way as Nature itself invariably binds together in a harmonious envelope of atmosphere any group of objects, however incongruous they may be or however awkwardly disposed. It was through truth of tone that they were able to achieve a new kind of accuracy. The power which they derived from their extraordinary command of tone, of giving unity to any stretch of landscape, to any group of persons, had the effect of inducing painters to visualize the world in terms of its surface and to be forgetful of the rock and bone beneath, to see, that is to say, in terms of colour rather than of form.

In order to set upon their pictures the final stamp of truth, it was logical that these should have the appearance of having been begun and completed at a sitting, under precisely the conditions of weather and light represented in the picture. In northern Europe these notoriously change from hour to hour, and as it is evident that large and elaborately 'finished' pictures could not be painted in such conditions, Impressionist paintings, in order to carry conviction, inevitably have something of the character of sketches.

Preoccupation with colour as distinct from form, and with verisi-

militude of so exacting an order, inevitably excluded from Impressionist art many qualities, notably the reflective and monumental qualities which characterized most of the great art of the past. It was the absence of certain of these from the art even of the masters of Impressionism that provoked in the most sensitive and independent among those who were always proud to proclaim themselves their disciples an uneasy awareness of the qualities it lacked. Cézanne's often quoted remark that they must recreate Impressionism according to the art of the museums was not an expression of a desire to return to a tradition, but of a consciousness of how small a part of the whole man was expressed by Impressionist art, of how great a sacrifice had been made to its coruscating perfection. The masters of Cézanne's generation each tried to restore to painting one of the qualities sacrificed: Gauguin an exotic poetry; Van Gogh a passionate humanity; Seurat monumental and elaborate formal harmony, and Cézanne himself the rocky or bony framework of things. The great Impressionists were themselves aware that, in their intoxicatingly new approach to the actual appearance of things, in their close pursuit of a beauty miraculous because it was not an imagination or a dream but the tangible beauty of all created things, their art lacked a certain massive reflectiveness. There came a time when the bathers of Renoir became sculptural in themselves and monumental in their composition, while Pissarro with a sublime humbleness made experiments under the guidance of Seurat, one of his own disciples, in directions clearly repugnant to his own innate genius, and declared that Impressionism 'should be nothing more than a theory of observation, without entailing the loss of fantasy, freedom, grandeur, all that makes for great art'.

Now that nearly a century separates us from the decade when the principal painters of an oncoming generation were manifesting their awareness of the failure of the art of their great Impressionist teachers to express the whole man, it is not difficult to understand the nature of the readjustment which was taking place. But from that decade onwards how increasingly difficult it becomes to perceive any 'norm' of vision or any central traditions. From decade to decade confusion grows, and what remains of the central traditions of Cézanne, Gauguin and Van Gogh becomes more and more dissolved into individual idiosyncrasy.

The heaviest emphasis was laid by art historians on the effect of monumental qualities in the painting of Cézanne upon his followers, the Cubists in particular. We are given to understand that upon the basis of the most austerely structural elements in his painting and of his precepts a great 'Classical' art had come into being. A return to Classicism is how the Post-Cézanne movement is often described.

'The idea behind the modern movement in the arts is a return to the architectural or classical idea' are the first words of R. H. Wilenski's closely reasoned introduction to *The Modern Movement in Art*, and his whole book may be considered as an amplification of them. This may well have been the Cubists' programme, but it is not easy to gather from the innumerable written accounts how far it was from being realized or how quickly it was abandoned. That certain of the early Cubist paintings had a severely structural character is obvious enough. They sacrificed in a passion of dour joy the shimmering surfaces of things in which Manet and Renoir had delighted, and which Cézanne, for all his preoccupation with structure, had striven so strenuously and sometimes, especially in his watercolours, with such breathtaking success to represent, and they created a new order of form, stark and subtle and, after the first brief 'analytic' phase, bearing scarcely more than a remotely allusive relation to the natural order. Among the best of these highly original and momentous works are a number by Picasso. In the light of this artist's subsequent development and the character of the intoxicating but disintegrating influence he wielded, the fact is significant. But what have been, in fact, the effects of this group of Cubist paintings; the creations of the apostles of solid construction, of dignified, self-sufficient form? It can hardly be denied that they have been, in the main, disintegrating; that in their shadow grew up an art as remote as any that could be conceived from the ideal of Cézanne 'to make out of Impressionism something as solid and enduring as the art of the museums'. The contrast between the spate of talk and writing about the rebirth of an architectural painting and of the classical ideal, and the overwhelmingly idiosyncratic character of the painting that was actually produced corresponds to the discrepancy, in the political sphere, between the proclamations, which grew thunderous upon the conclusion of both the World Wars, of international solidarity, and the persistent growth of aggressive nationalism. But whereas, in the larger sphere, the discrepancy between the ideal and the actuality is widely recognized and lamented, in the sphere of the fine arts a discrepancy not less startling is virtually denied, and the continuing chatter about 'architecture' and 'classicism' would lead a student who read about works of art instead of looking at them (a practice almost universal among students) to form radically different conclusions about the character of contemporary painting from those of anybody accustomed to use his eyes. Certain ideas about form implicit in the work of Cézanne and expressed in his rare sayings have gained the widest acceptance throughout the western world, but from the two other commanding figures of the Post-Impressionist movement, Gauguin and Van Gogh, also derive ideas, to a certain degree complementary,

which exercise a decisive influence. Upon the art of Germany and Scandinavia the influence of these two has been even more pervasive than that of Cézanne. Between the ideas of Van Gogh and Gauguin there are sharp distinctions, but their influence has been somewhat similar in its effects. Both painters were acutely aware of the exclusion of poetry and of the deeper human emotions from Impressionism; both, too, made the discovery that the tonal technique of the Impressionists, perfectly adapted although it was to the creation of harmonies in colour and light, was too vaporous to lend itself readily to the lucid expression of the poetic and dramatic emotions of their own passionate natures. Therefore gradually both abandoned the realism of the Impressionists and each evolved an art that was predominantly symbolic.

From the Impressionists they had learnt to dispense with the older type of formal, closely integrated composition; they early discarded the tonal system upon which the Impressionists relied to give cohesion to their pictures. The highly original poetry of Gauguin and Van Gogh was expressed in terms which proved as fascinating to these artists' younger contemporaries as they were audacious and novel.

In this expressionistic art the functions of form and colour were to convey, symbolically yet forcefully, the emotion of the artist. Expressionism and Cubism, and its later and highly logical development, Abstraction, have played, as already noted, complementary parts in the history of contemporary painting, the one, essentially subjective, with its emphasis upon the artist's emotion, the other, rather more objective, with its emphasis upon the created form. The one may be said to correspond to the Romantic as the other to the Classical motive in the earlier art of Europe; certainly Expressionism took most vigorous roots in Scandinavia and the Germanic countries, where the Romantic tradition had been persistent, and Abstraction in France and the Latin countries, where the rational values had always found a wider acceptance.

But just as the Abstract artists failed to fulfil the achievement of certain of the early Cubists to build upon the foundation of Cézanne an art of pure form, nobly defined and exact, so did the Expressionists prove unable to express anything beyond a narrow and, it would seem, a continuously narrowing range of human emotions; with the greater part of the human drama and of the poetry of life Expressionist painters were unable or else unwilling to deal. The Norwegian Edvard Munch showed himself, in a group of early paintings, pre-eminent among the rare exceptions. There would seem, in fact, to have occurred early in the period of which I am writing a catastrophic change which profoundly affected the fine arts. The word 'catastro-

phic' has been applied to this change both by those who regard it as the rejection of values which have been long regarded as constituting the foundation of European culture, and by those for whom such values represent, at the best, a series of intrinsically undesirable but historically necessary expedients, at the worst, conventions which served no purpose but that of confining the creative spirit in the interests of tyranny, political, religious or academic.

The more closely we read history the more aware do we become of the strength and intimacy of the relationships by which the fabric of human society is bound together; the relationship between our age and another of apparently opposite character, between two factions, which at first seem irreconcilably opposed. We see, for instance, how powerfully the forces which produced the Protestant explosion in the sixteenth century were also active within the Catholic Church; we see how difficult it would be to define with exactitude the issues which divided the North from the South in the War between the American States. We may therefore take it that the revolution in the arts which may be said to have begun with Post-Impressionism in the last decade of the nineteenth century and has gathered momentum progressively since, may present to the future art historian an aspect perhaps less radical than it does to us. The origins of phenomena which appear, even to learned and boldly speculative art historians, entirely novel, will reveal themselves in the course of time. '... Where, in the immediate ancestry of modern art', asks Sir Herbert Read, 'shall we find the forbears of Picasso, Paul Klee, Max Ernst . . .?' I suspect that the future art historian will marvel at our want of perception and at the complacency which allows us to attribute to our own art an unexampled uniqueness. It is, however, difficult for someone writing today not to share, to a considerable extent, the impression that the characteristic art of our time is, in fact, the product of a catastrophic change. The European tradition of painting owes its cohesion largely to the persistence of two impulses; to represent, as exactly as possible, the visible world, and to evolve the perfect forms of persons and things. These impulses crystallized in what are frequently termed the Realistic and the Classical ideals. Both have asserted themselves throughout the whole history of European art; from the Renaissance to the decline of Impressionism, the development and the intimate interaction of these ideals have been continuous. But towards the end of the last century both began to lose their compelling power for numbers of the most reflective and highly gifted artists. They persisted with reduced vitality, but those who followed them travelled, more and more, along sequestered byways rather than along the high roads. The ultimate causes for the rejection of ideals which had been accepted for so many centuries lie deep in the history of

religion, of philosophy, of politics and of several fields of scientific discovery, but certain of the immediate causes are obvious. Their achievement in representing brilliant light gave to the painting of the Impressionists the character of extremity and climax. It seemed that in this, the centuries-long ambition of European artists to represent in something of its fulness the world to which their senses bore witness had been fulfilled; the old excitement in the gradual approach to reality could hardly be experienced so intensely again. But the visible world exercised a diminished attraction over the artists of the Post-Impressionist era on account not solely of their predecessors' close approach to the limits of the possible, but of the doubts which they shared with their fellow men about the ultimate reality of the world perceptible to the senses. Science has conjured up a world which the senses cannot apprehend, a world in which the stars themselves – to artists and poets for thousands of years the embodiments of an eternal and changeless beauty – have no longer any substantial existence, but are instead hypothetical entities, light rays curving back to the points where once shone suns for millions of years extinct. And the very substances of which the material world is made – even the simplest and most solid among them – are now assumed not to be the stable entities they seem, but on the contrary to be assemblies of whirling particles. But when a man of education rejects the time-honoured 'commonsense' view that things are more or less what they appear to be, it is hardly any longer possible for him to believe that the profoundest truths about the world can be expressed by the representation, however searching, of its deceptive surface. The dissolution of the artist's confidence in the reality of what his eye sees is destructive of both Realist and Classical ideals: for it is equally foolish to represent or to idealize a mirage.

In another age general revulsion against the close representation of the world which the eye sees might have had less 'catastrophic' consequences than it has today. (I speak tentatively because the whole history of art records no previous revulsion against realism either so widespread or so deeply felt.) The imaginative treatment of subjects from religion, mythology, or simply from the inward vision might have withdrawn painting beyond the understanding of all but a perceptive few, while preserving a degree of continuity; but the scepticism which has weakened the confidence of modern man in the reality of the world to which his senses bear witness has yet more radically transformed his outlook: it has made him doubtful of its validity. In contemplating the art of past ages we are conscious of how much of it testified to an irrepressible delight in the multitudinous aspects of the world and human society, in its Creator, in the beauty of nature and of man, in the exciting spectacle of the

surrounding stream of life, so various and so dramatic as it flowed by. Even the most savage satire was inspired by the sense that mankind was sufficiently precious to be castigated for its own redemption. There would seem to prevail today, among artists, little of the sense of majesty of the world and the excitement of the human adventure. What has taken the place of the medieval artist's exalted conception of a God-centred universe in which every man and woman, and every created thing, had its value and its function? Or the Renaissance artist's intoxicating confidence that man, by the intense cultivation of his understanding, his inventiveness, his daring and all his faculties, might himself become godlike? Nothing, except an intense preoccupation with his separate and individual self. This individualism, historically, may be regarded as the culmination of the worship of the spirit of liberty. But now, in Western Europe and the United States, there are no more Bastilles to storm. For the artist there is now but one criterion: his own satisfaction.

The history of modern art is constantly depicted in terms of a perpetual struggle against 'convention'. It is true that in the arts as in other spheres of man's activity there is a continuous tendency for the disciples of an audacious innovator to reduce his practice to a system of rules more or less tightly formulated, and in so doing to obscure the true significance of his achievement. Thus they distort something which was a heightening of human perception into a complex of rules which at best alienates those perceptive and independent natures by whom the audacious innovator would have most desired to be understood. The activities of the academic mind, by transforming that which was thrilling and elusive into that which is dull and docketed, is a continual source of misunderstanding. So much is plain; but of recent years it has been habitual to exaggerate the importance of the mischief which pedants have done to painting. Among the forces which form the natures of great artists and bring about the flowering or the decline of traditions these pedants have a minor place.

Time and again we see the man of genius in conflict with the academician, but the activities of the framer of conventions are not for this reason devoid of positive value. If his effect is frequently to provoke the man of genius by repressing him, he plays a necessary part in the education of less gifted men; he makes available to them, in a readily assimilable form, not only the accumulated technical experience of his predecessors but even something of their vision. In those rare ages when many masters are at work they themselves will diffuse directly their fertilizing influence, but in those far commoner ages when there are few or none, the function of the academician in preserving, systematizing and handing on the heritage of the past –

even if in a desiccated form – is a useful one. Even though the academician's gaze is directed towards the past and his bias towards the form and away from the spirit, what, without him, would be the plight of the secondary artist, whose nature does not demand that he should have that immediate contact, intuitive or intellectual, with first causes which is one of the distinguishing necessities of genius? A distinctive, closely knit tradition is the most favourable seed-bed of the secondary artist, just as a profusion of these would seem to create the most favourable conditions for the emergence of genius. Thus the academician, invaluable to the secondary artist, makes his contribution, however pedestrian, however indirect, to the formation of the master also.

According to the contemporary history of art, 'convention' is the great positive evil against which all good artists have had to contend – a kind of artistic fascism – and new movements are explained by the necessity for 'breaking away from' or 'reacting against' such and such a 'convention'. As though the prime motive of those dedicated to one of the most exalted and most exacting of man's vocations was a bicker with obsolescent regulations! The fundamental causes for the new directions which the arts are forever taking under the hands of the masters are outside the scope of this book (although I have touched upon what I think is the most important of these, namely, the masters' preternatural sensibility to the respects in which the art of their times fails to express the whole man), but if there is one factor which plays no part in the formation of contemporary art it is the 'convention'. For 'convention', comparable to the older, clearly formulated, passionately upheld complexes of rules, can hardly be said to exist any longer. Some contemporary painters and a larger number of their advocates continue to behave as though there were still reactionary and, above all, realistic formulas against which they were under an obligation to struggle. But what restrictions are there upon the absolute liberty of the artist to please himself? The 'Old Bolsheviks' of the Cubist Revolution and their younger followers declined to recognize that they were tilting at a mirage, and aggressively asserting rights which for years nobody dreamed of challenging. They did not tell us against what they remained in a state of perpetual belligerence. The truth is that the revolutionary impulse has largely expended itself, and for the very reason that there are no longer any objects for revolutions; all doors are open. What remains to be seen is whether art can, in fact, flourish without laws. 'Art', declared Ozenfant, 'is structure, and every construction has its laws.' The question is whether the abolition of every law but the satisfaction of the artist is not vitiating those deeper impulses necessary to the creation of great works of art. Modern painters have easy access to

the knowledge of all traditions but the powerful support of none. I say 'powerful support' because many, indeed perhaps all traditions, in attenuated forms, still persist. The present situation in this regard is thus concisely described by Sir Herbert Read in *Art Now*:

> ... we have in some way telescoped our past development and the human spirit, which in the past has expressed itself, or some predominant aspect of itself, diversely at different times, now expresses the same diversity, without any stress on any particular aspect, at one and the same time. I might refer, as a modest illustration of my meaning, to those metal cups made of a series of what mathematicians presumably call conic segments which when pressed together, collapse into concentric rings – what was once continuous and spread over several sections of space becomes discontinuous within one section of space.

Sir Herbert sensibly disclaims the implication that the human spirit is more diverse today than at any other time, but it is true that the very absence of authoritative traditions and of imposed discipline of any kind allows for a more untrammelled expression by the artist of his own personality than at any previous time. Prior to the nineteenth century most art served a religious or a social purpose which demanded some subordination of the artist's personality; whereas for the artist of today the expression of himself has become his sole, or at all events his overriding preoccupation. And this preoccupation was shared no less by the Cubists and other Abstract artists, whose work at first glance has an objective look, than by the Expressionists, whose work is frankly personal. 'Cubism differs from the old schools of painting', said Guillaume Apollinaire, 'in that it aims not at an art of imitation, but at an art of conception, which tends to rise to the height of creation.' But in what sense can the concepts and the creations of Cubists be said to be less exclusively the products of the artist's mind than the 'literary' concepts of Expressionists? Both are manifestations of the forthright and uninhibited expression of personality which is the distinguishing characteristic of the art of our time. In the past artists have been inspired by exalted subjects, most of all by religious subjects, and their talents tempered and directed by tradition, but the artists of our own day rely upon neither of these external sources of strength: they are at once their own subjects and their own teachers. Their art therefore, in comparison with that of certain periods of the past, conspicuously lacks the sustained dynamic power which can result from the combination of an intrinsically inspiring subject and a comprehensive discipline; it resembles a river which has overflowed its banks. Paradoxically the perfect liberty of which so many artists have dreamed, now achieved, makes it the more difficult to realize the great work of art. But if in our own time the great work of art, rare in the most propitious circumstances, is

exceptionally rare, that does not mean that our own highly personal and, in consequence, infinitely various art has not qualities which are precious and unique. We have become so accustomed to regard art as primarily the expression of personality and as being practised for the satisfaction of the artist himself, that we are apt to forget how recently in the history of the world such an art came into existence. Almost all medieval art exhibits an anonymous and collective character; only with the early Renaissance did the artist begin to emerge as a highly differentiated individual, and it was not until the middle of the nineteenth century that the conception of personal and self-sufficient art lately so widely accepted began to prevail. And we have no assurance that it is certain, or even likely, to continue to prevail even in Western Europe and the Americas. Within the last sixty years it ceased to be accepted by the rulers of three great States, Russia, Germany and Italy, and in their dependencies. In all these the arts were transformed overnight into instruments of political propaganda and education and could no longer be the unforced expression of the individual human spirit, and their criterion became, therefore, social utility instead of intrinsic worth. And the time may come sooner than we expect when the kind of art which, to one living in Western Europe or the Americas, is now taken for granted, may have come to an end. There have been in the past many tyrannies and many states where the rulers have employed artists for purposes which allowed only the narrowest scope for the expression of their personalities, yet art as an expression of human personality has always survived and generally flourished. Those who argue from the example of the past that this kind of art can still be pursued in the totalitarian state of the twentieth century fail to distinguish the radical difference between these and the older authoritarian states in which even subversive art was sometimes tolerated, and the consequences of this difference for the artist. This difference arises from the fact that modern totalitarian states have come into existence at a time when democracy has already established itself over large areas of the world and become – in spite of the effeteness of many democratically elected governments – an active and formidable principle. The governments of such states, which by their very nature cannot allow their authority to be challenged, even implicitly, are therefore compelled to control with unexampled vigilance and severity the popular opinion which they have displaced as the most powerful element in politics. There is no manifestation of opinion, however insignificant, which is hostile, or even indifferent, to these régimes which they can safely tolerate. Art, with its unique power over the mind, must be subject to the most rigorous control, or rather, to the most precise direction. To the modern absolutism personal art is at the best an irrelevant display of

personal egotism, at the worst the germ of an alternative attitude towards life, and as such a subversive activity.

Let us therefore remember in considering the art of our own day that it is the most extreme expression of the Humanist tradition, which has always set a high value upon personality. Let us remember, too, that it may prove to be its last expression. Of recent years in particular there has been a tendency − an anticipation, perhaps, of what would seem to be the collectivist epochs ahead of us − to deplore Humanism's rejection of the anonymity that marked, during the Middle Ages, so many of man's activities. We may live to see the subordination of the individual to a totalitarian state and his merging in the anonymous mass.

At the beginning of this chapter I voiced my doubt whether the present would ever be counted among the great ages of painting, but its extreme expression of one aspect of Humanism, its astonishing variety and the unprecedented conditions with which its artists have had to come to terms give it, nevertheless, an extraordinary character. In this general interest in the art of our time many share, but very few indeed would seem to attach serious importance to the contribution of our own country. As I write I have before me a number of notices on the Tate Gallery exhibition of the last fifty years of British Painting which was shown at Millbank in 1946 after a tour of the principal capital cities of Europe. The press, I think without exception, praised the representative character of the selection; but certain of the most responsible papers referred in cool or else frankly disparaging terms to the school of painting it represented. 'What are its characteristics?' asked *The New Statesman and Nation*, and thus answered the question. 'Rarely original, even more rarely powerful, it is usually sensitive especially in colour.' The impression received by *The Spectator* was one of 'respectable talent, a general level of sensibility without authority . . . For eyes other than British it is not an impressive period, for we spent most of it in the backwaters of streams already grown stagnant at their source.' Such quotations would seem to be typical not of ignorant but of informed and responsive elements of British public opinion. While nobody would be likely to maintain that during the period with which this book is concerned English painting could compare with French in richness, in perfection or in inventiveness, it must be remembered that the latter derives much of its vitality from forming a part of one of the most inspired movements in all the history of European art. At the beginning of the present century the great Impressionists were alive: with the death of Bonnard in 1946 the last of their disciples departed. And who remained active in France thereafter? In my view two figures towered above the crowd, Rouault, the sombre suffering-haunted groping giant, and

Picasso (who was not a Frenchman), the prodigiously accomplished and prolific master of all styles and all media; the one a blundering but God-guided sleepwalker, the other very much 'all there', the resourceful master of every situation. To Matisse, gifted though he was with a singing sense of colour, as a designer and as a pure yet engagingly informal draughtsman, and with the nature which so limpidly reflected the temperate gaiety of the French character, I doubt whether posterity will accord so pre-eminent a place as he once occupied. There is a flimsiness in the central principle which informs the art of Matisse, which will, I think, grow more apparent in the coming years. These three apart there seem to me to be no painters with serious claim to the title of master. Braque was a grave and beautiful artist whose work projected with a rare and serene distinction a pre-existing vision, but he lacked, quite simply, the magnitude of a master, the magnitude which is not, of course, dependent upon the scale on which an artist works, and which is, for example, as manifest in a drawing by Rubens or an etching by Goya as in their largest paintings.

Is this commonplace of criticism – hardly less widely accepted here than abroad – that an immeasurable gulf still separates the painting of England from that of France in fact justified? Or is it an inevitable consequence of the dazzling ascendancy of France right up to the immediate past? And of the debt which every English artist of our age – with a single exception to be noticed later – owes to French inspiration in his formative years? I am conscious of the national prejudice, the parochialism, the personal affections that may have gone to the formation of my opinion, but I am conscious also of the obligation to place on record my conviction that no such gulf in fact exists, and that the English school shows no less excellence than the French and considerably more interest. It counts among its members a wide range of mature and highly individual personalities, and, although it cannot, of course, compare in inventiveness with the French School, it has shown a power, not conspicuous elsewhere, of applying the basic discoveries of the most original painters of Continental Europe to the representation of many of the traditional subjects of European art. Wyndham Lewis voiced the permanent disposition of many of his English contemporaries when he wrote, of his own attitude after the First World War:

> The geometrics which had interested me so exclusively before, I now felt were bleak and empty. *They wanted filling.* They were still as much present to my mind as ever, but submerged in the coloured vegetation, the flesh and blood, that is life . . .

WALTER RICHARD SICKERT
1860 – 1942

Some months before the beginning of the year 1900, which I have arbitrarily selected as my point of departure, Walter Richard Sickert left England, and did not return until five years later. Apart from being the senior among the subjects of these studies, Sickert was the most consistently and effectively articulate painter of his generation, who spoke with insight and authority, and not on his own behalf alone. By taking him as my first subject (in spite of his initial absence from the main theatre of operations) I shall be able to refer more readily without delay to ideas about painting current among artists. Sickert himself warned us 'to judge an artist by his works, not by his patter', but if patter is not to be accepted at its face value, it is equally not to be ignored. Sickert's placing of himself, in the May 1910 issue of *The New Age*, was very simple:

> I am a pupil of Whistler – that is to say, at one remove, of Courbet, and, at two removes, of Corot. About six or seven years ago, under the influence in France of Pissarro, himself a pupil of Corot, aided in England by Lucien Pissarro and by Gore (the latter a pupil of Steer, who in turn learned much from Monet), I have tried to recast my painting entirely and to observe colour in the shadows.

This gives an indication of one of the causes of Sickert's authority among English artists: his familiarity with French painting. Since the early days of Impressionism, the more independent artists in England had been increasingly aware of the momentous character of French painting and of the stature of Millet, Courbet, Manet, Pissarro, Degas, Renoir and Monet; but only to very few of them was the work or the personalities of these masters familiar. Of those few, Sickert was one of the best informed. In 1883 he went to France to take Whistler's *Portrait of his Mother* for exhibition at the Salon. 'I have a clear recollection', he has told us, 'of the vision of the little deal case swinging from a crane against the star-lit night and the sleeping houses of the Pollet de Dieppe.'

Although he was only twenty-three years old at the time, he was already well prepared to make the most of all he saw and heard in Paris. Oswald Adelbert Sickert (1828–85), his father, was a capable painter and draughtsman who studied in Paris with Couture. His

grandfather Johann Jurgen Sickert (1803–64) was also a painter and head of a firm of decorators employed in the Royal Palace of Denmark. (The family was originally Danish, but Sickert's father acquired German nationality as a result of Germany's seizure of Schleswig-Holstein but was subsequently naturalized in England, where he settled in 1868 with his English wife.) Sickert himself was born in Munich on 31 May 1860. The family was harmonious and united, and Sickert therefore eagerly assimilated, instead of reacting against, as might otherwise have been the case, his father's and grandfather's sober, professional attitude towards the arts. Of his father, Sickert declared that he never forgot anything he told him.

At King's College, London, Sickert must have laid the foundations of an excellent education, especially in the classics, for he enjoyed reading Latin and Greek throughout his life. After going down he wished to become a painter, but his father warned him against the uncertainties of an artist's career; so he fell back upon his second choice, the stage. For three years he acted, on occasions in Irving's company, but although he took only minor parts, his experience in the theatre was not an irrelevant interlude. It confirmed a love of the stage that lasted as long as his life, and, it is reasonable to assume, the histrionic elements in his own temperament. There was a sense in which, for Sickert, the world was always a stage, and he the player of many parts, but I think that Osbert Sitwell was justified in his opinion that none of these was without a genuine foundation in Sickert's character. In 1881 Sickert became a student at the Slade School, under Alphonse Legros, but a chance meeting with Whistler caused him to leave the well-trodden path. 'You've wasted your money, Walter,' he jibed; 'there's no use wasting your time too', and Sickert went off to help Whistler print his etchings. By forsaking Gower Street for Tite Street, Sickert entered a new world, for in Whistler's studio he found himself remote from the Slade and near to the mainstream of European painting. The at first almost daily association with Whistler was one of the two most important relationships of Sickert's life. For a time even his sceptical spirit was captivated by the master, the capricious, scintillating dandy who held sway over courtiers whose subservience was as unexceptionable, if not, perhaps, as demonstrative, as that of the courtiers of Xerxes. Sickert once wished to introduce D. S. MacColl to Whistler, identifying him as the author of an article in The Saturday Review entitled 'Hail, Master!' 'That's all very well, "Hail, Master!" ', replied Whistler, 'but he writes about Other People, Other People, Walter!' 'Of course', Sickert added, 'with Whistler there was always a twinkle.'

In time the friendship waned. In 1897 Whistler, giving evidence against Sickert in a lawsuit, described him as 'an insignificant and

irresponsible person'. For a man of Sickert's independence, friendship on the terms which Whistler demanded could not have been of long duration, but there existed a more active cause of disruption: Sickert's admiration for the master became more and more tempered with criticism, until at last Whistler's art came pre-eminently to stand for some of the weaknesses which Sickert most abhorred. In 1882, he has told us, he began a campaign in the press on the master's behalf which he did not wind up until ten years later. Subsequent references to Whistler contain searching criticism; at last there appeared an article in the 3 February 1910 issue of *The Art News* entitled 'Abjuro' which was, in Sickert's own words, 'an explicit repudiation of Whistler and his teaching'. It is not here, however, that Sickert gives his most explicit reasons for his repudiation. When the Pennells' *The Life of J. McN. Whistler* appeared, Sickert reviewed it at length in the December 1908 issue of *The Fortnightly Review*, giving his most considered estimate of his master. Insisting that Whistler's art was dominated by his taste, he developed the theme that 'Taste is the death of a painter'. 'An artist', he contended, 'has all his work cut out for him, observing and recording. His poetry is in the interpretation of ready-made life. He has no business to have time for preferences.' In an article in the 10 February 1910 issue of *The Art News*, entitled 'Where Paul and I Differ', he indicted Whistler of a yet more radical defect. After a tribute to 'the exquisite oneness that gives his work such a rare and beautiful distinction', which he obtained by covering the whole picture at one 'wet', Sickert proceeds to show how heavy a price Whistler had to pay for this quality. 'The thinness of the paint resulted in a fatal lowering of tone . . . and necessitated an excessive simplification of both subject and background.' Sickert then clinched his argument with an observation of the rarest insight: *'Mastery'* (he had denied that in the proper sense Whistler was a master), *'Mastery, on the contrary, is avid of complications,* and shows itself in subordinating, in arranging, in digesting any and every complication.' In a fourth article, in *The Daily Telegraph*, 25 April 1925, written twenty-five years after Whistler's death, he put the whole of this indictment into one simple sentence. 'Whistler accepted', he said, 'why, I have never understood, the very limited and subaltern position of a *prima* painter.'

> [His] paintings were not what Degas used to call *amenées*, [he continued] that is to say, brought about by conscious stages, each so planned as to form a steady progression to a foreseen end. They were not begun, continued and ended. They were a series of superimpositions of the same operation . . .

I have quoted Sickert's criticisms of Whistler at some length for

two reasons. Firstly, Whistler and all that he stood for may be taken as Sickert's point of departure, and his progressive repudiation bears a precise relation to his own development. Secondly, this repudiation, thoroughgoing although it was, was not absolute. There were qualities in Whistler which he continued to revere and which moved him to pay him this ardent yet discerning tribute in *The Fortnightly Review*, December 1908:

> I imagine that, with time, it will be seen that Whistler expressed the essence of his art in his little panels – pochades, it is true, in measurement, but masterpieces of classic painting in importance . . . The relation of and keeping of the tone is marvellous in its severe restriction. It is this that is strong painting. No sign of effort with immense result. He will give you in a space nine inches by four an angry sea, piled up and running in, as no painter ever did before. The extraordinary beauty and truth of the relative colours, and the exquisite precision of the spaces, have compelled infinity and movement into an architectural formula of eternal beauty . . . It was the admirable pre-liminary order in his mind, the perfect peace at which his art was with itself, that enabled him to bring down quarry which, to anyone else, would have seemed intangible and altogether elusive.

Nor was it only Sickert's admiration that outlasted his friendship with Whistler; his personal devotion survived it also, as expressed in *The Burlington Magazine*, December 1908:

> The diary of the painter's mother depicts the child the same as the man I knew; sunny, courageous, handsome, soigné; entertaining, serviable, gracious, good-natured, easy-going. A charmeur and a dandy, with a passion for work. A heart that was ever lighted up by its courage and genius . . . If, as it seems to me, humanity is composed of but two categories, the invalids and the nurses, Whistler was certainly one of the nurses.

If Whistler was Sickert's point of departure, Degas, for the greater part of his life was his ideal. 'The greatest painter of the age' is how, in a personal account, he described him. This account is remarkable in several respects, in none more than for being an entirely credible and entirely delightful portrait, yet painted without a single shadow. In short, for Sickert, Degas was without defects. I am far from having the good fortune to have read everything that Sickert has written or even all his published writings, but I cannot recall a single instance of adverse criticism of Degas. He did not regard him, I take it, as of the stature of Turner or of Millet but, within narrower limits, as the perfect artist. Sickert revered Degas for his achievements, but there was one question of method over which he was passionately con-vinced, and it is impossible to read his writings without coming upon frequent references to it, just as it occurred frequently in his conversation: whether large pictures of more or less complex subjects

should be painted directly from life, or in the studio from preliminary studies or photographs. His opinion was, I think, first expounded at length (and with admirable pungency) in a book published in 1892 on Bastien-Lepage and Marie Bashkirstev. This has long seemed to me to be among the best of Sickert's writings, and I was surprised to find it omitted from Sir Osbert Sitwell's judicious selection in *A Free House* (1947):

> To begin with, it was thought to be meritorious . . . for the painter to take a large canvas out into the fields to execute his final picture in hourly tête-à-tête with nature. This practice at once limits your possible choice of subject. The sun moves too quickly, you find that grey weather is more possible, and end by never working in any other. Grouping with any approach to naturalness is found to be impossible. You find you had better confine your composition to a single figure . . . that the single figure had better be in repose. Even then your picture necessarily becomes a portrait of a model posing by the hour . . . your subject is a real peasant in his own natural surroundings, and not a model from Hatton Garden, but what is he doing? He is posing for a picture as best he can and he looks it. That woman stooping to put potatoes into a sack will never rise again. The potatoes, portraits every one, will never drop into the sack . . .

With these melancholy procedures Sickert contrasted those of Millet, based upon the conviction that, in the master's own words, '*Le nature ne pose pas*'. 'Millet knew that if figures in movement were to be painted so as to be convincing, it must be by a process of cumulative observation . . . he observed and observed again . . . and when he held his picture he knew it, and the execution was the singing of a song learned by heart, and not the painful performance in public of a meritorious feat of sight-reading . . .' 'To demand more than one sitting for a portrait is sheer sadism' is a saying that recurred in Sickert's writings and conversation. That the method of Millet and of the old masters should also be, in this regard, the method of Degas was a source of constant satisfaction to Sickert. There was no conviction that he held more fiercely than that there was no fundamental difference between the old art and the new, and that the history of art was therefore a history of additions, not of revolutions. 'There is no new art', he wrote in *The English Review*, May 1912. 'There are no new methods . . . There can no more be a new art . . . than there can be a new arithmetic . . . or a new morality.' The painter who carried a large canvas into a field did not provoke him as much as the critics who treated the new as though it superseded the old.

> You are not to consider that every new and personal beauty in art abrogates past achievements as an Act of Parliament does preceding ones. You are to consider these beauties, these innovations, as additions to an existing family. How barbarous you would seem if you were

unable to bestow your admiration and affection on a fascinating child
in the nursery without at once finding yourselves compelled to rush
downstairs and cut its mother's throat, and stifle its grandmother.
These ladies may still have their uses.

Sickert's sympathies towards artists who attempted new themes was
readily kindled, but he remained steadfast in the conviction that the
classic or academic method constituted the only durable framework.

Oddly enough, Degas, whom Sickert venerated, probably influ-
enced him less than the master whom he abjured. In particular, the
low tones which Whistler taught him to use continued to distinguish
his painting until after 1903, but his ready acceptance of the accidental
elements in life as subjects for painting, no less than his preference
for subjects drawn from popular life, may reasonably be assumed to
have been derived from Degas.

During the years 1899–1905 when Sickert was living abroad, he
sent a number of his best pictures to the New English Art Club,
which, as he observed, set the standard for painting in England. The
Club was founded in 1886 in opposition to the Royal Academy, by
artists who had studied in Paris, for the purpose of establishing a
platform for realistic painting. Its earliest members worked chiefly
under Barbizon influence, but from about 1889 the more enterprising
among them had applied a colour vision derived from the Impres-
sionists to themes in general already accepted in England. The
preference of leading members, notably Sickert himself, for 'low-life',
no less than that of others, notably Conder and Beardsley, for exotic
and 'decadent' subjects, outraged academic opinion. Not since the
earliest days of the Royal Academy had so preponderant a part of the
keenest and ablest talents in England been gathered in a single
institution, and the resulting interaction of one temperament upon
another issued in a widely diffused spirit of audacity. Notwithstand-
ing the diversity of temperaments which found a welcome in the
New English Art Club, it became identified with a distinctive method
of painting, which Sickert thus described in The New Age, June 1910:

Technically we have evolved, for these things are done by gangs, not
by individuals, we have evolved a method of painting with a clean and
solid mosaic of thick paint in a light key . . . and . . . a whole generation
holds it in common . . .

Here, incidentally, Sickert voices an opinion rare among artists –
namely, that art is largely a collective pursuit. Most artists have a
sense, often a blinding sense, of their individual uniqueness, and of
the solitary character of their struggle with refractory material and
the buffets of fortune, but to Sickert, who was always learning and

always teaching, the collective aspect of their vocation was constantly present.

> It is well to remember that the language of paint like any other language, is kneaded and shaped by *all* the competent workmen labouring at a given moment, that it is, with all its individual variations, a common language, and not one of us would have been exactly what he is but for the influence and the experience of all the other competent workmen of the period.

It is related that, when some pictures alleged to be by Sickert were coming up for auction, an interested person who doubted their authenticity telegraphed to him: 'Did you paint the pictures signed with your name and at present on view at such and such auction rooms?' Other wits might have sent the reply; 'No, but none the worse for that.' Sickert is the only artist known to me who might have meant it.

During the early years of the new century Sickert's painting underwent a gradual change. Previously, many of his best works had had something of the character of coloured drawing. If we examine *Gatti's Hungerford Palace of Varieties, Second Turn of Katie Lawrence* (1888); *The Old Hotel Royal, Dieppe* (1900); *The Horses of St Mark's, Venice* (1901); *The Statue of Duquesne, Dieppe* (1902); *Rue Notre-Dame, Dieppe* (1902), all, in spite of the elaboration of their design and colour, are essentially drawings in paint. Their outlines are emphatic; the paint is applied lightly. The best works of the immediately following years reflect the movement, widespread among European painters, towards a certain massiveness, achieved by a more deliberate, more concentrated design, and by a thicker application of paint. Such paintings as *The Lady in a Gondola* (c. 1905); *Mornington Crescent* and *The New Bedford* (both 1907); *The Juvenile Lead* (c. 1908) all show how closely Sickert shared its aims. With the exception of the first (which was, however, painted in London), the subjects of all these later paintings were taken from Camden Town, where Sickert settled on his return from abroad. This grim and often fog-bound but roughly genial neighbourhood of small, square, late Georgian, or of tall, early Victorian long-windowed, houses, soot-encrusted and built in crescents or straight rows, was one in which he delighted. In accordance with his habit, Sickert rented odd rooms for working in. The nearby Caledonian Market was among his favourite haunts. One day he was seen there (according to an account which has reference to a later day) in an old trench coat and a straw hat with a broken brim, with his trousers stuffed into brown leather army boots that reached almost to his knees, and as the boots had no laces the uppers jumped backwards and forwards as he walked. He came upon an old piano. 'Mind if I try it?', he asked the owner of the stall. 'Go ahead,

guv'nor', was the reply. Thus encouraged, Sickert rattled off an old
music-hall tune and then spun himself round several times on the
revolving stool. 'Very fine tone', he gravely assured the owner, and
wandered off into the crowd. Of the four places where Sickert painted
most – Camden Town, Dieppe, Venice and Bath – the first was the
one which he most intimately understood. Yet in the biography
Sickert, R. H. Wilenski could bring himself to write:

> In painting these (the Camden Town) pictures Sickert was no more
> recording life in Camden Town than he was recording life in China-
> town. He let his North London cronies think that the locality had
> something to do with it. But in fact when he was painting, his mind
> was not in North London but in North Paris.

The artist's mind, surely, is always upon his subject, and Sickert
repeatedly affirmed that 'serious painting is illustration, illustration
all the time'. Sickert's sayings were sometimes paradoxical, but here
he was voicing a tenaciously held conviction which had immediate
reference to his own work. The quality which gives such peculiar
fascination to the North London paintings is the application of
procedures to conspicuously shabby and anecdotal subjects which
resume, with consummate erudition and taste, the distilled wisdom
of the foremost masters of the age, not only of Whistler and Degas,
but of Pissarro, Vuillard and Bonnard. And not of Sickert's age alone:
his colour, especially his muted but resonant pinky-carmines, shows
to what good purpose he had spent his time in Venice. When I just
now applied the attribute of 'taste' to Sickert, I was aware that it was
an attribute which he would have disclaimed with aversion, as, at his
behest, would some of his admirers. Sickert's own view of taste – that
it is the death of an artist – I have already noted. He spoke constantly
of painting as 'a rough and racy wench'. In an article entitled
'Idealism' in the May 1910 issue of *The Art News*, Sickert declared
that:

> The more our art is serious the more will it tend to avoid the drawing-
> room and stick to the kitchen. The plastic arts are gross arts, dealing
> joyfully with gross material facts. They call, in their servants, for a
> robust stomach and great powers of endurance, and while they flourish
> in the scullery, kitchen, or on the dunghill, they fade at a breath from
> the drawing-room.

Except where the question of taste is concerned, I believe all of
Sickert's opinions which I have cited this far have been objective
opinions which may be accepted at their face value. But about this
particular question he protests too much. It is true that an artist
cannot relish a tasteful 'arrangement' he has thought up for himself
as keenly as he can something suddenly perceived (either by the

outward or the inward eye), any more than a man can fully enjoy, as Sickert used to say, a meal that he has cooked himself. It is true that many of the greatest artists have ennobled some of the grossest of subjects; but that there is any necessary connection between serious art and – even in the broadest meaning of the word – the kitchen, is a notion which the history of art shows to be false. The great Italians, from Giotto to Tiepolo, to whom we owe so disproportionate a number of the masterpieces of the world, had scarcely a glance to spare for scullery or kitchen; nor had Van Eyck, El Greco, Poussin, Watteau, Delacroix or Turner. The cooks of Velazquez are no finer than his infantas or his *Virgin of the Immaculate Conception*. To persuade us of the truth of the view he propounded, Sickert wrote as though the drawing-room were the only conceivable alternative to the kitchen, but this is no more than a dialectical device, and a transparent device at that. Why should Sickert, a critic of the rarest insight, have persisted in so questionable a generalization? He gave us, I believe, a clue when he wrote in *The English Review*, March 1912:

> To the really creative painter, it must be remembered, the work of other men is mainly nourishment, to assist him in his own creation. That is our reason why the laity are wise to approach the criticism of art by an artist with the profoundest mistrust.

The answer to this question is, I believe, that Sickert was essentially a man of taste, and, in consequence, acutely aware of the vitiating effects of taste once it becomes predominant in a man's work. The acerbity and the frequency of his warnings against its dangers suggest that Sickert had had personal experience of them. An artist of robust stomach, wholly at ease in dealing with gross material fact, a Rubens or a Rowlandson, would be disposed to regard taste not with animosity, but rather as a minor, but on the whole enviable, sensibility. The circumstance which, as I understand the matter, so peculiarly exacerbated Sickert's animosity towards taste was his discipleship of Whistler. Gradually, he came to realize that he had come near to worshipping, in his first master, the very quality against which he should have been most vigilant. And was it not this circumstance, too, that eventually gave a personal twist to his special dislike of the predominance of taste in Whistler himself? May not his feeling have resembled the gradual and galling recognition by a child of a defect in a parent from which he also suffers? It was not that Sickert was lacking in robust qualities, but detested Taste was always at his elbow with its plausible ways. You have only to look at his painting and drawing to see how strongly taste was always working in him; the delicate slate-greys and violets, the lemons and the muted carmines of Tintoretto. And there were occasions when Sickert

capitulated altogether to taste: he forgot his sarcasms about the 'august site' motive, and took a ticket to Venice and painted St Mark's under a star-hung midnight heaven. Could any paintings be further removed from the scullery than Sickert's Venetian subjects, whether they be St Mark, Santa Maria della Salute, or, for that matter, La Giuseppina herself? It would be difficult, I believe, to show that Sickert's paintings of Venice – and, one might add, of 'august sites' in Dieppe, aspects of the venerable Church of St Jacques, of the stylish hotels, along the seafront or the spacious arcading by the harbour – were inferior to the shabby interiors of Camden Town. An intensely observant, or, as he himself said, 'a breathlessly listening' artist, he divined the history, the social ambience and everything which goes to make up the distinctive 'atmosphere' of a place, which enabled him to paint and draw it – 'beautiful' or 'ugly' – with extraordinary comprehension.

It was, I suppose, in the best of his Camden Town pictures that Sickert came nearest to realizing his aims as a painter. His criticism of Whistler for accepting the subordinate position of a *prima* painter, for persisting in the 'trial and error' method, has already been noted; also his corresponding praise of Degas for his deliberateness, resulting in the growth of the power to begin, continue and end pictures according to a minutely pondered plan. Sickert's abhorrence of the sketcher's attitude towards painting, and in particular of this attitude in Whistler, like his abhorrence of taste, derived, it is reasonable to suppose, from the knowledge that he himself shared with his first master something of the sketcher's temperament. The summary character of a considerable part of his early work would suggest that this was the case. I have already drawn attention to the fact that several of his largest, as well as his finest, Venice and Dieppe pictures have the character of drawings rather than of paintings. They may be said to be impressions rather than constructions. Constructions are precisely what the best of the North London pictures are. The *Mornington Crescent* already mentioned and *The New Home* (1908), are pictures of this different kind: there is nothing summary about them; they are deliberate, compactly designed and thickly painted. Such painting probably did not come easily to Sickert; it was the result of a prodigious effort of will, inspired by tenacious conviction. In general, it was the more summary method that he employed, but even with this he experienced difficulties which are at present unfashionable to admit. Sickert is freely spoken of as a master of his craft, and, more especially, as a master draughtsman. He was an artist of the highest intelligence and, in consequence, of the most exacting standards, but not, it seems to me, a natural master. Drawing did not come to him as it came, for instance, to Augustus John, as a gift of the

fairies. How poorly, even at the height of his powers, he could on occasion draw is apparent not only in acknowledged failures, but in such a widely admired picture as *The Camden Town Murder* (c. 1907). The torso of the recumbent woman, a confusion of clumsy planes which fail to describe the form, would not do credit to a student; the hands of both the woman and man are shapeless. This picture shows to an extreme degree Sickert's innate weakness as a draughtsman and summariness as a designer against which he fought a lifelong, but in the main glorious, battle. That by the exercise of constant self-discipline and of his superb intellect he made many splendid drawings and painted pictures which are marvels of reflective construction, is an indication of how powerfully the creative will worked in Sickert – a will which drew strength continuously from the difficulties which it overcame.

In the course of Sickert's Camden Town period, which lasted about nine years and ended with the outbreak of the First World War in 1914, his work underwent a radical change. This may be considered a manifestation of the increasing influence in England of Cézanne, Van Gogh, Gauguin, Seurat and those artists who repudiated important parts of the teaching of the revered Impressionist masters. The manner, or, more precisely, the timing of this change was singular, for Continental Post-Impressionism was familiar to Sickert long before its influence was felt in England. Why should he have continued year after year uninfluenced by it until it began to attract the excited attention of his juniors? Sickert's was a highly complex, and, in many respects, secretive character, and this question is one to which I hesitate to give a confident reply, but to which I offer an opinion.

One of the main springs of Sickert's actions was a love of change; of change simply for its own sake. From childhood to old age he would abruptly sever relations with old friends and companions, and welcome new ones; the variations in the character in which he presented himself to the world are legendary. In the conduct of his life he responded with a freedom that verged upon irresponsibility; in his work this love of change is sober and discreet, unobtrusive, but manifest. Sickert had the habit of making friends younger than himself. This was in part due to the desire for change, in part to his passion to teach and to lead the young, and, in so doing, perhaps to renew the illusion of youth. When Sickert settled in North London he began to gather about him a new group of young friends which included Spencer Gore, Harold Gilman, Henry Lamb and a contemporary, Lucien Pissarro, and, later on, Charles Ginner and Walter Bayes. The interest in one or another aspect of Post-Impressionism was electrified by the Post-Impressionist exhibitions held in London

in 1910 and 1912. Sickert, I surmise, was excited by his two-fold love of change and leadership into a belated – as well as a reserved and transitory – participation in the Post-Impressionist movement. When I say 'excited' I am far from meaning 'stampeded': the article he wrote on the Post-Impressionists – which contains a noble tribute to Gauguin in *The Fortnightly Review* in 1911 – shows all his accustomed independence and wisdom.

Sickert's relations with the English Post-Impressionists eventually became embittered, and he left them. The association had, however, lasting effects upon his own work: it led him to heighten his tones, to observe colour in shadows and to lay on paint in small mosaic-like patches instead of long strokes and large patches, previously characteristic features of his style. The end of the Camden Town period includes one especially notable work: *Ennui* (*c*. 1913). Although the picture is lightly painted and has a certain superficial appearance of slightness, it is a scrupulously composed and highly finished work: a work which could in no way be altered nor added to without loss. An air of deceptive simplicity veils the artist's mastery, rather as the unaffected manners of a man of the world may veil his accomplishments. In this picture, with even more than his customary skill, the artist has disguised his own weaknesses; particularly his difficulty in coming to grips with form – in describing it with fulness and precision. Its large scale and noble proportions, however, and the economy of means with which so much is so forcefully conveyed, make *Ennui* the culmination of the entire Camden Town series. Only once again did Sickert achieve so splendid a major work: the *Portrait of Victor Lecour* (*c*. 1922), in which Sickert's finest qualities, his rich, sardonic sense of human dignity; his power of conveying not only the atmosphere of a room, but the life which has been lived in it; his adroitness as a designer; and his vivid understanding of the essence of the European tradition are all radiantly present. I know of no late Sickert to compare with it; I detect, in fact, a steady decline in his powers after the beginning of the First World War, and *The Soldiers of Albert the Ready* (1914) I take to be the first symptom of this. There is much to suggest that his vital powers were waning; there was a change in his method of painting which was profoundly symptomatic of decline. About 1914 Sickert began to rely upon photographs and old prints rather than upon his own drawings and cumulative observations. In the early 1920s he gradually began to abandon drawing, although now and then he produced a drawing or an etching, such as, for instance, *The Hanging Gardens of Islington*, which show all the old mastery. In a letter to *The Times* in August 1929, he asserted that 'a photograph is the most precious document obtainable by a sculptor, a painter or a draughtsman', but he had many years

earlier, in *The English Review*, January 1912, expressed the qualifying opinion that

> the camera, like alcohol . . . may be an occasional servant to a draughts-man, which only he may use who can do without it. And further, the healthier the man is as a draughtsman, the more inclined will he be to do without it altogether.

The decline in Sickert's power did not show itself in a steady diminuendo, but in wild fluctuation. At no time did he paint or draw more finely than in the *Portrait of Victor Lecour* or in *The Hanging Gardens of Islington*, but there are also among his later works paintings in which no trace of his rare spirit is apparent. I do not refer to the failures which every artist abandons or destroys, but to works exhibited, frequently reproduced and authoritatively praised. What, for instance, has *Sir Nigel Playfair* (1928) – a work without a single merit – in common with the other works discussed previously? What are the *Echoes* – with one specified exception – of the late 1930s, but trivial pastiches, barely held together by Sickert's knowledge and taste? Yet so responsible a critic as Sir Osbert Sitwell said that there are among them 'paintings more magnificent than any that the artist had hitherto achieved'. The cause of the acceptance by many people, ordinarily of independent judgment, of any work by Sickert as a masterpiece, however ill-conceived and ill-executed, can only be due to the extraordinary power and fascination of his personality.

His was indeed an elusive personality, remote and detached, yet also entirely of the world, alternately needing to hold himself aloof and to enjoy the bustle of the world and the influence and affection that his manifold gifts ensured. Solitude was necessary for his work; he must also have been conscious that his withdrawals made the enchantment of his presence to be all the more enjoyed – an enchantment which he heightened by his legendary changes of 'character' – from dandy to fisherman or gamekeeper to chef, each one perfectly sustained. Latterly Sickert preferred a free and fantastic version of his 'workaday' self. I recollect, for instance, his coming to meet me at Margate Station in the summer of 1938 wearing a huge, long-peaked grey cap, a suit of bright red, rough material (the coat with long tails and the trousers egregiously ample) and an outsize pair of khaki bedroom slippers. The taxi in which he drove me to his house at St Peter's-in-Thanet resembled, in construction and even in smell, an ancient brougham.

Sickert's presence, which seemed to hold out the promise of the sunniest intimacy, conveyed simultaneously the threat of ruthless sarcasm and cold displeasure. What a fabulous subject for a Boswell! But Sickert had no Boswell, and he moved elusively from one to

another of the painting rooms he collected and showed constantly
differing aspects of his subtle, complex self. Despite an ultimate
heartlessness, he was capable of intimacy – I have rarely read letters
so self-revealing as two or three among those he wrote to my father
in the late 1890s – but intimate relations between him and his friends
were apt to be transitory or intermittent. With his power of discon-
certing by mingled charm and threat, Sickert possessed an extraordi-
narily retentive memory. In consequence he was able to quote at
length and minutely describe in a manner which held his listeners
spellbound – the artists, actors and writers, as well as low-life 'char-
acters' he had known – and to discourse upon the most fascinating
aspects of their private lives or their most abstruse ideas and their
loftiest achievements. It enabled him to draw easily upon a wide range
of reading, for he devoted, I suppose, as many hours each day to reading
as to painting and drawing. (He was as familiar with the classical
writings of Italy and Germany as of Greece, Rome and England.)

Sickert's personal ascendency is now being prolonged by the
republication of his writings. Their incisiveness, independency and
dry, racy wisdom equipped him to advocate the traditional values in
the arts, as Chesterton advocated the traditional values in theology
and morals, so as to delight, even if not to convince, a generation
which has grown up in the belief of the inevitability of continuous
revolution and is apt to confuse novelty with progress. But the effect
of Sickert's writings upon his reputation as an artist may prove
deleterious. For his prestige is now such that to criticize his work
with candour is considered scandalous. However, his reputation as
an artist must ultimately depend upon the best of his Dieppe, Venice
and Camden Town paintings, of his Degas-inspired music-halls,
upon *Victor Lecour* and his best etchings and drawings. The inclusion
of such pictures as the wretched *Camden Town Murder* and *Sir Nigel
Playfair* and the (by any standards) derisory *Signor Battistini* in serious
publications does his memory a grave injustice. For Sickert was at
his best a master of sober and exquisite colour, who could suggest the
atmosphere of places with a certainty and fulness which none of his
contemporaries were able to approach, as none were able to perceive
beauty so abundantly in places and objects generally considered ugly.
Without a trace of idealization, Sickert has the power of showing us
in a row of sooty Islington houses, a piercing beauty. That is true
glory. To claim that he portrayed the life of the ordinary man with
exceptional insight is the starkest nonsense. He produced (I am now
considering his work as he, like Hogarth or Keene, wished it to be
considered, as illustration) merely intriguing vignettes: incidents
which provoke our curiosity. But he could do no more than this, for,
as Roger Fry observed, 'things for Sickert have only their visual

values, they are not symbols, they contain no key to unlock the secrets of the heart and spirit'. Sickert lacked the emotional power that would have given reality to his figures. As it is, they are inert puppets, although marvellously, sometimes touchingly, resembling human beings; but they feel neither hunger nor thirst, neither love nor hate, only, perhaps, indifference, which at bottom was Sickert's own attitude towards his fellow men.

PHILIP WILSON STEER
1860 – 1942

The generalization made in the Introduction about the neglect of English artists does not apply to Philip Wilson Steer. D. S. MacColl's authoritative and spirited biography, tightly packed with information and pertinent comment, is but the epitome of a vast Steer legend. Its innumerable authors range from George Moore to fellow artists and students who, for the first and last time in their lives, added in print to the formidable sum of recorded anecdotes about Steer's idiosyncrasies: his solicitude for his health, his modesty, his love of cats and his inarticulate wisdom. I do not refer to the existence of this legend to question its essential truth, but because the dense aura of 'respect' which it engenders has made the just appreciation of the artist's work more difficult. What is of far greater consequence is the possibility, even the probability, that it had adverse effects upon the artist himself. George Moore's portrait, for example, gives several indications of how heavy with solicitude and adulation the atmosphere around Steer became. Upon the completion of Steer's portrait of his old housekeeper, *Mrs Raynes*, Moore describes, in 'Conversations in Ebury Street' (1924, 1930), how, as he and Henry Tonks stood before it, he asked if the blue vase on the shelf did not seem a trifle out of tone, and Tonks 'said in an awed voice: "It will go down" and begged me not to mention my suspicion to Steer . . .' Moore speaks, too, of friends who 'bring an abundance of love and admiration somewhat disquieting to the master', and he surmises that, in the recesses of Steer's mind,

> If not a thought at least a feeling is in process of incubation that perhaps Ronald Gray's appreciations lack contrast, the humblest sketch being hailed in almost the same words as the masterpiece that has taken months to achieve.

It is not my purpose to provoke scepticism as to the general verisimilitude of the huge, composite portrait of Steer (to which I have myself contributed a detail here and there) which so many of us cherish with affectionate admiration. Personal acquaintance with Steer, extending over a number of years, and the warm friendship which subsisted between him and my parents for the greater part of

47

their lives, have given me opportunities of comparing fact and legend, and observation and direct report have for me confirmed and rounded out the portrait which can be discovered in the pages of Moore, MacColl and its other delineators.

From these there emerges a big, small-headed, slow-moving, comfortable man, a lover of the quiet and the familiar, an impassioned valetudinarian ('Steer dreads getting wet even as his cat', wrote Moore, 'and he dreads draughts; draughts prevail even in sheltered nooks, and draughts are like wild beasts, always on the watch for whom they may devour'). A man with his feet planted firmly upon the material world: an assiduous and successful follower of the fluctuations of the stock market, and an economical man. Yet one who did not allow his preoccupations with property to impinge upon his paramount preoccupation: an instinctive and disinterested collector, to quote Moore again,

> instigated by a love of beautiful things, so pure, that he would collect Chelsea figures and Greek coins though he knew of a certainty that no eyes but his own would see them.

Steer was a man of chaste life but of Rabelaisian humour, usually cosy, but illumined on occasion by a flash of wit. At an evening party, an artist who had lately been charged with an attempt upon the virtue of a servant entered leaning upon a stick. A lady asked Steer what was wrong with the new arrival; 'Housemaid's knee' was his reply. But above all Steer emerges as an instinctive man, according a superficial wondering respect to the intellectual processes of his friends, but fundamentally sceptical of the value of ideas: indeed, for Steer ideas were hardly realities at all. Notoriously, when the talk of his intellectual friends departed from familiar ground – the technique of painting, connoisseurship, gossip – and took a philosophic turn, Steer slept. By instinct Steer was insular, independent, incurious and unimpressionable. As a student in Paris he seems to have had little liking for the French, almost no interest in their language, literature, or history. He did go to see Léon Gambetta lying in state, 'which', he characteristically reported, 'was not anything much'. Steer's ignorance of French, by which he was insulated from Parisian life and which even prevented him from becoming aware of the existence of the Impressionist School, eventually brought his studies to a sudden end. In order to reduce the number of their students, the Ecole des Beaux-Arts imposed the obligation to pass an examination in French upon its foreign students. Steer felt himself unqualifed to sit for it, with the result that, in 1884, he returned to England.

Such, in brief, is the legendary Steer. It is an authentic but superficial likeness, which does no more than hint at an infirmity which is

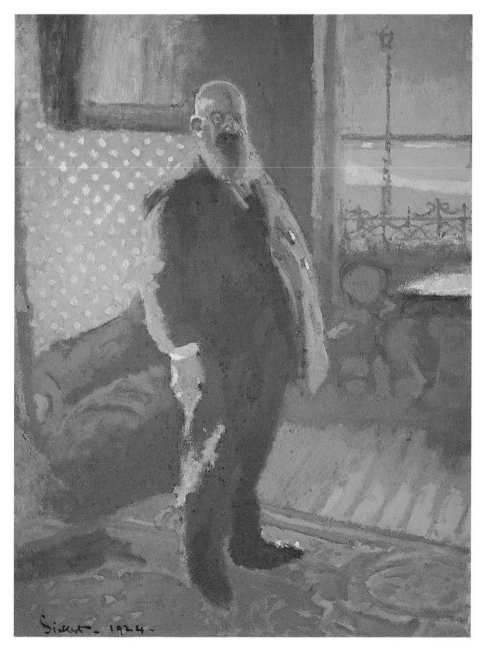

1. WALTER RICHARD SICKERT: *Portrait of Victor Lecour* (1922).
Oil, 23½ × 31½ in (59·6 × 80 cm). City of Manchester Art Galleries.

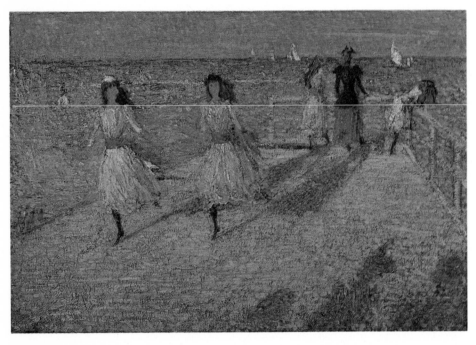

2. PHILIP WILSON STEER: *Girls Running, Walberswick Pier* (1894).
Oil, 24½ × 36½ in (62·2 × 92·7 cm). The Tate Gallery, London.

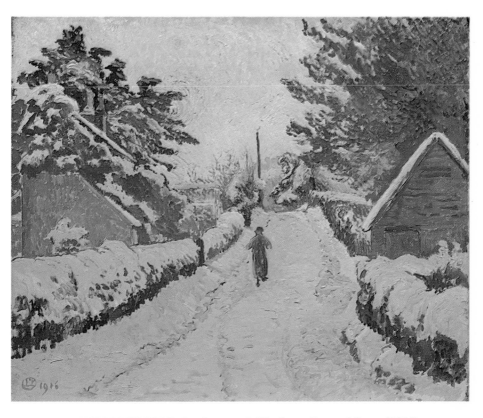

3. LUCIEN PISSARRO: *Ivy Cottage, Coldharbour: Sun and Snow* (1916).
Oil, 20¾ × 24½ in (51·8 × 62·2 cm). The Tate Gallery, London.

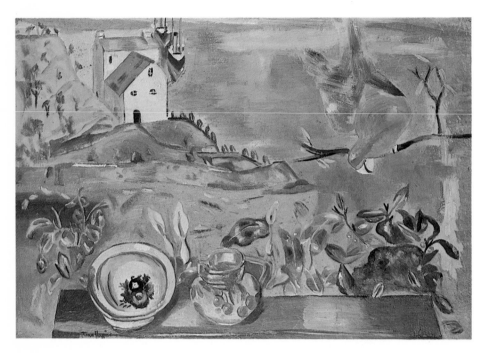

4. FRANCES HODGKINS: *Wings Over Water* (1935).
Oil, 26 × 36 in (66 × 90 cm). Leeds City Art Galleries.

manifest in his art, a radical infirmity of which his aversion from the
processes of conscious thought, from the what Rossetti called 'funda-
mental brainwork', and his sheer incuriosity were symptoms. This
infirmity was a strain of laziness, and it was, perhaps, Steer's
instinctive consciousness of it which disinclined him from any
activity, intellectual or physical, liable to divert his limited energies
from his painting. His other activities were conducted in an easygoing
fashion: he read desultorily; social intercourse, being invariably the
one *qui se laisse aimer*, he was able to sustain satisfactorily with the
minimum of sacrifice and effort.

Steer's duties as a teacher at the Slade School from 1893 until 1930
made even slighter demands upon him. There are stories of students
who, awaiting the criticism of their teacher seated behind them,
turned round at last to find him asleep. If a student said, 'I'm in a
muddle', Steer would reply, 'Well, muddle along then'. Because he
was apt to go to sleep and to make such comments, he was not
without value as a teacher – in fact, quite the contrary. He showed at
moments a power of imparting, by a benevolent, homely phrase,
something of his own instinctive wisdom; and his fame as a painter
and the massive integrity of his presence made what he said
memorable for his students. Like his agreeable social life, teaching
was conducted with the least possible exertion.

Steer's habitual lethargy of mind, and, to a lesser degree, of body,
exercised a far-reaching effect upon his human relations. He pos-
sessed most of the qualities which make a man lovable: a benign
largeness, an instinctive modesty, a slow, unaggressive geniality, an
impressive calm; he also possessed, from early days, the prestige
accorded to extraordinary powers. In most times and places such a
combination of qualities would by themselves have assured him a
sufficiency of affectionate regard; his lethargy immeasurably en-
hanced their appeal, for it put to sleep that most deadly source of
contention between artists, the spirit of rivalry. In spite of his mani-
fest superiority over the majority of the artists with whom, in the course
of his long life, he was associated, he probably excited less jealousy
than any artist of his generation. If often happens that the evident
satisfaction which a successful rival derives from the exercise of his
superior powers is even more provoking to his friends than his
possession of them. Steer not only disclaimed possession of superior
powers; he persisted, sometimes beyond the point of absurdity, in
denying that anybody had ever supposed him to possess them. The
lengths to which he was prepared to carry his pretensions were
exemplified in connection with his appointment in 1931 to the Order
of Merit. He was at first unwilling to accept it, but after much
persuasion on the part of friends he agreed. On the morning when he

received the royal offer he took it to show to Tonks, whom he greeted with the enquiry, 'Have *you* received one of these?'

With equal resolution, Steer disclaimed higher ideals than his fellow artists. He referred habitually to his own activity as 'muddling about with paints' and let it be understood that he regarded painting as an ordinary 'job', like any others, in connection with which the expression of any high ideal was out of place. He once complained of my father, whose exalted sense of the artist's vocation sometimes irritated him: 'Will Rothenstein paints pretty much like the rest of us – but from higher motives, of course.'

Steer's egalitarianism sprang partly from a genuine sense of his own shortcomings confronted with the infinite and never-diminishing difficulties of painting; partly from his instinctive wisdom in withdrawing the huge bulk of his talent as far as possible from the field of contention and thereby preserving it against distracting animosities. This difficult manoeuvre could hardly have been executed more adroitly: Steer, who was scarcely more inclined to put himself out for his fellow artists than he was to criticize them, became the personification of benign modesty. This is apparent from the various authoritative writings about Steer. What has been, so far as I am aware, totally ignored is the question whether his intellectual lethargy, which involved a reluctance to recognize the value – it might almost be said, the very existence – of ideas, was detrimental to his life as an artist. I am persuaded that it was.

Not until near the end of Steer's life did it occur to me that neither the familiar legend nor the accepted estimate of his art, according to which he was the Constable of our day – a Constable who had studied Gainsborough and Turner to some purpose – fully accounted for either his character or his art.

One day in 1942, G. E. Healing, the possessor of a collection of Steers, called at the Tate Gallery with a picture which he was prepared to sell. The picture was *The Beach at Walberswick* (1890). I can still see it clearly, propped up against the pink hessian of the sandbagged temporary quarters into which the staff had been driven by the bomb-wrecking of our permanent offices; I can well remember the electric effect it had upon me. Could anything, I asked myself, be more different than this from the green, opulent, complacent pictures generally accepted as characteristic Steers? There was no hint of greenness, opulence or complacency about the three intent, lanky but rather stylish young girls with their backs towards the spectator, gazing out across a boldly curving spit of sand to a sparkling sea. The elegance and the poetry of the scene had something of Whistler about it, yet more of Elstir, but nothing of the later Steer. And there was a suggestion of Lautrec in the incisively drawn boots of the girl on the

left, and the indication that the long legs of this at first glance ethereal creature are planted on the sand with an almost startling energy. The picture revived the vague admiration I had felt on seeing reproductions of some early Steers in the collection of the late Sir Augustus Daniel, and, upon my earnest recommendation, *The Beach* was purchased for the Tate.

A visit to the Daniel Collection, and above all the opportunity which this afforded of seeing his *Girls Running: Walberswick Pier* (1888), convinced me that here, surely, was the masterpiece of what I had come to regard as the most important period of Steer's production. It is not one of those pictures that imparts a considerable volume of information. It does not touch any of the deeper chords of human experience; still less does it contain any intimation of the life of the spirit. It represents, on the contrary, a spectacle in itself in no way extraordinary: two young girls running swiftly along a pier away from the sea. Yet the whole scene has been apprehended with an almost apocalyptic intensity. It has been seen as though by a blind man given the gift of sight the moment the two girls started to run towards him; it has been set down with visionary splendour. The composition is not remarkable, nor are the figures finely drawn, yet there they are, animated by an odd, incredible energy, racing towards us across the wide planks, the white, broad-sashed, rather formal dresses touched with the glory of the day. They are strange girls: so much is at once apparent; and why are they running so fast? There is something memorable about this picture. Had Renoir painted it, the effect might have been of greater breadth and resonance; if Lautrec, the strangeness of the girls might have been defined for us, yet as it is there is a freshness, an immediacy, an angular, unsophisticated grace which, added to the intensity of feeling manifest in every inch of this picture, make it memorable. Compared with works by either of these or by any of the other great Impressionists, it is marked by something of the lanky candour of adolescence, but it springs direct from the same vital source.

The owner of this picture rejected the overtures I made with a view to its purchase for the Tate, but this made me all the more determined to strengthen the Gallery's representation of Steer's early work. It was not long before other and only slightly less dazzling opportunities presented themselves. The Tate had purchased *The Bridge at Etaples* (1887), a small oil of two figures against a luminous background of lemon and grey river and sky, the year before, but this work, for all its pensive beauty, had not at the time struck me as expressing anything of the audacious vision of the painter of *Girls Running* and *The Beach*; later it seemed to me to be their reticent, less positive counterpart. From the Steer sale at Christie's the Gallery acquired *The*

Swiss Alps at the Earl's Court Exhibition (1887), a sketch in which echoes of Whistler and of Japanese colour prints are dashingly blended, and a much more personal work, *Southwold* (1887). Although it is not in quite the front rank of the artist's early pictures, *Southwold*, more conspicuously than any other early Steer, manifests the exulting spirits, the extremism, by which most of them are marked, and which most sharply distinguished them from all his later work – so conspicuously, in fact, that there was a moment when I wondered whether it could indeed be by Steer's hand. The theme of this picture is also of figures against the sea. The way in which the brilliant colours are laid on in ribbons, rapidly and thick, in immediate response to strong, uncensored emotion enables us to compare *Southwold* without absurdity with a Van Gogh. Steer's emotion is slighter in its volume, less deep and purposeful in its nature, and the ribbons of paint are appropriately thinner, but at the moment when he painted this picture the two artists were not remote from each other. There is something of a trumpet-call of defiance in the excessive size and redness of the head of the schoolgirl on the left: a sign of how little Steer cared for the aggressively complacent opinion of the British public. In MacColl's biography the principal critical chapter is headed by a remark made by Steer to an interviewer: 'They said I was wild.' The biographer's intention in prefacing his final summing up of his friend's achievement and place in history with such an opinion was evidently ironical. Yet what sign of wildness could be plainer than this oversized, empurpled, intrusive head?

During the same year protracted negotiations were in progress for the acquisition of another early Steer. *The Swiss Alps at the Earl's Court Exhibition* and *Southwold* I purchased quite simply on my own initiative at the Steer sale at Christie's, relying upon the enlightened mercy of the trustees of the Tate to confirm my action at their next meeting, but *Boulogne Sands* (1892) was elusive from the first.

When Frederick Brown – Steer's frequent summer painting companion, Tonk's chief at the Slade and a gruff old survivor of the early days of the New English Art Club – died in 1942, I paid a visit to Ormonde House, Richmond, where he had spent the latter part of his life. My expectation of finding some remarkable pictures in the house of this old incorruptible of somewhat circumscribed but intense loyalties was not disappointed. The walls of the dark but finely proportioned room were covered with paintings and drawings by his friends and associates of the New English Club and the Slade. Two of these attracted my attention at once: a small self-portrait by Gwen John, to which I shall refer later, and a large beach scene by Steer. This was in a lamentable condition, but between innumerable cracks and beneath a heavy coat of yellowed varnish, what MacColl had

beautifully described fifty years before when the picture was first shown in its pristine brilliance could still be discovered:

> The children playing, the holiday encampment of the bathers' tents, the glints of people flaunting themselves like flags, the dazzle of sand and sea, and over and through it all the chattering lights of noon – it is like the sharp notes of pipes and strings sounding to an invitation by Ariel.

I told Ellen Brown that I was convinced that this picture ought to hang in the Tate, and she allowed me to show it to the trustees, who were of the opinion that it represented an opportunity which should on no account be missed. After many setbacks the Tate Trustees successfully appealed to the National Art-Collections Fund, by whom, in November 1943, the picture was at last presented to the Gallery. The audacious and sparkling character, the overtone of tense, mysterious exaltation manifest in Steer's early paintings of which I have been speaking – *Girls Running* and in those acquired by the Tate Gallery between 1941 and 1943 – is shared by a number of other pictures by Steer painted between 1884 and 1894. Among the most notable of these are *On the Pierhead, Walberswick* (1888), *The Ermine Sea, Swanage* (1890), *Beach Scene, with Three Children Shrimping, Boulogne* (1890) and *Children Paddling, Swanage* (1894), all three of which belonged to Sir Augustus Daniel, and *Cowes Regatta* (1892).

Now whether these works – according to accepted opinion – are considered to constitute the awkward exploration, under the fugitive spell of Manet and the Impressionists, of a blind alley, or, as I suggest, a splendid beginning precipitately and mysteriously abandoned, the differences between them and the most characteristic works of the artist's later life are so radical as to be apparent to the least practised eye. So radical, in fact, that it would be difficult to distinguish any qualities common to, for example, *Girls Running*, and the characteristic masterpieces of Steer's maturity, *Richmond Castle* (1903), and *Chepstow Castle* (1905), apart from a certain looseness of handling which had become widely prevalent with the diffusion of Impressionist influence. Yet this almost total transformation of Steer's outlook, which appears to me to be the most important event in his life, has remained – so far as I am aware – unnoticed or ignored by all those who have written on his work. This is the case even in the authoritative biography by his lifelong intimate, MacColl. Perhaps the very closeness and continuity of the relations between the two rendered the changes in Steer's subject almost imperceptible to the biographer. MacColl seems almost unaware of the revolution in Steer's vision; a hint here and there, however, suggests that, in spite of his deeply convinced and comprehending defence of Steer's early work when it

was first publicly shown, he regarded most of it as slight compared with that of his maturity. MacColl alludes to the collection of the artist's work built up by Charles Aitken at the Tate as having been enlarged and – evidently with reference to the acquisitions already described – 'even diluted'. Elsewhere he notes with surprise the interest evoked by the early work in the memorial exhibition of 1943.

Even granting full allowance for the inevitable difficulty in distinguishing the changes which succeed one another in the life of an intimate contemporary, there is something singular in the failure of the possessor of so sharp a critical faculty as MacColl, as he looked intently backwards over his friend's life, to note the change in the whole character of his art which took place in about 1900. How could MacColl, who justifiably reminds us of his critical severity towards his friends, have failed to note the contrast between the profoundly purposeful spirit which informs Steer's early works – the intensity of the running girls, the vivacity of the paddling children, the intentness of the seaward-gazing girls, the subdued tension of the couple on the bridge – and the inanity of his later figure subjects? A predilection for inane gestures and vaguely allusive subjects showed itself early in the artist's career. In *The Pillow Fight* (1896) the girl with the solemnly lethargic face aiming the pillow wide of its archly posturing target has been 'posed' so as to be incapable of throwing it at all. For this 'promising romp' MacColl complacently notes that he was in part responsible, having sent the artist a reproduction of a Fragonard as an incentive. In *The Mirror* (1901), described by MacColl as one of Steer's two most memorable double-figure compositions, the attention of the woman reflected in the mirror is elsewhere, nor is that of the woman holding it engaged in what she is doing. In *Golden Rain* (c.1905), and *Reclining Nude* (1905), to mention two at random, naked women – who are never anything but studio models – loll inconsequently in incongruous or indeterminate surroundings.

Writing of these pieces, Steer's biographer extenuatingly alludes to his 'disinterest in event'. Artists have at all times exercised the right of modifying history and nature in the interest of their creations: Veronese could hardly have pushed to a greater extreme of improbability his huge representation of *The Supper at the House of Simon the Pharisee* at the Accademia in Venice; Turner declared that no one should paint London without St Paul's, or Oxford without the dome (*sic*) of the Bodleian. It is nevertheless true to say that the most serious artists have in general modified objective fact for the purpose of making their representation of it more, not less, convincing. Steer's later figure compositions, however, were but the merest pretexts for representing an aspect of nature in which he most delighted – soft, rounded female bodies. So did Renoir, but Renoir's nudes, while they

are hardly more purposefully employed than Steer's, are adolescent girls, with lips parted for an eager intake of breath, or who you know are smiling despite their averted faces; or great elemental women, who might be the mothers of the human race; while Steer's are usually Chelsea models or old men's pets, not made for generation and love.

Because of the sporadic character of Steer's development and the scarcity of evidence as to his innermost convictions about painting, it would be difficult to trace with anything like precision the radical change and, as I believe, the deterioration, of his creative faculties which unmistakably showed itself around the year 1900; yet its causes, principal and accessory, are tolerably clear. It may reasonably be supposed that in Steer's early years the effects of his mental lethargy (and to a less conspicuous degree of body also) were minimized by the exuberance of youth; and by the quickening sense of adventure which belongs to the beginning of the career of an artist of exceptional powers; and by the invigorating wind blowing from Paris. Even in those years Steer seems, as one critic observed, to have responded to the achievements of other masters in much the same manner as he responded to nature. Many of his early paintings clearly indicate the source of their inspiration: the paddling pictures, Monet; *A Procession of Yachts* (1893), Seurat, probably by way of Pissarro; *Mrs Cyprian-Williams and Children* (1891); and the *Self-Portrait with Model* (1894), Degas. In all these pictures, and still more conspicuously in *Girls Running* and others noted earlier, Steer took the work of other painters as points of departure, but in every instance, even in spite of a naive imitation of idiosyncrasies (witness the truncation of the artist's head, Degas-fashion, in the *Self-Portrait with Model*), it may fairly be said that Steer made what he borrowed unquestionably his own. But by 1900, when he passed his fortieth year, his youth lay behind him; painting, if still a continual joy and a continual agony, was no longer a breath-taking adventure. The fruitfully disturbing proximities of Degas, Manet, Monet, Pissarro and Seurat were only memories to be faintly stirred by the endless, reminiscent monologues of his friend, George Moore.

The fact was that Steer had entered another world, a closed world in which the air was stuffy with adulation. Here there was nobody to temper the intellectual sloth which so firmly asserted itself, nor the lazy, good-natured contempt for all investigation into the causes of things. There were, on the contrary, friends forever ready to see something impressive in the artist's defects, and their continual bluff, bachelor jokes depicted him as the great man of action properly indifferent to the chatterings of theorists. Steer's propensity for being sent to sleep by the serious conversation of his friends was a favourite

theme: it was indeed an endearing trait. The harm done to Steer was not the work of sycophants – he was quick to discount anything they said – but of intimates of high intelligence and high integrity, ardently devoted to his interests, whose pervasive attitude could hardly have been without effect. At a critical moment in his life Steer was surrounded and jealously guarded by friends who made an engaging virtue of his deadliest weakness. His very supineness excited a species of possessiveness in them, fierce and enduring. I remember conversations with several of them in the course of the organization of the memorial exhibition at the National Gallery in 1943 (for which I was the official reponsible) not long after Steer's death, and how anger was kindled in them at the idea of anyone outside the little closed circle of 'cronies' concerning themselves in any way with Steer: they had staked out their own claims over the big, immensely gifted but supine personality. In conversation with some of these, a sudden, venomous hiss would warn the unwary that he had unwittingly touched a vested interest in some episode of the artist's life, some personal characteristic or opinion. The impassioned possessiveness of 'Steer's friends' clashed in the extensive but closely contested no-man's-land of the artist's personality.

From the time when I first became convinced of the extraordinary merits of Steer's early paintings until the first of a short series of visits which I paid him shortly before his death on 21 March 1942, the problem of the change in his outlook remained only vaguely present in my mind. Two of these visits I partially recalled in a note in *The Burlington Magazine*, August 1944. Some years had elapsed since I had been to his house, and I was at once aware of changes in him. His eyesight had grown worse; but although he was almost blind it was wonderful to see the ease with which his large figure moved on the narrow stairs and in and out of the rooms, very dark that winter's morning, crowded with pictures and with the miscellaneous pretty objects he had accumulated in a lifetime of collecting. This ease was evidently due to his intimacy with the house where he had lived and worked for more than fifty years.

I had heard, of course, of Steer's increasing blindness, and the courage with which he accepted it did not surprise me. I was, however, unprepared for the comprehensiveness of his interests and still more for his detachment from the opinions and attitudes attributed to him in the legend that has grown up around his name. He showed the liveliest interest in public affairs, especially in the conduct of the war, in history, literature and music. Unable to paint, he listened to the news on the radio, to discussions, concerts, and, daily, to the evening service. 'Flo', his devoted housekeeper, and his friends read to him constantly. And, unlike other illustrious men in their old age, he

seemed interested in the present rather than the past. A lady once said to him that she would like to see the strange world which would take shape after the war; Steer responded with an emphatic 'So should I'.

The satisfaction he took in exercising his mind and reaching his own conclusions without the intervention of his clever friends was gradually made clear to me, by what stages I cannot now recall. One incident remains clearly fixed. I had gone to see him to discuss who should write the introduction to a volume to be devoted to his work in the series on British artists that I was editing for the Phaidon Press. I told him that I believed the work should be undertaken by one of the younger critics, who would attempt to make a fresh assessment of his work in a more detached spirit than would be possible for one of the intimates who had so early discovered and so consistently proclaimed his merits. The energy with which he expressed his concurrence came as a surprise. 'My old friends', he declared, 'have written well about me, and I'm grateful for their encouragement, but they've written enough.' I then explained that the person I had in mind previously had made no special study of his work and would even approach it in a positively critical spirit, but he was well-equipped to consider it against a broad background of European painting. 'He sounds to me just the man', Steer said, his face lighting up. 'Who is he?' I said that he was Robin Ironside, a colleague at the Tate. 'Very well then: bring him to lunch, any day you like.' Then, as though welcoming an occasion for speaking about matters which had troubled him, he referred to the project for an authorized biography, which I knew had been under consideration for some time. 'The idea of my life being written doesn't appeal to me', he said. 'Lives have a way of leaving out what's really important. Perhaps they have to.' Referring to various writings on Tonks, he said:

> Tonks was a big man, and big men have conspicuous faults as well as conspicuous virtues; but there seems to have been a sort of conspiracy to discount Tonk's faults. In any case, my own life has been very pleasant, but not very interesting. But my friends tell me that something of the sort will eventually be done, and that it had better be done by someone I don't disapprove of too much, and I expect they're right. There's one thing, though, I'm clear about: I don't want it done by someone who's already said his say about me. I'm tired of the old opinions, the old stories. In the last years, when I've been more alone, I've come to see many things differently; there are things I've only just begun to think out.

The impression Steer's attitude made upon me at the time was that, in spite of his affection and admiration for Tonks, he derived a

conscious satisfaction from his present independence of the influence of a friend whose energy, strength of purpose and intellectual grasp so far exceeded his own. This I placed on record in my *Burlington* note, but because of Steer's recent death, the occasion seemed inappropriate to me for dwelling upon imperfection in a complex of friendships of a singularly wholehearted and enduring character. Nor would I do so now were I not convinced that Steer had come to recognize the source of these imperfections; to realize that certain of his intimates, by flattering his supine attitude towards the 'funda-mental brainwork' necessary to the perfection of the work of even the most instinctive artists, and by persistent argument, had impaired the activity and narrowed the range of his mind, and had imposed their own ideas upon him, to the detriment of his art. Certainly Steer never seemed to lose an opportunity for qualifying his affectionate loyalty to his old friends by an attitude of marked detachment from them, and most emphatically from their opinions. To me, familiar with the solidarity and the exclusiveness of the circle in which Steer was enclosed ever since I was of an age to speculate about human relationships, these utterances were a surprise. It was they which caused me to question those parts of the legend which represent Steer as an artist so unerring in his intuition as to have no need for a reasoned apprehension of things. It became clear to me that Steer, no longer able to paint and brooding upon the past, had become aware of the baleful role which some of his friends had played in fostering his intellectual inertia.

Even if the jealously possessive circle in which he lived after the 'cronies' had closed in upon him, and the numbing blend of adulation and bluff fun disposed him to ignore the causes of things – even the causes of the effects in which he most delighted – and robbed his figure painting, especially, of the vivid purposeful character which had distinguished it, he remained nevertheless a memorable figure, and one of the great landscape painters of our time. Such is the opinion of his painter-friends and of the critics, accepted by a substantial part of the public which concerns itself with painting.

Steer's reputation is so high and the fervour of his advocates so fierce, that to dwell upon the shortcomings of his art is to invite the imputation of questionable taste. For those prepared to brave this it is necessary to insist that Steer lacked the artistic will of the greatest masters, and that he was tempted too readily to see nature in terms of other painters. I remember how easily visitors at the memorial exhibition of 1943 recognized which master he had unconsciously in mind in representing given subjects. The absence of a consistent personal vision left Steer without a firm basis for logical and sustained development, while his lack of intellectual convictions and his

delicate receptivity were apt to leave him at the mercy of chance memories. Few phases of his art, therefore, bear a logical, necessary relation to those which precede or follow them. But although a highly personal vision and logical growth may be said to be characteristic of the great masters, the relative lack of both in Steer does not invalidate the high claims put forth on his behalf. The art of Delacroix was affected no less than that of Steer by the art of other masters; the unfolding of Turner's vision, owing, among other causes, to his love of emulation, would seem to have been as arbitrary at many points.

There were moments when Steer, inspired not by particular works but rather by the spirit of Constable and Turner, painted landscape in which piercing observation goes hand in hand with a splendid poetry. I have in mind, besides such masterpieces as *Chepstow Castle* and *Richmond Castle, In a Park, Ludlow* (1909) and the two versions of *The Horseshoe Bend of the Severn* (both 1909). Turner taught him to see the majestic, rhythmical and glowing qualities in landscape; Constable the beauty of noonday light, the glistening surfaces of wet foliage and grass, and the contrast between white cloud and angry sky, between rainbow and thunder-shower – in fact, the living texture of nature. In these majestic, darkly tempestuous or glowing landscapes, traces of a devoted discipleship of Rubens and Gainsborough may be discerned.

In his mid-fifties, a change of style, corresponding to an inevitable ebb of physical energy, became apparent in Steer's work. The epic mood and the massive, mottled surface were slowly dissolving into something approaching the opposite: a long series of landscapes frankly inspired by the lyrical, thinly and limpidly painted sketches made by Turner as a result of his last visit to Rome twelve years before his death. Of the scenes Steer made at Harwich; at Bosham in 1912–13; of Shoreham, 1926–27, misty, subtly coloured visions, it would be no exaggeration to say that they are a worthy tribute to the miraculous originals of the master to whom he was faithful to the end. These subjects are closely related to his productions in water-colour, a medium he used from about 1900, at first occasionally and then, as he abandoned the practice of completing large canvasses outdoors, as a means of accumulating material for works to be completed in the studio. Steer became entranced, however, by the medium itself and was gratified by the success it brought him. Eventually he evolved a remarkable style, compounded of Turner, Cozens, Claude, with a faint but intriguing touch, as Tonks noted, of the Oriental, and dependent upon an astonishing dexterity.

Towards the close of his life, Steer's watercolours had come to be widely regarded as his principal achievement. In spite of the almost miraculous quality of the finest of them, I believe this to be a mistaken

view, and that his fame will ultimately rest securely upon three phases of his paintings in oils: his early figure subjects, the epic landscapes of his early middle years and the liquid, lyrical visions of his old age; and a single portrait: the tenderly wrought face and figure of his grim housekeeper, *Mrs Raynes.*

ETHEL WALKER
1861 – 1951

Camille Pissarro was quoted earlier as describing Impressionism as a way of seeing compatible with the free play of the imagination. However, he expressed this opinion at a time when, under the promptings of Seurat, he had lately become convinced that the *original* Impressionism – by its acceptance of the accidently discovered scene and of the necessity for completing the picture on the spot before the light changed; in a word, by its acceptance of the *sketch* as the highest artistic ideal – did by its very nature circumscribe the imagination. Pissarro made the assertion, in fact, with the new, consciously constructive Impressionism in mind, of which he was just then a transient advocate, rather than the earlier movement. It was clear enough that the latter was not readily compatible with a deeply ranging imagination. After its first wonderful flowering and within the lifetimes of its founders, it was rejected by the most imaginative of the younger painters, and eventually dwindled into the most tepid and unexacting of academic traditions.

Ethel Walker was the most senior of those English painters who were impelled by an imaginative temperament to reject Impressionism; or, rather, to modify it radically to suit her own highly personal ends. In her sense of the primacy of light she was innately Impressionist, but the golden age of her highest imaginings could not be represented with sufficient clarity by a system of tones; it demanded contours.

In the chapters on Sickert and Steer I was able to proceed quickly to the consideration of their work. Both were well-known personalities; both are the subjects of illuminating biographies, as well as of extensive mythologies. Ethel Walker was certainly 'the best-known woman artist', but there has been no serious attempt to appraise either her art or her personality; or even, so far as I have been able to ascertain, any attempt at all. In order to find out what had been written on the artist, I visited the two principal art libraries in London. The subject index of one recorded the existence of four catalogues of one-woman exhibitions; the other a single sketchy article in a then-recent issue of a monthly periodical. Not much after nearly ninety years' original, aggressively independent living, after more than sixty years of increasing and effective dedication to

painting. And now it is too late to obtain first-hand certain important facts about her life and opinions.

The last time I saw Walker, during the early days of 1950, it was plain that her memory had failed. She was able to recollect little and confusedly, except for a few incidents which she cherished as landmarks in the gathering darkness rather than for their intrinsic worth. One such was connected with the first occasion when she exhibited a picture. I had picked out from among the many curled and yellow photographs that were propped against the mirror above her mantelpiece, one of an interior with a girl wearing a long white dress turned away from the spectator. It was from a painting, I explained, which I had long regarded as one of her best, but of which I had never seen the original. 'Oh, I'm glad you like that,' she said, 'it's very beautiful. It belongs to a relative of mine, to – I can't remember his name. It was the first oil painting I ever made. There was an exhibition in Piccadilly. At the private view George Moore came in and looked attentively at something of mine. "You've got somebody new who's good," he observed to Steer. "There she is," Steer answered. "Come over and meet her." At that time I had no studio, so Moore invited me to his flat at Victoria Street, and told me I might work there whenever I wished. So one day soon afterwards I brought a model from Pulborough in Sussex, where I was living, and took her to Moore's flat. No sooner had we arrived than a dense fog closed down. We tried a pose or two, but it was almost dark. "It's no good," I said to the model in despair. As she turned away she took so beautiful a pose beside the fireplace, with her full white dress flowing away behind her, that I was inspired, and set feverishly to work in spite of the darkness.'

Where the exhibition was held she was unable to recall. It was probably at the Dudley Gallery, where this particular picture, entitled *Angela*, was shown in 1899. This is not only a beautiful but a mature painting, and cannot possibly (quite apart from Walker's admission that Moore had been attracted by a previous work) have been her first. I would have liked to have asked her about this and other matters, but I was reluctant to tax her failing memory.

I shall not forget that last sight I had of Ethel Walker. The previous November she had held the last exhibition of her work in her lifetime at the Lefevre Gallery. She was very old; she was illustrious; she had not long since ceased to paint, but the exhibition was virtually ignored by the public and the press. I had learnt that she was ill and indigent, but I should have been surprised to find her discouraged, for no artist I have known has ever felt so assured of the immortality of her work – or of the salvation of her soul.

When I came into her studio, unannounced and, for a moment, unheard, the scene before me epitomized Walker's confident delight

in the work of her own hand. She crouched beside an iron stove in which a large fire glowed in order to keep warm, but sideways, so that she could look out into the room. All round, on easels, propped against and on chairs, in fact on every level surface with some kind of support behind it, stood a dense and various assembly of her paintings and drawings, every one of them turned towards their creator as a flower towards the sun. She gazed at them enrapt, with pride and wonder. For her, in that dark afternoon, they shone like stars in the firmament. The scene lasted for but a moment. Seeing me, she got up and welcomed me, as though she had received an eagerly awaited visit from an intimate friend, instead of an unexpected visit by an old acquaintance. Presently, forgetting her age and infirmity, she was lifting and moving her pictures to enable me to see them in the best light, just as she had when I first called upon her in that same house nearly twenty years before. Perceiving the admiration which her activity aroused, she abruptly told me her age. 'I'm eighty-six. I was born on 9 June.' 'Were you eighty-six last birthday?' I enquired. 'Last birthday,' she said. That made 1863 the year of her birth; previously she had given it as 1867. She was born, in fact, in 1861.

Except for the orientation of the pictures, the large L-shaped studio overlooking the river on the first floor of 127 Cheyne Walk, which she had occupied for the past forty years, was little changed. It had silted up with her miscellaneous possessions, odds and ends of china, medicine bottles, photographs, letters and the like, and the dust had settled still more thickly upon them. It was typical of the room that the reflections yielded by the few mirrors it contained, although these were not particularly old, were foggy and reluctant. The room had changed little because its occupant had changed little. She had grown smaller, forgetful and infirm, but these were superficial changes: the deep voice, the courage, the benevolent indifference towards other people; the restless energy and, above all, the unquestioning conviction of her own greatness, were as conspicuous as always. This conviction was always expressed so frankly that each new manifestation of it had long been received with a partly admiring and partly malicious enjoyment. As a member, for instance, of a hanging committee of an exhibition, she would remove pictures already hung in favourable positions, replace them with her own, and walk out with an air of satisfaction at having contributed rather more than her share to the collective wisdom of the assembly. She would write to me from time to time to suggest that this or that picture in some current exhibition would be a particularly appropriate addition to the national collection. 'I would remind you', she wrote on one occasion, 'that every purchase of my work strengthens and enriches the sum of good pictures at the Tate Gallery.'

The declaration of her belief in reincarnation, repeated several times during this last visit of mine, gave me a less unsympathetic insight into her limitless vanity. In support of it she quoted Walt Whitman: 'As to you, Life, I reckon I am the leavings of many deaths'; she advocated it as the only valid explanation of genius, of all superior qualities. Therefore she regarded herself not so much as a unique phenomenon, but as the last of a long succession of previous 'incarnations', to whose remarkable merits she owed her own. Her pride, as I now understand it, resembled the family pride of the aristocrat rather than the wholly self-regarding pride of the upstart. But how constantly and how candidly she displayed it! I have never seen anyone so transported with delight by pictures as Ethel Walker was by her own. Such exclamations as 'That's beautiful, isn't it?', or 'Even though that is a little sketch, it has the scale of a great picture' formed a continuous paean of praise. She was sublimely confident that the admiration of others equalled her own. When one of her aunts died, the widower reproached her for neglecting to send a letter of condolence. When at last she wrote, it was to say that she was 'very sorry that Aunt Maud did not live to see my *Resurrection*, as she would have loved it so'. And when Steer died she said, 'Now he and Sickert are gone I'm the only artist left.'

Late on the afternoon of my last visit the fire of life died down in her and I prepared to leave.

> I owe a good deal to Sickert. He confirmed me in the habit of working fast. I've always worked fast, especially when I'm painting the sea. Sometimes, at Robin Hood's Bay, I've waited for weeks for a certain effect, a harmonious fusion of water and cloud. When it comes I rush to my canvas and paint furiously with the tide, for the sea and the sky won't wait for me, and, when the effect has gone, I never touch the canvas again. And Sickert taught me to paint across my forms, and not into them. I once said he was generous with his knowledge. Sickert, hearing of it said, 'But she never takes any notice of what I say.'

The deep voice died away and we said goodbye. As I stood by the door and turned for a last look at the small figure in the red jacket and gilt buttons, white blouse and black bow tie, crouched once again over the fire; at the amphitheatre of pictures and all the disorderly accumulations of forty years, scarcely visible now in the failing light, she spoke again, quietly, without looking round: 'A painter must be brave, must never hesitate. Timidity shows at once. I've always been brave – but now I've given away my palette and brushes.' She had nothing more to say and I went out quietly. I never saw her again. She died in that house on 2 March 1951.

*

When we consider Walker's character – her freedom from the ordinary conventions, her fanatical independence, her habit of uttering uncensored thoughts and her domineering ways – it is perhaps odd that she led so relatively tranquil a life. It is now fashionable to assume that artists live entirely for their work, which constitutes their only relevant biography. I remember hearing H. G. Wells assert that the life of the average commercial traveller was more eventful than that of the most adventurous artist. But that is not invariably the case. The life of Sickert, for example, would make a fantastic saga comprising half a dozen secret lives, fascinating relationships with the illustrious and the forgotten; nor has the life of Augustus John been barren of event. Even Delacroix, who led, if ever a man did, a life dedicated to art, confessed that in his earlier days 'What used to preoccupy me the least was my painting'.

That Walker's impact upon her generation has been slight (the only influence she has exercised has been upon the gifted spinsters, the 'matriarchs' of the New English Art Club) and her life little more eventful than Steer's, is due to the completeness of her self-absorption. People affect others principally because, consciously or not, they wish to. Her self-absorption was such that, given models and the sea to paint and a generous ration of admiration (and some dogs), she could have lived happily, so to speak, in a vacuum. She looked attentively at reproductions of the cave paintings at Ajanta, at the Blessed Angelico, Botticelli, Whistler and, longest of all, at Puvis de Chavannes, the Impressionists and Gauguin. And she looked with tender respect; yet these works were important in her eyes not so much on their own account as incitements to her own imaginative life. She spoke of her friends, however interesting their personalities, solely in relation to herself. Of George Moore, for instance, I once heard her say: 'He was in love with me; he tried to get into my bedroom and I threw him down the stairs. "You have the affection of a porcupine", he protested, "unconscious of its quills as it rubs against the leg of a child." ' But Walker's profound self-absorption was not inconsistent with constant and practical kindness to the afflicted and to animals. Of all religious bodies she most approved, I think, of the Salvation Army, on account of its special solicitude for the poor.

Ethel Walker was the younger child of Arthur Abney Walker, a Yorkshireman, and his Scottish second wife Isabella, born Robertson, widow of a Presbyterian minister. At the time of Ethel's birth her parents resided in Melville Street, Edinburgh. One of her ancestors, Hephzibah Abney, had assiduously practised the art of watercolour: his daughter, Elizabeth, married her first cousin, Henry Walker, of

Blythe Hall, Nottinghamshire, and Clifton House, Rotherham, and their son, born in 1820, was Ethel Walker's father. The Walkers were ironfounders, and built old Southwark Bridge. In about 1870 Arthur Walker left Clifton House, the large, bleak building where he was born and which now serves as Rotherham's municipal museum, and settled with his family at Beech Lodge, Wimbledon. Ethel attended a strict but excellent school kept by the Misses Clark in the then-rural neighbourhood of Brondesbury. Here she attracted the particular attention of Hector Caffieri, the drawing-master, who was the first person to encourage her tentative but growing interest in painting. His connection with the school came, however, to a sudden end: a train in which the Misses Clark, accompanied by a number of favoured pupils, were travelling with edifying purpose happened to draw up beside another train, in which Mr Caffieri was observed seated in a third-class compartment smoking a pipe. The Misses Clark thereupon decided there could be, of course, no question of a person capable of such conduct being permitted to continue as a member of their staff.

About this time Ethel formed an intimate friendship with a girl named Claire Christian, whose family were neighbours of the Walkers in Wimbledon. Claire Christian shared Ethel's principal interests, and one consequence of their friendship was a heightening of their preoccupation with the arts. About 1878, in the company of an aunt, Ethel paid her first visit to France. In the early 1880s she attended the Putney School of Art with Claire Christian. By this time art was her vocation: after a day's work at the school the two girls assiduously studied anatomy and drew from casts of Greek sculpture. Later they visited Spain together and made copies after Velazquez in the Prado. On their homeward journey they stopped in Paris, and, prompted by George Moore, saw the work of Manet and the Impressionists for the first time.

Early in the life of most artists there comes the miraculous moment when they look upon the work of a great master with understanding. I have more than once heard Ethel Walker declare that Velazquez taught her to paint. It does not appear to me that Velazquez affected her painting in any perceptible sense, and I am inclined to think that her often repeated avowal of her indebtedness was not a recognition of any specific debt, but of her awakening to a realization, under the first impact of his genius, of all that painting could signify.

Although she was adored by her mother and her old nurse, the atmosphere of Beech Lodge was not conducive to Walker's studies: with Claire Christian she went into lodgings in Wimbledon, and later rented a cottage at Pulborough in Sussex. She worked under Frederick Brown at the Westminster School, and followed him to the Slade

School in 1892 when he was appointed to the professorship, where she remained for two years.

Ethel Walker's early life presents one curious feature: she seems to have been talented, and from an early age she seems to have been possessed by the idea of becoming a painter. Her family's circumstances freed her of the necessity to support herself; she was endowed with a singular power of will. How was it, then, that, in these highly propitious circumstances, her beginnings were desultory and she came to maturity late? She had reached her late twenties before she went to the Putney School of Art; she was over thirty when she followed Brown to the Slade. The painting which she described to me and to others as her first, *Angela*, was probably done, as it was certainly shown, in 1899 when she was nearly forty. To this question I can offer no answer. But once Walker had reached the degree of maturity represented by *Angela*, she developed rapidly in a highly personal direction, and won an increasing measure of recognition among her fellow painters.

Angela is an example, although an admirable one, of a kind of painting that was being done at the New English Art Club, rather than an individual creation. The subject – a girl in a white dress – comes straight from Whistler, the Club's irascible patron saint, only it is represented, quite consciously, in a rougher, more homely style than the Butterfly's: the interior is less deliberately arranged, the thick paint is more loosely applied. It would not be difficult, in fact, had it borne their signatures, to accept it as the work of Steer, Tonks or of several other leading members of the Club.

It was not long before Walker abandoned her preoccupation with the representation of figures solidly modelled in sombrely lit Victorian interiors. The best of these paintings exhibited a truth of tone, a grasp of form, a grace, and a bold, easy handling of paint which gives them a place only just below the best of their kind, Brown's *Hard Times* or Steer's *Music Room*, for instance. But they are no more than admirable essays in a kind of painting already fully evolved, and even display symptoms of exhaustion.

The paintings of Walker's maturity differed in every important respect from those of her apprenticeship. Instead of representing facets, shadowy or shady, of the real world in terms of what might be called the common vision evolved by the New English Art Club, she became absorbed in the contemplation of a golden age of full if gentle light, which she represented in a highly personal fashion. Instead of the building up of solid form, she now aimed at the creation of forms which were delicately shimmering and evocative, rather than descriptive; and, more generally, at an art not based directly upon observation but upon observation frankly transformed by a poetic imagination.

Here I am thinking chiefly of what I consider to be her principal works: namely, her figure compositions, for in a considerable part of her painting – in a quantitative sense, indeed, the larger part – she continued to represent the visible world. But like her compositions, her later portraits of girls and paintings of the sea – her two favourite subjects – reflected the radical changes which transformed her outlook during the first decade of the new century. Like the compositions, they are no longer modelled in terms of light and shade, but in delicate and brilliant colour; her preoccupation with surface design is more, and with design in depth, less marked.

The transformation in Walker's art was due to two factors: the impact of Impressionism from without (the love of brilliant colour which she first learnt from the Impressionists was strengthened by her contacts with the Belgian painters de Smet, Jeffreys, Claus and Hess when they were refugees in England during the First World War) and the steady growth of her vision of a golden age within. From Impressionism she learnt how to illuminate groups of virginal figures in their vernal settings which became more and more the focus of her most intense imaginings. Although the influence of the Impressionists upon her was mainly technical, the contemplation of their sunlit landscapes must also have illumined her inward vision. In her pictures painted directly from life – the long, enchanting series of portraits of girls and of agitated seas off the Yorkshire coast – she showed herself a disciple of the Impressionists, but in her imaginary compositions too she used some of their technical methods: direct painting in small disjointed brushstrokes of pure colour without subsequent retouching, besides modelling in colour instead of tone, but for purposes remote from theirs. Her frankly ideal visions of a golden age, elaborately constructed and painted in her studio from studies, had little in common, except their colour, with the objective studies of the Impressionists in which the thing seen was accepted with slight modifications and completed on the spot. What I have called the golden age of Walker's imagining was not in itself an original conception; it had haunted the imaginations of numerous European painters ever since the Renaissance. Of Walker's older contemporaries, Puvis de Chavannes had portrayed it with most conviction, and he must therefore be counted among the chief of her masters.

The two paintings in which this vision is most completely expressed are *Nausicaa* (1920) and *The Zone of Love* (1931–33), both imaginative compositions. Like all her compositions, these were based upon numerous drawings made from carefully posed models, freely transposed into an imagined world of beauty: a rainbow-hued springtime world peopled by slender young girls, naked, dreamy and

innocent. These two big, tenderly wrought paintings are original creations.

In this ideal world the spirit of Walker was ecstatically at home, but how delightful a contrast it made with the studio in which her earthly body had its being – with the accumulated disorder, the long-gathered dust. How much nearer to reality was that other world in her eyes; how oblivious she was of her earthly surroundings was suddenly revealed to me when she exclaimed: 'I can't work today. I'm like the old Chinese artist who couldn't work if the smallest particle of dust in the air annoyed him.'

HENRY TONKS
1862 – 1937

A conversation which took place in 1892 between Frederick Brown, the recently appointed Slade professor of fine art at University College, London, and a thirty-year-old doctor named Henry Tonks, to whom he presently offered the post of assistant at the Slade School, had important results. The doctor abandoned his profession and became a painter and draughtsman, also a teacher of drawing – the most inspiring and influential, in fact, of his generation. This alone would entitle him to a place in the history of English art. But I make no apology for noticing Tonks in these pages as an artist in his own right as well.

Tonks was a phenomenon that has become rare almost to the point of extinction – namely, an academic artist. And by academic artist I do not mean one who supinely accepts whichever of the well-established conventions happens currently to prevail, but one whose art is based upon traditional canons, clearly apprehended. During the past century or so academies have become more and more conspicuous for their disregard for the fundamental traditional values; it is therefore no accident that when the real academic artist, the Alfred Stevens, the Henry Tonks, does appear, he is rarely counted among their members. Always traditional and scholarly in his orientation, Tonks deliberately chose his side when the values upon which the art of Europe had previously been based seemed to him to be challenged. Throughout his life as an artist he was an assiduous and reverent student of the methods of the great masters.

Tonks was a late-comer to art, and the road he followed, as he himself has told us, was a strangely devious one. The fifth of eleven children, he was born on 9 April 1862 of a solid, cultivated family, the proprietors of a brass-foundry in Birmingham, at nearby Solihull. There must have been many illustrated books in his father's library, as the son claimed to have been familiar 'from infancy' with the draughtsmen of the 1860s, with Charles Keene and Wilhelm Busch and, thanks to the catalogue of the 1857 exhibition at Manchester, with the Pre-Raphaelites. Sadistic ill-treatment at the High Church preparatory school to which he was sent left Tonks with a lasting aversion to dogmatic religion; at his public school his career was

undistinguished and he was scarcely less unhappy. 'I only began to live', he declared in old age, 'when I left that damnable Clifton.' His interests shortly turned towards medicine, and in January 1880 he entered the Sussex County Hospital at Brighton as a pupil. At school he was aware of a vague attraction to the artist's life, but there is no record of his having shown a special predilection for drawing. However, he early-on possessed one faculty invaluable to an artist: a retentive visual memory. How precisely and vividly this enabled him to evoke, years later, incidents from boyhood and youth! The particular use, for instance, of the cane by the headmaster of his preparatory school Tonks described in an article in *Art Work*, 1929:

> He was a tall, powerful man, and he had an ingenious way of lifting the boy up the better to adapt his clothing to the punishment, and swinging him round at the same time, so that all could see the result of his prowess.

Or the early stirrings of romantic sensuality in a letter to a friend:

> If I had met you, as I did not, as a little girl going for a walk in Kensington Gardens, that spot would have remained sacred for me, just as the sea end in Montpellier Road, Brighton, has a meaning for me, because once I saw up the street a girl who excited my passions (my word, she was a dull girl really but just like a ripe peach).

At Brighton Tonks made drawings which he attempted without success to sell at half a crown apiece from the window of a small shop; he also made his first attempt at painting, which he quickly abandoned in discouragement. Eighteen months later he transferred to the London Hospital, where he remained for three years, devoting himself to anatomy and physiology. During this time he became more and more absorbed by drawing, taking both the living and the dead as his subjects, until it gradually became his ruling passion.

One winter Tonks visited Germany. One of the critical moments of his life occurred at Christmas in Dresden (again I quote from the article in *Art Work*):

> One of my family sent me as a present 'The Life of Randolph Caldecott'; the flat in Moscincksy Strasse, my room, the position in it of the bed, and the moment of the night when I read how he had, almost by chance, from being a bank clerk, found the way to become the charming artist he was, come back to me with extraordinary vividness. I will not say that I registered a vow at that moment, but the determination of making myself into an artist then became fixed.

Although he won his fellowship of the Royal College of Surgeons and was appointed senior resident medical officer at the Royal Free Hospital, on his return Tonks quickly found his way to the 'truly comic and dirty little studio', as he described it, 'which under

Frederick Brown became the centre of a revolution which has done much to destroy the powerful vested interests of those days', the London County Council's Technical Institute, Westminster. The association between Tonks and Brown led shortly to the appointment, referred to earlier, which had a decisive effect upon his career and upon the draughtsmanship of several generations of students in England.

For the rest of his life Tonks was obsessed by having reached the age of thirty before he was able to devote all of his energies to drawing and painting. The disadvantage under which he fancied himself to labour on account of this late start seems to have aggravated his innate diffidence and the strain of irascibility he inherited from his father, for he became, especially where his drawing and painting were concerned, a secretive and touchy man. Criticism of any kind was liable to provoke his resentment and to bring him to the point of despair. No doubt unknown to them, his angry suspiciousness must have been provoked continually by three of his most intimate friends: Steer, on account of his wonderful natural gifts; George Moore, notorious for a strain of obtuseness in his human relations; and D.S. MacColl, most inveterately critical of men. Moore's criticisms corroded the friendship of Tonks, to whom his death, as he confessed to his intimates, came as a relief. MacColl's more deeply informed judgments sometimes caused coolness between the two, but they also bore positive fruit in a series of watercolours, *Mr MacColl visits Heaven and Criticizes*, made during the First World War, which exhibits Tonks's satirical humour and flexible draughtsmanship.

Irascible suspicion, an ingenuity in finding pretexts for offence, with its issue in coolness, quarrels and separations, pronounced though they were, did not dominate Tonks's relationships. He possessed, on the contrary, a particular talent for friendship. In social contacts of a casual or routine order he was inclined to be sarcastic and aloof; he was mostly content to reserve his sociability for the friends of his choice. These he met constantly and maintained a regular correspondence, sometimes, late at night, pursuing by letter the subject of a conversation only just ended. During the latter part of his life Tonks set aside a part of each day, often as much as two hours, for correspondence with his friends. Of them the closest was Steer, for whom he showed a devotion which never wavered. Among others with whom he was particularly intimate at one time or another were, besides Moore and MacColl, Sir Augustus Daniel (already mentioned as the possessor of the finest of Steer's early paintings) for whose judgment he had an exceptional regard; the brothers Laurence and Leonard Harrison; Sargent's sister, Mrs Ormond, and my father – for whom his friendship suddenly turned to enmity, apparently

upon the unwarranted suspicion that he had written a flatterng letter
to Sargent with a view to securing his election to the Royal Academy
– C. H. Collins Baker, and, towards the end of his life, St John and
Mary Hutchinson.

The duality in Tonks's nature, which revealed itself in a capacity
for friendship of the most constant intimate kind, together with a
proneness to suspiciousness, secretiveness, jealousy, touchiness and
even malignity, was evident in other contradictions. A dour, puritan-
ical strain, revealed by the thin-lipped, sour mouth, the chilly stare,
and a fussiness in the ordering of his daily life (he smoked, for
instance, at fixed times of the day, usually with reference to his
watch), seemed incongruous with Tonks's sometimes Rabelaisian
humour, the faint strain of impropriety apt to reveal itself in his
conversation, and the sheer prettiness of much of his art.

His relations with his students were mostly as happy as they were
fruitful. The famous sarcasms, which provoked so continuous a
profusion of tears among the women students, and for which he has
sometimes been blamed, caused little lasting pain, and were, in fact,
a characteristic expression of an exhilarating personality whose
impact upon the Slade was that of a bracing wind. To students whom
he considered to be of promise, in particular, his kindness was
proverbial, although his ability to distinguish great talent from
promise was far from unerring. He recognized the genius of Augustus
John (whose influence as a student at the Slade exceeded his own)
with reluctance, while the modest geese whom he acclaimed as swans
were many.

Tonks was so quintessentially, so almost, on one side of him,
parochially English that the discovery that he read the French
intellectual periodicals with diligence, and was conversant with the
ideas of Valéry and Proust seemed to me, in spite of the voracity of
his intellectual appetite, as hardly less odd than the knowledge that
one of the most intense and solemnly high-minded of my painter
friends not only never missed the now discontinued 'Radio Rhythm'
programme, but was familiar with the careers of even minor compos-
ers of 'swing' music.

During the years 1910 and 1912 there occurred events, which will
be described at a more appropriate place in these pages, which had
a decisive effect upon Tonks's outlook, and upon, perhaps, the
majority of his generation. These were the two exhibitions of Post-
Impressionist painting held at the Grafton Galleries, at which the
work of Van Gogh, Matisse and Cézanne was first introduced to the
British public. Until that time, Tonks's eager intelligence had ranged
freely among the arts, in general taking a logical and rather detached
view of things. The New English Art Club – where he first showed in

1893 and with which he was closely identified – although conservative by Parisian standards, had been a rallying point since shortly after its formation for the most brilliant and adventurous talents. Tonks therefore inevitably counted himself a man of 'progressive' affiliations and sympathies. The presence of serried ranks of Post-Impressionist pictures, fiercely coloured, vehement, harsh, and, to an even greater degree, I imagine, the general aesthetic theories deduced from them by Roger Fry and their other sponsors and supporters, provoked a violent revulsion of feeling in Tonks which resulted in a settled antipathy towards contemporary art, and the conviction that it was the negation of the traditional values to which he had pledged his loyalty. 'I don't believe', he confessed to Daniel, 'I really like any modern development.'

By 1910 Tonks was nearly fifty years old, and the character of both his art and his teaching had assumed a rigid pattern. Had he been content to allow that the new modes of expression were outside his province and even his sympathies, as one who had long since made up his mind upon fundamental principles, and that they posed problems to which younger generations must apply themselves, he would have ridden the storms which Post-Impressionism raised with dignity and without adverse effects for himself. But he was not content with an attitude, however critical, of detachment: instead, with sour monotony, he elected to condemn. I am not at this point concerned with the degree of justification he had; only with its effects upon him. I believe these to have been harmful, in that Tonks's attitude of condemnation raised a barrier between himself and the most gifted of his younger contemporaries. The last twenty-two years of his life – he died on 8 January 1937 – were spent in an exasperated insulation from the issues which agitated the most creative minds. Was he not, he once disarmingly enquired, 'a crabbed old hopeless piece of wood that had been taken by the flood into a backwater'? Tonks constantly talked, and occasionally wrote, in denigration of the new directions in the arts; he never, I think, defined his own attitude so lucidly as he did in the course of some reflections upon Proust, quoted by Joseph Hone in *The Life of Henry Tonks*:

> Artists are perhaps as likely as any to come nearer to the meaning of life: why I hate Post-Impressionism or any form of subjectivity is because they, its followers, do not see that it is only possible to explain the spirit as long as we are in the world, by the things of the world, so that the painting of an old mackintosh (I don't pretend to explain how) very carefully and *realistically* wrought may be much more spiritual than an abstract landscape. There is no short-cut to poetry, it has to be dug by the sweat of his brow out of the earth, and it comes to a man without his knowing it; in fact one must never look for it . . . a painter who is not a poet ought to be put in the stocks.

One great quality which Tonks possessed in common with his friend Moore was an inflexible will to succeed. Both were almost without natural talent; both, by sheer effort of will, made themselves serious artists. The early works of Tonks, drawings and paintings alike, were dry, slight and affected, self-conscious Pre-Raphaelite echoes, *A Lady in her Garden* (1894), for example, which belonged to Frederick Brown, is characteristic of his work during his early years at the Slade. The late start, which he so frequently lamented, was, I suspect, the spur that pricked him remorselessly onwards. He drew, he painted, he studied the methods of the masters; he was never satisfied, no artist was less complacent than he. Slowly, his drawing began to express his hardly won grasp of construction and gesture, and his painting the solidity and the variety of light-suffused colour and the vernal, romantic atmosphere for which he struggled. Among his own paintings I fancy that *The Crystal Gazers* (1906), was the one in which he considered that his aspirations were most nearly fulfilled.

Most, perhaps, of Tonks's admirers would agree with Collins Baker that none of his works stands so surely for his highest endeavour as *Spring Days* (c.1928–9). In any case, the two pictures have much in common. The themes of both are pairs of young girls in sunlit rooms, one absently engaged upon a domestic task, the other withdrawn in dreamy meditation. The artist succeeded in endowing both with a certain enchantment; but the enchantment fades a little, it seems to me, under close scrutiny. In the earlier picture, for instance, the figure of the girl holding the crystal is perceived to constitute a vast and shapeless mass, in itself ungainly to the point of absurdity and bearing no proportion to the shapely head and shoulders. In drawing this figure, the artist, evidently working close up to the model, was mesmerized by his ruler and neglected to use his eyes. The effect of the foreshortening of the corresponding figure in the later picture, although less flagrant, makes it awkward and bunchy; moreover, the two figures have only the most perfunctory formal relation to each other. It is not, however, errors in drawing and other technical defects, serious as they are, which arrest the spectator's delight in these pictures, which abound in obvious beauties; it is something more radical. In the passage just quoted from Tonks's writings, he observes with wisdom that 'there is no short-cut to poetry . . . it comes to a man without his knowing it; in fact one must never look for it'. How interesting an anthology could be made of wise precepts – and, of their authors' neglect to observe them! For, surely, in no two pictures has poetry been looked for with so obvious and, it may be said, so laborious a pertinacity; never has every short-cut been more assiduously explored, lovely girls young and dream-rapt, enveloped in an atmosphere of sunlight and elegance. Nor is there any earth for

the poetry to be dug from. Even Collins Baker would hesitate to claim that the hardly won poetry in these two pictures came to the artist 'without his knowing it'.

Superior to both these pictures is, I think, a cracked ghost of a picture, *The Hat Shop* (1897). In this work, so ardently admired by George Moore, from the earth, so to speak, of an ordinary hat-shop the artist has dug up authentic poetry, compounded of elegance and a mysterious, almost haunted spaciousness. Another and much later picture in which he has succeeded wonderfully in a similar feat is *An Advanced Clearing Station in France* (1918), a monumental work in the authentic academic tradition.

Tonks cherished a passionate belief in poetic painting ('A painter who is not a poet ought to be put in the stocks.'). There would seem to be something in common between Tonks's strenuous aspirations towards poetic painting and the sense of obligation felt by many English artists of the late eighteenth and early nineteenth centuries to paint historical pictures. If only they had been content to represent closely observed, contemporary subjects instead of personified virtues and vices, how much anguished perversion of talent to unsuitable ends and how many pretentious failures – even from the brushes of Hogarth and Reynolds – would have been avoided. *Spring Days* is a far better picture than *Sigismunda Mourning over the Heart of Guiscardo*, or the various versions of *The Snake in the Grass*, yet when I see one of the too rare examples of the kind of painting for which Tonks's qualities best adapted him, it seems to me that these poetic pictures are the fruit, if not of their perversion, at any rate of their diversion from their proper ends. I refer to the small series of interiors with figures of friends or familiars, such as *Steer at Home on Christmas Day with Nurse* (c.1928), *An Evening at the Vale* (1929), and *Sodales: Mr Steer and Mr Sickert* (1930). These paintings, which are closely related to Tonks's own caricatures, derive from the satirical group portraits of Hogarth, Reynolds and Patch. In *The Evening at the Vale*, the satire is gentle, almost tender, although Moore wrote angrily that he had been represented as 'a flabby old cook' and the artist himself as 'an elegant young man striking an attitude like a demi-god against the mantel-piece, and he is nearly as old as I am'. In *Steer at Home*, where his friend is shown pouring tea for his formidable housekeeper Mrs Raynes and for her friends, the satire is broader but no less affection-ate; in *Sodales* it is uproarious.

All these paintings abound in 'earth', from which the artist has dug to good purpose, and, in unaffected innocence, has discovered an abundance of genial and acutely perceptive poetry. Because he has worked in a vein so entirely natural to him, and because he has followed his own wise precepts so closely, the spectator is conscious

of nothing of the painful strain under which the artist laboured in order to create, or rather, perhaps, to piece together, the various beauties in the ostensibly 'poetic' pictures. The figures, on the contrary, fall so easily into place that they seem to be real people, inevitably, indubitably present. The three more elaborate pieces – on account of the expressive and harmonious formal relations between the sharply contrasting and incisively characterized personalities, and of the intimate atmosphere which unites them – take their places among the best conversation-pieces of our time.

Sodales presents the critic with a more difficult task in that there is a puzzling disproportion between the means and the effects which they produce. The means in the 'poetic' pictures are of a formidable elaboration; in *Sodales* they are elementary and, at points, frankly imperfect. Steer's drawing is woolly; Sickert is incompletely related to his background and the whole composition is too shallow for comfort. Yet how little these imperfections appear to compromise the effect of richness, energy and character that the picture unquestionably has! Perhaps it is, after all, the very detachment of Sickert from his surroundings which so eloquently depicts him as a bizarre wanderer who, just for an hour or two, has blown into the snug world of Steer. It is my belief, at all events, that it is upon these too few conversation-pieces that the reputation of Tonks as a painter will principally rest.

LUCIEN PISSARRO
1863 – 1944

The path of Lucien Pissarro was as straight and untrammelled as Tonks's was circuitous and beset by chance. Of all contemporary painters at work in England, Lucien Pissarro was the most completely prepared for his profession. From his infancy it was assumed, in the face of stubborn opposition from his mother, that there existed only one vocation for him, and as soon as he was able to hold pencil and brush he was taught by his father Camille Pissarro. Whenever the two were separated, the father addressed a stream of letters to his son, which, when they were first published in 1943, were immediately recognized as documents of great importance to students of nineteenth-century painting. In these almost daily letters, written for the instruction and encouragement of his son, Camille spoke of his contemporaries with perfect candour and illuminating insight, especially his great fellow Impressionists, and with unrivalled authority of the problems of vision and technique which preoccupied them all. So that, when most of his contemporaries were groping in provincial obfuscity, Lucien was the recipient of a continuous inner history of the art world of Paris during the most brilliant epoch of modern painting from the pen of one of its masters.

Lucien Pisarro was born in Paris on 20 February 1863, the eldest of seven children, of whom all five brothers became artists, but he spent his boyhood at Osny near Pontoise, where his parents lived. All the boys showed powers of observation and draughtsmanship at an early age in which their father frankly delighted, but their mother, too familiar with the privations and griefs which harass the lives of materially unsuccessful artists, was bitterly averse to their following her husband's vocation. In order to alleviate his family's poverty in some small measure, Lucien left his school at Pontoise at the age of fifteen and went to work in Paris for a firm which sold English fabrics, but his employer eventually told his father that he was an excellent boy, but lacking any trace of talent for business.

In 1883 Lucien was sent to London to learn English, where he lodged at the house in Holloway of his uncle by marriage, Phineas Isaacson, whose wife was half-sister to Camille Pissarro, and supported himself by working at Weber & Company, music publishers,

at 84 New Bond Street. This employment stimulated Lucien's musical taste and he regularly attended concerts and gained a fair knowledge of the works of the classical composers. He did not continue long in this occupation, for in the following year his parents moved from Osny to Eragny, a village not far from Gisors, and they required his help, both in this undertaking and on account of their unusually severe circumstances. Not long after the family was established in their new home, Lucien went to work in Paris with the lithographers Manzi Joyant. This experience proved invaluable, for in the studios of the firm he became familiar with the various processes of colour reproduction. In the evenings, with his friend the artist Louis Hayet, he either drew from the model at an obscure school in the Rue Brequel, or frequented cafés and music-halls to make studies; in addition, he continued to paint. Slowly he began to make a modest reputation. In 1886, for instance, he was commissioned by the editor of *La Revue Illustrée*, F. G. Dumas, to make four woodcuts as illustrations for 'Mait' Liziard', a story by Octave Mirbeau. These woodcuts clearly show the influence of Charles Keene, who was admired in the Impressionist circle and whose engravings for *Punch* Lucien collected.

It was in that same year that Lucien, together with his father, came to be intimately linked with Seurat and Signac, and an enthusiastic participant in the Neo-Impressionist movement, of which these two were the originators. Already in 1887, Camille Pissarro – deeply implicated in the Impressionism of which the new movement was in some measure a repudiation, and the possessor of a temperament too spontaneous and a hand too vigorously expressive not to feel cramped by its rigid procedures – began to recede from it. But it was not until some years later that he abandoned the practice of divisionism.

The impact of Neo-Impressionism upon Lucien was lasting in its effects. He belonged by birth to the generation which was acutely conscious of the disorderly, fugitive elements in the earlier – in what his father termed 'romantic' – Impressionism; his personal relations with Seurat, Signac and Fénéon, the principal literary advocate of Neo-Impressionism, were close. What is more important, Lucien did not have the particular qualities which the discipline of the movement repressed. He was thus able to continue harmoniously with the most vigorous and fruitful impulse of the time: that of restoring imagination and conscious architectural design to their rightful places in painting – and in harmony with his friends; in harmony, above all, with his own particular vision. But Lucien was not infected by the air of pedantry which hung about the movement. It is to be expected that the son of a master, especially when he has much in common with him, should be dismissed as his shadow. Lucien Pissarro, because of his

innate affinities with a father who inspired in him an unreserved and unclouded devotion, and his own modest, unassertive character, was particularly exposed to denigration of this sort. In comparison with those of Camille, his gifts were of a secondary order: he was an altogether tamer, less creative, figure, but to call him a mere shadow is to do him much less than justice. His father, for all his devotion to his favourite son, praised him sparingly. He told him, however, that delicacy and distinction were his outstanding qualities, and that he possessed naïve good faith and discreet reserve. These certainly are not the supreme attributes of a painter, but, cultivated with the single-heartedness and sober judgement of Lucien Pissarro, they produced an art which was sensitive, dignified and consistent. In the best of his paintings the forms, thoughtfully disposed, scrupulously realized, scintillate with a sober, even luminosity. The artist's vision had reached its maturity by the time he was in his early twenties, and he spent the remainder of his life in the unremitting effort to strengthen and purify it.

Lucien Pissarro was represented with his father, Degas, Cassatt, Morisot, Gauguin, Redon and Seurat at what was, in fact, the eighth and last Impressionist Exhibition (although, on the insistence of Degas, the word 'Impressionist' was omitted from the announcement, held above the Restaurant Doré at the corner of the Rue Lafitte and the Boulevard des Italiens from 15 May to 15 June 1886.

In November 1890 Lucien took the decisive step of settling permanently in England; in 1916 he became a British subject. The most compelling of the several reasons which prompted this migration was fear of his father's influence. Letters show how the effects of Camille's mighty talent upon theirs, tentative and unformed, preoccupied both father and sons: 'I know you fear my influence, but there is such a thing as going too far'; 'It has to be England, for here I am a hindrance to you all'; 'I feel you are still too close to my work'. But Lucien was also moved by other considerations, of which the chief was his lack of success in Paris as an illustrator of books. Only the commonplace in conception and the mechanical in execution, it seemed to him, were acceptable in France. England, on the contrary, he regarded as the country where the inspiring revival in book making, which originated with William Morris, was still in progress. He expected to learn from this movement and aspired to make his contribution to it. He took a small painting room and tried, without success, to support himself by giving lessons in drawing and engraving to private pupils. Thanks to introductions from Fénéon and Mirbeau, Lucien met English writers and artists. One of these was the poet John Gray, author of 'Silverpoints', who was soon to enter the priesthood of the Catholic Church. Gray performed a

valuable service to Lucien by introducing him to Charles Ricketts, for many years his closest English friend and most influential mentor. Through Ricketts the world of book illustration, typography and binding was immediately open to him. Ricketts and his intimate friend, Charles Shannon, invited Lucien to contribute to their elegant and esoteric journal, *The Dial*, illustrated with woodcuts, the first number of which was published in the previous year. Woodcuts by Lucien appear in the second number, published in February 1891.

In 1892 he married Esther Bensusan, a distant relative, and Camille Pissarro came over for the wedding. After a visit to France, the young couple settled in April 1893 in Epping, at a house in Hemnall Street which he called Eragny, in honour of his father. Here, in 1894, he established the Eragny Press. He had already printed two folios of woodcuts, of which the second, *Les Travaux des Champs*, contained six subjects designed and drawn upon the wood by his father. The first book to issue from the Eragny Press, *The Queen of the Fishes*, was handwritten and the text reproduced by process. Of the thirty-five books produced by the Press, a series of sixteen was printed in Vale type, designed by Ricketts, who lent it to the Pissarros (Esther quickly showed herself a conscientious and skilful assistant), and a later series, similar in number, appeared between 1903 and 1914, in Brook type, designed by Lucien.

It was not long before Lucien took an honourable place in the small group of artist-craftsmen-printers, of which Morris was the first and Ricketts, at the time of Lucien's arrival in England, the most active. 'Unity, harmony, such are the essentials of fine book building,' Ricketts declared. 'A work of art is a whole in which each portion is exquisite in itself yet coordinated.' Of them all, Lucien strove most uncompromisingly after the unity of which Ricketts spoke. In his later books, he not only designed and cut the type, but designed and, with the help of his wife, engraved the illustrations and embellishments, thus dispensing with the services of the professional wood-engraver (upon whom even Morris had depended), and made their bindings.

This is not the place to dwell upon the achievements of Lucien Pissarro as a designer and maker of books, but that feature which was most nearly related to his painting should be mentioned – namely, his use of colour. It would have been surprising if an artist so deeply imbued with Impressionism had not expressed it in his books as well as his painting, and in fact the distinguishing feature of the products of the Eragny Press was their delicate colour and tone. Lucien's double preoccupation with unity and with colour on occasion led him to knit his coloured woodcuts closely to his text by printing it in muted greens and greys instead of in black. His successful use of

colour as a primary element within a completely harmonious whole was his most enduring achievement in this field.

The Pissaros remained at Eragny House, occupied chiefly with the making of books, until 1897 when they moved to London, living at 63 Bath Road, Bedford Park, until 1900. They then settled at a house known as The Brook at Stamford Brook, where they made their home until the death of Lucien on 10 July 1944 at Hewood, Somerset. The stables at The Brook, a pleasant Georgian house, were adapted for a studio.

During its earlier years the Eragny Press absorbed the greater part of Lucien's energies, but he was continuously active as a painter as well. At Epping his contacts with his fellow painters were comparatively few, but his establishment in London marked a change – gradual, but eventually notable – in the position he occupied among them. As a young man he was inclined at times to be irresolute in his aims and fitful in his work habits. In the *Letters* there is evidence of his father's awareness of these defects. After Lucien's illness in the spring of 1897, for instance (when Camille had come to England to bring him, Esther and their daughter Orovida back to Eragny), it seemed to him that his eldest son was prolonging his convalescence unduly. 'I hope that now you are back in your own circle', he wrote, 'you will be able to work. You must give proof of will-power; it is also a question of habit. With a little courage you will succeed.'

As Lucien passed from youth to middle age his self-confidence and his industry increased. As the Impressionists' fame grew steadily in England, the son of one of the most illustrious among them came to be regarded with a kind of reverential respect. Before, however, he was able to speak with authority as his father's son and from his own experience as a painter, a valued friendship had to be broken. Increased knowledge of Impressionism, while it inspired the ablest among the younger painters, confirmed in their seniors a bitter prejudice against it. Among the militant sharers of this prejudice was Ricketts. Camille Pissarro was concerned at the 'Italian influence of Ricketts' over his eldest son: '. . . you give me the impression that you listen only to him', he complained. Ricketts's influence over Lucien as an engraver and a maker of books, as a typographer above all, was constant and valuable; as a painter it was negligible. The eager susceptibility Lucien showed on the one hand, and the indifferent imperviousness on the other, has puzzled certain of his admirers, but I think with little cause. He was consistent in each instance in that he adhered to the more vigorous tradition, but his course was determined by consistency upon a level deeper than where conscious judgments are formed. As a boy he had given himself heart and mind to the Impressionism taught by his father: as a young emigrant in England he

had also identified himself, and with scarcely less reserve, with the tradition of William Morris as an engraver and a maker of books. To have abandoned either would have been at variance with the unyielding constancy of his nature. Lucien's quiet adherence to the principles of an eminent father was understandable, a trait even to be respected in a young man, especially as they continued to be little understood for a long time. But as these principles gradually made more of a stir in the world and gained numerous adherents, and Lucien, no longer a reserved youth, became their respected advocate, the days of his friendship with Ricketts were numbered. How easy to understand the growing coolness towards his young friend, the dictatorial Ricketts, hostile to realism as the enemy of the imagination, and impatient of rival preachers, especially young disciples of his own who set themselves up in middle life as preachers of heresy! Therefore it is not surprising that the day came when Ricketts passed Lucien by without recognition.

Lucien continued to produce books until the closure of the Eragny Press in 1914, but for the better part of a decade painting may be said to have been his most constant preoccupation. His vision was steady and sensitive rather than original, and his technique was solidly adequate rather than brilliant, but everything he did was marked by a delicate perceptiveness and a gentle candour. A certain unworldliness, a detachment from intrigue, are somehow mirrored in his art. Lucien's paintings did not excite either passionate admiration or passionate censure, but they were held in a constantly growing regard. And the artist himself, his earlier hesitancies and lack of urgency gradually outgrown, exerted a positive and fruitful influence, not only upon Sickert, but upon the chief personalities of a younger generation. But, as learning is more important than teaching, I will defer treatment of his influence until I come to write of the school of painters which he helped to establish.

After his first penurious years in England, Lucien never consented to give formal instruction in drawing or painting, but he used to invite serious students who approached him to bring their work to his studio. His quick and accurate discernment of the needs of students, and his quiet, modest fashion of responding to them, spread his influence among a widening circle of younger painters.

From the time of Sickert's return to England from Venice in 1905, and for several years afterwards, Pissarro and he were on close and friendly terms. The focus of their association – the focus, too, of the activities of the most gifted among the younger generation – were the memorable meetings at 19 Fitzroy Street. Each member of the group, which formed around Pissarro and Sickert, had the right to a rack in which to store his pictures and to an easel upon which to show them to the many persons who became interested in this novel group,

which included honoured exponents of the Impressionist tradition and a group of young painters of conspicuous talent; in this novel means of circumventing the dealers, with their burdensome commissions, and the exhibiting societies with their rigid and undemocratic constitutions. On Saturdays the 'members' entertained their friends, showed and sometimes sold their work. At lunchtime they would adjourn to the Etoile in neighbouring Charlotte Street.

These 'Saturdays', Ricketts's and Shannon's 'Friday evenings', and the second and fourth Sundays in every month when Lucien entertained his friends at The Brook (in fair numbers for tea; a smaller company of the more intimate were privily invited to remain to supper), became the principal events of his social life. At his own somewhat studious but hospitable evenings, spent in serious talk and the study of his excellent collection of prints and illustrated books, among the most regular guests were his associates of 19 Fitzroy Street: Thomas Sturge Moore, the poet, Campbell Dodgson, keeper of the Print Room of the British Museum, Ethel Walker, William Rothenstein and, until the final breach, Ricketts and Shannon. Lucien exhibited with the Camden Town Group (which grew out of 19 Fitzroy Street) in 1911, with the New English Art Club from 1906, at the Allied Artists, and his first one-man exhibition was held at the Carfax Gallery in May 1913. I had the privilege of opening the last considerable exhibition of his work to be held during his lifetime, 'Three Generations of Pissarros', at Millers in Sussex, in which his father and his daughter Orovida were also well represented. I remember how proud I was to have been invited to perform the ceremony, and how Lucien behaved as though it were they who were indebted to me. I can see him very clearly against the Pissarro paintings and drawings, among the crowd which had gathered in Lewes from all parts of Sussex: his short, stout figure, his full white beard shot with black, his cloak, his black wide-brimmed hat, and, behind the thick lenses of his spectacles, his slightly protuberant dark eyes; I remember the grave and gentle expression they radiated. Just as he had nothing of 'the melancholy, harsh and savage' elements which his father noted in his own temperament, or of his pungency as painter or writer (it would never, for instance, have occurred to Lucien to say, with reference to his politics, 'Gauguin . . . is always on the side of the bastards'), so his art differed from that of Camille. The father's was fluent and direct; the son's was conscientious and constructive. Lucien derived his palette from his father as a boy at Eragny, and his conception of design – the forthright, somewhat rigid system of design partly imposed upon, partly discerned in nature – from his Neo-Impressionist contemporaries, Seurat and Signac, but he gradually modified the uncompromising divisionism which they

taught him. No new impulse would seem to have affected his tranquil, sensitive and deeply honest development of an outlook and methods acquired early in his life. His painting therefore changed little – his brushstrokes became rather shorter, less vigorous, but more sensitive as he grew older, and the quality of his paint a trifle drier – but the centre of gravity remained precisely where it was: no painter at work in England during the present century showed a greater consistency of aim than Lucien Pissarro.

JAMES PRYDE
1869 – 1941

There are certain painters about whom I find it difficult to determine whether they succeeded in expressing some important element in human life, or whether they produced, with whatever integrity and accomplishment, what are, in the last analysis, mere variants of existing works. I catch myself peering, as it were, into the faces of artists living or remembered, whose works I have pondered, trying to read there the answers to my doubts – doubts which a future historian will find it easy to resolve – into the venerable face of George Clausen, nobly marked by sixty years of humble and devoted dedication to painting, or at the fresh handsome face of Charles Shannon, which carried even into old age the same unsullied spiritual look it had worn when he was a youth. I am conscious of a painful sense of arrogance in ignoring their solid, honourable achievements in these pages, but I am compelled to conclude that the art of the one is an unreflective projection of the art of Jules Bastien-Lepage, and that of the other of the art of George Frederick Watts, both of which lack the principle of organic growth; that they belonged to that category of artists whom James Northcote described as cisterns rather than living streams. I am the more conscious that my judgment may be at fault in that I propose to consider an artist who, in comparison with Clausen and Shannon, was deficient in creative power and skill and, what was worse, in belief in his own vision – in fact, a failure: James Pryde. My justification is the originality and the consistency of his vision, which, however, he lacked the intellectual power to organize and the energy to develop.

James Ferrier Pryde was born in Edinburgh on 30 March 1869. The circumstances of his early life conspired to foster, if not to stimulate unduly, a highly romantic imagination. Every important element in his vision derived from his earliest days, and it is no exaggeration to say that no subsequent experience changed or added to it. The house in which Pryde was born, and where he spent his first two years, was as tall and sombre as a building in one of his own paintings. After an eight-year suburban interlude, his parents established themselves in Fettes Row, where they lived for twenty years, first at No. 22, moving two years later to No. 10. This house, also high, narrow and dark, was

lit by a chilly north light; its narrow staircase mounted steeply up and up through a sombre half-light. This narrowness, gloom and perpendicularity made an impression on Pryde which deepened with the passage of the years. At either end of Fettes Row stood a church which would have further encouraged his predeliction for the tall and the impressive, and made him aware of the dramatic possibilities of columns and steps. Although it offered the sharpest contrast in architectural style to the New Town in which Pryde passed his boyhood, the Old Town, with its narrow streets of gaunt and gloomy tenement buildings and washing fluttering from the windows, ministered to his abiding sense of the beauty of grandiose dereliction. There was one particular object, the great four-poster bed of Mary Queen of Scots at Holyrood, that haunted Pryde's imagination for at least as long as he was able to paint. The importance of Edinburgh in the shaping and furnishing of his mind, apparent to any student of his art, is acknowledged in a brief autobiographical fragment. 'To me,' he wrote, 'it is the most romantic city in the world . . . I was very much impressed with the spirit of Holyrood, the Castle, and the old houses and Close, in the High Street.'

But there must have been thousands of young men and women in Edinburgh whose imaginations were stirred by the sombre architecture of that wonderful city; environment moves one readily enough to poetic imaginings, but rarely, of itself, to their transmutation into art. There was one improbable circumstance of Pryde's home life which made him familiar with the idea of transmutations of such a kind: his whole family, from his father, Dr David Pryde (from 1870 headmaster of the Edinburgh Ladies' College) downwards, was stage-struck. Irving had played in Edinburgh in the 1850s, and the admiration which Dr Pryde formed for him and communicated to his wife and children became a hysterical family cult. There is reason to suppose that James Pryde, besides participating in the solemn rites of Irving-worship, was addicted to more popular devotions in the shape of attendance to the 'penny gaffs', the boisterous shows held in street booths behind the Royal Scottish Academy. Besides giving him an insight into a living art which made the prospect of his becoming an artist appear an immediate possibility instead of a perilous voyage into the unknown, his associations with the theatre made a deep and manifold impression upon both his life and his art. They inspired in him the ambition, intermittently and lamely realized, of becoming an actor himself; they began a connection with the theatrical world which lasted until the end of his life, and they stamped his personality with something of the actor, and his painting with the character of stage scenery.

By his early twenties Pryde would seem to have possessed almost

all of his assets as an artist. At what periods of his life he became familiar with Hogarth, Velazquez, Guardi and Piranesi is unknown. The study of the work of all these artists was of manifest value to him. From them he must have gained an enhanced confidence in his own highly personal way of looking at the world; from them he evidently learned much about the making of pictures, and, it must be said, a repertory of pictorial mannerisms. Pryde's biographer, Derek Hudson, discovered, for instance, that he possessed a photograph of Velazquez' *View from the Villa Medici: La Tarde*, and he considers it probable that it was from this picture that Pryde appropriated several of his favourite themes, notably the high archway, boarded up in a manner to give it a look of dereliction, the tall cypresses, the eroded statue, the balustrade with the drapery hung over it. But although he had reached the fulness of his growth by his twenties, the time had not yet come for him to blossom as a painter. How gifted and serious an artist he was is apparent from the charcoal drawing he made of *Miss Jessie Burnet* (c. 1886), a study of a young girl which puts one in mind of a Gwen John, only it is fuller and finished with the conscientiousness of a beginner.

After the end of Pryde's desultory studies at the Royal Scottish Academy School and a brief visit to Paris without apparent consequence to his art, he settled in 1890 in England. Chance, however at first directed his energies not towards painting but to the designing of posters. Mabel, one of his five sisters and an original character, met William Nicholson, a fellow student under Sir Hubert Von Herkomer at his imitation Beyreuth school at Bushey, and, after a singular courtship, the two were married. They established themselves in the spring of 1893 at The Eight Bells, a small former public-house at Denham, Buckinghamshire. A day or two after their arrival James Pryde came for a weekend and remained for two years. The visit led to the fruitful collaboration of Pryde and Nicholson as 'J. & W. Beggarstaff', who designed the best posters that had been seen in England. There is a sharp division of opinion as to whether Pryde or Nicholson was the dominant partner, a question which is outside the scope of this book. The chorus of well-merited praise of the Beggarstaffs' posters has obscured the probability that the collaboration was prejudicial to Pryde's prospects as a painter. Pryde was lazy, and the habit of imagining in such broad, simplified terms as poster-designing demanded, and his dependence upon his energetic brother-in-law to do the greater part of the executive work must have fostered, a laziness which showed itself in the emptiness of much of Pryde's later painting, and in a disposition never to do for himself what he could persuade others to do for him.

In the autobiographical fragment earlier referred to, Pryde observed

that the early impressions gained in Edinburgh did not affect his work until considerably later. It was in about 1905 that the emotions which had charged his mind during his early years in Edinburgh began to show themselves – emotions which, during the fifteen years or so since his departure, had been growing, as it were underground, in strength and clarity. With a curious suddenness, they fused into a romantic, dignified, sombre and highly personal vision, which, for the next twenty years, was expressed in a series of paintings of imaginary architectural compositions with small figures. Owing to Pryde's habit of giving the same title to several pictures, which may have been due to carelessness, perhaps even to a deliberate intention to mystify, the dates of his pictures are difficult to ascertain. The earliest of his architectural compositions was probably *Guildhall with Figures*, first exhibited in 1905, purchased by Sargent and subsequently lost. The architectural compositions are beyond question Pryde's original contribution to painting. Thirteen of them had as their principal feature a great bed, based upon his early memories of the bed of Mary Queen of Scots at Holyrood.

At first sight there is something deeply impressive about the best of these compositions; there is something about them which, even after the critical faculty has been provoked, lingers in the memory. It would hardly be possible to forget the way of seeing which Pryde compels even the most recalcitrant to share for a few moments. For to Pryde belonged one of the qualities of a great imaginative artist: that of imposing his vision by the sheer force of conviction. Augustus John, in the course of a brief description of his visits to Pryde's studio, indicates the particular character of these architectural pictures (again I quote Derek Hudson):

> This studio had the lofty, dignified and slightly sinister distinction of his own compositions. Upon the easel stood the carefully unfinished and perennial masterpiece, displaying under an ominous green sky the dilapidated architectural grandeur of a building, haunted rather than tenanted by the unclassified tatterdemalions of Jimmy's dreams.

The tall, derelict buildings, the high rooms, darkly painted and harshly coloured, convey a powerful suggestion of a malignant and inescapable fate overhanging man. Pryde has been likened to Poe, but he is closer to Hardy. But even the best of Pryde's paintings will not withstand scrutiny. The general impression they leave is lasting because there was something memorable and unique about his way of seeing, but it may be fairly said that never, in one single instance, did he succeed in giving it form which will satisfy an exacting eye for long. I remember years ago, in the presence of Gordon Craig, saying of a picture that it was too theatrical for my taste, and how sharply he

rebuked me with the words, 'And why shouldn't it be theatrical?' The answer which I was too slow to give is, I suppose, that the quality of theatricality, with its appeal to ephemeral emotions, is proper to a play, because when the curtain is brought down nothing remains, but improper in a work of art intended for prolonged scrutiny. And the defect of Pryde's painting is its theatricality: it is designed to make only a momentary impression. The spectator, suspicious of the degree to which his emotions have been played upon, becomes coolly critical, and his attitude hardens as he notes, one after another, the crude devices the artist has employed. The unvarying and excessive disparity in scale, for instance, between his buildings and his human beings is perceived to be grotesque. The doors are so vast that nobody could push them open. The viewer notes, too, the slipshod manner in which these crude devices are constructed, the poverty and flimsiness of forms which at first seemed so imposing, and the way in which most of the pictures are designed, according to a formula, in three planes parallel to the picture surface, each separated from the other by a pace or two, like drop-scenes in a theatre.

The art of Pryde, in fact, is lacking in all the qualities of good, let alone of great, painting, except for the vigorous and consistent vision which he was never able to realize fully. Or, rather, which he was not equipped to realize fully in paint. Pryde's gifts fitted him ideally for the theatre, where his particular defects would not have mattered. The theatre was alive to his talents: both Gordon Craig and Lovat Fraser were deeply in his debt, and after he had all but ceased to paint, his theatrical sense was recognized by an American producer, Miss Ellen Van Volkenburg, who induced him to design the scenery for Paul Robeson's *Othello* at the Savoy Theatre in 1930. Pryde himself was always drawn to the theatre; from time to time he played a small part himself. In the summer of 1895 he toured with Gordon Craig, taking the part of the priest in the last act of *Hamlet*, and another priest in *Villon*, a one-act play. I quote Craig from Hudson's biography of the artist:

> As an actor he never really existed: but the idea of acting, the idea of the theatre – or rather the smell of the place – meant lots to him. Yes, I think he got much 'inspiration' from the boards – and the thought and feel of it all, as of a magical place . . . There were little moments when in a bar or in the street he would put on the actor, as it were. He thought well of his own 'stage personality' off the stage: on it, it all vanished. But I'll swear he saw into the marvellous possibilities.

Pryde not only thought well of his stage personality; he came to regard the world as a stage. Four sentences from Augustus John's account of him, already quoted from, bring back to abounding life the Pryde of the later years:

Jimmy had been an actor and he still seemed to be playing a leading
part in some robust old melodrama. Whatever his role might have been,
it was a congenial one and he hadn't seen fit to remove his make-up.
The performance in fact was non-stop and must have put a strain on
even his constitution. When I last saw him in 'Rules', Maiden Lane, it
looked as if it were almost time to bring the curtain down.

My father has noted Pryde's passion for dressing up as Pierrot, and
another friend described him so dressed and playing the harmonium
on Southwold beach. His everyday appearance continually engaged
his attention: his attitudes were studied and practised, and his dress
was the product of serious thought. He took pleasure in the contrast
between the bohemian appearance of his brother artists, sporting
earrings and hobnailed boots, beards and cloaks, and his own
dandified and dignified but no less distinctive appearance in a long
maroon overcoat with enormous buttons, and a velvet collar and a
plush top-hat such as cabbies wore.

The contrast which Gordon Craig observed between Pryde's ina-
bility to act and his enchantment with the idea of acting and his
sense of the theatre as a magical place, is in some degree paralleled by
his inability to find forms to express, nobly and exactly, his sense of
the grandeur of a towering dilapidated building or of a high,
curtained bed and the littleness of the human figures which they
overshadow. In a moment of exultation, his biographer acclaimed
Pryde as the greatest painter since Turner. For making this and other
high claims for his subject, Derek Hudson was taken to task by
various reviewers. The suggestion that Pryde could hold his own
with Turner as a painter will not, of course, bear an instant's calm
reflection, but a comparison between Pryde the painter and Turner
the poet would not be irrelevant; between the series of high, derelict
buildings and rooms and beds, sombrely shadowed and gloweringly
lit, and the inept and never completed 'Fallacies of Hope'. To press
the comparison would be unfair to Pryde, but his painting, like the
poetry of Turner, conveys, for all its imperfection, intimations of a
vision more powerful and more deeply felt than its maker was able to
express. It is for the occasional glimpses they afford of a harsh,
gloomy but authentic poetry that the best of Pryde's paintings deserve
to be remembered.

The comparative study of the careers of artists shows how little, by
themselves, even high gifts of mind and hand are able to achieve
unless they are directed by an unfailing purpose. In every generation,
many artists gifted – and sometimes abundantly so – with the first
two, but who lack the last, vanish without trace. Pryde totally lacked
purpose, so that neither the power and consistency of his vision nor
his skill as a draughtsman were able to arrest his premature decay as

an artist. Very early in his life he showed a broad vein of irresponsibility not only towards his obligations as a citizen, but aso as an artist. It mattered little that he upset coffee-stalls upon their owners and patrons, that he engaged in street fights or that he was frequently in hiding from his creditors or that he drank heavily. Artists who have been guilty of all these and more, from Benvenuto Cellini to our own time, have succeeded, notwithstanding the diversion of creative power involved. But Pryde neglected to cultivate with assiduity his sombre, grandiose vision. To name a single instance of this neglect, though possibly the gravest: he was a painter of architecture, yet, his biographer informs us, he only admitted having painted a single building 'from the life'. This may not have been literally true, but the repetitiveness, the absence of development, an airlessness and a want of definition at key points are clear indications of his neglect to refresh his vision by the study of nature. At the heart of his failure lay, I think, the simple and awful fact that he slowly lost interest in painting.

Between 1915 and 1918, in the middle of that period of his life which his biographer calls his 'years of achievement', which extended from about 1905 until about 1925, a friend of mine saw Pryde frequently. She was one of a small circle of intimates of which Pryde was the focus. The members met several times a week at one or another of their houses, and often at Pryde's studio at 3 Lansdowne House, Holland Park – lent to him by Sir Edmund Davis, a wealthy patron of the arts – where he settled in 1914 after his separation from his wife. The studio, dark and lofty as one of his own compositions, was furnished similarly with deep-red hangings and ornamental columns, and elaborately arranged to give an impression of careless, opulent profusion. On an easel stood the 'carefully unfinished and perennial masterpiece' noted by Augustus John, which, my friend assured me, during those three years underwent no perceptible change. In the face of his aversion to talk about painting, his friends, she said, exerted as much pressure as they dared to revive his manifestly languishing interest in his vocation. But Pryde at times gave the impression of positive boredom with painting, and of awaiting, with eager anticipation, the hour when he would gather with his friends. He accomplished nothing of consequence, and during the last ten years or more of his life he appears to have done nothing ·at all. His languishing energies were directed towards dignified and gentlemanly forms of begging, whether it was writing to friends to purchase a picture, or choosing, at public gatherings, the company of those most likely to stand him drinks or drive him home. On rare occasions, when pressed for debt and unable to extract the sum from a friend, he would take up his brushes as a last resort.

By a curious stroke of fortune, it happened that early in the 1920s, at the very time when his creative energies began to fail, his reputation blossomed. Perhaps this combination of circumstances was not so curious after all: his most productive and fruitful years lay immediately behind, and the fact that he spent his time at the Savage Club, bars in the Strand and other places much frequented by journalists instead of at his easel, resulted in the widespread fanning by gossip-writers of a merited reputation. He became a sort of legendary king of bohemia. When sober he was inclined to be taciturn, at other times his conversation delighted those privileged to hear it. He occasionally showed flashes of wit: one night some years earlier, at the National Sporting Club, a friend, indicating Augustus John, who looked a Christ-like figure in those days, asked Pryde, 'How old is Gus?' Pryde looked across the ring. 'I don't know', he answered, 'but it must be getting dam' near time for his crucifixion.'

Pryde's friends, devoted and exasperated by turns, expected, his biographer tells us, to find him one day lying dead in his own four-poster with the curtains in tatters round him and the cobwebs spread over his special possessions: a last great dramatic tableau. But when he described himself as having 'one foot in the grave and the other on a banana skin', he showed greater prescience than his friends. Early in 1939, infirm in mind and body, he was taken to St Mary Abbots Hospital, Kensington. Here he spent his last two years in a ward for old men, sucking sweets and reading detective stories. Here he died on 24 February 1941, aged not, as his friends supposed, seventy-one, but seventy-four; the old actor had consistently lied about his age. The providence which ordained that he should not die in his four-poster had prepared a stupendous tribute to the vestiges of greatness in the lazy old inebriate who had lost his memory. As he lay dying the earth trembled under the impact of falling bombs, black smoke covered the city and flames leapt up the shattered buildings. For an apocalyptic moment, nature, whom Pryde had neglected to his infinite cost, was transformed according to his vision.

FRANCES HODGKINS
1870 – 1947

In the late 1920s the public was made aware of a new talent through an exhibition held at the now defunct Claridge Gallery. The works shown were oils and watercolours in an assured handwriting, some-times to the point of carelessness, and marked by arresting combina-tions of colour. It was not easy to decide whether they were the emana-tions of a simple or of an artfully sophisticated mind. Some of them were evidently original. It was presumed that an artist hitherto unknown and one so easily familiar with contemporary modes of seeing must be young. This impression was strengthened by the ap-pearance of work by the same hand in exhibitions representative of the avant-garde, and it was deliberately fostered by the artist herself. It was, however, erroneous: the dashing arrival was almost sixty years old. In her determination to preserve her identification with the younger painters whose ideas, after a lifetime of painting, she had come to share and whose admiration she deeply valued, Frances Hodgkins was inclined to suppress and distort the facts about her life before she was, so to speak, reborn. These attempts to mislead the inquisitive were deliberate, but not systematic. After the acquisition of her first picture by the Tate in 1940, I asked her for certain biographical facts, which she readily gave, and, I believe, accurately. These included the precise date of her birth, which has not, I think, been recorded, not even in Myfanwy Evans's excellent essay on the artist in the Penguin Modern Painters series.

Frances Hodgkins was born in Dunedin, New Zealand, on 28 April 1870, the second daughter of William Matthew Hodgkins, a solicitor born in Liverpool who had gone out as a young man, spending some years in London and Paris on the way. He played a zestful part in the artistic and intellectual life of the colony: he helped to establish the Art Gallery, was founder and first president of the Otago Art Society, and well known as a topographical watercolour painter, in a politely modified Impressionist style. He also gave lectures, and he and Mark Twain, Miss Evans has told us, once changed platforms without warning; 'a joke', she cryptically adds, 'that was not as successful as they had hoped'. Frances's father taught both his daughters to paint in watercolours, but it was not Frances who was considered to have

talent, and not until the 1890s, when her sister married, did she inherit the status of 'the artist of the family'.

The presence of Girolamo Nerli in New Zealand, a dashing Italian portrait-painter, had the effect of setting up a professional standard and of sharpening artists' discontent with the pleasant but still amateurish culture of New Zealand. Nerli had twice painted Robert Louis Stevenson in Samoa and been a quickening influence upon Charles Conder and other painters in Australia. At Dunedin he taught at the art school, but his instruction was dilatory and intermittent. 'In the morning I open the student', he said, 'and then I go over to the public-house and rest. In the afternoon I shut the student up. Good to get the salary, but I do not like the Accademia – too much work.' Frances's occasional contacts with this bizarre person seem to have been without profit, but she evidently acquired a certain conventional competence, by one means and another, for a picture of hers, *Maori Woman* (1900) was bought by the National Gallery of New Zealand. I have never seen this painting, but I understand that it is capable but commonplace and affords no hint of the direction in which her art eventually developed.

Before the end of the century, Frances's father had died, and she had made up her mind to go to Europe. Although he had lived well, he died poor, and she had to exert herself in order to pay for the expensive journey. She gave lessons in watercolour painting and piano, and she drew illustrations for the *Otago Witness*, her first published works. According to Miss Evans, these 'manage to show both her distaste and her capacity'. In 1900 she went to Europe and spent two years travelling, visiting Brittany, Holland and Morocco. It was in Morocco, she used to say afterwards, that she had her first glimpse of her way ahead. Here she found the subjects that she had drawn with her father, in the mountains and the bush at home, moving figures in bright light; but in Morocco the moving figures were strange and more vivid than any she had seen before and they made a sharper impression. (The circumstances of the life she led exercised a bracing effect upon her adventurous temperament. She joined a native caravan with a woman friend and went to Tetuan, where she had to remain for three months because the place was besieged by bandits.)

The work of her first dozen years or so in Europe is lost, scattered and difficult to see, but the impression I have of it (based, let me insist, upon very little evidence) is that it reflects a bold, energetic personality, eminently capable, but entirely lacking the delicate poetry of her later years. And lacking more than this, for I also detect a distinct strain of vulgarity. It was a symptom of this insensibility, I fancy, that Miss Evans had in mind when she wrote (of her work of

a slightly later period) that Frances Hodgkins 'had felt the influence of the gipsy-caravan storm – that purely English-bohemian thunder-storm . . . that was still shaking such diverse trees as . . . Brangwyn and Lovat Fraser'.

In 1902 Hodgkins settled in Paris, where her particular qualities won her considerable success. She was asked to join the staff at Colarossi's (where no other woman has taught, I believe, either before or afterwards, and where there have been few teachers who have never attended any school) as a teacher of watercolour. Eventually she opened a school of her own. Her work seems to have been welcomed wherever she chose to send it, the Internationale (which was traditionally reluctant to accept work by women) and the Société des Aquarellistes among others. Sudden, unexpected success (I am not speaking of the success that crowns a life or a great achievement) is an experience that enslaves certain temperaments by a process of intoxication, but repels others. Those 'others' seize the chance of seeing it at close quarters, and decide that they do not want it on the terms on which it is to be had. It is significant that Hodgkins's progressive isolation from the world and her living more intensely within herself began with her first taste of success. But it often happens that success, when treated with reserve, redoubles its attentions. In 1912 she returned to New Zealand, and held exhibitions there and in Australia. The work of 'the girl from "down under" who conquered Paris' (as she was called by Australian newspapers) was purchased for public collections and was presently sold out altogether. After her visit home, she returned to Paris to her painting and teaching, but it was not long before the First World War was declared, and she left for England, where she made her home. She lived in St Ives from 1914 until 1919; after the war she travelled, living at various times in London, the Cotswolds, Bridgnorth, and also abroad, chiefly in France and Spain. From 1922 until 1926 she lived in Manchester, where she worked without any notable success as a designer for the Calico Printers' Association, and conducted a painting class. The fact that she had joined so wholeheartedly in everything that was going on made her regard the rejection of her works, when the City Art Gallery organized a large inclusive exhibition, with a bitterness, Miss Evans has told us, out of proportion to its consequence. But there were compensations at hand. After many vicissitudes Hodgkins began at last to discover the peculiar angle and range of vision, the strangely singing colour, the fluid composition from which sprang the seemingly artless poetry (which was in fact the result of calculation and industry) that became so memorably her own. All this was plainly apparent to discerning visitors to her first one-woman exhibition in London, especially (to her delight) to the younger painters. It

consisted of twenty-five watercolours, four drawings and nineteen oil paintings, and was held at the Claridge Gallery in the spring of 1928. The enhanced status that the exhibition conferred upon Hodgkins was confirmed the following year by her election to the membership of the Seven and Five Society, a small group, notably free of dead wood, to which the ablest of the younger artists belonged. From this time onwards she was so completely identified with her much younger contemporaries that new acquaintances perceived her approximate age with astonishment.

The change in the character of her work that led to her identification with a school of much younger artists had nothing of the nature of the sudden 'conversion' to which academic painters are occasionally subject. Although not yet easy to trace in detail, it was beyond question a process of steady growth.

During the First World War an observant spectator might have noticed, besides the dashing proficiency of Hodgkins's work, a note of intensity and a complicated but certain sense of colour. Both are perceptible in her first oil painting, *Two Women with a Basket of Flowers* (*c.* 1915), aesthetically a strange blend of vice and virtue. One of the women, for instance, but for a touch of robustness, resembles one of those arty masks in white china made for the decoration of suburban walls, yet the colour, suggested by Vuillard, one would suppose, has been subtly and personally transposed. (We know that she looked with attention not only at Bonnard and Vuillard, but at Cézanne, Derain, Dufy and other Parisian contemporaries, and even attended the opening of the first Futurist exhibition.) The picture was purchased by the Tate in 1944. The following summer I wrote to her to ask for certain facts regarding it. I give her reply in full, as it shows that she began to paint in oils some years earlier than is generally believed (according to Miss Evans, this was in about 1919), and, more generally, gives an indication of the warmth and impulsiveness of her character:

<div style="text-align:right">

Studio,
Corfe Castle,
Dorset.
Oct. 7th 1945.

</div>

Belated reply to letter dated July 13 1945.

Dear Mr Rothenstein, – This is the letter that should have been written 2 months or more ago, rather late, indeed *very* late and I am filled with remorse that such an important event for me as the acquisition of my earliest painting should go unacknowledged by the artist. My excuse must be for not replying earlier to your letter, is that I was in Wales painting at the time.

Please accept my apologies.

I was absolutely overcome by the high honour paid me – and I greatly
appreciate the recognition of my worthiness as creative artist.

In reply to your request for the date when *Two Women with a Basket
of Flowers* was painted I think 1915 St Ives is sufficiently accurate – I
remember Mr Moffat Lindner liking it so much that he bought it as
soon as it was finished and from then on it hung in his beautiful house
among the Elite – Sickert, Steer, etc.

It would be interesting to know how it came to the Tate Gallery – and
when.

(2) It gives me intense pleasure to know my picture is enshrined in
glory at Millbank. I hope I shall soon see it. I was delighted with the
copy of 'Windmill' and the excellent reproduction. It gave me a thrill –
a nostalgic one. Will you convey my grateful thanks to the Editors from
me – and the great pleasure it has given me.

Thanking you for the warm sympathy and interest you have shown
my work.

<div style="text-align: right">Yours sincerely,

Frances Hodgkins.</div>

In reference to the Drawing of a Woman that you mention I believe it
belongs to me. I shall verify this when I am next at the Lefevre Gallery.
If this should be the case I would like to present it to the Gallery.

The drawing mentioned in the postscript is a big half-length of a
seated woman made probably during the 1920s, which is so complete
a statement in the formal sense that a sculptor could carve from it
(indeed, it has the look of something carved out of a tree trunk). Its
noble, clearly defined forms make it, to my thinking, one of the finest
drawings of our time. But it is neither for a painting such as *Two
Women with a Basket of Flowers*, intriguing as it is, or the somewhat
similar *Portrait of Moffat Lindner* (1916), nor even the drawing I
mentioned just now, that Frances Hodgkins is chiefly to be valued,
but for the intimately personal poetry of her last years, when she had
shed the last of her borrowed plumage. Writing in December 1929 to
Arthur R. Howell from the south of France, she described the
panoramic splendour of what she saw:

> But let me tell you that in my humility I have not lifted up my eyes
> higher than the red earth or the broken earthenware strewn about
> making such lovely shapes in the pure clear light . . . you may hear
> them clink as you unroll the water-colours I am sending along to you
> by this same post.

Today Hodgkins has found favour with fashionable opinion: she is
even spoken of as a great master. But of course she was not that: she
lacks the scale, the range, the variety, the purposefulness. What
Frances Hodgkins succeeded in doing, after twenty years of ceaseless
experiment, was to attune her eye and train her hand so as to respond
'to the broken earthenware strewn about making such lovely shapes
in the pure clear light', and to make out of such things intimate and

lovely fantasies, yet so convincing that, in her own words, we can hear them clink. This, in picture after picture, was what she had succeeded in doing, when, on 13 May 1947, in Purbeck, where, for the last fifteen years of her life she had made her home, she died. Neither her talents nor her industry, nor even the admiration of people of influence, enabled her to make more than a precarious living, and latterly not even that. In 1942 she was granted a Civil List pension.

WILLIAM ROTHENSTEIN
1872 – 1945

Biographies, memoirs and journals always fascinated my father, but he used to complain of the disproportionate attention that is often given to childhood. Yet I have never known anyone whose own childhood so manifestly and so decisively shaped his character. First and most potently the countryside around Bradford, Yorkshire, where he was born, at 2 Spring Bank, Horton, on 29 January 1872, the third of the six children of a wool merchant.

> Above Saltaire, a couple of miles from home, were the moors, and one could walk, I was told, as far as Scotland, without taking the road. In winter sometimes when the moors lay under snow, no footmarks were to be seen; one walked through a landscape strange, white and virginal, while above one's head the peewits wheeled and uttered their haunting cry. The low stone walls on the moor looked black against the snow . . . the mill chimneys along the valley, rising up tall and slender out of the mist, would look beautiful in the light of the setting sun.

Again:

> These old quarries had a great fascination for me; there was a haunting stillness and a wildness about them . . . A deserted old quarry, not more than fifteen minutes' walk from our own house, was a favourite playground. It lay off a path, a hundred yards from a canal, among black and stunted trees; there hung about it that haunted atmosphere peculiar to places where men have once been quick and busy, but which, long deserted, are slowly re-adopted by the old earth.

Here and there over the stark and sombre earth stood the stone skeletons of the great medieval abbeys, in those days not restored and tidied up, but grass-tufted, masonry fallen, weed-choked, widely scattered over the surrounding land. The nearest of these were Kirkstall and Bolton; beside this last was the famous 'Strid' across the Wharfe, which became a sacred place in my father's eyes when he knew that Wordsworth had written a poem about it. And at nearby Haworth the presiding genius of the region was still a living memory: my father heard old people there speak of 'Miss Charlotte'. The two sons of Brontë's successor were in his form at school, and on Sunday he used to walk across the fields to the church where Brontë had lately ministered and spend the day with his friends at the vicarage

which had been the Brontë's home. 'The Vicarage, the church and churchyard, and the Black Bull close by', he noted, 'and the steep grey street with the austere stone-roofed houses were all much as they were in the Brontës' time.' Of all these places he made his first childish drawings.

A man of sensibility born and reared in this grim, twilight region is likely to respond in one of two ways: he may shudder, recoil and depart as soon as possible, for some tamed, mellow place; or he may take the starkness and the grimness to his heart. In the material sense, my father did, at the age of sixteen, leave Yorkshire forever, but it is my conviction that the Yorkshire landscape – its dour, smoke-blackened buildings, yes and the stubborn, unsmiling people, strong in their frankness, and in their conscious rectitude – nurtured the most fruitful as well as the most enduring element in his personality. There was, in his bewilderingly many-sided personality, much more than this; but it is my conviction that these made up its core. And it was a core of unusual strength, ever predisposing him towards an assertive and unyielding independence and against compromise of any kind.

The quality of liberalism which he imbibed at home, besides fostering a natural love of justice and a natural humanity in him, also sanctioned an openness of mind, even sometimes in those spheres where decisions are imperatively called for. He would often observe, for instance, that it was possible for a man to lead a life of virtue, no matter what religion he professed, or even if he professed none at all, but from this truism he was disposed to draw the conclusion that all religions were therefore equally true. This disposition derived partly from his abiding sense of the unchanging nature of man, and of the identity of the predicaments in which in all ages he has found himself, of the need, for instance, for reconciling the desire of the artist for perfection with his needs and duties as a social being. One which constantly preoccupied him was the problem of whether the man who desires the perfection of his own soul ought to retire from the world or remain in it and struggle with deadly and multifarious temptations. His disposition derived no less directly from that indeterminate quality in the heart of liberalism that declares itself in a shrinking from sharp-edged definitions. This is less noticeable in the political sphere, where the loosely but generously conceived principles which liberalism prefers have often compared well with opportunism to the Right and pedantry to the Left, but in the quest for the absolute they are apt to prove equivocal guides. My father was apt to regard any precisely formulated principles with suspicion and to discount them as arbitrary theories to which men must, in his own words, 'conform or be damned'; religious dogma he discounted with

that bland incomprehension common among Englishmen. He never saw it as possibly an assertion, in its starkest, most enduring form, of objective truth, but, at best, as a perhaps necessary but artificial construction. I remember how, as a schoolboy, when I contended that the doctrines of the Catholic Church were either (as I believed) true or false, but in either event they treated of realities, he insisted that 'the Church needs dogma as a garden needs walls to enclose it'.

Besides a passion for drawing, a responsiveness to beauty and an eagerness for experience, such were, I think, the most important emotional and intellectual features of the sixteen-year-old boy who, in 1888, left Bradford for the Slade School and a year later for a four years' stay in Paris. In addition, he possessed immense energy and a power of concentration to match it. For the rest he was a striking combination of moral earnestness and high-spirited wit, of shyness and audacity.

The year he spent at the Slade was of value to him because of the personality and methods of Alphonse Legros, the professor. 'We really did *draw* at the Slade', my father used to say, 'at a time when everywhere else in England students were rubbing and tickling their paper with stump chalk, charcoal and india rubber.' Legros, whose earliest exhibited work had attracted the favourable notice of Baudelaire, had settled in England on the advice of Whistler where he became friendly with Rossetti. In the true but almost forgotten sense of the term, Legros, who had studied under Ingres, was a fine academic draughtsman, a disciple of Mantegna, Poussin and Rembrandt.

> He taught us to draw freely with the point, to build up our drawings by observing the broad planes of the model . . . he would insist that we study the relations of light and shade and half-tone . . . this was a severe and logical method of constructive drawing.

This method of drawing was one to which my father wholeheartedly responded; subsequently constructive drawing became both an incitement and a discipline for him. From Legros he also had an immediate sense of contact with the great succession of European draughtsmen: he listened rapt while Legros quoted sayings of his master, Ingres, and spoke of Millet and Courbet with a familiarity tempered with reverence. But by the late 1880s Legros had grown tired of teaching, and my father, oppressed by the spiritless atmosphere of the Slade, was easily persuaded to go to Paris.

In Paris, he who scarcely more than a year before had been a provincial schoolboy and who at the Slade had vainly longed to speak to one of the older students, aroused the benevolent interest first of his professors at the Académie Julian, and soon afterwards of

Whistler, Pissarro, Lautrec and Degas. One day Whistler paid an unexpected early-morning call at his studio, thus beginning a close friendship and, on my father's side, an ardent discipleship, which continued for some years until the friendship was suddenly extinguished in one of 'the Butterfly's' most envenomed quarrels. My father's drawing in those days was lighter in touch and feeling, more stylish, than it afterwards became, yet Whistler showed an almost prophetic insight into the underlying weight and intensity of his nature when he used to say of him that he carried out right to the end what with others was mere gesture. The effect of the friendship with Whistler was conspicuous, but not enduring. It is manifest in a series of portraits of men painted in the early 1890s, such as *L'homme qui sort* (1892), a portrait of Charles Edward Conder, shown at the Salon du Champ de Mars, another portrait of *Conder*, and portraits of *Gordon Craig, Max Beerbohm and Marcel Boulanger*, in all of which the subject is represented as a tall frock-coated figure in elegant silhouette against a low-toned but slightly lighter background.

My father's friendship with Degas and Pissarro resulted from his first exhibition, held with Conder in 1891 in a small gallery in the Boulevard Malesherbes which belonged to a courageous dealer named Thomas, whom Lautrec had interested in their work. Degas sent word by a model of his that my father might, if he cared, pay him a visit. Pissarro came to the exhibition with his son Lucien. My father's relations with Degas were never as intimate as they were with Whistler, but I think their effects, if less apparent, nevertheless struck a deeper chord. Creative powers of the highest order, united as they were in Degas with austerity and an uncompromising integrity, commanded his utmost admiration. That such a man should befriend a boy hardly nineteen years old aroused his gratitude. The long evenings in the Rue Victor Massé (where Degas lived in two flats, the walls of the lower hung with the French masters he collected and the upper with his own works), spent in detailed discussion and close examination of works of art did more to broaden and sharpen my father's critical faculties than any other experience in his early life. He delighted in Degas's deadly wit, the phrases that deflated or drew blood; in his stories about his master, Ingres, and the great men of his age.

For all his veneration, my father was unable, in one important respect, to profit from Degas's advice. Degas not only seldom painted direct from nature, but was apt to ridicule this practice as an odious outdoor sport, and he urged my father to paint only from studies, and showed him how to correct and simplify these by redrawing on tracing paper pinned over them. But my father's visual imagination was weak; he was dependent upon the immediate presence of nature,

which alone incited his faculties to function at their highest pitch. In the course of his life he carried out a number of elaborate figure compositions. These called for the redrawing, often the radical modification, of studies made from nature, but it is true to say that everything most living in his work was done in the heat generated by direct contact with his subject. Degas's belligerent nationalism expressed itself in various ways, but in none so consistently as in his hatred of the cosmopolitanism that had already begun to supplant the culture of France, the disintegrating effects of which he continually deplored. In so speaking, he strengthened my father's own innate antipathy for cosmopolitanism, above all for its frequent concomitants, the exotic and the smart.

The effects of his contacts with Pissarro are difficult to isolate from those of Impressionism as a whole. For some years before my father's arrival in Paris, the movement had put a powerful spell upon students, especially upon English students. However, the influence of Whistler, with his insistence upon low tones and severely selective composition, and of Degas, with his insistence upon precise drawing and his continuous praise of Ingres, combined to postpone the day when my father had to reckon with Impressionism.

After he had lived in Paris for four years, chance, in the guise of two commissions, led him home to England. Lord Basil Blackwood, son of the British Ambassador, invited him to stay at Balliol to draw his portrait, and some drawings he did there attracted the attention of John Lane, the publisher, who commissioned him to make a set of twenty-four Oxford portraits. These commissions he interpreted as signs that his life in Paris was drawing to its close, and as good omens of a new life in his own country. He possessed the talent for applying himself with such passionate industry to any work he had in hand, and for experiencing any phase of life to the utmost, that when the call came to undertake something fresh he was able to make changes without regret. 'You have gathered in your sheaves', I remember MacColl saying to him towards the end of both their lives. But when the time came to give up his studio he was troubled by doubts as to whether he was wise to leave Paris, for his four years there had been years of achievement and experience. His drawing had become expressive and elegant; his sense of character vivid and humane; his intellect had been enriched and sharpened in the quickest-thinking, the most critical and creative society there was. He had won the respect and the friendship of those whom he most ardently admired, and all this by the age of twenty-one. Whistler, Wilde and Conder urged him to remain. Reflection confirmed his intention to return to England and, with a brief interlude spent painting landscape at Montigny, he went from the society of Lautrec

and Verlaine to that of the Common Rooms of Balliol and Christ Church. At Oxford, and in London where he settled a year later, he added to the already extensive gallery of portraits, begun in Paris with Verlaine, Zola and Rodin, likenesses of Pater, Swinburne and Henry James.

Soon after the beginning of the new century a radical change, involving both loss and gain, began to be manifest in his work. It was a change perhaps due mainly to intellectual conviction, but it may have been in part the consequence of some psychic disturbance possibly unconnected with painting. I know nothing of the cause of such a disturbance, but I offer it as a possible explanation of a change of outlook more radical than an intellectual reorientation would be likely to effect. Before about the year 1900 his work was distinguished by an eager, curious insight into character, whether of face, figure or locality, which expressed itself, notwithstanding his obvious high spirits and irrepressible humour, with a grave, disciplined detachment. His drawing, elegant and tenuous though it often was, showed a surprisingly sure grasp of form. The intellectual motive for the change is clearly expressed in my father's own words. Of the years after his return to England he wrote in *Men and Memories*:

> My sympathies were with the Realists; but I felt there was something accidental, a want of motive and of dignity, in contemporary painting. To achieve the vitality which results from direct contact with nature, with nature's final simplicity and radiance, how unattainable! Yet only by aiming at an impossible perfection is possible perfection to be reached.

A few lines later he expressed what was, I think, the central article of his own belief:

> . . . I was possessed with the faith that if I concerned myself wholly with appearance, something of the mystery of life might creep into my work . . . Through devotion to appearance we may even interpret a reality which is beyond our conscious understanding.

The Wordsworthian conviction that form is the discipline imposed by God upon the universe, and that by subjecting himself to it, the artist may approach the innermost realities, is one which again and again finds expression in his critical writings. Such reasoning was cogent enough, yet there is something mysterious about the transformation of my father's outlook. He had always been serious and industrious, but in the course of the early 1900s he became increasingly marked by an extraordinary earnestness and intensity, an almost fanatical industry and an increasing severity with himself. This heightened earnestness showed itself in every one of his many activities. 'Your father is far more interested in religion than the

average person', Eric Gill said to me. There was the occasion when a French Benedictine, perceiving this preocupation, tried to persuade him to enter the Order's house at Flavigny. He was strongly affected by the writings of Tolstoy. He was shocked at the impoverishment of English provincial life by the progressive concentration of civilization in London, and he struggled to arrest it. The revival of fine traditional craftsmanship and the recognition of the undervalued art of India were other active preoccupations. And his efforts were unremitting for the recognition of the achievements of those artists whom he most admired, especially of his younger contemporaries. Of Steer, Augustus and Gwen John, Stanley Spencer and Paul Nash his praise was constant, and, if occasion required it, no exertion on their behalf and on that of many others at different times was too great. I had never known an artist whose generosity towards his fellow artists was so positive and so unstinted.

It is with this heightened earnestness and intensity as it showed itself in his work that I am chiefly concerned. Far from wavering in his conviction that realism was the inevitable means of interpreting nature, it seemed to him, on the contrary, that the defect of all but the greatest Realists – Rembrandt, Velazquez, Chardin and a handful of others – was that they were too easily satisfied, that they stopped complacently when they should have pressed audaciously forward to pierce the baffling complexity of the appearance of nature so as to approach the innermost truth more closely. So it was without illusions as to his own shortcomings that he attempted, with the whole force of his own passionate nature, to come to closer and closer grips with the world of appearance. The attempt resulted, broadly speaking, in a vast increase of power at the expense of grace. It seems to me that nothing he did after the change approached the noble elegance of his lithographed drawings of *Henry James* (1898), of *Fantin-Latour* (1897) or of the big double portrait of *Ricketts and Shannon* (1897), or even the pastel *The Model*, made when he was eighteen years old. He renounced, or rather the more exigent ideal which possessed him involved the renunciation of, certain felicities of style. His grim determination to be faithful to this ideal exposed him to serious temptation. First, because of his conviction that he should always be ready to take advantage of every spark of inspiration, he worked too continuously and always under the highest pressure. This led to a species of recurrent imaginative exhaustion, a recurrent aridity; and this in turn led, as he himself confessed, to much painting for the sake of painting. Second, his ardour to probe his subject to its very depths, to resolve its complexities and to achieve final simplification led him, as Sir Charles Holmes complained, to 'aim to put too much into each canvas'. What was still worse, there were occasions when,

in his eagerness to 'intensify' (the term was continually on his lips) some aspect of his subject, he would take insufficient care with his composition.

About this time, an artist some seven years his junior, a man infinitely remote from him in temperament and convictions, made an observation which was curiously relevant to my father's predicament. In 1903 Paul Klee noted in his diary:

> I shall have to disappoint people at first. Things are expected of me which a clever fellow could easily simulate. But my consolation must be that I am more handicapped by the sincerity of my intentions than by any lack of talent or dispositions.

I have expressed my admiration for my father's earliest work: I have called attention to the principal defects of the later; but I do not suggest that the total effect of the change was for the worse. The change itself may be interpreted as his determination to face all the risks of total failure in an attempt to paint greatly, rather than to continue as a minor artist; 'to aim,' in his own words, 'at what was beyond me rather than to achieve an easier and more attractive result'. To this attempt – to vary a famous naval order – to engage nature more closely, to wring the very utmost out of his subject, he brought an inflexible will and extraordinary powers of concentration, and an inability to compromise.

The effect of this rededication, renewed daily – indeed, hourly – was by its very earnestness and strenuousness, in part self-defeating. The grace and ease that distinguished the work of his boyhood and youth gave way to a dourness, an almost aggressive 'probity' (to use one of his own highest terms of approbation), even when his subjects – young women, children, sunlit orchards or fields of ripe corn – would seem to call for lighter handling. But if dourness and aggressive probity dried up much of his later work, this passionate rededication was not in vain, for when inspiration came, there he was, alert and disciplined, with the pent-up energy of a coiled steel spring. At such times, as though compensating for the months of humble and dutiful effort so grudgingly rewarded, he painted pictures which – it seems to me – possess qualities of greatness; they realized Baudelaire's artistic ideal: 'The creation of a suggestive magic containing at one and the same time the object and the subject, the world outside the artist and the artist himself . . .' Of these I would name *The Quarry* (1904), *Aliens at Prayer* (1905), *Farm in Burgundy* (1906), *St Seine L'Abbaye* (1906), *Cliffs at Vaucottes* (1909), *Morning at Benares* (1911), *St Martin's Summer* (1915), and *Portrait of Barnett Freedman* (1925). There is at least one painting which anticipated the later attitude, *Vézélay* (1896), while the earlier one persists in two of the best of his later

paintings – *Mother and Child* (1903). *Portrait of Augustus John* (1899) and *The Doll's House* (1899) show him in happy transition.

The effects of his enhanced seriousness of purpose might have been oppressive had it not been for another apparently unconnected change in his vision which also occurred in the early years of the century. This was a sudden preoccupation with full daylight, with a consequent intensification of his palette. Its chief cause was probably his increasing interest in landscape. He worked, almost always, in front of his subject rather than from studies, which at once brought him up against the problems of the representation of open-air light. Another cause was the delayed influence of Impressionism, from which he had been temporarily immunized by Whistler's advocacy of low tones. Rejection of Whistler's dandyism, I surmise, led naturally to the end of this immunity, and his eye was gradually filled by dazzling light. But the twentieth century had begun, and it was impossible for an artist of sensibility to respond, quite simply, to the original Impressionism of Monet. The emphasis on conscious design, structure and poetry and drama, which crystallized in the Post-Impressionist movement, accorded too closely with my father's predilections that the Impressionism that so richly coloured his vision should not be an Impressionism transformed. Although the theories of Seurat attracted him as little as those of Monet, in so far as he attempted to unite hard structure with brilliant colour he may properly be regarded as something of a Post-Impressionist, but the appellation would have surprised him. For, far from being associated with Post-Impressionism, he was widely regarded as hostile to it. His positive alienation from it was due to a personal clash with Roger Fry, the promoter of the movement in England. Fry was a warm admirer of my father's work, and had written in forthright praise of it. Perceiving, perhaps, the elements which it had in common with those of the avowed Post-Impressionists, he urged my father to associate himself with them. Lack of respect for the work of some of the Post-Impressionists, a certain mistrust of Fry's leadership and a sense of loyalty to the New English Art Club with which he had exhibited since 1894 impelled him to decline. His refusal eventually aroused an enmity in Fry which was as active as it was lasting.

The critical opinions expressed by my father with regard to several aspects of Post-Impressionism, and the hostility towards him within the movement, opened a breach between him and painters whose principal aims he shared. Certainly he showed no sympathy at all for one derivative of Post-Impressionism – abstraction – which he regarded as a cardinal heresy because it seemed to him to involve nothing less than a new atheism: implying a denial of the material world and the reliance of artists on their intellects rather than on

their eyes. Nor had he any particular sympathy for the work of Van Gogh or Gauguin, yet he shared the sense these artists had of the inadequacy of the Impressionists' aims. He held that the urge to express form and colour was primary among the painters' impulses:

> but the minds of artists are not so limited, so poorly furnished, that they cannot associate their sense of form with those touching elements in man's pilgrimage through life which bring the arts within the orbit of common experience.

It seems to me that there was a certain inconsistency that at one point marked his attitude towards the subject of a work of art. Although the subjects to which he responded most naturally were faces, figures, buildings and the things fashioned by man for his use, such as were beautiful or interesting in themselves, he had a clear apprehension that no object in itself is trivial, and that only trivial treatment can make it so. He spoke often of Rembrandt's making so noble a work of art out of the split-open carcase of an ox, and of Chardin's power of representing a knife and a loaf and Cézanne a dish of apples with similar breadth and force. Yet for all his passionate preference for subjects that pertained, as he put it, to 'man's pilgrimage through life', and his indifference to subjects that were fortuitous or slight, he showed, nevertheless, an odd reluctance to make due allowance for the power of the noblest of all subjects – religion – to inspire great works of art. Of the early Italians he wrote:

> The notion that these were great religious artists because all painters and sculptors believed in the stories they were hired to illustrate, is a fallacy . . . such . . . subjects . . . allowed the artist to paint the streets and buildings of the towns which they lived in . . .

Granting the element of truth contained in this contention, the suggestion that Giotto and Duccio, Piero della Francesca and Fra Angelico were the Courbets and Manets of their times, drawing their inspiration solely from the life around them, is to deny the mainspring of their art. To regard the world as a complex of forms to be aesthetically related to one another seems to me to imply a pitiably impoverished vision, but at least a consistent one. But if subject is to be regarded as significant, where is the logic of praising Chardin and Cézanne for their belief in their loaves and apples, and calling in question the belief of the great religious artist in the Incarnation? And where is the logic of extolling the nobility of subject, if the noblest is not, in fact, held to be inspiring at all? It is easy, however, to insist too much upon this contradiction, for it arose from his deeply felt conviction that both the fundamental concern and the most vital inspiration of the artist was the beauty of the visible world. Later in life he experienced, in altered form, a renewal of the inter-

mittent religious impulse of his childhood and youth, heightened later by his contacts with Indian mystics. But his sense of his obligation as an artist to interpret this beauty was so overwhelming as to confuse his vision of the religious life which, nevertheless, increasingly absorbed him. Towards the very end he drew near to the Catholic Church, but the final act of entry into her communion was inhibited by his abiding conviction that all of himself that was of any account had already been offered to God in the only way in which he knew how to offer it – the praise of the world which God had created. Two priests of the Society of Jesus followed this inconclusive struggle with respectful sorrow. To the last there remained an inner recess of his consciousness where he still believed, like Dubedat, that the great artists were his saints, whose creative activities were the only ones of any abiding significance. Even the understanding of these, he used to maintain, was a mere social amenity – as though works of art are not created to be understood; as though they are not fulfilled by comprehension.

This habitual opinion did nothing to mitigate the recurrent bitterness that seared his later years, arising from the precipitous decline in his own reputation as an artist. That he did not suffer oblivion was due to the impossibility of ignoring so formidable a personality. To one who in youth won the admiration of Degas and Pissarro; who in middle age was regarded without question as one of the most representative English artists; who had exerted himself so continuously in the service of his fellow artists; who had been the teacher of so large a proportion of the ablest among his juniors, the neglect of his paintings was a grief – a grief sharpened, if anything, by the undiminished respect paid to him as a writer, as an authority, and as a person. There was something particularly ironical to him in the praise which he continued to receive for everything except his painting, for almost all his other activities, with a single important exception, were at the time confined to those hours when the light was insufficient for painting. To his writings in particular no time was allowed which he could have given to his art. A grave illness, which made work impossible during the middle 1920s, seemed to me to be aggravated by his enforced inactivity, and I therefore urged him to set down his recollections. He made a beginning during his convalescence, and after his recovery he wrote the remainder of three large volumes of his *Men and Memories*, amounting to about half a million words, before rising in the mornings, and, rather less frequently, after nightfall. During these hours he was also occupied with a vast correspondence.

The important exception was his teaching; the principalship of the Royal College of Art, which lasted from 1920 until 1935, inevitably

involved continual interruption of his painting. In the same way, his passionate advocacy of the art of India and the formation of his own collection of Indian paintings, of the revival of wall painting, of local craftsmanship, farming, and many other activities at Far Oakridge, the Gloucestershire village which, apart from a brief interlude, was his home from 1912 until his death, were all the occupations of what, in another man, would have been his leisure hours. And as though these and, at one time or another, many more were insufficient to absorb his energies, he used to rise with the sun and, with axe and billhook, clear acre after acre of overgrown woodland. He possessed the capacity of experiencing all his activities and his friendships with an extraordinary intensity; and above all, the various phases of his own art. From each he extracted all that he was capable of extracting. The sustained exaltation with which he experienced a new subject is expressed most explicitly, I think, in the chapter on India in the second volume of Men and Memories. During both World Wars, in the first as an artist on the Western front, in the second with the Royal Air Force, his comrades, bored, uncomfortable, exasperated, noted with incredulity the entranced activity of a man for whom every instant of those dreadful days was manifestly precious.

The bitterness of his last years must not be exaggerated: cheerfulness kept breaking in. At work, in spite of the almost inevitable falling-short of the exacting standards he set himself, in spite of the grimness of the struggle, his happiness was intense. It was not only painting and drawing that he enjoyed to the end, but the various incidental experiences which they involved. When the Second World War broke out he was sixty-six years old. On account of his age and unfashionable reputation, his chances, he rightly considered, of official employment as a regular war artist were small, and he resigned himself to serving, at best, upon some appropriate committees. I persuaded him to offer his services as an artist directly to the Royal Air Force, which offered subjects as inspiring as they were novel. Neither he nor I was unaware of the dangers which would attend such a course of action, for he had suffered, for more than twenty years, from a heart gravely weakened by overwork.

So it was that he had the delight of working as an artist to the end. We did not meet often during the war, but I shall always carry with me the memory of the slight, straight-backed, energetic figure in a sky-blue uniform, carrying his portfolio of paper, setting eagerly off for some airfield, or else returning with a sheaf of drawings and innumerable stories of new-made friends. What a strange conjunction of two remote periods of time when this small figure, mentioned in the Goncourt Journals, the familiar of Verlaine, Pater and Oscar Wilde,

was out over the North Sea in a Sunderland flying-boat, with a crew in which not one member was less than half a century his junior.

Want of success had reduced his income to minute proportions, yet he gave his services to the Royal Air Force and presented all the work that he did on his own account while on active service to the nation. But he gave even more than his work. The ordeal of constant flying, the draughty messes, the indifferent food imposed a strain upon his injured heart heavier than it could withstand; he became ill, and after a year or two of restricted activity, he died.

Portraits had formed the largest part of his production, but when he sat on the terrace of his house at Far Oakridge, knowing that he had only a little time to live, it was not faces, illustrious or beautiful, that occupied his thoughts; it was the Stroud Valley with its severely defined contours, its sonorous depths. It was as though he saw all the loveliness of nature gathered in between its steep, wooded declivities. As he sat and watched it with rapt attention hour after hour under the changing effects of light, marvelling at its beauty, he was convinced more deeply than ever that by yielding himself humbly and absolutely to the attempt to represent this beauty, the artist might reveal, here and there, a glimpse of the reality behind it. Strong in this faith, but able no longer to act in accordance with its dictates, he died on 14 March 1945.

When I learned of his death and looked back over his benevolent, industrious and amazingly full life, in the mass of memories one incident, trivial at first glance, disengaged itself from the rest, and stood forth as peculiarly typical of my father's daily conduct. Not many years before, he and I had visited an exhibition, where he was attracted by an example of the later work of Sickert, of which he was in general highly critical. He was soon engaged in conversation with a lady, to whom I heard him say: 'That small study is absolutely enchanting, and it's delightful to be able to praise it. Certain of Walter's recent works have made it difficult for his old friends to look him in the face.' As we were leaving, I warned my father, whose often untimely candour provoked resentment, against speaking in such terms in public, 'How can you place,' I asked, 'the slightest reliance on that lady's discretion? Incidentally, who was she?' In sombre tones came the reply: 'Mrs Sickert, John.'

5. WILLIAM ROTHENSTEIN: *The Doll's House* (1899).
Oil, 35 × 45 in (87·5 × 112·5 cm). The Tate Gallery, London.

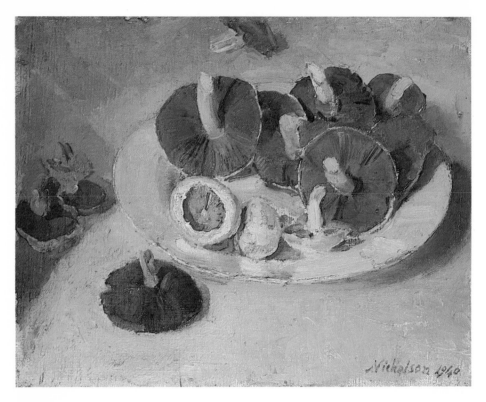

6. WILLIAM NICHOLSON: *Mushrooms* (1940).
Oil, 13¼ × 17⅜ in (33·6 × 43 cm). The Tate Gallery, London.

Opposite
7. HAROLD GILMAN: *Mrs Mounter at the Breakfast Table* (1917).
Oil, 36 × 23 in (91·4 × 58·4 cm). The Walker Art Gallery, Liverpool.

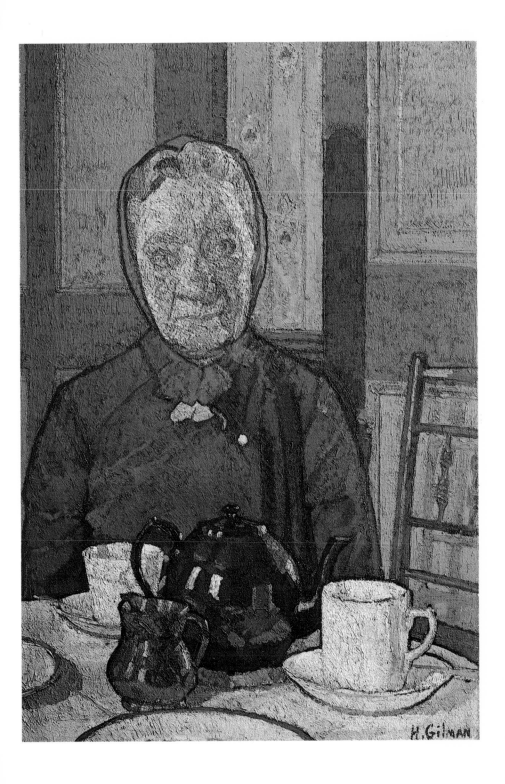

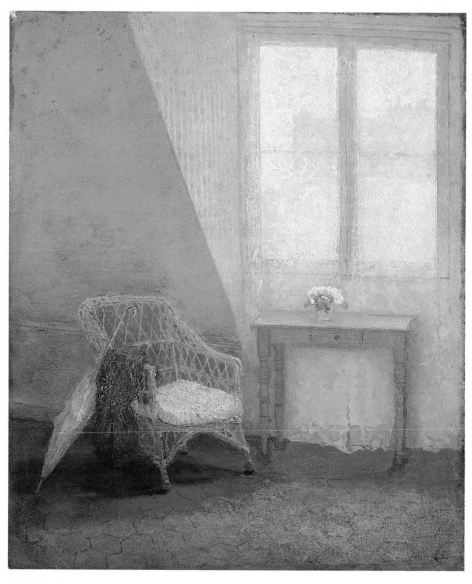

8. GWEN JOHN: *A Corner of the Artist's Room in Paris* (1900–05?).
Oil, 12½ × 10½ in (31·2 × 26·2 cm). Sheffield City Art Galleries.

WILLIAM NICHOLSON
1872 – 1949

When William Nicholson was twenty-one years old he made a woodcut portrait of Queen Victoria which, published in *The New Review*, then edited by W. E. Henley, made him famous in a day. Among its numerous admirers was Whistler. 'A wonderful portrait, Mr Nicholson', he said. 'Her Majesty is a wonderful subject', Nicholson modestly replied. 'You know,' rejoined Whistler, 'Her Majesty might say the same of you.'

Nicholson was a wonderful subject, but, in my estimation at least, for reasons different from those voiced by the friends who have written about him from the most intimate knowledge. In a biography as vivacious in tone as it is pious in intention, Marguerite Steen tacitly endorses the opinion of certain unnamed authorities whom she quotes that 'William Nicholson is the greatest master of Still-Life of his own or any other age'. In the most discerning appraisal of his art that has yet appeared, the late Robert Nichols asserts that 'a Nicholson, albeit surrounded by twenty other paintings, can be instantly recognized across a room on first entry to a gallery'. One has only to think of the still-lifes of Chardin, of Velazquez, of Manet and of a dozen others to see that Miss Steen's claim will not bear an instant's scrutiny. Nor is Nichols's claim justified. A dandy is rarely conspicuous, and William Nicholson, artist and man, was a dandy. He was not a great master, and as a painter he was as little original as a man of high gifts and undeviating independence could well be. (His originality showed itself in his woodcuts and, to a lesser degree, in the posters over which he collaborated with Pryde.) William Nicholson the painter seems to me to be something quite different; something rare, especially in England – namely, a little classical master. As a little master, he would have been acclaimed in several periods of history, but our own is not interested in modest perfection. Today Van Gogh is the most popular painter; the heroic failure is preferred to the completely achieved but minor success; the vehement, unstudied utterance is preferred, and infinitely so, to the polished epigram. (The very expression 'polished epigram' has become as incongruous with what is most admired in contemporary art as a frock coat is with contemporary dress.) The little master is, then, of all

113

kinds of artist the least fashionable; to such an extent unfashionable that those who loved and admired William Nicholson will, I am afraid, regard this description of him as disparagement.

The dandy, as Baudelaire noted, has his special discipline to follow, his special sacrifices to make, and William Nicholson was no exception. He needed a measure of success to enable him to develop his small but perfect talent, sufficient to bring up a family early established and quickly increasing, and thereby to place him beyond the caprices of patrons. In addition to his talent, he possessed three invaluable assets. First, a remarkable capacity for work – a capacity not so much the product of will-power or of a sense of moral obligation as of a restless creative activity; he could never be idle. Second, an acute business sense which brought him early and increasing material success. Third, and most important, an intimate understanding of the nature of his own talents. Many artists waste half a lifetime vainly pursuing objects unattainable through their particular gifts; Nicholson understood early what he should be about, so that, wasting no time, he took every opportunity of learning what he needed to learn. There is, in consequence, a close-knit coherence about his fastidious life-work.

Nicholson was born on 5 February 1872 at 12 London Road, Newark-on-Trent, and christened William Newzam Prior, the second son and third child of the second wife of William Newzam Nicholson, the proprietor of the Trent Ironworks and Member of Parliament. Exceptionally observant and continuously active, Nicholson lacked the ability to concentrate upon anything which did not engage his interest; and at Magnus Grammar School, Newark-on-Trent, nothing engaged his interest except drawing. His schooldays were unfruitful and unhappy and he later attempted to erase the memory of them. But now and then the nightmare would come seeping back through the doors he supposed he had bolted and barred, and he would describe how he and the other boys scraped the loathsome grease they were given in the place of butter off their bread and pushed it through the iron grating which covered the heating pipes in the floor; and how the rats swarmed to eat the grease, and the deadly stench given off by the combination of grease and rat when the furnace was lighted. 'Greek before breakfast', he used to say, 'on an empty stomach, after breaking the ice in the washbowl, prevented me from ever wishing to visit Greece.' Yet these years were not utterly unfruitful or utterly unhappy. They were redeemed by the presence of a drawing master named William H. Cubley, a humane and perceptive man who was a pupil of Sir William Beechey, who was in turn a pupil of Reynolds. So it came about that in this malodorous wilderness was an old man who gave precise but unheeded instruc-

tions in the technical methods of Sir Joshua. Cubley not only gave Nicholson an insight into traditional methods of oil painting, he persuaded his father to allow him to study art and enabled him to escape from a school which offered him only misery and no prospect of success.

Herkomer's art school at Bushey, to which Nicholson's father sent him at the age of sixteen, if less positively disagreeable to him, was hardly more profitable than the Magnus School. The instruction perfunctorily given in Herkomer's grandiose Bavarian castle was not based upon rational principles, and it was not long before Nicholson realized that he was learning nothing – nothing, at least, from Herkomer. One day the life-class was aroused from its apathy by the noisy intrusion of a flock of geese, driven in by a student from an adjacent common. This spirited and whimsical act, so incongruous with the portentous atmosphere of the school, attracted the attention of Nicholson to the boisterous, intractable girl responsible. Her name was Mabel Pryde; she was, as she proudly informed him, sister to James Pryde, who himself soon arrived at Bushey. The company of a brother and sister as original and exhilarating as Herkomer was dull made Nicholson more and more refractory to teaching and intermittent in his attendance. Relations between master and student became tense. One day, it being Nicholson's turn to arrange the model, he brought in a woman from the village and posed her with an open umbrella behind her head. Nicholson made a lively sketch which Herkomer described as 'a piece of Whistlerian impudence' and dismissed Nicholson from the school for 'bad attendance and bad work'. The displeasure of Herkomer put an end to his profitless pupillage, but an incident of a strangely similar kind a little later embittered Nicholson's relations with his father. He painted a portrait of his mother, and his father, invited by his diffident son to look at it in the studio by himself, came out speechless with uncomprehending rage.

There followed a short period of study in Paris at the Académie Julian. The particular problems which preoccupied his French contemporaries had no special relevance to Nicholson, who made few intimate contacts and remained a somewhat solitary figure. A chance visit to Ridge's bookshop in Newark shortly after his return to England had consequences more important for his life as an artist than the sum of his Parisian experience, even though this included the copying of a Velazquez, a master whose combination of the most searching realism with the most exquisite taste must have helped Nicholson to realize some knowledge of himself. Ridge's was an old-established firm which had published some of the early work of Byron, and possessed a large and interesting collection of old

woodblocks. Excited by what he saw, Nicholson went home, secured a piece of wood, planed it down, and with nails and a penknife cut a block from which he printed his first woodcut. Nicholson's work as a wood-cutter lies outside the scope of these pages, but it radically affected his work as a painter.

Not long after his return from Paris, Nicholson's courtship of the girl who had driven the flock of geese into the life-class at Herkomer's culminated in marriage. The Prydes were a violently opinionated, quarrelsome and eccentric family, and Nicholson, sensible, shy and a hater of 'scenes', conducted his unobtrusive courtship of Mabel largely in the coal-cellar of the Prydes' house in Bloomsbury, where the family had migrated on Dr Pryde's retirement. Mrs Pryde, under the spell of one of her successive enthusiasms, had installed a vapour bath in the cellar, wherein the victim sat, the lid closed firmly over his head, while steam was raised by an interior lamp. So long as this enthusiasm lasted, the interior mechanism of this formidable apparatus was shown to the more privileged visitors to the house. One day, when William and Mabel were chattering among the coalsacks, Mrs Pryde – whose disapproval of the courtship was notorious – descended the steps followed by a body of visitors; embarrassed, Nicholson jumped into the vapour bath and held down the lid, to the disappointment of Mrs Pryde when her utmost efforts failed to raise it.

The unpredictable temper of the Pryde household persuaded the young couple that it would be prudent to make their plans without consulting either of the parents. They were accordingly married in secret at Ruislip on 25 April 1893.

Nicholson's marriage immediately led to an association more momentous for his work than the marriage itself. Within a few days of his settling with his wife into the first of their many houses – The Eight Bells, a small former public-house at Denham – James Pryde arrived for a weekend and remained with them for two years. The collaboration of the brothers-in-law as the 'Beggarstaffs', for the designing of posters (briefly treated earlier in these pages), was the chief consequence of this prolonged visit. The estrangement of Nicholson and Pryde in later life has led to a tendency on the part of the advocates of each to belittle the contribution of the other to the illustrious partnership. To assess the contribution of these two with any degree of precision would be, after so many years, as difficult as it would be unfruitful. Pryde's was the more mature and audacious personality. Edinburgh had not yet dwindled into a repertory of conventional formulae; memories of her high, sombre buildings, her dark history, still haunted his dreams. If he was lazy and irresponsible, the reckoning was yet to come. Nicholson's personality had

greater potentiality for growth, but at this time he no doubt seemed, in comparison with Pryde, a diffident, pedestrian being, which no doubt accounted for the discernible condescension in Pryde's attitude towards him. But there was no doubt about Nicholson's industry, manual dexterity and business capacity. If the original conceptions were, perhaps, mostly Pryde's, their translation into finished designs was chiefly due to the skill and pertinacity – doubtless heightened by his responsibilities as a married man – of Nicholson. If the assumption of Pryde's readier invention is justified, Nicholson's work of the immediately ensuing years as a wood-cutter proclaims him an apt pupil. Like Pryde, Nicholson learnt two obvious but important lessons from their joint experience as designers of posters: clarity and economy of statement, and effective distribution of light and shadow.

The Beggarstaffs were so intimately identified – as collaborators and as brothers-in-law – that the radical differences between them have sometimes been overlooked. They had, in fact, very little in common. They were alike in that both lacked the humility found in most serious artists. Pryde's pride, which proclaimed itself in grandiose talk, was obvious enough; Nicholson's was masked, but it went deeper. To boast, like Pryde, would have been repugnant to the dandyism which governed Nicholson's conduct of his life as well as of his art, but somewhere in his innermost being there was, I suspect, a hard core of spiritual complacency. But not the kind of complacency that ever excused him from the utmost exertion. He was never a facile artist: the suavity, cool vivacity, truth of tone, buoyancy and the character in his portraits – all were purchased at the price of an agony of effort sustained throughout a lifetime. With Pryde there was little or no agony of effort. So long as his Edinburgh memories were sufficiently fresh to stir his imagination, he exploited the consequent ferment. When they faded, he exploited his prestige, his dignified handsomeness, his odd engaging humour – in a word, he cadged. He trod the broad path as inevitably as Nicholson trod the narrow.

Potentially, Pryde was, perhaps, the larger artist, as he was the larger human being – he was built upon a scale more ample and generous than Nicholson – but he lacked Nicholson's capacity for growth. Even the latter's most conspicuous qualities – his taste and sense of perfection – were not 'gifts', but endowments painfully acquired and improved upon. Those who admire the work of Nicholson are apt to be impressed so deeply by his most perfect achievements that they can scarcely perceive his defects. Yet could anything show the tastelessness of art nouveau more clearly than the landscape backgrounds of his several paintings of Morris dancers, made during the first years of the century? Could anything be more badly drawn than the obtrusive near thigh – too long, too flat and a

ludicrous match for the far one – of *Carlina* (1909)? Or a more ostentatious display of dexterity than the famous *Hundred Jugs* (1916)? I cite these examples of failure (which, incidentally, have found places in the principal exhibitions and publications devoted to the work of this artist) to support my contention that Nicholson's perfection, like the perfection of the prose of George Moore's maturity, was the outcome (but at no time the certain outcome) of anguished effort. Yet none look more effortless than his best paintings. In these he shows a suave and assured perfection or an insight into character which will, I fancy, offer an effective resistance to the blind but mercilessly probing assaults of time. Of the still-lifes, for which I would claim the relative perfection possible in an age which cares little for perfection, I would name: *The Lowestoft Bowl* (1900), *The Marquis Wellington Jug* (1920), *Glass Jug and Fruit* (1938), and *Mushrooms* (1940); of portraits *Miss Jekyll* (1940), *Walter Greaves* (1917), and *Professor Saintsbury* (1925), and of intimate landscapes, *Black Swans at Chartwell* (1932).

Nicholson was at his best when he responded directly to a simple subject (in so far as any subject might retain its simplicity under the subtle scrutiny of this being whom Robert Nichols aptly compared to a sophisticated child), for he seems to have been little interested in the deeper implications of the appearance of things. His mind, like his eye, was preoccupied wholly with the intimate segments of the surface of the world that came under his minute and affectionate observation (with foreign or unfamiliar subjects he had no success). Never was there a less enquiring or reflecting, or, in the best sense, a more *superficial* mind. Very occasionally Nicholson did probe beneath the surface. For instance, in the amusingly contrasted double portraits of *Mr and Mrs Sidney Webb* (*c.* 1927), and *The Earl and Countess of Strafford* (1940), he has made, in the words of Miss Steen,

> an almost Hogarthian commentary on the new and the old aristocracy. In the one with its ugly modern fireplace of a suburban villa, its litter of documents, the earnest shapelessness of Lord Passfield's trousers, his carpet slippers, his wife's hand clawing absently towards an economical fire, epitomizes high living and as little thinking as possible ... Lady Strafford changing one of the cards of her Patience, Lord Strafford dangling 'The Times' from one drowsy hand.

Miss Steen's claim is justified: the artist has summed up and contrasted two ways of life and thought with extraordinary acuteness. Ordinarily he is content with an almost wholly visual regard – not simply a retinal regard, as Monet's sometimes was, but a vision disciplined by his sense of style and amplified by knowledge. 'Painting isn't only sight', he observed to Nichols; 'it's knowledge. In addition it's capacity to remember.' Nicholson's intimate, civilized vision is a highly traditional vision, for it perceives clearly defined

objects and has little in common with that newer vision evolved by Rembrandt, Turner, Constable and Delacroix, according to which appearances are composed of planes and contours which change continually under the influence of light. Now and then, not only in landscapes, but even in such a still-life, for example, as the *Glass Jug and Fruit* referred to above, he was conspicuously affected by it, but he was most himself among objects which existed tangibly, so to speak, in their own right. This remained essentially though less emphatically the case, it seems to me, until the end, even though he moved steadily from the umbrageous glossiness of *The Lowestoft Bowl*, *The Marquis Wellington Jug*, to the light-suffused *Gold Jug* (1937).

The relation between the art and the personality of William Nicholson was not complementary nor in any sense paradoxical: the one was, quite simply, an extension of the other. There was about his personality, as both Miss Steen and Nichols have observed, something childlike: he lived in the present, without much troubling himself about past or future. He delighted in what was civilized – preferring the intimate, the highly finished, the whimsical – and he was alienated by anything which might be regarded as pretentious, but he occasionally condemned as pretentious persons and achievements authentically great. When he served as a trustee of the Tate Gallery, he praised with an endearing conviction and pugnacity, and I recall with gratitude his advocacy of two painters, favourites of mine, whose art had nothing in common with his own, Walter Greaves and Edward Burra. Dandyism, in his case a desire for an unobtrusive yet original elegance, was, I believe, the strongest and most enduring motive of his actions: such elegance he also aspired to achieve, though with less passion, in his clothes, his houses – in fact, in everything with which he was intimately concerned. He would wear white duck trousers and patent-leather shoes in his studio. He was the pioneer, I believe, of the spotted collar worn with the spotted shirt. When collars were worn high, he, 'seeking glory', he admitted, 'even in the cannon's mouth', wore higher collars than anyone else. I cannot recall his appearance in these early days, but I well remember the small, neat figure in the olive-green coat and white trousers, and the 'ivory-coloured, enquiring little face, with a hat cocked at a knowing angle' which impressed Miss Steen when she first met him in the mid-1930s. He gradually transformed No. 11 Apple Tree Yard, St James's, the stable which he took in 1917, into a studio that was efficient, a delight to live in, and a monument – a miniature monument – to his taste, filled with the whimsical precious accumulation of years: lustre jugs, sporting prints, caricatures by Max Beerbohm, Callot maps, military drums, a top-hat in which to hold his brushes . . .

About 1947, following a stroke, he experienced a sudden failure of his mental powers. Miss Steen, with whom he lived since shortly after their first meeting in 1934, took him to Blewbury, the Berkshire village where she had a house, and devoted herself to a vain attempt to restore him to health. It was suggested that he should continue to paint because of the tranquillizing effect of this occupation. Rather than fall below the severe standards which he had always set himself, he renounced the possibility of recovery and the greatest pleasure which life had to offer him. His health continued to decline, and he died on 16 May 1949.

HAROLD GILMAN
1876 – 1919

Earlier in these pages I mentioned the cooperative activities of a group of friends radiating from 19 Fitzroy Street, one of Sickert's accumulation of odd painting rooms. Sickert, whose opinions underwent frequent changes, never changed his prejudice against the selection-by-jury of works for exhibition – a prejudice shared by his Fitzroy Street friends. There was no exhibition in London in those days that was not picked by a jury, but in 1907 the art critic Frank Rutter undertook to organize one. The Allied Artists' Association, a body similar in organization to the Société des Artistes Indépendants in Paris, was consequently formed. The new Association gained enthusiastic support in Fitzroy Street. At the general meeting, held in the spring of 1908, in response to a plaintive proposal by an obscure member that 'the best works by the best artists' should be given the best places in the exhibition, Sickert thus voiced the prevailing sentiment: 'in this society there are no good works or bad works: there are works by shareholders'. The Association's first exhibition – a huge assembly of pictures by some six hundred members – was opened in the Albert Hall in the July of the same year. The Association, although open to anyone who cared to join, in fact replaced the New English Art Club as the rallying point for adventurous talent, and as the most effective rival to the Royal Academy. The attitude which members of the new society maintained towards the old was exemplified in the reply of a member of the hanging committee, Theodore Roussel, to a lady who asked him how he could hang such dreadful pictures, 'Madam', he said, 'we have the same privilege, as at the Royal Academy, of hanging bad pictures; only here *we have not the right to refuse the good.*' But there was in general a geniality about their disapprobation. 'You're going to tell me', said Walter Bayes to Rutter, who had invited him to become a member, 'that your exhibition will be better than the Royal Academy.' 'I'm not', Rutter said. 'It's going to be bigger and worse.' 'In that case', Bayes said, 'I'll join with pleasure.'

In accordance with the democratic constitution of the Association, all members were eligible to serve on the hanging committee, and invitations were sent out in alphabetical order. By the third year,

1910, it was the turn of the 'G's. This system brought together Harold Gilman, Charles Ginner and Spencer Frederick Gore. The result of this fortuitous meeting was to give a new impetus and a new direction to English painting. Not since the earlier years of the New English Art Club had there been so quickening a centre of energy and enquiry as was presently provided by the intimate association of these three painters.

The outlook of the New English Art Club, although ferociously attacked in academic circles, was, in fact, sufficiently temperate to remain content to develop the ideas which had animated the Barbizon painters and the Impressionists – ideas which, for Paris at least, had long since ceased to be a novel focus of interest. It was not, however, the principles of its most articulate members, nor even the brilliant performance of its most gifted, that enabled the Club to play a part so singularly fructifying in the history of English painting. It was enabled to sustain this part for more than two decades because of the discriminating liberality of its management, and the resulting inter-action of temperaments issued in a widely diffused impulse to creativity. The movement generated by Gilman and his friends was more firmly anchored to principle, and its impact, although sharper, was necessarily more limited in duration and extent.

Gilman was a massive, confident figure, tenacious and fond of argument, with the kind of presence suggested by a contemporary journalist, who wrote of his 'bald head and regal mouth'. Ginner, one of the most consistent painters of the time, possessed a knowledge of Parisian theory and practice approached by very few of his English contemporaries. Gore fostered a wonderful talent for reconciling all honourably reconcilable attitudes.

Gilman and Gore were already old friends who had studied together at the Slade and were also friends of Sickert and Lucien Pissarro, and frequenters of 19 Fitzroy Street. Gore had admired the paintings that Ginner sent over from Paris to the first exhibition of the Allied Artists' Association two years before and asked Rutter who he was. Rutter knew nothing of him except that he lived in Paris. In 1910 Ginner came to London especially to serve on the hanging committee. Gilman and Gore introduced themselves, and told him they liked his work.

Harold Gilman was the second son of the Revd John Gilman, Rector of Snargate with Snave, Kent, whose father, Ellis Gilman, had been head of the firm of Hamilton, Gray & Co., Singapore. Harold was born at Rode, Somerset, on 11 February 1876, and educated at Abingdon, Rochester and Tonbridge schools. In 1894 he went up to Brasenose College, Oxford, but ill-health compelled him to terminate his studies before he could take his degree. He spent 1895 in Odessa.

In 1896 he decided to become a painter, spending a year at the Hastings Art School and then four more at the Slade, working under Brown, Steer and Tonks. He spent the year 1904 in Spain and visited the United States in 1905 and Norway shortly before the First World War. At the Slade he seems to have learnt little and made no impression. The one important event in his early life as a painter was his study of Velazquez at the Prado, of whose works he made careful copies.

I have seen few of Gilman's paintings which resulted from an attempt to apply the principles of Velazquez, but they appear to have been mostly portraits, often life-size, low-keyed harmonies of greys and browns, smooth in texture and somewhat Whistlerian in intention, with something about them of Manet and the Belgian painter Alfred Stevens. One landscape, a crepuscular, weakly drawn Whistlerian essay, *The Thames at Hammersmith* (*c.* 1909), is, although far from undistinguished, a tidy compendium of the very qualities which only a few years later he was most fiercely to abjure. The real significance of Gilman's discipleship of the Spanish master was not, however, apparent in these paintings, but in the insight he gained into the mind of one of the supreme realistic painters. Gilman's was one of those powerful temperaments which mature slowly, but however unconvincing its first-fruits, it is clear that prolonged contact with Velazquez strengthened his own innate realism. It is reasonable to suppose that it was from him that he learnt that one could not pursue nature too closely.

Gilman next came into the orbit of 19 Fitzroy Street. At this time he was still preoccupied with tone values, but his admiration for Lucien Pissarro, and through him for the Impressionists, led him to an enhanced sense of the attractions of pure and brilliant colour. At the same time, Sickert opened his eyes to the poetry of popular subjects, of public-houses, of Camden Town 'interiors' with their chests-of-drawers and iron bedsteads, and showed him how to extract poetry from the near and the familiar. Camden Town, for Gilman, was literally the near and the familiar, for he spent the greater part of his life as a painter in this neighbourhood, first in the Hampstead Road by the railway bridge, later at 47 Maple Street, Tottenham Court Road. (The last time I saw this square Georgian house, the rooms of which Gilman depicted in such brilliant colours, it had become a blackened ruin, the wooden shutters furiously banging in the cold night wind.) He also adopted the broken brushstroke from Sickert, but he used rather lighter tones than his friends, and his touch was already more deliberate.

It was at this point in Gilman's development that he and Gore met Ginner. Immediately afterwards, Ginner called on him and found him

painting the portrait of the wife of his friend, R. P. Bevan. Gilman, although very much aware that there had been momentous movements on the Continent since Impressionism had passed its climax, had no precise idea of their nature. The discovery that his new friend Ginner was familiar with the work of those fascinating but, so far as London was concerned, mysterious leaders of the younger generation, Gauguin, Cézanne and Van Gogh, in Gilman's eyes further enhanced the value of his friendship.

An event took place at this time that provoked more radical and widespread differences than, perhaps, any single event in the history of art in England. This was the Manet and the Post-Impressionists Exhibition (generally known as 'the first Post-Impressionist Exhibition' to distinguish it from the Second Post-Impressionist Exhibition held in the same place from 5 October until 31 December 1912) organized by Roger Fry, and held at the Grafton Galleries, Grafton Street, from 8 November 1910 until 15 January 1911. For it was through this exhibition that the British public (including almost the entire body of British artists) first received the full impact of Cézanne, Van Gogh and Matisse – and a shattering impact it was. When the ensuing controversy died down, it was seen that the exhibition had changed the face of the London art world. Here, as everywhere else, there had always been conflict between 'progressive' and 'conservative' opinion. 'Progressive' opinion upheld, while 'conservative' opinion condemned, for instance, Benjamin West's use of contemporary costume, in place of the traditional classical in the painting of 'history'; and Pre-Raphaelitism, and the 'Impressionism' of the New English Art Club. Yet it was also the case that 'progressive' and 'conservative' had always merged one into the other by insensible degrees. One of the principal consequences of the first Post-Impressionist Exhibition was to sharpen the differences between the opposing factions. Thereafter, one had to be either for or against 'modern art', without qualification. Another consequence was that British painting assumed a less insular character. A third was the emergence of Roger Fry as the most influential English art critic and politician in the place of D. S. MacColl, the severe and eloquent theorist, champion and chastener of the New English Art Club and scourge of the Royal Academy.

Gilman and Ginner visited this momentous exhibition together. At first sight Gilman was captivated by Gauguin, in particular by the richness of his colour and his variety as a designer, but he was unable to accept Van Gogh as an entirely serious painter. What he saw at the Grafton Galleries impressed him so deeply as to call for a complete examination of his own fundamental convictions. For a nature so scrupulous, so deliberate, so confident in the validity of ideas as

Gilman, this was a serious process. Ginner took him to Paris, where they saw everything that could be seen: the room decorated by Van Gogh at Bernheim's; Pellerin's fabulous assembly of Cézannes; the great collection of Impressionists at Durand-Ruel's, and the work of painters of more recent growth – Rousseau, Bonnard, Vuillard and Picasso at the galleries of Vollard and Sagot. On his return, Gilman's judgments were compared, in the course of innumerable discussions, with the maturer judgments of Ginner. As Gilman reflected and talked, his original enthusiasm for Gauguin cooled into respect. He deeply admired Cézanne, but it was Van Gogh who in the end emerged for him as the greatest of modern masters, and as the master who could teach him most of what he wished to learn. (*Letters of a Post-Impressionist, being the familiar correspondence of Vincent Van Gogh*, which was constantly in his hands, might be termed his Bible.) These discussions, in which Gore often joined, and assiduous experiment, crystallized in a distinctive aesthetic, to which all three artists subscribed. (This was set forth in an article entitled 'Neo-Realism', which first appeared in *The New Age*.) Ginner eventually formulated the general idea which formed the heart of this when he declared:

> All great painters by direct intercourse with Nature have extracted from her facts which others have not observed, and interpreted them by methods which are personal and expressive of themselves – this is the great tradition of Realism . . . Greco, Rembrandt, Millet, Courbet, Cézanne – all the great painters of the world have known that great art can only be created out of continued intercourse with Nature.

The arch-menace to the great tradition of Realism, he contended, is always

> the adoption by weaker commercial painters of the creative artist's personal methods of interpreting nature and the consequent creation of a formula, it is this which constitutes Academism . . . It has resulted in the decadence of every Art movement . . . until it finally ended in the 'debacle' of Bouguereau, Gérôme, of the British Royal Academy . . .

He then proceeded to the analysis of the form which the archmenace had assumed at the time at which he wrote. Although

> the old Academic movement which reigned at Burlington House and the Paris Salon counts no more . . . there is a new Academic movement full of dangers. Full of dangers, because it is disguised under a false cloak. It cries that it is going to save Art, while, in reality, it will destroy it. What in England is known as Post-Impressionism – Voilà l'ennemi! It is all the more dangerous since it is enveloped in a rose-pink halo of interest. Take away the rose-pink and you find the Academic skeleton.

Those who adopted the superficial aspects of the work or the teaching of Cézanne, whether straightforward imitators or Cubists, were singled out for particular condemnation. A sharp distinction

was drawn between the Romantic Realism of Gauguin, who himself went to the South Seas, and his personal interpretation; and the formula created by Matisse and Co., 'to be worked quietly at home in some snug Paris studio . . .' He attacked the idea that decoration is the unique aim of art, and spoke of the importance of subject to the realist:

> Each age has its landscape, its atmosphere, its cities, its people. Realism, loving Life, loving its Age, interprets its Epoch by extracting from it the very essence of all it contains of great weak, of beautiful or of sordid, according to the individual temperament.

Impressionism in France, he concluded, was beyond question the latest and most important realistic movement, for 'the Impressionists, by their searching study of light, purified the muddy palettes by exchanging colour values for tone values'. The Neo-Impressionists neglected, in their scientific preoccupations,

> to keep themselves in relationship with Nature . . . On the other hand we find Cézanne, Gauguin and Van Gogh, all three children of Impressionism, learning from it, as a wholesome source, all that it had to teach, and with their eyes fixed on the only true spring of Art: Life itself.

I have quoted from Ginner's essay at some length not because it adumbrates a theory – albeit at points somewhat summarily – to which I can subscribe, but because it provided a basis for the practice of three serious and gifted painters and general guidance for a number of others.

The close association of Gilman, Gore and Ginner affected Ginner relatively little, as his own highly personal style was already mature when he came to England in 1910, but it did result in the formation of something approaching a common style. This left the widest latitude to the individual eye and hand: it would hardly be possible to mistake any single canvas by one of these three for one by either of the others. The most noticeable consequence of their study of the Impressionists, of Cézanne and of their two great successors, was their adoption of a brighter palette. This involved, for Gilman and Gore, an end of their discipleship of Sickert, who continued to use the sombre colours which they came to regard as anathema. In *Harold Gilman: An Appreciation* (1919), Wyndham Lewis has described how Gilman

> would look over in the direction of Sickert's studio, and a slight shudder would convulse him as he thought of the little brown worm of paint that was possibly, even at that moment, wriggling out on to the palette that held no golden chromes, emerald greens, vermilions, *only*, as it, of course, should do.

Equally important was their repudiation – most emphatic with Gilman and least with Gore – of the Impressionist conception of a painting as having something of the character of a sketch, of something begun and completed under the same ephemeral effect, or of having that appearance. Gilman was determined to give his work the qualities of permanence and dignity. To this end he broadened his planes, simplified his masses and gave his designs firmness to the point of rigidity. He rejected the light brushstrokes of the Impressionists and Sickert: he painted with slow deliberation, putting the utmost thought into every touch. His colour assumed a splendid and forthright brilliance. In the course of his struggle to obtain these qualities, and on the advice of Sickert and Ginner, he worked less from life and relied more upon his admirable pen-and-ink drawings. Ardently as he rejoiced in broad planes, firm designs and deliberate brushstrokes which made mosaics of brilliant colour, Gilman never painted for painting's sake, nor was he moved solely by the aesthetic impulse. On the contrary, he was intensely moved by the human significance of the spectacle of surrounding life: he did not paint his mother, nor Mrs Mounter, the landlady whom he has made immortal, nor his rooms in Maple Street, nor even his massive teapots as Cézanne painted apples, because they were accessible and they stayed still. He painted them because he loved them. Discussing Daumier's series of Don Quixotes, Gilman confided to his friend Sir Louis Fergusson that one of his greatest ambitions was to create a character, or rather to seize the essence of a character in real life and exhibit it on canvas in all its bearings. His love for the persons and things nearest to him grew with his growth as a painter.

The consistent growth of Gilman's powers of heart and eye and hand can be traced by comparing four paintings of different periods of his maturity: *The Little French Girl* (c. 1909), is a delicate work, beautifully true in tone, in greys and pinks plainly derived from his study of Velazquez. The girl is affectionately portrayed; so, too, is the furniture. When we set this beside *The Artist's Mother* (1917), it seems to lack personality and candour: we become aware that the touch of pathos in the little girl is a consequence of the expedient of placing her alone in a big room. The dignity and repose of Gilman's mother are obtained, as Americans put it, 'the hard way', by the most direct rendering in deeply pondered, immediately arrested, brushstrokes. But next to *Mrs Mounter* (1917), even his mother, splendid painting though it is, looks small in form and confused in colour. *Mrs Mounter*, with its majestic design in broad planes, its intensely brilliant colour and its tender insight is in my opinion one of the great English portraits of the century, one among, perhaps, a dozen. I do not think that Gilman ever surpassed this portrait, but his last big painting – of

a panoramic and entirely unfamiliar subject, which called for a composition infinitely more complex – showed that he had not reached the limit of his development. This was the radiant and stately *Halifax Harbour after the Explosion* (1918), which, when I last saw it, shed an incongruous lustre in a dark, Neo-Gothic gallery in the New World, above the door of which, unless my memory is playing tricks, was carved the word FOSSILS. Although this must be among Gilman's finest paintings, in order to obtain grandeur of form he did not require a 'grand' subject, as Halifax Harbour is, in any ordinary sense. A picture which it is instructive to compare with this great work is one scarcely inferior to it which represents the interior of a small *Eating-House* (c. 1914). Here, three wooden partitions against walls of pitch-pine and wallpaper and casual glimpses of nondescript diners have been transformed by Gilman's robust affection into a noble design in which glowing colour is fused with closely knit form.

By 1914, when he was thirty-eight years old, Gilman had evolved a way of seeing and a way of drawing and painting which enabled him, when circumstances were propitious, to produce masterpieces. Five years later he and Ginner caught Spanish influenza in the great epidemic of 1919 and were taken to the French Hospital, where he died on 12 February.

The death of Gilman was a grave loss to English painting. He was the acknowledged leader of a group of friends who had infused a new vigour into a great modern tradition. His character, in particular the union of intense seriousness with exuberant goodwill, endeared him to a wide circle of friends. Something of the flavour of this character is caught in this description by Wyndham Lewis, again from *An Appreciation*:

> The Gilman tic was a thing prized by his friends next to the sternness of his painting. He was proud of a pompous drollery, which he flavoured with every resource of an abundantly nourished country rectory, as he was proud of his parsonic stock. He was proud of his reverberating pulpit voice: he was proud of the eccentricities of his figure. He was also proud of a certain fleeting resemblance, observed by the ribald, to George Robey, the priceless ape. But, above all, he was proud to be a man who could sometimes hang his pictures in the neighbourhood of a picture postcard of . . . Van Gogh.

Unlike many, possibly the majority of artists, Gilman was deeply concerned for the well-being of the art of painting in general. He favoured working with a small, cohesive group of painters, partly because he believed that new methods are evolved not by individuals, but, as Sickert used to say, by 'gangs', partly because he regarded such a group as an effective means of propagating sound methods. He was also an able and earnest teacher.

The Allied Artists' Association was recognized by Gilman and his friends as a valuable means of enabling artists, especially independent and lesser-known artists, to show their work, but its exhibitions were on altogether too vast a scale to exert influence in any particular direction. The more clearly their opinions crystallized, the more aware they became of their need for a platform from which to proclaim them. The question of how they were to obtain one was the occasion of numerous discussions. This question quickly resolved itself into a simple issue: whether to try to capture the New English Art Club or to form a new society. In 1910 Sickert wrote in *The Art News*:

> ... I doubt if any unprejudiced student of modern painting will deny that the New English Art Club at the present day sets the standard of painting in England. He may regret it or resent it, but he will hardly deny it.

This estimate of the Club's importance was shared by Gilman and his friends, but of recent years his own work and that of the painters whom he most admired had been rejected by its juries. Sickert was of the decided opinion that they stood no chance of obtaining control of the Club and Gore (who had become a member the previous year) was reluctantly convinced that it had tacitly renounced the pioneering policy for which it had been conspicuous, and had become, in fact although not in profession, an academic force, and that its capture was therefore not even to be desired. Augustus John firmly maintained the view that the Club stood for the highest prevailing standards, and it would be wrong to secede, especially for him who owed everything to it. The climax of these discussions came early in 1911 when, over dinner at Gatti's, it was decided to form a new society. Gilman, innately uncompromising, who had favoured this course from the first, was jubilant, and Sickert, leaving the restaurant ahead of the others, grandiloquently exclaimed, 'We have just made history.' A meeting was held at 19 Fitzroy Street to settle details. There were further meetings at the Criterion Restaurant and, finally, in May, at a restaurant long since demolished, off Golden Square, the new society was formed and appropriately christened by Sickert 'The Camden Town Group'. Gore was elected president. The Group held only three exhibitions, in June and December 1911 and December 1912, all at the Carfax Gallery in Bury Street, St James's. None of these was a financial success, and Arthur Clifton, the director of the Carfax Gallery, was not prepared to continue them. Members of the Group then approached William Marchant, proprietor of the Goupil Gallery, with the view of transferring their exhibitions to his premises. He was sympathetically disposed, but objected to the title of the

Group for the very reason that had led Sickert to choose it – namely, that a sensational murder had given Camden Town an ominous reputation. He also favoured an enlarged society to ensure that his more capacious galleries should be filled.

By 1913 a spirit of fusion was abroad. Of the various groups active in the region about Tottenham Court Road – of which the membership was largely identical – each had its particular difficulty. All suffered from insufficient resources and the consciousness of being too small to be effective. The Camden Town Group fused with 19 Fitzroy Street, and successfully sought the adherence of the Vorticist Group led by Wyndham Lewis, of which Frederick Etchells, William Roberts and Edward Wadsworth were the principal members. After protracted negotiations, a meeting was held on 15 November 1913 at 19 Fitzroy Street, with Sickert presiding, at which it was decided to form yet another and more comprehensive society, and to call it the London Group. Gilman was elected president and continued in office until his death. The new group represented a fusion not only of the three groups already mentioned, but also of the Cumberland Market Group which came into being on the initiative of Gilman and Robert Bevan as a successor to 19 Fitzroy Street. Shortly afterwards Spencer Gore died, and with his death the tensions within the London Group, latent in the presence of his disinterested benevolence, his tact and charm, caused dangerous rifts. The outbreak of the First World War brought a further confusion, and when this confusion cleared away, the Group fell under the control of Fry, whose aims were totally opposed to those of its founders.

More satisfying to Gilman than all this formation and amalgamation of groups – for he lacked the adaptability, guile, ambition and the talent for intrigue; all, indeed, of the political talents except clarity of aim, persistence and the more doubtful asset of courage – was his teaching. For a time he taught an evening life-class at the Westminster School. The class had for some time been taught by Sickert, who resigned shortly after the outbreak of war, and Gore was appointed in his place. On the death of Gore, or possibly earlier, the class was taken over by Gilman. Before long, Sickert, wishing to resume his teaching at Westminster, secured Gilman's dismissal. This caused a breach between him and his friend and teacher that was never healed.

Gilman's evening classes, both at the Westminster and at the small school at 16 Little Pulteney Street, Soho, that he afterwards ran with Ginner, were attended by admirers of his painting who, in the words of one of them, 'wished to learn to see colour as he saw it'. The usual subjects were nudes and charwomen. Gilman, who shared Sickert's disapproval of the painting of figures in isolation from their environment, used to fit up a screen with a boldly patterned wallpaper for a

background. The method of painting he taught was, of course, that which he had himself evolved. In accordance with this method his students made no underpainting or anything like a preliminary sketch, but instead built up their pictures in separate brushstrokes, each carefully considered and correctly related to the rest. They began with the highest lights and worked downwards to the darker passages, looking for colour rather than tone relations, for Gilman did not subscribe to the widely held belief that if tone relations were right, correct colour relations would inevitably follow. The students were taught that there was no such thing as a uniform surface that could be represented by a wide sweep of the brush; that all surfaces that presented this appearance at first glance under scrutiny proved to have infinite subtle variations. Although they were enjoined to aim at finality with each brushstroke and never to be content with less, it was recognized that this was a counsel of perfection, and they were bound to err, especially at first; but it was infinitely preferable to err on the side of overstatement of a colour's strength and purity – the grossest error was to take refuge, when in doubt, in some indeterminate colour such as brown. Colours inclined to be neutral must be forced to confess a tendency to positive colour, and this was to be intensified. They used the colours of the spectrum and white. One day Gilman said, after some deliberation, that an occasion *might* arise when, say, raw sienna was the proper colour to use, for one touch, but this he thought most unlikely, and he advised them (for the hundredth time) to avoid, if they were to escape the danger of muddiness, all earth colours. He never favoured the scraping off of any paint from their canvases, advising them instead to add fresh touches on top of the old; nor did he mind how thick, in consequence, they painted, observing that some of Rembrandt's canvases must originally have been very heavily loaded.

Gilman gave his students the strong impression of *seeing* the clear, pure greens, lilacs and yellows he used in painting flesh, and of being unable to see in any other way. Inevitably they themselves came to see nature in terms of pure colour relationships. Certain of his methods evidently derived from Signac and Seurat, but his aims, unlike theirs, were in no way affected by their scientific preoccupations: with Gilman the emphasis was always on the *beauty* of the colour in the subject. He shared Sickert's opinion that even a knowledge of perspective and anatomy was superfluous to someone able to render tone and the direction of lines with sensibility and precision. He surprised one of his students by telling him to begin drawing a nude with an outline silhouette. So confident was he that he tempered his own dogmatic approach by taking any observations a student ventured to make with the utmost seriousness, and by an openness to

new ideas. This combination of certainty and modesty made him an admirable teacher. He did not work on his students' canvases, and their familiarity with his own work made 'demonstration' unnecessary. His criticism generally took the form of a searching analysis of the subject in terms of colour relations.

In spite of the brevity of his professional life and of his restricted scope as a teacher, and of the diversion to ends with which he could have had no sympathy, there are signs that the reputation and influence of this single-minded and uncompromising painter stand higher than at any time since his death. Higher, certainly, in one particular aspect: during Gilman's lifetime scarcely anybody except his friends bought his modestly priced pictures; now, year by year, they are more difficult to acquire.

GWEN JOHN
1876 – 1939

Gwen John was in almost every respect the opposite of her brother Augustus. He was an improviser; she developed methodicity, as he has told us, to a point of elaboration undreamed of by her master, Whistler. He was expansive; she was concentrated. He was exuberant; she was chaste, subdued and sad. He was Dionysian; she was a devoted Catholic. He enhanced or troubled the lives of those whom he touched; she stole through life and out of it almost unnoticed.

Neither in France, where she mostly lived, nor in her own country, did her work arouse sufficient interest during her lifetime to inspire, so far as I am aware, a single article. In 1946, seven years after her death, a memorial exhibition consisting of two-hundred and seventeen works in various mediums was held in London. This was received with marked respect, but a few months later, if she was not quite forgotten, she occupied only a tiny niche in the public memory. The most memorable consequence was the arresting evocation of his sister's memory in Augustus John's foreword to the catalogue.

Yet few of those privileged to know her work fail to receive a lasting impression. Many are moved to compare it with that of her brother, to his disadvantage. The expressions of personalities so opposite as Gwen and Augustus John are hardly comparable; we can only note the contrasts between them. About this there would be nothing invidious, for he was his sister's most ardent advocate. The very extremity of the contrasts between these two children of the same parents always seemed to fascinate Augustus John: I saw him peer fixedly, almost obsessively, at pictures by Gwen as though he could discern his own temperament in reverse; as though he could derive satisfaction in his own wider range, greater natural endowment, tempestuous energy, and at the same time be reproached by her single-mindedness, her steadiness of focus, above all by the sureness with which she attained her simpler aims.

The case of Gwen John provides a melancholy illustration of the neglect of English painting. I am not expressing an original opinion in saying that I believe her to be one of the finest painters of our time and country, yet – apart from her brother's eulogy and a discerning article on the memorial exhibition by Wyndham Lewis in *The Listener*,

October 1946 – her work has received no serious consideration whatever; indeed, it can scarcely be said to have been noticed at all. (This essay was written in the early 1950s; Susan Chitty's admirable *Gwen John* – to which I was privileged to write the foreword – did not appear until 1982.) Outside the Tate, which possesses a dozen of her paintings and drawings, she is insignificantly represented in public collections and there are relatively few of her works in private hands. Gwen John is, in fact, in danger of oblivion. It would be unjust to her contemporaries to suggest that they are solely to blame. She herself deliberately chose a life of seclusion and, after her death, a number of her paintings disappeared from the little room she had occupied. No work by her later than 1932 is known, and so withdrawn was her life towards its end that it is uncertain whether she ceased to paint or whether the paintings she made were lost. Not many of her friends survive, and those who do recollect curiously little about her. One of them invited me to his house not long ago, telling me that he often saw her during that last obscure decade, but he confessed that his memory retained nothing precise. Even her family's recollections are meagre. So it is an elusive personality that I am trying to reconstruct.

Fortunately, thanks to the kindness of Edwin John, her favourite nephew, I have had access to a number of important documents. During her last years at Meudon she possessed a little shack on a piece of wasteland where she lived and worked, and an attic room in a neighbouring house which she had previously occupied but later used for the storage of her effects. After her death her nephew, who is also her heir, went to Meudon, and found in the attic room, besides a number of pictures, a mass of papers, covered with dust, that had lain for years undisturbed. These include a few letters from Rilke, a number from her father, and a long series of intimate brief letters from Rodin. The letters addressed to her are largely complemened by copies she made of others of which the originals are missing (several evidently from M. Jacques Maritain, for example); by numerous drafts or copies of her own letters to Rodin and others; and copies of prayers and meditations and extracts from the writings of the saints and other Catholic writers, as well as from Bertrand Russell, Baudelaire, Dostoyevsky, Oscar Wilde and Diderot. There is something puzzling about these copies. It is understandable that she should wish to preserve copies of those of her letters which she valued, and make drafts of letters difficult to compose, but this does not account entirely for the number of such copies. There is one meditation of which there are seven, several of them identical. Through the kindness of her brother and her nephew, I have had permission to quote from all these papers, but in view of the intimate character of many of them,

and of Gwen John's own extreme reticence about her life, I shall do so as sparingly as the requirements of my narrative allow.

Gwendolen Mary John was born on 22 June 1876 at Haverfordwest, Pembrokeshire, the second of the four children of Edwin William John, a solicitor, and his wife Augusta, born Smith, of a Brighton family. Not long after her birth the family moved to 5 Lexden Terrace, Tenby. Here, in an attic, Gwen and Augustus, whose vocations were declared early, had their first studio. An extraordinary capacity for devotion was also early evident in Gwen, who was always, her brother related, 'picking up beautiful children to draw and adore'.

In 1895 she followed Augustus to the Slade and they shared a series of rooms together, which they constantly changed, living solely on fruit and nuts. The intensity of Gwen's friendships at times made the atmosphere of the group of which the two were the focus 'almost unbearable', according to her brother, 'with its frightful tension, its terrifying excursions and alarms'. The break in one such friendship brought a threat of suicide. But the 'excursions and alarms' did not interrupt the progress of Gwen's art. How beautifully she drew while she was still a student is apparent from her *Self-portrait at the Age of about Twenty* (in which she looks considerably younger). One of her passionate attachments, in fact, was invaluable in fostering her technical knowledge of painting, for Ambrose McEvoy imparted to her the results of his researches into the methods of the old masters. Without his help she could hardly have painted the *Self-portrait*, which depicts the artist in a red sealing-wax coloured blouse, which, although I am unable to date it precisely, was probably done soon after she left the Slade. The portrait – to my thinking one of the finest portraits of the time, excelling in insight into character, purity of form and delicacy of tone any portrait of McEvoy's – owes the technical perfection of its glazes to his knowledge, which was as generously imparted as it was laboriously acquired.

On leaving the Slade in 1898 Gwen lived in a little room over a mortuary in the Euston Road, and later in a cellar in Howland Street, where she made watercolour drawings of cats. After leaving Howland Street, she lodged for a time with a family (father, mother and two sons, one of whom became a celebrated painter) in a house where the shutters were always closed, for they paid no rates. Before long she left England and settled in France, returning only for occasional visits. How bleak the interlude was between the Slade and Whistler's school in Paris to which she presently attached herself is clear from a letter to her brother:

> I told you in a letter long ago that I am happy. Where illness or death do not interfere, I am. Not many people can say as much. I do not lead a subterranean life (my subterranean life was in Howland Street) . . . If

to 'return to life' is to live as I did in London – *Merci, Monsieur*! . . .
There are people like plants who cannot flourish in the cold, and I want
to flourish . . .

At Whistler's school, taking to heart her master's saying that 'Art
is the science of beauty', she proceeded, her brother has told us, to
cultivate her painting in a scientific spirit. She used to prepare her
canvases according to a recipe of her own, and invented a system of
numbering her colour mixtures which, however helpful to her, makes
her notes on painting and schemes for pictures unintelligible to
anyone else.

> . . . She had no competitive spirit and rarely went out of her way to
> study her contemporaries, but was familiar with the National Gallery
> and the Louvre.

When asked her opinion of an exhibition of Cézanne watercolours,
her reply, scarcely audible, was 'These are very good, but I prefer my
own.'

Whistler's school was not a school in the current sense, but a class,
managed by a former model named Carmen, which Whistler visited
once a week. A comment by Whistler on the work of Gwen John is
related by her brother, who met him in the Louvre and introduced
himself as the brother of one of his pupils:

> Mr Whistler with great politeness asked me to make Gwen his com-
> pliments. I ventured to enquire if he thought well of her progress,
> adding that I thought her drawings showed a feeling of character.
> 'Character?' replied Whistler, 'Character? What's that? It's the tone that
> matters. Your sister has a fine sense of *tone*.'

Gwen's attendance at Whistler's school was confined to the after-
noons. She lived in a top flat in the Rue Froidveau, which she shared
with two fellow students, Ida Nettleship, who was shortly to become
the wife of Augustus, and Gwen Salmond, some years later the wife
of Matthew Smith. The three girls practised the most rigorous
economy, and, although Gwen John outdid her companions in this
respect, she was not able, out of her tiny allowance, to save enough
to pay the small fees required to attend Whistler's school. By a
benevolent act of intrigue, Gwen Salmond secured her admission as
an afternoon pupil. 'I've written home', Gwen John delightedly ex-
claimed, 'that I've got a *scholarship*.'

In spite of her dedication to painting and drawing, she seems to
have done little of either at this time. An incident related by a friend
who was also a witness may explain this singular circumstance. Some
time after Gwen had gone to Paris, her father arrived on a short visit.
By way of welcome she arranged a small supper to which she invited
several of her friends, at which she wore a dress copied from one in

a picture by Manet. She had gone to infinite trouble over the making of the dress, the fabric having been purchased at the price of many frugal meals. 'You look like a prostitute in that dress', was her father's opening observation. 'I could never accept anything from someone capable of thinking so', she answered. My informant believes that in order to replace the rejected small allowance she posed regularly as an artist's model. She was qualified for this by a grave dignity and a beautiful, slender figure, *'un corps admirable'*, as Rodin, an authority on the subject, called it some years later. To judge from the long series of unintimate but prosily friendly letters from her father, which she preserved, the incident left no bitterness.

Dates are difficult to establish, but it was probably in the autumn of 1898 that Gwen first settled in Paris. A year or so later she was in London again. For a time she shared what my father described as 'comfortless' quarters with her brother in Fitzroy Street; then they moved into a house lent to them by my parents. (I was born in this house, 1 Pembroke Cottages, Edwardes Square, eighteen months later.) My father, having to return to London for a night in the middle of the following winter, telegraphed to the Johns to warn them of his arrival, which he thus described in *Men and Memories*:

> When I reached Kensington I found the house empty and no fire burning. In front of a cold grate choked with cinders lay a collection of muddy boots . . . Late in the evening John appeared, having climbed through a window; he rarely, he explained, remembered to take the house-key with him.

Recalling, in the winter of 1951 the events of that earlier winter, Augustus John observed confidentially: 'I'm afraid Will did not find Gwen and me very satisfactory tenants . . .' Augustus married in 1900, and Gwen must have remained in England for a while, for Ida, his first wife, wrote to my mother many months later saying: 'I long for Gwen; have you seen her lately?'

In the autumn of 1902, Gwen returned to France in circumstances which should enable me to fill in the tenuous outlines of the portrait that I am trying to draw – a portrait which nevertheless I shall find difficult to bring clearly into focus. She was accompanied on a journey to Paris, by way of Bordeaux and Toulouse, by Dorelia, whom her brother married shortly after the death of his first wife, and to whom I am indebted for some details about the journey and her companion. The two girls travelled by boat to Bordeaux, from which they walked to Toulouse. They spent their first night in France in a field on a bank of the Garonne, and were wakened in the morning by a boar. They intended to walk on to Italy, but after spending three months or so in Toulouse and visiting Montauban they went to Paris instead. (Here

Gwen stayed for the rest of her life, apart from a few brief visits to
England and to the French coast, for she loved the sea, and from time
to time she needed, with a curious urgency, the refreshment she was
unable to draw from any other source.) On their journey the two girls
lived spartanly. In Toulouse they lodged in two bare rooms which
they rented for two francs a week; they subsisted upon bread, cheese
and figs which cost them fifty centimes a meal, and which they ate in
the fields; and they bathed in the river, maintaining themselves
meanwhile by making portrait sketches in cafés for three francs each.
The person who emerges from Mrs John's description was attractive
to men and susceptible to their admiration; reserved and quiet-
voiced; pale and oval-faced, her hair something in colour between
mouse and honey, done with a big bow on top; with a slender figure
and tiny, delicate hands and feet, yet of exceptional strength, able to
carry heavy burdens over long distances at speeds which her com-
panion found excessive. 'I shouldn't like to carry *that*', shouted a sturdy
Montauban workman, indicating the big bundle on her back. While not
unsociable, Gwen loved solitude; indifferent to mankind as a whole,
she was passionately attached to her few friends, and apt to form
strong attachments that cooled quickly. Beneath a reserved friend-
liness occasionally varied by moodiness, Mrs John was aware of a
strain of censorious puritanism. Gwen disapproved, for instance, of
the theatre; she spoke angrily of the 'vulgar red lips' of a beautiful girl
whom they used as a model. She rarely spoke of painting or other
serious matters, but when they became subjects of conversation she
was able to express herself with ease and conviction.

A few days after Mrs John had given me the foregoing information,
I received the following note from her, evidently intended to correct
the rather austere impression she thought she had given:

> Fryern Court,
> Fordingbridge,
> Hants.
> *Jan. 19th/51.*

Dear John,
 ... You asked me how Gwen dressed and though I cannot remember
what she wore she always managed to look elegant, and though I
cannot remember what we talked about I do remember some very light-
hearted evenings over a bottle of wine and a bowl of soup. She wasn't
at all careless of her appearance; in fact, rather vain. She also much
appreciated the good food and wine to be had in that part of France,
though we mostly lived on stolen grapes and bread.

> Yours sincerely,
> *Dorelia.*

During her three months in Toulouse, Gwen worked steadily. She
painted at least two portraits of her companion, the lamp-lit *Dorelia*

at Toulouse, and *Dorelia in a Black Dress,* both from life, directly onto the canvas without preliminary studies. She drew and painted quickly, her brother told me, 'with an intensity you could scarcely believe'. *Dorelia at Toulouse* is one of her best portraits. The beautiful young woman reading at night, facing the full lamplight that casts her large shadow on the wall behind, is painted with extraordinary tenderness, as though expressing pity for a being trustfully unaware of the scarring realities of life. Yet it is not with a sentimental, but a serenely detached, an almost impersonal pity that the beautiful reader is portrayed.

By 1902, when she was twenty-six, Gwen John's art had reached maturity. It may indeed have matured still earlier, but I am unable to assign a definite date to any painting done before *Dorelia at Toulouse* (my surmise that the Tate *Self-portrait* was painted some three years earlier is based upon slender evidence). I have examined a number of her paintings with her brother, her nephew Edwin, Mrs Matthew Smith and others who knew her, but I was able to elicit, with regard to dates, few opinions and no facts. *A Lady Reading, Nude Girl* and other paintings of the same character would seem to be among the earliest that survive, but what of the lovely *A Corner of the Artist's Room in Paris?* This picture, surely an ultimate expression of the intimiste spirit, by its tiny perfection reminds us not of any other picture so much as it does of the song of a bird. When was it painted?

The art of Gwen John shows throughout an extraordinary consistency and independence. There are few painters whose origins do not appear, or, rather, obtrude themselves, in their early works (if not their later). But where, outside her imagination, are the sources of this artist's inspiration? There are artists wider in range (indeed, there are few narrower), but I can think of none in our time to whom the term 'original' can be applied more properly. Nothing could be more restricted than Gwen's subjects: a handful of women: her sister-in-law Dorelia, a girl called Fanella, a few nuns, a few orphan children, herself; some cats; but beyond these – except for an occasional empty room or view from a window – she scarcely ever went. Nor was her treatment of them various: all are represented singly and in simple poses; all (except the cats) are chaste and sad.

So deep were the roots of her art that it seems hardly to have been affected by two events, one of which whirled her, she said, like a little leaf carried by the wind, the other eventually transforming her life. The first of these was her long intimacy with Rodin; the second her adoption of the Catholic faith. That they were to some extent coincidental made the years of her life that were affected by them a time of extraordinary anguish.

Their correspondence suggests that she met Rodin in 1906. At their

first encounters at all events there was no trembling of the leaf. In an early letter she even alluded to her lack of respect for his work. In another, undated but evidently later, she wrote with bitter reproach: 'Quel vie vous me donnez maintenant! Qu'est-ce que je vous ai fait mon Maitre. Vous savez toujours que mon coeur est profonde . . .' ('What a life you're giving me now! What have I done to you, my Lord? You know that I have a warm heart . . .') We may surmise that Rodin quickly overcame her indifference and tapped the deep wells of her adoration, and, having reduced her to a condition of helpless dependence upon him, found her single-hearted devotion, when the first excitement ebbed away, an added complication that his already complicated life could hardly sustain. In 1906 he was already sixty-six years old and constantly, he complained, 'enrhumé' or 'grippé'. He was the most illustrious sculptor of the modern world, and deeply involved in a wide complex of professional, social, amorous and financial relationships. But it would be unjust to depict him as a man who, under the spell of a superficial attraction, recklessly established an intimacy that he soon regretted. The numerous brief letters he wrote to Gwen testify to a friendship that was close and enduring, and that certain of them should be evasive, given the circumstances, need be no matter for surprise. They speak of his appreciation of her painting and drawing, but above all of his concern at her neglect of her health. In one of the earliest, written in 1906, he says. 'Il faudrait changer de chambre [her room at 7 Rue Ste. Placide] qui est trop humide et n'a pas de soleil.' ('We must change rooms, this one is too damp and doesn't get any sun.') He urges her continually to eat well, to take exercise. There is a sentence in a later letter that sums up their relations: 'Moi je suis fatigué et vieux. Vous me demandez plus que je peux mais j'aime votre petit coeur si devoué, patience et moins de violence.' ('Me, I'm tired and old. You ask more of me than I can give but I love your warm heart and total devotion, be patient and less violent.') A singular, if unimportant, fact about their friendship is Rodin's continuing vagueness about her name. He addressed her letters 'Mademoiselle John Mary', 'John Marie', sometimes simply 'Mary'. Anguishing although Gwen John's friendship with Rodin evidently became, it was incomparably the largest and most deeply felt friendship of her life.

Not comparable in its intensity nor, indeed, in its character with her relationship with Rodin was that which she formed with Rilke, probably the most enduring friendship she had. There is a letter from him dated 17 July 1908 in which he offered to lend her books, and expressed regret that since the previous year she had not wished to remember him; and there is a brief, cool reply from her, written in the third person. But their friendship grew, and a letter from her dated

April 1927 shows how much she came to rely upon his guidance and affection:

> I accept to suffer always, but Rilke! hold my hand! you must hold me by the hand! Teach me, inspire me, make me know what to do. Take care of me when my mind is asleep. You began to help me. You must continue.

It was her concern for Rilke's soul that caused her, the day after his death, to call on the Maritains (who also lived at Meudon) to ask whether she should pray for it there or at the place where he died.

Precisely when Gwen John was received into the Catholic Church I have been unable to discover, but it must have been early in 1913. On 10 October 1912 she wrote to the Curé of Meudon to excuse herself for not attending an instruction, and on 12 February of the following year she noted: 'On Saturday I shall receive the Sacrament for the 5th time'. But it would seem that her relations with Rodin had not changed. Her religious life therefore began in circumstances of extraordinary difficulty, but the courage and the implacable clear-sightedness with which she faced them made her will, already exceptionally strong, into an instrument of formidable power. But the process was one of prolonged, unmitigated anguish. 'A beautiful life', she wrote, 'is one led, perhaps, in the shadow, but ordered, regular, harmonious.'

The many prayers and meditations she left do not reveal an aptitude for speculation, nor an intellect of exceptional interest, but she did possess, in a high degree, the quality of *immediacy* by which we are constantly arrested in the writings of Newman and Pascal. 'Do not think', runs one of her notes, 'that you must wait for years. In tonight's meditation God may reveal himself to you.' She was relentless with herself in her determination to transform her life.

> I have felt momentarily a fear of leaving the world I know, as if I should be loosing [sic] something of value, but I cannot tell what there is of value in it that I should be loosing [sic]. It is because I cannot criticise the world I know, because I have not been able to criticise it that it appears to have a value [she wrote in English or French according to her fancy; inaccurately in both].

In the notice of her memorial exhibition from which I have quoted, Wyndham Lewis asked how she could have isolated herself so successfully from the influences of her age. 'Part of the answer', he wrote, 'is that one of her great friends was Jacques Maritain: she belonged to the Catholic Revival in France.' Apart from the question of whether the friendship of M. Maritain would be likely to isolate an artist from contemporary influences, the fact is that neither of the scorching and exalting experiences she underwent appears to have

had any immediate effect on her art; they seem to have neither hastened nor retarded its serene progress. She was protected from the effects of current modes of feeling and expression – just as she was protected from the insecurity that such experiences bring to shallower natures – by her extraordinary, although wholly unassertive, originality and independence.

I do not mean that her painting did not change; in its unhurried fashion, it changed greatly. In her early paintings, the Tate *Self-portrait* and the other probably rather later and equally fine *Self-portrait* belonging to her brother, she used glazes or thin fluid paint, gradually and delicately correcting until the picture corresponded with her vision of her subject. In her later painting her method was the opposite of this: she used thick paint, and was reluctant to touch her canvas more than once in the same place, preferring, in the event of failure, to begin again. She gradually abandoned the use of dark shadows – shadows which were sometimes almost black – and kept her tones light and very close together. As her tones grew lighter with advancing years, so her austerely simplified forms attained still greater breadth. But these changes were never accompanied by diffuseness, as they have been sometimes, even in the work of so considerable a painter as Monet. Gwen's later work, on the contrary, is distinguished by a heightened intensity. The delicate colours – they look as though they were mixed with wood-ash – applied with touches so modest but so sure, and the firm draughtsmanship beneath produce an impression of extraordinary grandeur, no matter on how small a scale she worked. The wisdom she gained from her emotional and spiritual ordeals was little by little embodied in her deeply rooted art. In the later years her mastery, which had earlier been instinctive and unfocused, became radiantly manifest.

The last twenty-five years of her life or so were spent at Meudon, to which she had no doubt followed Rodin not long before her reception into the Church. For some years she occupied the attic room at 29 Rue Terre Neuve, in which her pictures and her papers were found after her death, but in the summer of 1927 she acquired a small piece of ground in the Rue Babie, at the back of which stood a garage. In this secluded and rather dilapidated structure, the trees and shrubs growing up to shield it, she lived and painted. Without any of the domestic arts (she could scarcely cook the simplest of dishes), she existed in what to an ordinary mortal would have been unendurable discomfort, eating scarcely anything (although never neglecting to feed her cats) and sleeping in summer in the open in her flowering wilderness. Cats were her constant companions, and she experienced in their acutest form the anxieties from which those who have animals for friends are never immune. 'Fearful anguish because of the cat',

runs one of her little notes. 'All équilibre lost.' It was on their account that she revisited England so rarely during these years. 'The cats more than my work make it too difficult for me to cover over', she wrote to a friend. 'I've had so many tragedies [sic] with them, now I'm afraid to leave the two I have now.' Nor was she easily persuaded to send her pictures for exhibition in London or New York, where, in spite of her indifference to the opinions of anyone except her friends, she had a few deeply convinced admirers. My father was one of the few whose praise she valued. In an undated letter to my mother she wrote: 'You say my pictures were admired. I tell myself since reading that, that Will admired them. I do not care for the opinions of others.'

The innumerable pieces of paper upon which she wrote down her drafts and copies of letters, prayers, meditations and notes on painting tell the story of her later life. The notes on painting are the rarest. Some of them are indecipherable, others unintelligible, but a few vividly evoke her palette. 'Smoky corn and wild rose', runs one of them, 'faded roses (3 reds), nuts and nettles faded roses and vermilion roses in a yellow basket . . . cyclamen and straw and earth . . .' Another, in a draft of a letter to a friend, recalls her loving intimacy with nature: 'At night I used to pluck the leaves and grasses in the hedges all dark and misty and when I took them home I sometimes found my hands were full of flowers.' But most of these random notes concern the religion which shared her life with painting: 'Ma religion et mon art, c'est toute ma vie', ('My religion and my art are my whole life'), she said to her neighbour in the Rue Babie. She took Holy Communion daily, but when she reached the point in a painting when her undivided attention was demanded she would work continuously and absent herself from Mass, sometimes for as long as a month. Reproached gently by her neighbour about these absences, she consulted the Curé (I quote from an unpublished account of Gwen John written by her neighbour):

> . . . un prêtre en qui elle avait la plus entière confiance, très éclairé et de grande largeur d'idées. Il savait qu'il avait à faire à une artiste, qu'il ne pouvait traiter comme tout le monde, aussi, elle rev int toute joyeuse: 'il ne m'a rien dit, il ne m'a pas dit que j'avais fait un péché'. Je compris a mon tour, et je ne lui en palai plus.

> (. . . a priest in whom she had complete confidence, who was very understanding and had breadth of mind. He knew what it meant being an artist, that artists could not be treated like everyone else, thus, she returned full of joy: 'he didn't say anything to me, he didn't say that I had committed a sin'. Then, I understood, and no longer spoke to her about it.)

Although she lived a devout, even a saintly life, Gwen John preserved her independence in all the spheres where it was appro-

priate, and never felt, like many others, in particular, perhaps, English converts to the Church, the need to make excessive demonstrations of piety. As her neighbour quaintly put it:

> Sous un certain angle, elle était restée protestante; j'en eus un bel échantillon le jour de la mort du Pape PIE XI. Outre qu'il était le chef des catholiques, c'était un ami de la France, et nous avions été tres émus de sa disparition. Je l'apprends à Mlle. John qui me répond 'qu'est-ce que vous voulez que ça me fasse', et à son tour, elle m'apprend la mort d'une vieille voisine, assez peu sympathique que nous connaissions à peine l'une l'autre. Vexée de la réponse je lui dis: 'mais vous semblez plus fâchée par la mort de Mme. M. que par de celle du Pape.' Elle part d'un éclat de rire franc, prolongé, qui m'interloque 'Bien sûr que je suis plus fâchée par la mort de Mme. M. . . . un million de fois plus. Elle je la connaissais, je passais tous les jours devant sa porte, mais le Pape! Il y en aura un autre, et puis voilà?' C'est tout le regret que j'en pus tirer.

> [In certain aspects, she had remained a Protestant; I witnessed a fine example of this the day Pope PIE XI died. Apart from the fact that he was the head of the Catholic Church, he was a friend to France, and we had been very upset by his demise. I told Mlle John about it who replied 'what do you want me to say?' and in turn, she told me about the death of an old woman who was a not very likeable neighbour of ours and whom we scarcely knew. Annoyed by her reply I said to her: 'but you seem more upset by the death of Mme M than by that of the Pope'. She let out a loud burst of laughter which disconcerted me. 'Of course, I'm a hundred times more upset by Mme M's death. I knew her, I passed in front of her door every day, but the Pope! There will be another, then another! That's the only regret I have about it.'|

During her last years her passion for solitude grew more imperious than ever, but she was friendly with the several orders of nuns in Meudon, in particular the Dominican Sisters of the Presentation. The Sisters, and the orphans who were their care, became her principal subjects. She did nothing better than her best portraits of them, *Mère Poussepin* (the Mother Superior, and her special friend), for example, and *Portrait of a Nun*, in which her uncompromising search for visual truth is beautifully balanced by her affection for her friends.

But her way of life was one that could not last for long. For a person of her temperament the price of such entire independence and solitude as she demanded was increasing ill health. The self-neglect which Rodin had ceaselessly protested against ended her life. A friendly neighbour complained that,

> To go to a doctor inconvenienced her, to take solid nourishment inconvenienced her also, and without comfort, without ease, treating her body as though she were its executioner, she allowed herself to die.

In the early autumn of 1939 she became ill, and, too late, felt a sudden longing for the sea. She took a train for Dieppe, but on arrival

she collapsed, and was taken to the hospital of a religious house, where she died on 13 September. She neglected to take any baggage with her, but she had not forgotten to make provision for her cats in her absence. 'This retiring person in black', as her brother once described her, 'with her tiny hands and feet, and soft, almost inaudible voice', died as unobtrusively as she had lived. He has also related, in the catalogue to the memorial exhibition, how narrowly she missed having a part in a great public monument:

> Commissioned by the Society of Painters, Sculptors and Engravers to execute a memorial to Whistler, Rodin produced a colossal figure for which my sister posed, holding a medallion of the painter. This was rejected by the Society, following the advice of the late Derwent Wood, on the grounds of an unfinished arm, and instead a replica of the *Bourgeois de Calais* took its place on the Embankment.

Her brother came upon it years later, he told me, neglected in a shed in the grounds of the Musée Rodin.

AUGUSTUS JOHN
1879 – 1961

Not long ago I was discussing the relative merits of contemporary English painters with one of the most serious and influential of English art critics. 'I suppose', he said, gazing into the distance, and speaking with the conscious open-mindedness of a man to whom no field of speculation is closed, 'I suppose there *are* people who would place John among the best.' Future ages, I am convinced, will marvel at the puny character of an age when even the most highly regarded critical opinion is so little able to distinguish between average and outstanding stature.

There are, of course, obvious reasons why Augustus John should not, for the time being, greatly excite the curiosity of the young. His aims are not theirs, and in any case he has been illustrious for so long that he is apt to provoke their impatience. Today, so far as critical opinion is concerned, he is on the way to becoming 'the forgotten man' of English painting, and his fanciers are the old and the ageing for whom his work was the inspiration of their formative years, or else 'outsiders', intelligent stockbrokers and the like, with the wit to consult their eyes rather than their ears when buying pictures. The withdrawal of the aura of fashionable approval leaves a man's faults exposed, and many of John's paintings and drawings expose him to legitimate criticism. There are paintings which, owing, perhaps, to some lack of constructive power, he was unable to finish and compelled to abandon, wastes of paint which his utmost efforts failed to bring to life. And there are paintings in which, under the spell of El Greco, he coerced his own robust forms into a kind of parody of the gaunt and rhetorical forms of the great Cretan. There are paintings which manifest a vulgarity unredeemed by any positive merit, such as, for instance, *Rachel*. Nor are John's drawings always beyond criticism. It is not difficult to discover instances of a figure marred by a forced or purposeless posture, or a face 'improved' into conformity with a type which momentarily monopolized his admiration. The occasions for criticism offered by such defects are genuine enough, and it would be wrong to discount them, but considered in relation to the magnificence of John's life's work they furnish material for, if not a negligible, at least a comparatively tame indictment.

146

Contemporary critics, from a nice aversion from dwelling upon the obvious, end by ignoring the obvious altogether. It is therefore necessary to say that, according to the accepted canons whereby an artist can be judged, elusive although these admittedly are, Augustus John – to make no higher claim – was a considerable painter. He was able, not sometimes but again and again, to fuse, by the intensity of his imaginative heat, the four ingredients of painting so well and simply defined by Allan Gwynne-Jones as drawing, design, colour and a sense of space. And he did this, not only often, but with an audacity and a majestic sweep that I believe justifies my use of the term 'magnificence' to describe the sum of his achievement.

I propose to say little about the landmarks of the painter's life. At the time of this writing I had not had the advantage of seeing his as yet unpublished autobiography, and the extracts that appeared in *Horizon* (published during the years 1941 to 1948 under the title of 'Fragments of an Autobiography'), he told me were radically revised. Furthermore, although I expect his book to be of absorbing interest and written in the evocative and poetic prose of which he possessed the secret, I would be surprised if it contained very many of those basic facts that must form the framework of any biography, even of the briefest sketch. This supposition I base upon the knowledge that, although John's memory retained innumerable images of rare interest and beauty, it did not so easily retain the sequence of events, their dates, or even their causes. Nor did he preserve, except by accident, letters or documents of any kind. I remember a few years ago, when I was engaged upon my Phaidon monograph on the artist, I called at his studio in the faint hope of his dating certain of his paintings. There was one in particular, a portrait of one of his sons, of which I required the date. 'Dodo will be able to help you,' he suggested, and we consulted his wife forthwith. 'It oughtn't', I said, 'to be so difficult. He might, mightn't he, be about six in the portrait? When was he born?' His parents, so eager to help me, looked at each other with abysmal blankness. They could not remember. This would be no great matter had the artist's life been an uneventful affair, a life of uninterrupted toil in a garret, say, or a quiet pastoral life. It was, however, a many-sided life, deeply implicated in many other lives, adventurous, bold, robust and long: in fact, a saga. Like the life of Sickert, it is too vast a subject to be attempted, however briefly, in these pages. Nor is it likely to suffer neglect. John, like Sickert, will be lucky if he escapes his Thornbury.

Augustus Edwin John was born at 5 Lexden Terrace, Tenby, Pembrokeshire, on 4 January 1879, the third of the four children of Edwin William John. In the combination of powerful impulses which formed his temperament, a passion for personal liberty and entire

independence was primary. To judge from a letter, written in 1939 on revisiting his birthplace, to my father more than forty years after he had left it, from very early days John was painfully aware of his temperamental incongruity with the constricted life of Tenby. 'I am . . . suffering again from the same condition of frantic boredom and revolt', runs the letter, 'from which I escaped so long ago.' But he and his sister Gwen formed a close alliance to make their escape into the world of art, of which they knew themselves to be its citizens. First Augustus, and shortly afterwards Gwen, entered the Slade School, where Augustus remained from 1894 until 1898. The phenomenal mastery of John's drawing at the Slade has been generally acclaimed. Before he was twenty he had become the first draughtsman in England. The admiration his drawings evoked among his fellow students is described by Spencer Gore in an unpublished letter of 1909 to Doman Turner:

> I think that John when he first went to the Slade started making the very slightest drawings; when I went there he was making hundreds of the most elaborate and careful drawings as well. I have seen sketchbooks full of the drawings of people's arms and feet, of guitars and pieces of furniture, copies of old masters, etc. He used at that time to shift his rooms occasionally, and people used to go and collect the torn-up scraps on the floor which was always littered with them and piece them together. I know people who got many wonderful drawings in that way.

The best of his student drawings can hang without dishonour in any company. In the expression of form and movement, they are not inferior to the drawings of Keene, nor in energy to those of Hogarth, while their combination of lyricism, robustness and strangeness make even the poetry of Gainsborough's drawings a little tame and expected in comparison. Palmer could, at his rare best, draw with a greater imaginative intensity, but how very rare that best was. With John the power of drawing slendidly endured for decades, changing its character, flickering, faltering and slowly sinking, but always present, and even in old age apt to blaze up suddenly.

The moment when he seems to have first shown his extraordinary talent was attended by a singular circumstance. My father used to relate a story, which also finds a place in his memoirs, which he heard, he said, from Henry Tonks. According to the story, John was 'quiet, methodical and by no means remarkable' when he first came to the Slade, but while diving at Tenby struck his head on a rock, and emerged from the water 'a genius'. He told this story occasionally not, I fancy, because he thought that it had any basis in fact (he was inclined to be severely sceptical about occurrences that appeared to involved the suspension of natural laws), but because it seemed to

him amusingly in keeping with the fabulous personality of his friend. Not long ago I happened to read some memoirs by John Everett, a close friend of John's and his contemporary at the Slade. In the memoirs – an extremely candid and detailed record – the same story is related by someone who literally believed it and who, although not a witness of the dive, was a witness of the transformation of John, after the visit to Tenby, from a plodding student into a commanding personality with a genius for drawing. The Gore letter just quoted also suggests that John's early Slade drawings were unimpressive.

Although he drew like a master at the Slade, John painted like a gifted student. He had studied the painting of Rembrandt and Rubens at the National Gallery, and on his first visit to the Louvre in 1899, in company with my father, he received from Puvis de Chavannes such strong impressions of an idealized humanity, and of the beauty of the relation between figures and landscape, that they never left him. The inspiration of this painter is manifest in many of John's figures in landscapes, whether in big compositions, such as the *Lyric Fantasy* (1911), or the small, brilliantly coloured paintings he made in company with Innes in the years preceding the First World War. One other painter on this first visit to the Louvre made an impression upon him which, although perhaps more powerful, was less enduring. This was Daumier, who reinforced with immense authority the lesson he had begun to learn from Rembrandt – of seeing broadly and simply – and who taught him to interpret human personality boldly, without fearing to pass, if need be, the arbitrary line commonly held to divide objective representation from caricature. *The Rustic Idyll*, a notable pastel of about 1903, was made under the immediate inspiration of Daumier.

Whatever its effect upon his draughtsmanship and personality, John's dive at Tenby did not make him a painter. The *Portrait of an Old Lady* (1899), done the year after he left the Slade – which the artist told me was his first commissioned portrait – is probably a fair example of his painting of this time. In its grasp of character as well as in drawing it is far inferior to the best of the drawings he did at the Slade. The hands, for instance, are without form or the power to move. When, having found this hesitant essay in a dealer's gallery in 1941, I brought it to his studio for identifcation, he did not at first recognize it as his own.

Only three years later, however, his *Portrait of Estella Dolores Cerutti* proclaimed him a master in the art of painting. Certainly he did not often surpass it, but then neither did most of his contemporaries. A comparison between these two portraits gives the measure of his progress. The earlier is niggling in form; the later is clearly stamped with that indefinable largeness of form characteristic of major

painters, except for occasional youthful accidents, scarcely ever of minor. The paint of the earlier is laboured almost in vain; that of the later powerfully radiates a cool light. The old lady is modelled hardly at all; the young lady as plastically and as surely as a piece of sculpture. The earlier can be taken in at a long glance; the later holds the spectator's interest indefinitely, without, however, yielding up the secret of the artist's power.

From the time when he painted the Cerutti portrait John must be accounted as having been a masterly painter as well as draughtsman, but his painting is most masterly when it approximates drawing. Most of his finest paintings have the strong contours and the clearly defined forms that belong particularly to drawing. This is especially true of his early and middle years. The vision of painters tends to grow broader and more comprehensive with age: one need only compare the later and earlier work of those who in other respects have so little in common as Titian, Rembrandt, Turner and Corot to see how pronounced this tendency is. In later years John's vision underwent a similar change. Not only his painting but his drawing grew broader, more comprehensive, more 'painterly', although he remained essentially a draughtsman.

During the past century there has been a widespread decline in technical accomplishment, and the wisest painters have felt obliged to try to compensate for this loss of manual skill with greater thoughtfulness, above all by giving their utmost attention to design. Almost from the beginning of his life as an artist, John commanded immense technical resources; never, therefore, was he aware of any need for a compensatory concern with composition (still less for the cultivation of an esoteric taste or – in spite of possessing an intellect of exceptional range and power – of protective aesthetic theories). Little hampered by technical obstacles, his art grew freely, and it reveals the personality of the artist with an extreme directness. For the style of the man who is able to set down his emotions, intuitions and ideas without greatly troubling about the means he employs, reveals more than the man who organizes, minutely qualifies, polishes; in fact, a style of such a kind may hide almost as much as it reveals. 'Do not be troubled for a language', said Delacroix; 'cultivate your soul and she will show herself.' Confidently trusting in his preternaturally gifted eye and hand, John implicitly followed this injunction. Like the periods of a great natural orator, John's designs were improvisations. Organization and theory would have stultified John's vision and the flow and flicker of his wonderfully expressive natural 'handwriting', just as the classical conventions so integral to the drama of Corneille and Racine would have stultified the poetic impulse of Hugo, Lamartine, Baudelaire or Whitman. There is, of

course, a weakness inherent in the very nature of the improviser: spontaneous invention depends upon intense emotion; and intense emotion notoriously fluctuates. In a work of art that has been meticulously planned, and its every detail worked out in advance, the conversion, at a critical moment, of failure into success may be achieved by some slight adjustment; but in an improvisation a mistake can be redeemed as a rule only by a painful struggle of which the outcome is uncertain. John often carried all before him in a first impetuous assault, and produced masterpieces almost without effort, but there are times when no efforts, however tenacious or prolonged, suffice to avert the results of some apparently insignificant error.

Later in these pages I say something of the contrast between two categories of artist: between those whose work is an obvious extension of themselves, and those whose work is a compensation for what they are not. John belongs unequivocally to the former class: the people whom he represented (with the inevitable exception of the subjects of many commissioned portraits) are the people who attracted or interested him as human beings, and the landscapes are the places where he most enjoyed living. His work, that is to say, is, in the most intimate sense, an extension of himself. Wyndham Lewis once wrote in *The Listener* that:

> Nature is for him like a tremendous carnival in the midst of which he finds himself. But there is nothing of the spectator about Mr John. He is very much a part of the saturnalia. It is only because he enjoys it so much that he is moved to report upon it – in a fever of optical emotion, before the selected object passes on and is lost in the crowd.

The love of liberty that was John's strongest passion was not a remote, political concept (although in so far as he was interested in politics he was libertarian enough), but personal liberty. The almost physical urge from which it sprung is expressed in an undated but very early letter to my father:

> ... You know the grinding see-saw under a studio light cold formal meaningless – a studio – what is it? a habitation – no – not even a cow-shed – 'tis a box wherein miserable painters hide themselves and shut the door on nature. I have imprisoned myself in my particular dungeon all day to-day, for example all day on my sitters' faces nought but the shifting light of reminiscence and that harrowed and distorted by an atrocious 'skylight' . . . this evening at sun down I escaped at last to the open to the free air of space, where things have their proportion and place and are articulate . . .

It was thus neither chance nor casual romanticism that drew John to the gipsies – those nomads in whom the spirit of personal liberty burns most obstinately – but his apprehension of a community of outlook between himself and them. 'The absolute isolation of the

gipsies seemed to me the rarest and most unattainable thing in the world,' he wrote.

The early part of John's life was devoted mainly to the subjects in which this spirit was plainly manifest. At the Slade he used to discover – among tramps and costers, as well as gipsies – strange characters whom he took on for models. During summer holidays in remote parts of Wales he sought out primitive peasants, the unconscious purveyors of strains of wild poetry that come singing out in his drawings of them. In Liverpool, where in 1901 he spent about a year as a teacher of art, it was the homeless wanderers by the docks, wayward old men, in whom he discovered a novel and expressive magic. In his early days he discovered such people, but later he mostly had to content himself with emphasizing such aspects of the gipsies' spirit of 'absolute isolation' as he was able to discern in the faces of the sitters who knocked at his studio door. For in England, then as today, every painter without means who wishes to make a living from his art must paint portraits. If John had been able to continue to devote himself to the portrayal of the types of men and women who have resisted the pressure of urban civilization and preserved their primitive way of life, we would possess a dramatic and unique portrait of an aspect of England and Wales that has almost vanished from sight. But life is not kind to artists, and John never completed this portrait. But we must be thankful that, with brush, pencil and etching-needle, he enabled us to share his haunting vision of a freer, braver and more abundant way of life than that which most of us know.

John's art was always marked by an audacious and independent, but not revolutionary, character. He always readily admitted his own debt to the past. 'I am', he wrote in an early letter to my father 'about to become a *mother*. The question of paternity must be left to the future. I suspect at least four old masters.' His chosen masters, besides Puvis de Chavannes and Daumier, were Rembrandt, Goya and Gauguin; among his contemporaries, the two from whom he learnt most were Conder and Innes. At all times, however, he took freely according to his needs, but there was little danger of the integrity of a personality so positive and so robust being impaired by what is assimilated. There was one master, however, from whom he took much that resisted assimilation. This, as I have already noted, was El Greco under whose spell of ecstatic rhetoric John was not entirely himself. He was inclined to regard 'advanced' movements in painting with sympathetic curiosity, but also with detachment. A sentence in an early undated letter to my father, evidently written from Paris early in the century, gives an indication of his attitude. 'the Independents', he wrote, 'are effroyable – and yet one feels sometimes these

chaps have blundered on something alive without being able to master it.'

The introductory chapter of this book deals at some length with the diminished attraction exercised by the visible world over the minds of artists of the Post-Impressionist era, which led to the virtual abandonment of the traditional European ideal of representing in something of its fulness the world to which the senses bear witness. This disinterest, although it has affected many, even, perhaps, the greater part of the most original painters of our time at one time or another, never touched John. Every one of his paintings and drawings, be it failure or success, testifies to his passionate response to the world that his eyes saw. It may nevertheless be of interest to quote a passage from a letter that also speaks – as vividly, I think, as any of these – of the quality of his vision, with its combination of frank enchantment with the nearest and most obvious material realities, and of a mysterious apprehension of deeper realities beneath. The passage comes from the letter, already quoted, about his studio:

> Never have the beauties of the world moved me as of late. Our poultry run I see to be the most wonderful thing – so remote, so paradisaic, so unaccountable it seems, under the slanting beams of the Sun, and loud with the afflatus of a long day's chant of love. The birds move automatically, like elaborate toys, but with a strange note from the East (subdued now, their wild flight forgotten on the long journey) amidst dappled gold under gilded elders, old medicine bottles, broken pots and pans and cans; the unseemly debris – the poor uncatalogued treasures – of a midden.

Three short sentences in a letter written to my father many years later in 1939 succinctly sum up his confidence in his preoccupation with what was at hand, with what he liked and, above all, with what was alive:

> I find the country better to live in than the town. One comes across thrilling things which don't take place in the studio. In art one should always follow one's nose, don't you think?

John's small figures in landscape, his pure landscape, his still-lifes and, above all, his portraits, however boldly idiosyncratic, however romanticized, are firmly based upon what he saw, but he engaged in one kind of painting which depends primarily not upon observation but on invention: the big composition. No other kind of painting interested him so deeply. I remember his saying when he opened the exhibition of photographs of contemporary British wall paintings at the Tate Gallery in 1939, 'When one thinks of painting on great expanses of wall, painting of other kinds seems hardly worth doing'; and shortly afterwards, in a restaurant: 'I suppose they'd charge a lot to let Matt Smith and me paint decorations on these walls.' In a

monograph on the artist published in 1945, I spoke with some indignation of the neglect of John's powers of painting upon a great scale. Although the world would beyond a doubt be a more beautiful and inspiring place if there were a number of public buildings embellished by big completed wall paintings by John, I now think that I slightly overestimated his capacities as a painter on a monumental scale. Certain important qualities he did possess: a rich and abundant creative impulse, extraordinary powers as a draughtsman, and above all a noble largeness of style. In all his paintings on such a scale, these qualities are luminously apparent. I spoke earlier in this study of the weakness inherent in the improviser's temperament: it follows that the larger the scale of operations, the greater the likelihood of their being frustrated by this weakness.

The small improvisation can be abandoned without regret and started afresh. How many thousands of failures Guys or Rowlandson must have crumpled up! But in a large picture, too much is at stake from the first; such a work can be brought to a successful conclusion only by the science and intellectual discipline that alone can compensate for the inevitable fluctuations of intense emotion. Genius is rightly held to be the capacity for taking infinite pains, but there is a kind of genius capable of taking infinite pains only while it is, as it were, in action. In fact, a special kind of genius is required to take infinite pains by way of preparation. John belonged to the first order: he enjoyed painting pictures rather than planning them, and while no effort was too strenuous while he had his brush in hand, he lacked all those qualities that go to make a great organizer. I doubt whether any human achievement on a monumental scale is possible without a pre-eminent capacity for organization. And so it is that John's monumental paintings, even the finest of them, remain unfinished, dazzling sketches abandoned with their difficulties unresolved. The *Study for a Canadian War Memorial* (1918), an immense and complex composition in charcoal, peopled by scores of figures, was never carried out. *Galway* (1916) for all its brilliance is no more than a gigantic sketch. (Its 400 square feet were covered, the artist told me, in a single week.) The vivid and animated *Mumpers* (*c.* 1914) could have been carried further. So also the *Lyric Fantasy* (*c.* 1911), which is more highly charged with a mysterious poetry than any of his other works of this order. The subject is a group of wild, lovely girls, to whom John gave something of the fierce and lofty isolation that he envied in the gipsies, and some ravishing children in an arid, Piero-haunted landscape. John was acutely regretful of its unfinished state. Their incompleteness is not, of course, due solely to the lack of this capacity in the artist. The times are uniquely unpropitious. Artists cannot be expected to undertake works that call for great expenditure

of time and energy wtihout any assurance of being able to sell them, and neither governments nor private corporations give painters or sculptors opportunities remotely comparable with those which their predecessor enjoyed of working on a heroic scale.

Perhaps the most notable quality of John's monumental paintings – in particular, the *Lyric Fantasy* – is the poetic relation between figures and landscape. This he developed, less magnificently but with more completeness, in a whole series of paintings on a relatively miniature scale. As a young man he became friends with Innes, a painter with an original and lyrical vision. Innes burned with a passion for mountains – those of his native Wales and the south of France, especially – and for pure, vivid colours, with a heat particular to men conscious of having a short time to live, for he was consumptive and died at the age of twenty-seven. Innes's intense and romantic vision of mountain country was an inspiration to John, who who assimilated and enhanced it. Among glowing, exotic Innes-conceived mountains he placed brilliant and evocative, but summarily painted, figures in peculiar harmony with their surroundings. When Innes died and the focus of John's interest shifted, something went out of English painting that left it colder and more prosaic. The importance of the group of poetic paintings inspired by the association of John, Innes and the delightful but much less gifted Derwent Lees has yet to receive full recognition.

During the course of his immensely productive life he had been attracted by a wide range of subjects, but portraiture remained his principal concern. England is the portrait-painter's paradise: from the sixteenth century onwards it has given, not only to native portrait-painters but to a long succession of foreigners, full scope for their talent. The death of Sir Thomas Lawrence seems to mark a singular change in the history of portrait-painting. Until about 1830 the best exponents of this art were professionals. No amateurs rivalled Holbein, Van Dyck, Lely, Kneller, Gainsborough, Reynolds or Lawrence himself, but since then 'amateurs' have painted the outstanding portraits. Few portraits by professionals are comparable with Alfred Stevens's *Mrs Collmann*, Watts's gallery of great Victorians, Whistler's *Miss Cecily Alexander*, Sickert's *George Moore*, Steer's *Mrs Raynes*, Wyndham Lewis's *Miss Edith Sitwell* and *Ezra Pound*, or Stanley Spencer's early *Self-portrait*. Like his contemporaries McEvoy and William Orpen (who began as genre painters and turned professional portrait-painters later on) John, especially during the latter part of his life, painted great numbers of portraits, but, unlike these two, he may be said (though the distinction is a fine one) to have remained something of an amateur, for he was constantly at work on compositions large and small, flower-pieces, landscapes and

drawings of the figure, and from time to time lost interest in commissioned portraits and abandoned them, a course which a professional would be unlikely to adopt. Change of subject preserved the spontaneity of his response to the drama of faces.

The portrait-painters of the epoch which Lawrence brought to an end were sustained, during spells of lassitude and indifference (to which most artists are subject), by the momentum of a workmanlike and dignified tradition: but the waning of that tradition left the painter face to face with his sitter, dependent, to an extent which his predecessors never were, on his personal response to the features before him, on his power to peer deeply into the character which they mask or reveal. Very rarely is a man's response to faces, or his understanding of them, sufficiently powerful and sustained to enable him to make it his whole profession, and he who paints little or nothing except portraits deadens by exploiting this response. To paint portraits supremely well, it would seem to be wise to refrain from painting them too often. A passionate preoccupation with portraiture only occasionally tempted John to overindulge or to exploit it for the benefit of those who were eager to purchase the immortality, which at certain moments it lay in his power to confer. At such auspicious moments he gave splendid expression to the qualities of nobility, strength, courage, wisdom, candour and pride in his sitters, and should they happen to possess none of these, he was able to make little of them. His portraits are therefore not merely romantic tributes to the elements of greatness which he discerned; they rarely suffer from the absence of the critical spirit; they are free from the touch of personal approbation that marks Watts's portrait of his great contemporaries. John's portraits are the products of a more sceptical nature and a less reverent age. Watts portrayed select spirits as almost wholly noble; John, whose sitters were more arbitrarily chosen, portrayed the noble qualities in men and women whose natures, on balance, were as often base as noble. Where Watts brought a grave and exalted mind to bear upon his sitters, John comprehended his with a flame-like intuition, as in the superb *Robin* (c. 1909), *David* (c. 1918) and *Joseph Hone* (c. 1926).

Genius which is intuitive and spontaneous is, of necessity, uneven in its achievement. If John's crowded annals record failures, in his inspired moments no living British painter so nearly approached the grandeur and radiance of vision, the understanding of the human drama, or the power of hand and eye of the great masters of the past.

CHARLES GINNER
1878 – 1952

While I did not have the pleasure of knowing Gilman and Gore, I always climbed the stairs that led to Ginner's little painting room at 66 Claverton Street with the pleasurable anticipation not only of seeing a friend, but of entering a presence for whom these two others were living memories. They had been dead for more than thirty years, and Claverton Street is miles away from Camden Town, yet something of the way of life which all three lived intimately together in North London was still gently sensible in these rooms in Pimlico: the way the landlady loomed large, the way her choice in wallpapers was accepted, and the way the streets outside receded in long, grey, symmetrical vistas, down which, on certain auspicious evenings, one made one's way with Ginner to some 'eating-house' with shabby, comfortable red-plush seats. I lived only a few minutes' walk away, but I mostly saw chromium and neon lighting, except when I walked with Ginner along streets which are, or seem in recollection to be, gas-lit. Sickert used to say that English artists live like gentlemen, but Ginner lived with a simplicity that put one in mind of a Continental artist: two small (meticulously tidy) rooms, adorned by half a dozen studies given to him by friends, a small library consisting of a few score well-read classics, half English and half French, took an annual 'painting holiday' – these about represented the extent of my friend's needs.

Charles Ginner was born on 4 March 1878 in Cannes, the second son of Isaac Benjamin Ginner, an English physician practising on the Riviera. Dr Ginner originally came from Hastings; his wife was a Londoner of Scottish descent. Ginner's grandfather was a mysterious figure: meagre vestiges of legend attribute to him a propensity for smuggling and a detailed knowledge of the Bible. Of his grandfather's six sons, all left England, and one was murdered in China. Ginner attended the Collège Stanislas at Cannes. For as long as he could remember he wished to be a painter, but he had to overcome the opposition of his family. At the age of sixteen his health broke under the combined assault of typhoid and double pneumonia. For almost a year, in a successful attempt to restore it, he sailed the South Atlantic and the Mediterranean in a tramp steamer belonging to an

uncle. On his return he spent some time in an engineer's office, and when he was twenty-one he left Cannes for an architect's office in Paris.

In 1904 Ginner's family withdrew their opposition to his becoming a painter and he entered the Académie Vitti, where Henri Martin was teaching, but he worked mostly under Gervais. From the first he used bright colours; Gervais expressed sharp disapproval and used to hide them beneath coats of umber. The year following Ginner entered the Ecole des Beaux-Arts, but in 1906, after Gervais had left, he returned to Vitti's, where his principal teacher was the Spanish painter Hermens Anglada y Camarasa. At that time the art schools of Paris were being slowly permeated by Impressionism, but the Post-Impressionists were still officially regarded with contempt. When Ginner confessed his admiration for Van Gogh, Anglada replied, 'A man who'd paint his boots can't be an artist.'

Ginner left Vitti's in 1908 and worked on his own for two years in Paris, where he took Van Gogh, Gaugin and Cézanne for his guides. In April 1909 he visited Buenos Aires where he held an exhibition, thus introducing Post-Impressionism into the Argentine. In January 1910 he came to London to serve, as already noted, on the Hanging Committee of the Allied Artists' Association's third exhibition. It was owing to his friendship with Gilman and Gore, and to their urgent persuasion, that he decided to settle in London. At first his mother kept house for him at Prince of Wales Mansions, Battersea, and he had a studio in Tadema Street, Chelsea, near the World's End, but later he took rooms on his own in Chesterfield Street, by King's Cross Station, in the heart of 'Camden Town Country', where Gilman and Gore were near neighbours. The three met constantly in one another's studios, at the Etoile Restaurant, at the Café Royal and at the Saturday afternoons at 19 Fitzroy Street, which were also regularly attended by R. P. Bevan, John Nash, Albert Rothenstein, C. R. W. Nevinson, Jacob Epstein and Walter Bayes, with Sickert and Pissarro presiding.

The four years between Ginner's arrival in London and the two events that brought this period to a melancholy close – Gore's death and the outbreak of the First World War – were the happiest of his life. Although he had neither the authority of Gilman nor the charm of Gore, he enjoyed affection, influence and respect. He had many qualities to warm the hearts of his friends, among which modesty, benevolence, generosity and candour were conspicuous. His own work, which was at first more mature than that of his two friends, showed qualities that they were eager to emulate. He was, furthermore, familiar with the work of Continental masters, who for almost all his English contemporaries were distant demigods. This made him something of an oracle among them, although Beven had worked

with Gauguin at Pont Aven. Ginner also possessed the capacity – too rarely exercised – for expressing himself in lucid, energetic prose. The essay on Neo-Realism, for instance, quoted at length in the chapter on Gilman, aroused considerable interest and was the subject of a long review by Sickert in *The New Age*, April 1914. All these circumstances combined to give Ginner during these years the exhilarating consciousness of playing an honourable part in one of the chief artistic movements of his time and country.

War, however, brought about the disruption of the circle, and with it their intimate and delightful collaboration, and the death of Gilman intensified in Ginner the sense of loneliness that had followed the death of Gore. Ginner was called up about 1916, serving first as a private in the Royal Army Ordnance Corps, but his knowledge of French – he was completely bilingual – resulted in his transfer to the Intelligence Corps. He was promoted sergeant and stationed at Marseilles, and later recalled to England to work for the Canadian War Records, with the honorary rank of lieutenant. This involved an eight-week visit to Hereford to make drawings of a powder-filling factory for an elaborate painting. Back in London he took studios in the Camden Road and at 51 High Street, Hampstead, meanwhile living above the Etoile Restaurant. In 1937 he moved to 66 Claverton Street, where he lived until his death on 6 January 1952. In the Second World War he served as an official artist, specializing in harbour scenes and bomb-damaged buildings in London.

Ginner's faith in the value of friendly cooperation between artists had been expressed by his membership to many societies. Soon after he settled in London, he was invited to become a member of 19 Fitzroy Street; he was a foundation member of the Camden Town, the Cumberland Market and the London Groups. He joined the New English Art Club in 1920 and was elected an Associate of the Royal Academy in 1942, where he consistently advocated the admission of younger contemporaries of talent.

The most conspicuous attribute of Ginner as an artist was the stability of his vision. Such an attribute in itself of course affords little indication of either the presence or absence of high qualities in an artist. It may accompany deep convictions or mere laziness, sterility or the determination to exploit a market. Ginner's achievement as a whole offer no evidence of laziness or of sterility, and in the changeable circumstances which prevail today, a market is more readily exploited by politic change than by stability. In fact, stability has become as much the exception as it was the rule in, for example, fourteenth-century Siena. Constant changes in aesthetic fashion – the result of the absence of an authoritative tradition and of prevalent curiosity, restlessness, and the unprecedented accessibility of exam-

ples of the art of other civilizations – conspire to make stability difficult to maintain. Therefore it may fairly be taken today as a sign of a convinced and independent mind. The stability of Ginner's vision, at all events, is so pronounced as to be phenomenal. I have never seen a painting of Ginner's Paris period, but those he sent over to the first Allied Artists' Association Exhibition in 1910 seem to have resembled those of a later date. (According to Rutter they were a nuisance to handle because the wet paint stood out in high ridges.) The practice of painting thick was at this time fairly general, both on the Continent and in England. 'We have evolved a method of painting with a clean and solid mosaic of thick paint in a light key,' Sickert wrote of the New English Art Club in *The New Age*, June 1910. Ginner's practice was in this respect, however, based upon that of Van Gogh: he applied the paint in strips. (It was from Ginner that Gilman learnt this method of painting.)

In other and more fundamental respects Ginner's style was already what it remained until his death. In *The Café Royal* (1911), there is, for instance, the extremely complex yet entirely firm and logical construction, the mass of detail severely disciplined to the requirements of the design as a whole, that mark, though still more emphatically, the work of his later years. There are also the same defects. His pictures lack atmosphere, and often, in consequence, have an archaic look, as though they were conceived before Constable and Turner showed that the accepted distinction between the solid objects of nature and the atmosphere through which they were seen – between, say, tree-tops and clouds – from the point of view of the painter is not invariably a real distinction. There is an evident lack of interest in, and an incapacity to represent, the human figure; weaknesses the more felt in view of the artist's unvarying preoccupation with the environment of man, usually, indeed, his own actual habitation. And his touch lacks subtlety or variety.

But these weaknesses are far outweighed by Ginner's qualities. If he largely ignored atmosphere, few of his contemporaries represented urban landscape or individual buildings with such intimate insight. The shabbiest of them, under his minute but tender scrutiny, reveals beauties that at a casual glance are scarcely conceivable. His representation of even so apparently monotonous a structure as a brick wall or a tiled roof – which were among his most favoured subjects – will be seen to present surfaces of astonishing variety, and each brick or tile to have its own identity. If, like Turner, he had little aptitude for portraying men and women, he created an ineffable impression of their unseen presence: his steps are worn by their tread, his walls are blackened by the smoke of their fires, his flags are put out to declare their rejoicing or their mourning; there is little, indeed, in his pictures

that does not refer, and always with an implicit affection and respect, to his fellow men. And if his touch inclined to monotony, is there not adequate compensation in what Sickert called his 'burning patience'?

Ginner's earlier paintings were all done from oil sketches made in front of his subject. During a visit to Dieppe in 1911, Sickert showed him how to work from squared-up drawings. After 1914 he relied entirely upon detailed drawings of this character, accompanied by elaborate written colour notes, which he sometimes made by the use of a little homemade viewfinder. I am inclined to think that the words 'burning patience' go to the heart of his achievement. Ginner did not possess a tithe of the genius of his master, Van Gogh, nor even a tithe of the natural capacity of his exact contemporary, Orpen, yet this 'burning patience' enabled him to create, both in oil and pen and ink and watercolour, a long series of pictures which reflect the continuous growth of a personality entirely humane, honourable and modest.

SPENCER GORE
1878 – 1914

Spencer Gore died at the early age of thirty-five, only a few months before the outbreak of the First World War, an event that obliterated the memory of many merely delicate talents. His paintings might be mistaken by an inattentive observer for essays, tentative and lacking in decided character, in the manner of the French Impressionists. Gore himself might have been discounted, too, by a casual acquaintance, as a cultivated genial person, a shade too genial, perhaps, to be an entirely serious person. Yet after his death, Sickert, in an article entitled 'A Perfect Modern' (in *The New Age*, April 1914), paid tribute to his work and character with higher praise than I recall his using for any other English painter of the time. Gore's obituary in *The Morning Post* expressed the opinion that 'his personal character was so exceptional as to give him a unique influence in the artistic affairs of London in the last dozen years'. Those who meditate today upon the achievements of those last years of the Indian summer of European civilization, if they do not entirely subscribe to the opinions of Sickert and the unknown obituarist, will at any rate weigh them with sympathetic comprehension.

Spencer Frederick Gore was born on 26 May 1878 at Epsom, the youngest of the four children of Spencer Walter Gore, Surveyor to the Ecclesiastical Commissioners and holder of the first Lawn Tennis Championship held at Wimbledon in 1877 (and brother to Charles Gore, Bishop of Oxford); and his wife, Amy Smith, daughter of a member of the firm of solicitors who acted for the Ecclesiastical Commissioners in Yorkshire. Spencer Gore's boyhood was spent at Holywell, his parents' house in Kent. He went to Harrow, where his vocation was declared, and he won the Yates Thompson Prize for drawing. After leaving school he entered the Slade, where he worked for three years under Brown, Steer and Tonks, whose teaching he always recalled with gratitude; and he formed a lifelong friendship with Gilman. About the time that he left the Slade his parents suffered a financial reverse, and after his father's death his widow took Garth House, a much smaller place, at Hertingfordbury in Hertfordshire, where then and later he painted many landscapes.

At the beginning of the new century there was not much to

162

distinguish Gore from other Slade students. Certainly the few Steer-like landscapes of about 1905 that I have seen give no indications of special promise, nor do the landscapes of the following years, which show that Corot and Sisley had displaced Steer as the principal subjects of Gore's study. It was in the summer of 1904 that he first met Sickert. The meeting was effected by my father's younger brother Albert, who was a fellow student of Gore's at the Slade. The two went to Dieppe and spent two days continuously in Sickert's company. So began an intimate friendship that was to end only with Gore's death. The meeting had other consequences. After years of wandering abroad, Sickert, always disposed to change, always interested in what his friends were about, had begun to grow tired of his self-imposed exile. In London the New English Art Club had entered upon the most brilliant and influential period of its history. The illustrious painters of mature talent (with two exceptions, every one of those treated in these pages was associated with the Club, most of them as members, a few as exhibitors only) were being joined by the most talented of the younger generation. The enthusiasm of his two visitors for what was happening at the Club, and at the Slade, from which its membership was so largely drawn, focused Sickert's interest upon London and sharpened his desire to return there. As already noted, he settled in Camden Town in 1905. That same year Sickert lent his house at Neuville to Gore, where he stayed from May until October.

Of the paintings Gore did at Neuville – the Corot-Sisley inspired essays already mentioned – none of those that I have seen reflects a personal vision, but what they convincingly show is a deepened understanding of the science of painting, and, in particular, of the methods of the French Impressionists. His sympathies with Impressionism were not only, nor, perhaps, even principally aroused by his six months' intensive painting in France, for it was about this time that he formed an intimate friendship with Lucien Pissarro. This friendship was of cardinal importance for Gore not for what it enabled him to learn about Impressionism – by this time the movement was widely known among the intelligent, even in England – but for the insight it gave him into Impressionism's ultimate development. Reference has already been made to the double part played by the younger Pissarro in substituting knowledge of Impressionism among English painters for rumour, and often alarmist rumour at that, and in explaining the activities of those by whom Impressionism had been 'remade', of whom Cézanne and Seurat were the chief. By none of the younger painters was this body of knowledge more intelligently assimilated than by Gore. His knowledge of Continental painting – like that of many of his generation – was notably enlarged by the first Post-Impressionist Exhibition. It is significant of the temperamental

difference between Gore and Gilman that Gore was most attracted by
Matisse, whose impact, coming after that of Gauguin, excited him to
bolder experiments in colour and pattern, while Gilman received an
impetus from the burning realism of Van Gogh that lasted to the end
of his life. During his time at Neuville Gore visited Paris and saw the
big Gauguin exhibition at the Salon d'Automne. The Renoirs he saw
at the Durand-Ruel exhibition at the Grafton Gallery that year had
particularly impressed him, and after studying the Cézannes, prob-
ably the first that he had seen, he observed to a friend that 'there was
something in them'. It was not until three or four years later that he
arrived at a full understanding of the master's art.

It was in 1905, too, that the results of Gore's always grateful yet
independent discipleship of Sickert and Pissarro, and his meditations
upon the nature of painting and his assiduous practice, revealed
themselves in a series of paintings of music-hall and ballet subjects
that were both personal and mature. These subjects continued to
occupy him until about 1911. It may be presumed that Sickert first
drew Gore's attention to the beauties of the theatre, but his treatment
of them derives from Lucien Pissarro. Gore used to spend every
Monday and Tuesday night, over long periods, at the Alhambra
Ballet; after seeing the Russian ballets produced for the first time in
London by Fokine, with Nijinsky and Karsavina in the leading parts,
he turned to a friend and said, 'I've dreamt of things like this, but I
never thought I should see them'. His method was to visit the theatre,
always occupying the same seat, equipped with a small notebook,
Conté chalk and a fountain-pen. Thus stationed and equipped, he
would add a stroke or two, at the relevant moment, to a study of a
transient pose or relationship of figures. A tightrope walker involved
a succession of visits to capture a pose held only for an instant. 'Every
time she got to a certain spot', he wrote, 'I had my pencil on the spot
where I left off and added a little. It took some time.' From the
numerous resulting studies, oil paintings were built up. Gore, like
Gilman and Ginner, observed a strict distinction between paintings
and drawings made in front of the subject and those made in the
studio. In a letter to Doman Turner of 1909 he wrote,

> I think that when in front of nature what you produce should be exactly
> what you see and not touched except out of doors. If you set out to
> arrange or compose, it should be done entirely away from the subject,
> making of course as many studies from nature as you want.

Gore painted few portraits, but in one of them, *North London Girl*
(1912), his sense of colour and tone, as well as a strong sense of
character, are happily combined. (The subject is the girl who served
tea at the 19 Fitzroy Street 'at homes'.)

In 1907 he visited Yorkshire, where he painted several landscapes which showed that he was able also to handle outdoor subjects maturely. Although for technical reasons it was impossible to paint directly in the theatre, Gore did not share Sickert's belligerently held conviction that to paint in front of the subject was a cardinal error, and that pictures ought to be painted from studies. He always worked as directly from nature as circumstances allowed. His method was to draw his subject on the canvas in paint, next putting in the cool and the warm colours, keeping the range both of tones and values as narrow as possible, for he believed that fine distinctions were more 'telling' than violent contrasts. Upon this foundation he slowly built up a mosaic of paint unmixed with medium. It was his aim to define form in terms of colour. Gore found it easy to pay attention to Sickert's warnings against the dangers of overstatement, for overstatement was foreign to his nature and contrary to his upbringing: his statements about the form, colours and relations of things were never, like those of his friend Gilman, challenges.

Up to about 1906 Gore was scarcely more than a serious and gifted student, but he had already begun to exert 'the unique influence in the artistic affairs of London' noted by *The Morning Post*. Of the several qualities that combined to give him special authority among his fellow artists, the chief was a combination of disinterestedness and charm. Disinterestedness without charm might have provoked exasperation, and charm without disinterestedness liking without esteem. It was the spectacle of this tall, young man of distinguished bearing, whose extreme carelessness of his personal appearance seemed to symbolize a carelessness of his personal interests, devoting himself wholeheartedly to the general good – in particular to the reconciling of differences that could honourably be reconciled – that won him this special degree of authority and affection. In addition he possessed an integrity that was not questioned and an unassertive assurance. Sickert wrote: 'I never heard him complain of anything.'

No one was more emphatic in his recognition of Gore's qualities than Sickert. In reply to those who spoke of Gore's indebtedness to him, he used to insist upon what he had learnt from Gore, and after Gore's death he wrote of his career as being 'the most complete object-lesson on the conduct of a life and of a talent that it is possible to have experienced.

Gore had a quality which only reveals itself in his work upon the closest scrutiny – extreme intelligence. By the kindness of the artist's widow, I have had the privilege of access to a remarkable series of letters by Gore – written at odd moments snatched from his own laborious hours of work or from those of exertion on behalf of his friends, at moments, often, when he was too tired to paint or draw or

organize – which shows how concentrated, supple, uncompromising and, above all, how lucid his intelligence was. These letters were addressed to Doman Turner, a deaf fellow artist to whom Gore undertook to teach drawing. The first of them is dated 8 June 1908 and the last 24 November 1913. They give a clear insight into Gore's beliefs and his practice as a painter and draughtsman, and, although they are impersonal in tone, they reveal almost as much of Turner's character as of the writer's. They show that, while he was satisfied with his pupil's technical progress, Gore was dismayed to discover that he did not value his own talent as a serious artist must, and that he suffered from a radical apathy. 'From your letters', wrote Gore, 'I always have a kind of suspicion that the things you do interest me more than they do you.' The correspondence therefore lost its didactic character. I hope that one day it will be published in full. Here, in the meantime, are a few characteristic extracts:

> Don't think about making patterns but of drawing objects in such a way that a sculptor could model from them . . . Contours and light and shade have no value of themselves, it does not matter whether the lines are clumsy and the shadow ragged so long as they both help to explain the size or shape of some form in relation to the other forms which go to make up the object or objects you are drawing. What one asks of a draughtsman is What is your personal view of this head or figure or landscape? not how neatly or how smoothly you can cover up so much paper with lines and shading making up a pattern, even to imitate fairly accurately the general features of the thing seen.

> In drawing, everything must grow out of something else – be in relation to it and everything else be referred back to it . . . The interest is in what you see not what you know.

> Drawing deals with the forms of things alone. Directly you go outside this you get to painting. That is to say, relations of tone or colour. And I think that drawings of effects are absolutely uninteresting or only interesting on account of the form and not of the effect . . . Drawing from memory always leads to some kind of mannerism which may be good if it has enormous knowledge and purpose behind it as in J. F. Millet or Lionardo [sic], but it is interesting to notice in Millet and in Daumier and others who did not always get their facts first hand, that such things as the folds of a coat are never very interesting however magnificent the whole figure may be . . . Whistler was a great artist . . . but he made the great mistake of setting up a standard of beauty derived from other painters . . . If you compare this attitude with that of Renoir Degas Manet Monet Pizzarro [sic] Siseley [sic] . . . or Courbet . . . who all went to nature like children to find new beauty and whose work points to the fact that beauty exists everywhere; then you will find that Whistler like a backwater leads you nowhere while they are like a river carrying you wherever you want to go.

> A drawing is an explanation of an observation. If you observe nothing special your drawings will have nothing to them . . .

These brief extracts will give, I think, an indication, of one reason at least, for the fruitful character of Gore's influence: his capacity for giving lucid and practical expression to the convictions that formed in his mind as a consequence of continuous practice and long meditation. They also show how firmly his own art was rooted in the visual world. It has been a disposition among those who, especially of recent years, have mentioned Gore to suggest that he began as an Impressionist and ended as a Neo-Impressionist. This would be altogether an overstatement. His vision underwent no transformation; there was only a change of emphasis. Gore was a close and perceptive observer of the work of the masters whose art was so radically affecting most of his generation, fully aware of the contributions of Cézanne and Seurat to European painting, and interested in Cubism from its beginnings. (There exist several of his own paintings which may be regarded as essays in a modified Cubism.) All these interests served to stimulate his preoccupation with design and with the structure of things. But with what detachment he regarded Neo-Impressionism years after he had become familiar with the movement from Lucien Pissarro and others is clear from an allusion to one aspect of it in a letter to Doman Turner written in 1910:

> Neo-Impressionism was the name given to people who tried to reduce the system of divided colour to a science . . . The two chief exponents were Signac and Seurat . . . Lucien Pissarro learnt to paint in this manner. It was not a great success because it made a painting very mechanical . . .

Gore was, in fact, nearer to this movement in his ballet and music-hall scenes – the *Inez and Taki* (1910), – than in his last Richmond landscapes. His Post-Impressionist sympathies showed themselves in an enhanced awareness of the structural elements in nature, and of the designs they formed, hidden from the inattentive eye. To the end his procedure was one of discovery, a seeking out of the design already there, never the imposition of a design upon nature. Gore's evolution has been succinctly described by his friend Ginner in the July 1917 issue of *Art and Letters*:

> I have a fine example of a broad-minded artist who was ready to learn from the various modern schools. Spencer F. Gore, who was first influenced by Mr Walter Sickert, corrected in himself his master's degraded colour by absorbing the influence of the Impressionists through Mr Lucien Pissarro. Later on he did not close his eyes to the Cubist and Vorticist movements, but learned much from them while remaining a realist in his outlook on life. He had received from these schools of painting a stronger sense of design [and] saw it in nature . . .

From about 1906, when Gore may be said to have reached maturity until his death was a span of only eight years. These he devoted first

of all to painting, but he was also constantly concerned with the welfare of the art of painting, and the service of his painter friends. 'He discovered and encouraged', wrote Sickert, 'any talent that came his way with devotion and sequence . . .' He was a founder-member of the Allied Artists' Association, of 19 Fitzroy Street, the unanimously elected president of the Camden Town Group (he selected and arranged the Group's comprehensive exhibition at Brighton), a member, from 1909, of the New English Art Club (on its juries, Sickert has also told us, 'he exerted a salutary influence') and an active founder of the London Group. The obituarist already quoted wrote that:

> Nothing as a rule can be less interesting than the small politics of the formation and conduct of artistic societies. Mr Gore saw the necessity for these activities . . . It was often asked . . . what was the bond of union which enabled the Camden Town and London Groups to hold together . . . It is hardly an exaggeration to say that it was simply the character of Gore, so liberal in his enthusiasms, so incapable of petty jealousy . . .

I never had the privilege of knowing Gore, but everything that I have heard from those who did confirms the justice of this tribute. His year of teaching at the Westminster School in 1914 has already been noted, and in 1912 he supervised and carried out decorations at a highly intellectual night-club, the Cabaret Theatre Club, at 9 Haddon Street. Among the collaborators he secured were Wyndham Lewis – whose large panel won for Cubism its first success in England – and Eric Gill. At the height of his activity, at the moment when his work was showing a new breadth and firmness of structure, without sacrifice of the delicacy that had earlier distinguished it, he died. In the early summer of 1913 he left Camden Town – where he had spent the greater part of his working life, first at 31 Mornington Crescent, now demolished, and later at 2 Houghton Place – for Richmond, where he settled at 6 Cambrian Road, in order to be near the Park. On 25 March 1914 he got wet while out painting, contracted pneumonia and forty-eight hours later, on the 27th, he was dead.

Small memorial exhibitions were held in February 1916 at the Carfax Gallery and in October 1920 at the Paterson Carfax Gallery, and in April 1928 a fully representative one at the Leicester Galleries. The following is from an article by Sickert in the April 1914 issue of *The New Age*:

> He drilled himself to be the passive and enchanted conduit for whatever of loveliness his eyes might rest upon . . . But it is not only out of scenes obviously beautiful in themselves, and of delightful suggestions, that the modern painter can conjure a piece of encrusted enamel. Gore had the digestion of an ostrich. A scene, the drearyness and hopeless-

ness of which would strike terror into most of us, was for him a matter for lyrical and exhilarated improvisation. I have a picture by him of a place that looks like Hell, with a distant iron bridge in the middle distance, and a bad classic façade like the façade of a kinema, and two new municipal trees like brooms, and the stiff curve of a new pavement in front, and on which stalks and looms a lout in a lounge suit. The artist is he who can take a flint and wring out attar of roses.

AMBROSE McEVOY
1878 — 1927

The branch of the McEvoy family to which the painter Ambrose belonged has no history. His father, a man as gifted as himself, emerged suddenly on a dark night in the 1850s from a turbulent sea upon the coast of one of the southern states of North America. After a quarrel with his parents, two shadowy Irish emigrants to New England, Charles Ambrose McEvoy ran away from home and embarked with a few companions in a small sailing ship. Overwhelmed by the waves, the vessel broke up, and he and two Negroes succeeded in reaching a small lighthouse. They were the only survivors. After being cared for by the lighthouse keeper for a short time, he was adopted by a cotton millionaire. A few years later, the War between the States broke out. Young McEvoy, who seems to have sympathized with the emancipation of the Negroes, nevertheless assisted in the capture of John Brown and fought for the state of his adoption. He served first in the army of the Confederacy, but was disabled from further service by a wound received at the Battle of Bull Run, which was tended by Dr Whistler, brother of the illustrious artist. He next placed at the service of the Confederacy his audacious resourcefulness as an inventor. Certain of his ideas were embodied in the construction of the primitive ironclad, the *Merrimac*, others in the fantastic *David*, a submarine vessel consisting of two immense concentric iron balls, which, setting out to raise the blockade of Charleston, moved out along the seabed with a 25-foot spar bearing a torpedo projecting from her bows. The Federal sloop, *Housatonic*, was marked out for destruction. The *David*, submerged, rammed her with her torpedo. There was a devastating explosion. The blockader and the *David* both sank. From this disaster to his own vessel, McEvoy evolved the principle of the depth-charge, with which, with extraordinary prescience, he predicted that the submarine would eventually be fought.

After the defeat of the Confederacy, Captain McEvoy and Dr Whistler both settled in England. Here McEvoy evolved and sold to the British Admiralty his principal invention, the first submarine-detector, the hydrophone. Science and engineering did not, however, absorb the entire energies of this prodigiously ingenious and versatile

man, for he was interested in music and the visual arts. He was the first to discover the unusual talent for drawing of his elder son, Ambrose. Instead of treating it as an effeminate propensity, after the fashion of the usual prosperous Victorian parent, he experienced nothing but joy in watching its development.

Ambrose McEvoy was born on 12 August 1878 at Crudwell, Wiltshire. Shortly before the birth, a year later, of his brother Charles, the future playwright, the family moved to London and settled at 51 Westwick Gardens, West Kensington. Both brothers attended a long-defunct school known as Elgin House without notable results.

Through the friendship between his father and Dr Whistler, Ambrose McEvoy enjoyed the privilege of knowing Whistler, who showed a sympathetic confidence in his talent. Later in life, he used to recall how Whistler took him as a boy to Hampton Court, and, stopping before Tintoretto's *Five Muses of Olympus*, enjoined him to 'drink it in,'; and how they stood in front of it for a long time in silence. It was on the advice of Whistler that his father sent him to the Slade School in 1893, where he remained for three years.

Those for whom the name McEvoy evokes the dashing creator of fashionable beauty in a nimbus of rainbow-coloured light may be surprised to know that at the Slade he was a slow and laborious worker and an impassioned student of the technical methods of the old masters. Upon this subject, at this time and later, he kept copious and detailed notes.

At the Slade he became engaged to be married. A fellow student, Mary Spencer Edwards, had watched him at the National Gallery while he was making a copy of Titian's *Noli me tangere*, and had been so moved by the tall young man with the poetic and gentle expression that marriage to the man to whom she was engaged became impossible to contemplate. She wrote to him to break their engagement. A few days later, in front of the Titian, she and Ambrose McEvoy were introduced by Augustus John. A few days later she saw him again, at John's Fitzroy Street studio, and she watched him attentively, as, talking to a group of fellow students, he pushed his hair out of his eyes with long fingers. She was too shy to speak to him, but that day, he told her afterwards, he also loved her. Immediately afterwards they became secretly engaged. For the time being marriage was a remote prospect. Captain McEvoy had met with financial disaster the year his son entered the Slade, and Colonel Edwards, her father, would have regarded his daughter's marriage to an artist with repugnance.

When McEvoy left the Slade he lived for several years in extreme poverty, continuing his intensive study of the methods of the old masters, in particular of Titian, Rubens, Rembrandt, Claude, Gains-

borough and Hogarth, at the National Gallery and the Soane Museum. In order to give the requisite time to his studies, he produced little. He was determined to give his painting the soundest possible technical basis, whatever the sacrifice of present comfort or reputation. In the course of his studies, he pondered his findings and slowly discovered the methods best suited to the fulfilment of his aims. In the several notebooks in which, mostly between 1898 and 1902, he wrote down his miscellaneous observations upon the methods of the old masters, his aesthetic philosophical reflections, his injunctions to himself with regard to his procedures over a given painting or painting generally, there is nothing to suggest that he evolved either a consistent system of painting or a comprehensive aesthetic outlook. His dull disjointed writings clearly show how deficient he was in the necessary intellectual power. But they show also a habit of close, first-hand observation, especially of the various methods of glazing, and constant preoccupation with capturing upon his canvas the utmost that was possible of the harmony which he saw everywhere in nature. 'Harmony produced by all the means at our disposal,' he wrote, 'is the most interesting subject of thought to me . . .' But he was a painter and not a writer, and if his notebooks suggest that as a thinker he was pedestrian and incoherent, his paintings and drawings of those early years proclaim him to be an artist of exceptional sensibility and insight.

McEvoy's principal works were figures in interiors, low in tone, tranquil in mood. In spite of their beautiful, pensive quietude, McEvoy did not emerge as a distinct personality. The painting *Hard Times*, by his master Frederick Brown, and paintings by other members of the New English Art Club contain, in a somewhat robuster form, most of the elements of McEvoy's works. In method, McEvoy's were based, more deliberately than theirs, upon his studies of Rembrandt and Rubens: that is to say, the composition was put in in black and white and the local colour added to it. They are, in other words, not original pictures, but there is a quality in their mood of shadowy, pensive quietness, and in the delicate deliberation with which each form is defined precisely without in the slightest impairing the total unity, that raises them above mere school pieces. The most characteristic of them, *The Engraving* (1900), was bought in 1901 by Frederick Brown for £25. The sale of two other pictures in the same year, *The Thunder-Storm* – a not very successful attempt at a dramatic subject – and a landscape, enabled McEvoy to marry Mary Spencer Edwards on 16 January 1901. For a time they lived in Jubilee Place, Chelsea, but he developed an almost obsessive desire to acquire 107 Grosvenor Road, a house overlooking the river, which he bought in 1906 and which remained his home for the rest of his life and

provided the background for many of his pictures. Others he began elsewhere, often in his studio in Trafalgar (now Chelsea) Square; they were mostly finished in the big studio he built at the back of his riverside house.

The years immediately following his marriage were industrious, penurious years. He worked almost continuously, and, although he gave more time to painting than he had as a student, he still spent two evenings a week at the South Kensington Museum studying the methods of the masters. Before long the self-discipline, which enabled him to resist the temptation to hurry in the face of actual want, was rewarded by the appearance of a discriminating patron in the person of Sir Cyril Kendall Butler. From him McEvoy received very small prices, but he and his wife were maintained for more than a year in a cottage near their patron's house at Bourton, near Shrivenham. Gradually McEvoy received a more valuable reward: the laborious-ness, so irksome to sitters, was transformed into an extraordinary facility. Confident of having evolved methods which would ensure that his pictures would last, this slowest of painters became the most rapid. Mrs Archibald Douglas, the wife of his most generous and constant patron, told me that his *Portrait of Lady Tredegar* (1919), was completed in twenty minutes.

The absence of a clearly defined personality, of deeply felt convic-tions, is apparent upon close scrutiny of the subdued and tranquil interiors of McEvoy's first decade. How impressionable he was is shown by an incident which occurred in 1909. At the annual exhibition of the New English Art Club, there was a painting of a favourite Dieppe subject of Sickert's, painted in that artist's highly personal style. This painting brought Sickert much commendation. 'Better than anything you've ever done', remarked a brother artist with a fulsome smile. 'I'm afraid', Sickert answered, 'it is', and referred him to the catalogue. The painting was in fact the work of McEvoy, done in the course of a visit to Sickert at Neuville. Nothing could be more different than this picture from his interiors, or from his own earlier landscapes, *The Orchard* (1904), a highly artificial fusion of memories of Gainsborough and Claude, or the more closely observed and genuinely poetic *Winter* (1905).

During the few years following the painting of the Dieppe picture, changes in the character of McEvoy's art proclaimed even more plainly that his interiors and landscapes offered inadequate means of expressing what became his most passionate and almost exclusive preoccupation: beautiful women. Such, in all probability, had always been the case, for such passionate and exclusive preoccupations, although they may show themselves suddenly, are rarely of sudden growth. This hypothesis would account for the element of reserve

which prevents McEvoy's early interiors and landscapes – distinguished and poetic as they are – from carrying complete conviction. In painting them McEvoy was making beautiful pictures as a craftsman makes a beautiful object, but one look at any of the fashionable beauties of the later years – by comparison sometimes ill-considered and even vulgar – makes it clear that his interest was fully engaged. Although fashionable women came at last to absorb his energies entirely, and although his portraits of them could be, indeed, what his *Portrait of Lady Tredegar* so unabashedly is, examples of the vulgarest display, his habitual attitude towards his subjects was far removed from vulgarity.

The radical change in his outlook became apparent in 1913. Two years earlier he had painted the best of his interiors, *The Ear-ring*, which, in so far as it is in essence a study of a woman and only formally an interior, foreshadows the change to come. In 1912 he painted what I believe to be the last of his interiors, *La Reprise*. This is an elegant and tender but listless work; comparison between it and *The Engraving* or *The Book* (1902), shows how far his interest in the representation of rooms was exhausted. It was the model for *The Earring* and *La Reprise* – a Basque governess who in 1911 came to look after the two McEvoy children and who subsequently married the portrait-painter, Gerald Brockhurst – who provided the occasion for the change. In 1913 McEvoy painted a portrait of her which he called *La Basquaise*. This, shown at the New English Art Club's autumn exhibition that same year, brought him popular success, which two other portraits shortly confirmed. These were *Madame* (1914), an unnoteworthy portrait of his wife, purchased by the French Government for the Luxembourg, and *Lydia*, of the same year, an entirely wretched portrait of the wife of the painter Walter Russell. The success of these three pictures was such that by 1916 this laborious and almost starving painter of reticent interiors was besieged by fashionable ladies determined to have their portraits painted.

McEvoy made a reputation as a fashionable portrait painter with three inferior works, but it was abundantly justified by others. The opinion has been pretty widely accepted for many years that McEvoy began as a serious and sensitive painter of interiors and landscapes and that, dazzled by the glamour of fashionable women, he degenerated into an audacious, even a flashy, sycophant. I have already intimated that this is an opinion from which I dissent. Even if the early works had been still more distinguished and the later more frequently as bad as the artist's detractors claim they are, I would be reluctant to rate orthodox variants of existing works – however impeccable in taste and however sensitive – which reveal the fundamental dullness from which all such works must suffer by their

nature, more highly than original works called into existence by an ardent emotion. These last are the creations of Ambrose McEvoy; the earlier, in the last analysis, of his teachers and his older contemporaries. Let it be conceded without delay that he suffered a number of egregious, indefensible failures of method and of taste, but no more, I think, than might be expected of any artist working in an audacious manner beset by the many trials – capricious and unpunctual sitters, exacting social obligations, the frequent necessity of working in unfamiliar environments and the like – to which the fashionable portrait-painter is always subject. But there are other and, it seems to me, most notable works to McEvoy's credit.

In McEvoy's miscellaneous writings the expression 'beauty' occurs frequently in contexts which suggest that his conception of this attribute was strictly confined to things pleasing in themselves, a conception remote, for instance, from that of Sickert or Stanley Spencer, artists largely concerned with the discovery of beauty in things – iron bedsteads and amorous octogenarians – not in themselves beautiful. Among things-in-themselves most eminently pleasing – especially to men – are, quite obviously, women. Upon them, in his interiors of the very early 1900s, McEvoy fixed a searching but reticent scrutiny. After the passage of some years, this had grown franker: in an unconvincing *Interior* (1910), one of them, for instance, is represented nude. After 1912 his interest in the women he painted was undisguised: the rooms in which in former times he had so carefully placed them withered away, and they emerged as the sole subject of his pictures. On the comparatively rare occasions when he painted portraits of men, it is reasonable to suppose that his successes – *Viscount d'Abernon* (1916), and, more notably, *The Rt. Hon. Augustine Birrell* (1918) – owed much to the enhancement of his sensibilities in the face of a subject of a different kind. The last ten years of his life were devoted almost exclusively to painting beautiful and fashionable women. Had he been unconscious, had he not been, indeed, acutely perceptive, of their desirability as women and scarcely less of the distinction of the positions they occupied in the social system, he would not have succeeded as a painter of fashionable portraits. These two qualities must always be emphasized by the successful portrait-painter, whether his subjects are hieratic and remote infantas or princesses pretending to be milkmaids.

His sitters' allurements as women and as fashionable women never included overt sensuality, anything remotely corresponding to the wet, sensual mouths and the bare bosoms of Sir Peter Lely's ladies, or any traditional aristocratic symbolism, the vista of park, the fluted column. McEvoy's intention was, in fact, an extremely subtle one and the allurements and the social distinction of his sitters merely formed

part of the raw material to be transmuted into an ethereal likeness in which direct allusion to such qualities would be intrusive and entirely destructive of the effect at which he aimed. This was to paint a beautiful woman as a man in love with her would see her: to paint her transformed into an unearthly being, her most exquisite qualities of body and mind projected in a radiant, many-coloured nimbus. (His daughter Anna told me he could not bear to hear the slightest disparagement of any sitter while her portrait was in progress, lest the spell which he wove about her should be broken.)

Such an aim, impossible to realize in terms of the muted tones and the meticulously rendered detail of the early works, called for technical methods of an entirely different kind. The change in the focus of McEvoy's interest was accompanied by a reliance upon brilliant lighting, often from below, as well as the very loose, very rapid way of painting already noted. In a book entitled *The Technique of Portrait Painting*, the author – the portrait-painter Harrington Mann – in the course of a eulogistic comparison between McEvoy and Botticelli, tells us that in the work of the former 'the design and the drawing are unimportant'. McEvoy's brother artist had evidently looked with insufficient care at his later portraits – for instance, at *The Hon. Daphne Baring* (1817). McEvoy's design and drawing were relatively unimportant except at the principal point of focus. Here – and it is precisely this that gives the poetry and the delicate distinction to the best of his portraits – the features, or certain of them, are drawn with extreme sensibility and precision. Without this point of lucid definition, a late portrait by McEvoy would be a mere iridescent chaos; and that, in fact, is just what his failures are. But *Daphne Baring* is far from being a failure. It is one of the best portraits he ever painted. The drawing of the face, the mouth in particular, and even, at certain points, the Botticelli-inspired dress, is beautiful and exact. The farther removed, however, from such delicately wrought points of intrinsic interest, the broader, the less decisive was the artist's touch, until, as he approached the margin of his canvas or paper, the scarcely defined forms dissolve entirely.

In one respect McEvoy's procedure in his later portraits was similar to that used in the early interiors. Neither were painted 'directly' in opaque colour, but usually in thin glazes over an almost monochrome sketch of yellow ochre, black and white, a procedure used by few of his contemporaries, and the result of his studies of his chosen masters of the seventeenth and eighteenth centuries, among whom it was general practice.

It was inevitable that a painter who sought such elusive aims should suffer failures, and a number of McEvoy's society portraits, for all his taste and all his application, are garish and, in the worst

9. AUGUSTUS JOHN: *Portrait of Joseph Hone* (1932).
Oil, 20 × 15¾ in (50 × 39·3 cm). The Tate Gallery, London.

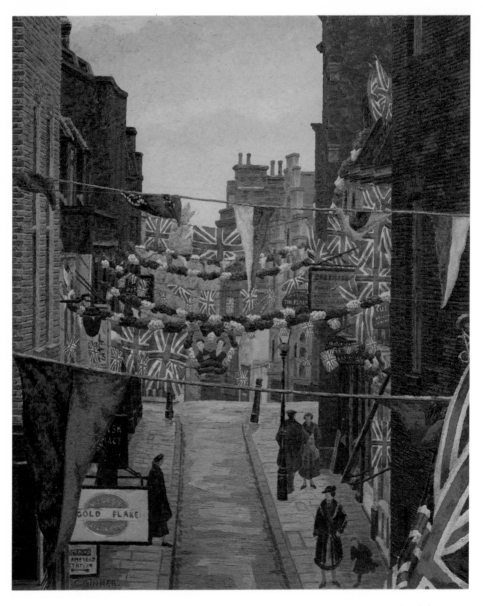

10. CHARLES GINNER: *Flask Walk, Hampstead*, on Coronation Day (1937).
Oil, 24 × 20 in (60 × 50 cm). The Tate Gallery, London.

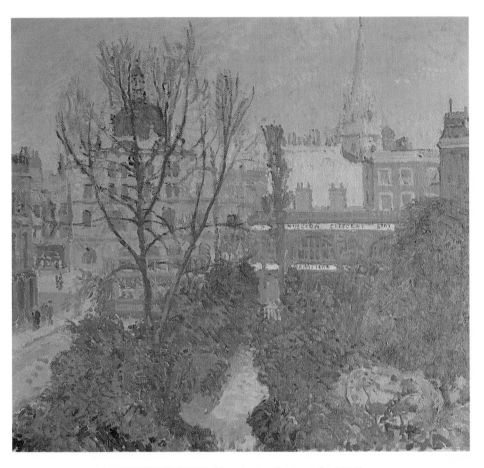

11. SPENCER GORE: *Mornington Crescent* (*c*. 1910).
Oil, 23 × 20 in (59 × 49·5 cm). The British Council.

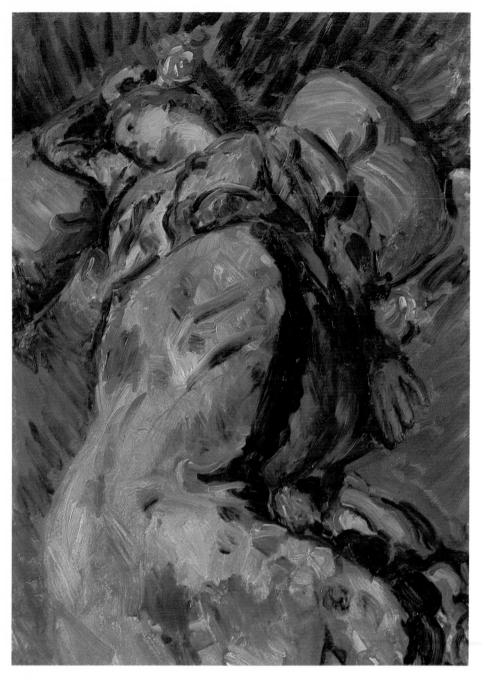

12. MATTHEW SMITH: *Model à la Rose* (1928).
Oil, 35½ × 25½ in (90 × 63·5 cm).
Collection of Mr and Mrs J. W. Sutherland-Hawes.

sense, 'dated'. But there are his successes: besides *Daphne Baring*, these include *Mrs Charles McEvoy* (1913), *Lady Gwendoline Churchill* (1917), *Viscountess Wimborne* (1917), and *Miss Violet Henry* (1918). But in none of his oil paintings did he achieve so high a degree of perfection as in his watercolours. In this medium, so much more readily adapted to realize his particular aims, he did his finest work. Unfortunately for him, a painter of society portraits must carry these out in oils. But he has left *Black and Green*, a magical portrait of a young girl in which he realized his highest aims and that could hold its own beside a Gainsborough; the only slightly less lovely *The Artist's Wife* and two *Portraits of Zita*, all of 1923. In the early 1920s he began to use watercolour more and more often, but he had by then only a few years left to live. Pneumonia cut short McEvoy's life as Big Ben struck four on the morning of 4 January 1927.

WILLIAM ORPEN
1878 – 1931

The story of William Orpen's life is a story of material success more spectacular and continuous than that of any of the other subjects of these pages. In terms of material success he is to be ranked with the most successful painters who have ever worked in England – Van Dyck, Kneller, Reynolds, Lawrence and Sargent.

In my own early memories (he was my uncle by marriage), he survives clearly as a small man with a pale, high-cheekboned face, light grey eyes that observed much and revealed little and a figure without a trace of the atrophied staidness that marks most adults, being slim and active as a boy's. I remember an occasional sense of embarrassment when, having missed something he said on account of the rapidity of his speech, I had to ask him to repeat it. He was always ready to join in any game or sport, always as an equal, without making facetious references to his age or arrogating to himself any authority as an adult – and he always excelled. One night we were playing table tennis at his house in Chelsea; he said: 'I'm going to ask one of the best players I know to come round.' Presently we were joined by a pale, small, old man in his middle twenties, whose name I did not hear, who beat us all without exertion. Many years later when I met Ben Nicholson I recognized him as the masterly player.

Orpen seemed to enjoy discussing, sometimes long afterwards, games we had played, which he was able to recall with surprising minuteness. Not long ago I came upon a copy of his book, *An Onlooker in France*, which he gave to me inscribed 'In memory of a bathe at Groom's Farm, March 1921, an occasion when we had played water-polo at a house in Buckinghamshire where the Orpen family spent a summer.

As a painter I was at first aware of him as a member of the as yet not sharply differentiated group at the New English Art Club, which included Sickert, Steer – all the painters, in fact, about whom I have been writing. I can just remember my father being challenged for maintaining that John was a more considerable artist than Orpen. Presently I was aware of him as the most successful painter in England, and as one esteemed by many as the best. In those days his success seemed both glittering and firmly based. There were the

178

Rolls-Royces waiting beyond the paved forecourt of his magnificent studio in South Bolton Gardens, and there was the adulation of critics. But there was also the admiration, or at least the respect, of his fellow artists. If voices were raised in criticism of the forced lighting and obvious interpretations of character that marred certain of his portraits, these could be silenced by an allusion to one of his classic portraits; or, if that did not suffice, to some prodigy drawing of his student days, or to the triumphant *Play Scene in 'Hamlet'*.

To this impression of success built upon rock-like foundations the personality of the artist also contributed. His industry was prodigious; and in my own home I was able to apply the severest standard of comparison. There was always a sitter, or, in case the sitter should fail to arrive, a self-portrait in progress. His pretensions – always within my hearing – were of the most modest: to be a good craftsman, to paint what was in front of him, not blindly accepting its appearance, but making the fullest use of his knowledge. Whether in his high white studio, or the small house, long since demolished, in Royal Hospital Road, Chelsea, in which the little rooms resembled, in their subdued light and the polished high-lit quality of their furnishings, his own early 'interiors', there were always drawings – late as well as early – of which any artist might be proud, and which seemed to proclaim the fundamental soundness of his art. Today hardly anything remains of that vast reputation. Orpen is a fading 'period' memory. When his name is mentioned it is, more often than not, as a symbol of the hard, glossy portraiture patronized by successful public men in the second and third decades of the century.

Orpen was born on 27 November 1878 at Oriel, Stillorgan, County Dublin, the fourth son of Arthur Herbert Orpen, a Dublin solicitor, and christened William Newenham Montague. The Orpens are a respectable Protestant family, who claim descent from a Robert Orpen, who came to Ireland from Norfolk in the seventeenth century. William Orpen's mother was the eldest daughter of Charles Caulfield, Bishop of Nassau. Membership in an Anglo-Irish family, the exceptional happiness of his childhood, a lack of formal education and attendance at an art school as a full-time student while still a boy were four circumstances which, in their particular combination, chiefly determined his character.

From his Anglo-Irish inheritance and upbringing Orpen derived those divided loyalties which always set him a little apart from his fellow citizens, whether Irish or English. His Protestantism, his English descent, and his residence in England during virtually the whole of his adult life made him an unquestioning member of the British, as distinct from the Irish social system. Yet he had a strong sense of being an Irishman, and, although without the most cursory

interest in politics, he regarded several of the Irish leaders with an affection and veneration such as he never accorded to any public figure in England – with the exception, towards the end of his life, of Lord Derby. In a letter to my father he wrote: 'Larkin is the greatest man I ever met.' I remember how particularly his three daughters, my first cousins, maintained as children that they were 'Irish', even though born in England of a mother with no traceable strain of any blood but English. Until the First World War Orpen often took holidays in Ireland, taught occasionally at the Dublin Municipal School of Art, and retained touch with fellow countrymen, notably Hugh Lane, but also George Moore and others. It would be true, I think, to say that Orpen's Irish life bore the same sort of relation to his English life as the unconscious does to the conscious. Had he received more than the most elementary education or intellectual discipline of any kind he might have reconciled his sentimental love for his native country – he had no trace of reasoned sympathy for its most ardent aspirations – with his effective identification with his adopted one. But he left school at twelve, and never formed any habit of reading great or even serious literature, and therefore grew into a man, in the deeper sense, without a country.

Orpen's possession of extraordinary dexterity as a draughtsman at an early age, and a consuming ambition to develop it to the utmost, seem to have disposed him to discontinue, with his departure from school, an education that may hardly be said to have begun, and which issued in lifelong intellectual dyspepsia. Finally, his exceptionally happy childhood combined with this lack of education to give him a kind of resentment against 'growing up', an instinctive sense of identification with the irresponsible spontaneous child as against the pompous adult.

At the age of seventeen he entered the Slade School where he remained for four years, leaving in 1899. He was fortunate in that during his time the School was at the climax of a period of extraordinary brilliance: the result of fierce and continuous competition between contending talents of a high order. Among his contemporaries were Wyndham Lewis, Ambrose McEvoy, Edna Waugh and Augustus John. If on his arrival his drawing, although distinctly above the average and remarkable for a boy of his age, was not phenomenal, nothing that impassioned ambition could do to transform capability into brilliance was left undone. He drew, and shortly afterwards painted, with an intense and disciplined industry, and every moment he could spare from these labours he applied to the study (not like McEvoy, of the methods, but of the style) of the old masters. He was discovered by a fellow student at three o'clock one morning at work upon a Sketch Club composition, who afterwards

observed: 'I have little doubt that he was punctually in his place at the School the same morning.' Whether he was looking at a model or at the work of an old master, Orpen assiduously cultivated his exceptional powers of observation.

This combination of talent and industry did not have long to wait for its reward. Orpen shortly became one of the most accomplished draughtsmen in what was at the time probably the leading academy of drawing. The staff – Brown, Steer and Tonks – enthusiastically acclaimed him as the prodigy he was, and the attitude of many of his fellow students was accurately reflected in the opinion of one of them, who wrote not long after Orpen had left: 'When I was at the Slade, it was a one-man show; that man was Orpen.'

However that may have been, there is no doubt that at the Slade Orpen made drawing after drawing of extraordinary brilliance. In my opinion, in his student years Orpen was within the first dozen draughtsmen that these islands have produced. Others have drawn with deeper insight, loftier imagination and greater originality, but only very few have possessed so full and easy a command of the full possibilities of drawing. Such an opinion will be dismissed by many – especially by my younger contemporaries – as fantastic, but I should be surprised if a comprehensive exhibition of British drawing did not confirm it.

But Orpen did not only excel at drawing at the Slade: he painted one picture which seems to me, in a curious way, to be a masterpiece. This is *The Play Scene in 'Hamlet'*, the 'Summer Composition' which won him the £40 Slade Prize in 1899. *Hamlet* was the subject set, but Orpen understood that the play scene alone offered scope for his exuberant whimsicality. It may be regarded, his biographers tell us, as 'an undisguised avowal of the sources from which he took nourishment'. It would be truer to say that it was a distillation of all his arduous and well-memorized studies. The lighting, at once dramatic and unifying, was derived from Rembrandt (of whose works there had been a great exhibition at Burlington House the previous winter), and the nude figure in the foreground was an ingenious theft from the same source. Yet the fruits of this young student's intense scrutiny of Goya, Daumier, Hogarth, Watteau, Rowlandson, Velazquez, Hals, Conder, Augustus John and a dozen others – most, in fact, of the romantic-realist masters of Northern Europe and Spain – are also easy to discern.

The notebooks which Orpen filled during these years with detailed copies of every conceivable manifestation of art and craftsmanship to be found in the art galleries and museums of London and, to a lesser degree, of Paris and Dublin – Renaissance jewels, Gothic fan-vaulting, Assyrian reliefs, medieval works – testify to a fanatical determination

to master the elements of style of all periods and races, and, most positively of all, of the great European draughtsmen, in particular Rembrandt, Rubens, Michelangelo, Watteau and Hogarth. But to take note of the huge extent of Orpen's debt is by no means to suggest that *The Play Scene* lacks originality. On the contrary, it is highly original. The saying that to copy from one book is plagiarism but to copy from several is research, has a certain applicability to this strange, precocious little masterpiece. There is an odd sentence in an essay on Orpen published a few years after the picture was painted which conveys something of the quality of the picture's strangeness. 'The workmanship', wrote a fellow student, 'is so vigorously unhealthy as to appear to prove that refined morbidity is the only road to rude health.' *The Play Scene*, organized and executed with extraordinary skill and informed with a spirit in which irrepressible wit blends harmoniously with mysterious grandeur, holds the spectator's attention, even now, as few pictures of the time can hold it. It is an astonishing achievement for a twenty-one-year-old student: it was also the culmination of Orpen's career as a painter. From this point onwards the history of his life as an artist is the history of decline. The 'Summer Composition' picture raised his already brilliant reputation among artists to one of eminence. It was agreed that a new star had risen; no one suspected that it had already reached its zenith. There seemed no occasion for the slightest misgivings; in fact, the three principal paintings which Orpen exhibited at the New English Art Club the following year set at rest the doubts of those few disposed to discount his *Hamlet* as a happy accident, and won him a place among the leading painters of the day. These included a romantic *Portrait of Augustus John* (1900), frankly based on Whistler's *Carlyle*; *A Mere Fracture* (1900), an admirable conversation-piece, inspired, I think, by my father's domestic interiors (one of which, *The Browning Readers* (1900), shows my mother with her sister, Grace, whom Orpen married in 1901), and *The Mirror* (1900).

It was this last work that was decisive in the establishment of Orpen's reputation. I know nothing about the particular circumstances in which it was painted, but it seems to me to mark a change in Orpen's outlook as decisively as it did to his contemporaries at the time. To them it marked the settling down to a steady mastery of a brilliant but wayward student, but in retrospect it seems rather to mark the rejection by a precocious master of precisely the qualities that gave significance to his vision: the exuberant but slightly sinister humour, the vivid if not yet steadily focused sense of satire, and, notwithstanding his innumerable quotations (and long, familiar quotations they often are) from the works of the old masters, the capacity to see life from a queer, unexpected angle. *The Mirror* marks

the rejection of all this and more, in favour of a mastery that was without compelling purpose. Orpen's biographers exaggerate pardonably when they write of it as being 'painted with the minute precision of a Terborch or a Metsu', for it is beyond question a highly accomplished display of painting, although, compared with that of the two Dutchmen, the handling is cold and brittle. I have referred to this picture, notwithstanding the entirely unassuming character of the subject – a model named Emily Scobel seated beside a circular, convex mirror in which the artist is reflected at his easel with a woman looking over his shoulder – as a 'display' of painting, for it is no more than a brilliant essay in a style perfected centuries before. Orpen has not taken Dutch seventeenth-century subject and style as, for instance, Delacroix took the style and subjects of Rubens, or even Haydon the Elgin Marbles, as incitements or as points of departure, but simply as a convenient and popular means of exercising his conspicuous skill. The culmination of Orpen's biographers' eulogy of *The Mirror* is their claim that it is 'a picture that would have gained the wholehearted applause of an Academy jury'. The claim is but too well founded, for it is one of the ablest manifestations of the moribund, and therefore aimless, academism of our times.

The Mirror is a melancholy portent, for the greater part of Orpen's subsequent endeavour was given to unreflective representations of aspects of the real world – representations which, with the passage of the years, first grew commonplace and finally on occasion shamelessly vulgar. But this did not exhaust his energies, for there was a part of him which was not satisfied by so commonplace an activity, and which clamoured for expression for as long as he was able to hold pencil or brush. *The Play Scene* expressed the whole of Orpen: in this painting his skill, memory and observation are the faithful and wonderfully efficient servants of a personality full of wit and fantasy and the sense of mystery.

After the dedication of his talents to commonplace purposes, the imaginative elements in Orpen's nature were without adequate means of expression. As he became ever more preoccupied with painting portraits of fashionable and highly placed persons, these elements were apt to obtrude ineptly, even absurdly, in the products of the few working hours he spared from the execution of his innumerable commissions, in such pointless whimsies as *Myself and Venus* (1910), *On the Irish Shore: Fairy Ring* (1911), and *Leading the Life in the West* (1914). By this last year it seemed as though the submerged imaginative side of his nature had sufficiently atrophied to need no stronger expression than whimsies of this kind, but the First World War stirred it into violent animation.

Throughout the war Orpen continued to record the faces of generals

and statesmen with all his customary industry and skill, if with little
of his former distinction. The urge to comment upon life as well as to
record it, the urge to satirize, protest, laugh and to mourn surged up
irresistibly. What moved him most deeply and most continuously (as
it moved the other war painters and poets) was the contrast between
the men at the front – those who were torn and burnt, blinded and
crazed, and who suffered these things and the fearful prospect of
them with such stoicism and even cheerfulness – and the people at
home – above all, those in authority and those who in some way
profited by the war – who accepted sacrifices beyond description with
complacency and even with cynicism. This contrast, although Orpen
himself was in certain respects a hard man, caused him an anguish
which at the Peace Conference, where he was the principal British
painter and in daily contact with the peacemakers, became an
obsession. The only occasion when I can recall his speaking with
vehemence upon a serious theme was one night in 1920 when we
were sitting alone after dinner at his house. He talked, more than he
habitually talked, incoherently and faster, about the sickening impact
of the callousness and the petty self-interest of the peacemakers in
Paris, above all of their forgetfulness of the millions of mangled,
rotting corpses in the Flanders slime. He took from his pocket a copy
of Maurice Baring's poem 'In Memoriam' to his friend, Lord Lucas,
which he read out, his jerky diction obscuring its qualities as a poem,
but giving an enhanced intensity to its meaning. 'This poem', he
declared, 'is the greatest work of art that's come out of this whole
war. I got Maurice Baring to copy it out for me. Maurice Baring said
to me: "I'm mad, but nobody's noticed it yet." That's true of us all:
the whole world's mad.' Spoken at that particular time by any one
else, I might easily have forgotten these words. Spoken by Orpen,
who had, as his biographers justly note, 'few prejudices and no
opinions', and whom 'any sort of serious talk bored', they were
memorable.

It is necessary to insist upon the earnestness of Orpen's obsession
because this earnestness is not convincingly manifest in the pictures
that he painted under its spell. Of these the chief was *To the Unknown
British Soldier in France*. It was arranged that he should paint a group
of the victorious Allied politicians, generals and admirals in one of
the great rooms in the Palace of Versailles. To quote the artist (from
William Orpen: Artist and Man):

> I painted the room and then I grouped the whole thirty-nine, or
> whatever the number was, in the room. It took me nine months'
> incessant painting; hard work. And then, you know, I couldn't go on.
> It all seemed so unimportant, somehow. In spite of all these eminent
> men, I kept thinking of the soldiers who remain in France for ever . . .

so I rubbed all the statesmen and commanders out and painted the picture as you see it – the unknown soldier guarded by his dead comrades.

The picture, as originally painted, showed the flag-draped catafalque standing at the entrance to the room, shown in significant darkness, where the Peace Treaty had been signed; on either side stood the two guardian figures based closely upon a study, *Blown up – mad*, done during the war. The arty pose of the legs (feet in the 'fifth position') and the length of classic drapery, calculated a shade too precisely to answer the requirements of modesty, gave these figures an air of utter incongruity with the grimness of the tableau in which they play the leading parts. The air of incongruity struck by these two wan, artificial figures was transformed almost into one of mockery by the presence of two frolicsome little cupids on the wing above their heads. The exhibition of the picture at Burlington House in 1923 provoked a public outcry, which led to its rejection by the Imperial War Museum, for which it had been destined. (The Imperial War Museum finally accepted it after the artist had deleted the guardian Tommies and the winged cupids.)

It may perhaps be asked why I should dwell at some length upon one of the failures of an artist who painted other pictures of exceptional merit. I would answer that the weakness that made *To the Unknown British Soldier* so conspicuous a failure are just those weaknesses that betrayed the extraordinary combination of talent and industry which at first seems so surely destined for triumphant achievement; the defects of this picture are the defects of Orpen's achievement as a whole, writ large.

In writing of Orpen's early life, I noted a combination of four circumstances which, as it seems to me, were principal agents in the formation of his character. I noted how the divided loyalties to which the Anglo-Irish are liable made Orpen sentimentally an Irishman and practically an Englishman: a man who put down no deep roots anywhere; his removal from school at so early an age that his innate intellectual incuriosity never had to meet the challenge of education; his total dedication to drawing and painting when he had scarcely emerged from childhood, which increased beyond the possibility of redress his predilection for manual skill as opposed to a developed mind; and the happy childhood, with which, in the course of his journey through life, he unconsciously compared the disappointing present, thereby feeding his antipathy to the operations of the intellect as being distinctively adult activities. These four circumstances combined to make him, and to an extraordinary degree, a man lacking in settled principles or convictions; a man lacking, above

all, the means whereby settled principles and convictions could be forged – namely, an enquiring and a disciplined mind.

I have seldom known any man, and never a man of superior talents, with so little intellectual curiosity and so feeble an intellectual grasp, or with so contemptuous an attitude towards the life of the mind as Orpen. 'He had nothing but scorn', say his biographers, 'for the lesser intelligentsia'; but the truth is that his attitude towards those whom they would perhaps have called the greater intelligentsia was not very different. It is true that he revered Maurice Baring and entertained an affectionate regard for George Moore, but it was the personalities of these two, I fancy, rather than their intellects, which appealed to him. His biographers note that he was unable to read Ruskin. He used to say, with a touch of pride, that he was brought up on the Irish Question, but what it was he had no idea. Yet this ignorance precluded the slightest rational sympathy for the aspirations of a people with whom upon a certain level of consciousness, he felt intimate ties. Except for the occasion I have referred to, I never heard him speak at length upon any serious subject. He could not, of course, avoid allusions to serious subjects, but they were in general of the nature of epigrams, staccato but ambiguous, and an instant later the disjointed, machine-gun talk had rambled far away. Games – lawn tennis, table tennis and especially billiards – were the subjects about which he talked most consecutively, and now and then he evoked a vivid image. (For instance when W. H. Hughes, the Australian Prime Minister, came sullenly and reluctantly to a sitting, read *The Times* throughout the grudgingly conceded hour, then at its conclusion folded the paper up and walked out without having spoken a word.) My own experience of Orpen's aversion to serious discussion, of his total lack of intellectual curiosity, is paralleled by the experience of others who knew him better. But what, I shall impatiently be asked, has intellectual curiosity to do with the creative faculties? Little or nothing, according to the opinion which strongly prevails today. Art with an intellectual basis is contemptuously condemned in Academic circles as an 'art of "-isms" ' (so runs the current cliché), while in avant-garde circles it is often quite deliberately rejected; Picasso, for instance, has declared in an interview with Christian Zervos in *Cahiers d'Art*, 1932,

> I don't know in advance what I am going to put on the canvas, any more than I decide in advance what colours to use. While I work, I take no stock of what I am painting on the canvas. Every time I begin a picture, I feel as though I were throwing myself into the void. I never know if I shall fall on my feet again.

The influence of such opinions is clearly reflected in an aggressive

preference shown by the avant-garde for the art of children, primitives and the insane over that of rational men, and by the contemptuous belittlement of the most intellectual of all the great periods of art, the Italian Renaissance.

So long as Orpen was content to make the 'straightforward' representation of the human face and figure his principal concern, his dismissal of intellectual preoccupations as mere pretentiousness had no conspicuous consequences for his art. Even such accomplished paintings as *The Mirror* and *Charles Wertheimer* (1908) – an expertly Sargentesque portrait of the well-known art dealer, the first picture he sent to Burlington House – involved little intellectual exertion. A year later, in 1909, Orpen painted a conversation-piece so admirable in its complex design and distinguished by such penetrating insight into character as to suggest that even then he might, by a great effort of will, have recognized upon what a broad and downward road *The Mirror* and *Charles Wertheimer* were signposts, and have returned to the other and narrower way that he had left after *Hamlet*. This picture was *Hommage à Manet* (in fact, a homage to his friend, Sir Hugh Lane), in which Moore, Steer, MacColl, Sickert, Lane and his own master, Tonks, are gathered round a tea-table beneath Manet's *Portrait of Eva Gonzales* at the house in South Bolton Gardens which then belonged to Lane and which Orpen afterwards acquired and used as a studio until his death. This seems to me beyond question his best picture after *Hamlet*, and among the best conversation-pieces of the time. But evidently the day for the retracing of steps was past, and *Hommage à Manet* proved to be Orpen's *Ave atque Vale* to his own most exacting standards as a painter, and to his old friends of the New English Art Club circle. Already commissions for portraits, attracted by the *Charles Wertheimer* and others, were pouring in. By 1910 Orpen was the most successful portrait-painter of the age. There was no time for reflection; it was the golden treadmill for him.

When I said just now that Orpen's failure to recognize the potential contribution of the intellect to the creation of a work of art had no conspicuous consequences for his portrait-painting, I did not mean that it had none. On the contrary, it declared itself in an increasing obviousness in his interpretation of character. There were splendid exceptions, in particular the Moore in *Hommage à Manet*. There are a number of others sufficiently well known, and a retrospective exhibition would no doubt bring yet more to light. But it can hardly be denied that, as the years passed, Orpen's magnates became more obviously magnates personified, his aristocrats more obviously aristocrats, in the sense that in Victorian popular drama heroes were quite simply heroes and villains were villains. The effects of this increasing reluctance to meditate, to probe, and Orpen's increasing willingness

to accept the most superficial aspect of a sitter and approximate it to
that of some stock type, was made the more conspicuous by fierce
and obviously artificial highlighting and the virtual suppression of
backgrounds. How rapid was the change may be seen by comparing
the 'Moore', painted with such intimate satire, such comprehending
affection, and the Lord Spencer painted seven years later in 1916, the
personification of stagy spotlit hauteur. However, neither the super-
ficiality of interpretation, nor the forced and arbitrary lighting, nor
the arbitrary sundering of heads from their backgrounds can obscure
the extraordinary sureness and vigour with which the best – even,
perhaps, the majority – of Orpen's portraits were painted.

It was when he was under the necessity of representing not
something material that could be observed but an intellectual percep-
tion that the consequences of his neglect of the intellectual values
were shockingly apparent. The contrast between the heroism that
animated the soldiers at the front and the selfish complacency that
prevailed at home, which stirred in Orpen such depths of indignation
and pity, was a contrast grasped by the mind. To give it convincing
visible form called for the exercise of intellectual powers far beyond
his resources. His indignation and pity therefore did not move him
to scathing utterance, but to incoherence. It is not surprising that the
man who was brought up on the Irish Question, but who had no
notion as to what it was, proved incapable of understanding or
disentangling the complex question of the comparative conduct of
those at the front and those at home. To Orpen there was, on the one
hand, 'the simple soldier man', of whom (I quote from his poem,
'Myself, Hate and Love'),

> No man did more
> Before.
> No love has been
> By this world seen
> Like his, since Christ
> Ascended.

On the other there was the petty, bickering, profiteering, and callous
'frock'. The fact that the men at the front and others elsewhere,
however different their conduct may have been, were parts of a single
whole, inextricably bound up together, entirely escaped him. He
forgot that those at home were the fathers and mothers, brothers and
sisters and children of those who served, and that veterans could be
profiteers, that even profiteers in khaki were sometimes heroes.

Orpen in the grip of a sympathy at once generous and bitter for the
ardours and endurances of the inarticulate serving soldier – the most
deeply felt emotion, I believe, of his entire life – is a subject tragic to
contemplate. He possessed the emotional force, above all the capacity

for indignation, the satiric spirit, a singular gift of incisive, expressive draughtsmanship and high competence as a painter – almost all the qualities needed to produce memorable works upon this theme. Yet with these almost superabundant talents he was able to accomplish scarcely anything because he was unable to understand the nature of the events which so deeply moved him. It was inevitable that he should fail to express what he could not understand. Instead of memorable works, his indignation and pity spent themselves – except, of course, when he was recording what was before him – on tasteless incoherencies, such as *To the Unknown British Soldier in France*, *The Thinker on the Butte de Warlencourt* and *Adam and Eve at Péronne* – and in ludicrous verse.

During the epoch of peacemaking in Paris, the small, whimsical, prodigiously gifted figure who, although he moved familiarly among the great statesmen of the day, was well known to hold them and their doings in small esteem, became a legend. When the satirical panorama of the feverish and glittering scene he had observed so closely and which was so expectantly awaited failed to take shape, his reputation waned.

Failure to express what he had felt most deeply caused Orpen to respond with growing apathy to the unending succession of sitters who presented themselves at South Bolton Gardens. But if he could no longer be moved, he determined to give everything that he had in him to give. Driven by bitter conscientiousness, he harnessed all his energies, all his will to the single end of securing a perfect 'likeness' of face and figure. What he produced was something akin to what we may expect of the mechanical brain when it is adjusted to paint portraits. Of these post-war mechanical marvels, *The Surgeon: Ivor Back* may stand as an example.

The succession of portraits painted by Orpen hardened the scepticism about his stature, engendered by his inability to exploit the possibilities offered by Versailles to his satiric talents and his angry mood. At his death his reputation, which was once so solidly based, looked imposing only to those who took little notice of professional opinion, or else were ignorant of it. Coming out of St James's Church, Piccadilly, after the memorial service, I remember the florid chairman of the Walker Art Gallery in Liverpool exclaiming, 'We have lost the greatest artist England ever had', and I remember the unresponsive faces of Orpen's painter friends. Yet abilities so ample, matched by a sense of life so vivid and personal as Orpen's – even if, for want of a lucid and enquiring mind, incapable of that 'fundamental brain-work' which Rossetti postulated as necessary for the artist – resulted in work of more merit than current opinion is disposed to allow. The best of his painting is likely to be valued more highly than it is today,

and his drawing more highly still. He continued to draw well long after his painting was in decline. Certain of his war drawings I would place not far below his best work at the Slade, and the pen-and-ink sketches with which he used to illustrate his letters are often brilliant revelations of a wit and imagination absent from all but his earliest painting.

Orpen died on 29 September 1931. I have tried to suggest something of the spiritual barrenness which he experienced as a consequence of harbouring deep emotions to which, as an artist, he was unable to give coherent expression. During the years between his return from Paris after the signature of the Peace of Versailles and his own death, his malady showed itself in an almost desperate reluctance to speak of, or even to hear, anything that was not trivial, as though it might turn his thoughts towards the aridness within. It declared itself, in the presence of the slightest threat to triviality, in outbursts of horseplay (to which he had earlier been more moderately addicted). He would get down from the dinner table to bark at a dog, or he would bring out a mechanical toy. But it declared itself most plainly in the trivial relations which he cultivated with those with whom he came in contact, a symptom of which was his habit of speaking of himself in the third person as 'little Orps' or even as 'Orpsie boy'. It would be difficult to imagine a more effective protection against intimacy. Whether such a reading of the inner life of his last years would find favour with his friends at the New England Arts Club, where he used to take me to lunch, or the Savile Club, where we often met, I am inclined to doubt, for in these places his total freedom from pretentiousness, innumerable small acts of kindness, and above all his staccato yet rambling conversation, half inaudible yet strangely vivid, won him an aura of popularity that masked the sterility within.

A few days after his death I saw on the easel in his studio a recent version of *Lord George Hell*, a picture he had painted years before as an illustration to Max Beerbohm's *Happy Hypocrite*. This he painted when, forbidden to work, he escaped to his studio from time to time from the nursing-home where he spent the last months of his life. His biographers assert that his 'last pictures do not mark a final step in his artistic evolution . . . and without hesitation may be eliminated from the sum-total of his achievement'. This judgment can hardly be questioned, but this picture testifies that the last act of the dying man, amid the failure of his mental and physical powers, was an attempt, however feeble, to recapture the imaginative qualities of his earliest years.

MATTHEW SMITH
1879 – 1959

There are certain artists whose work is an extension, direct and obvious, of their personalities. No friend of Rubens or of Byron would have been surprised by the painting of the one or the poetry of the other. There are others whose work is the expression of a part, sometimes a hidden part, of their personality. Shakespeare, for instance, does not appear to have impressed his contemporaries as a great man as distinct from a great dramatist. The painting of Rossetti and of Whistler respectively, while not incongruous with their personalities, discloses nothing of Rossetti's robust sense of humour nor of his robuster tastes and appetites, nor of the combative arrogance that was Whistler's most conspicuous characteristic. Then there are the artists whose work is an entire contradiction to all that they seem personally to be: men and women whose art represents, in the psychological jargon of today, a 'compensation', an ideal which they cannot realize in their lives. Nothing could have been more incongruous with the critic and essayist Walter Horatio Pater, the fusty don, the zealous follower of the fortunes of his College on river and playing field, than Pater the author of *Marius*. It is in this last category that we must place Matthew Smith.

How completely the painter seems to differ from the man will emerge in the course of this brief study: a study in which I shall attempt to give something more than biographical landmarks. If facts about the man are of any value, as in my opinion they are, in the study of his art, facts concerning a man who appears to differ from his art are evidently of more value than those which relate to a man of whom his art is an unmistakable projection of himself. Furthermore, very little is known about Matthew Smith. He constitutes the outstanding example of the paucity of writing about English painters to which I have earlier referred. Matthew Smith is probably one of the most admired painters in England, yet, so far as I am aware, the elementary facts concerning him have never been put down. Even the admirably informed and highly patriotic *Yorkshire Post*, the leading newspaper of his native county, once published the statement that he was born in Manchester.

Matthew Arnold Bracy Smith was born at 20 Elmsfield Terrace,

191

Halifax, on 22 October 1879, in the West Riding of Yorkshire, the third of the five children of Frederic Smith, a wire manufacturer, and his wife Frances, born Holroyd, who came from Edgbaston, Birmingham. Frederic Smith was a cultivated man and an amateur of the arts. He wrote occasional verse, a collection of which, *A Chest of Viols*, was published in 1896; he collected pictures of the kind then in vogue with northern manufacturers, representing monks fishing or carousing and similar subjects, by Dendy Sadler and other painters of popular genre. The principal interest of his leisure hours was violins, of which he seems to have been an impassioned and discerning collector. He possessed two or three by Stradivarius, and his house became a place of pilgrimage for those who shared his interests. A memorial of his preoccupation with pictures and violins survives in the form of a painting, *Stradivarius in His Studio*, which he commissioned Seymour Lucas to make and which was shown at Burlington House a few years before the First World War.

At about the age of ten, Matthew began to show a vague interest in painting. He collected invitation cards which bore reproductions of drawings and stuck them into a book, and elaborately copied a portrait of Lord Leighton out of *The Pall Mall Gazette*. But he took no interest at all in the paintings by the popular academic artists that hung on the walls of his father's large, gloomy house. His preoccupation with painting grew in intensity, but it brought with it no definite aspirations, only a growing sense of isolation. He yearned to speak to someone about painting. One day a successful painter named Prescott Davis called to see his father. As he was about to leave, the shy boy formed the desperate resolution of showing him his sketchbook, but the drawer in which it lay stuck fast. After this humiliating, although unwitnessed defeat, his sense of isolation reached a pitch where he could hardly endure it.

Believing that a businessman ought to have intelligent interests to occupy his leisure time, Matthew's father at first encouraged his predilection for painting, but as soon as it threatened to exclude all other interests, he began to regard it with hostile apprehension. Presently, by means of an occasional reproduction, news of the Impressionist painters found its way into the grim twilight of the West Riding. It at once filled Matthew with an unfamiliar agitation which his father recognized as subversive of what he himself believed. From that time relations between father and son were strained. If Matthew suffered from a sense of isolation at home, his school life at Hildersthorpe near Scarborough, Heath Grammar School, Halifax, and worst of all, at Giggleswick, was one of unredeemed misery.

The unhappiness of his early years was no doubt aggravated by a

lack of sympathy at home with his vague aspirations towards painting, and by the conditions which prevailed at the schools he attended, but it would be unjust, to his parents at least, to conceal the fact that he was a neurasthenic child, and his ailment heightened an extreme natural sensibility. At the age of seven he had the misfortune to see another boy suffer from a fit in a Halifax street, and for years the memory of the struggling figure at the foot of a lamp-post, his contorted face picked out from the surrounding darkness by the yellow gaslight, was one he was unable to suppress.

After he left Giggleswick, at about the age of seventeen, he was sent to Bradford to work in the firm of Empsall and Firth, and although at the time he showed no aptitude for business, his father took him into the family concern. When he was about twenty the family moved to Bowden in Cheshire. His by now constant preoccupation with the arts and his manifest incapacity for business brought about some modification in the attitude of his father, who agreed to his entering the art department of the Manchester School of Technology, but only for the purpose of learning industrial design. The four years he spent there were wholly wasted except for a short period towards the end when he managed to insinuate himself into the life-class.

By this time it was evident to his father that he was no more fitted to become an industrial designer than a businessman; he resigned himself, but without a vestige of confidence, to his son's attending the Slade, where he remained for two years. Henry Tonks shared the opinion of his father in respect to his talents, and took every opportunity of giving it humiliating expression. On one occasion, in front of the whole school, he said to Smith, 'What in the world made *you* think of taking up painting? I give you six months to see what you can do.' The fear aroused by the threat to expel him, to proclaim his failure to his family, brought about the complete breakdown of his health. He had to leave the Slade for a doctor's care. When he had partially recovered, Smith secured his father's consent to study abroad, on condition that he did not go to Paris. A London friend had often talked to him of Brittany, and the knowledge that Gauguin had worked there quickened his interest. To Brittany he therefore went in 1908 and settled in Pont Aven, where Gauguin had lived. 'Here', he once said to me, 'my life began; my mind began to open out.' At Pont Aven he made two friends, Guy Maynard, an American painter and the most interesting personality it had yet been his fortune to meet, who thought much as he did, only more maturely and in the light of a wider experience; and Madame Julia, the proprietress of the Hôtel Julia where he lodged, who enjoyed doing kindnesses to the young

man in whose face and bearing she discerned perhaps something of his bleak and troubled life.

Smith remained at Pont Aven from September 1908 until June of the following year, when he migrated to Etaples, which, besides a change in landscape, possessed for him the yet stronger attraction of relative proximity to Paris. It was at Etaples that he painted a *Self-Portrait*, one of the few surviving examples of his work of this period, and the earliest known to me. It represents a shy, friendly young face, with blinking eyes that peer out at you with an expression of mild surprise. When Smith first showed me this picture in the winter of 1949, I was at once reminded of another, not only curiously similar in character, but which occupies a similar position in the oeuvre of a painter as dissimilar as possible. A few months previously, in Léger's studio in Paris, I had noticed a portrait of an elderly man painted throughout with the same short strokes, with brushes heavily loaded with the same drab colours. It too expressed the same diffident honesty. When I asked Léger what it was, he said: 'But that's where I started from.'

In 10 January 1910, having sold his bicycle to be able to pay the fare, Smith went at last to Paris, Here he attended Matisse's school in the Boulevard des Invalides, but his pupillage was of brief duration for the school closed after he had been there for a month. Matisse went round on Saturday mornings and any student who wished for criticism might leave out his work, but Smith was too shy to invite this ordeal. It has sometimes been stated that he was closely associated with Matisse, but this is not the case. He attended none of the 'open Sundays' that Matisse held for students and others; he saw him, in fact, only on the three occasions when he visited the school. On one of his visits, Matisse put up a copy of a drawing of four figures by Signorelli and analyzed its structure with an acuteness which delighted his diffident English student. 'Voici l'architecture,' he concluded, and walked out.

For the rest of the time Smith worked by himself in a small, impossible studio in the Avenue du Maine (steel tramlines were hammered into shape on the floor below), existing on the £6 a month that his father allowed him. For the first time, life assumed an aspect at once benign and settled: his own work and his studies in the Louvre (where he made an elaborate copy of Ingres' *Madame Rivière*) and at the galleries where contemporary art was to be seen were giving him the beginnings of confidence in his powers and clarity to his ideas. In February 1912 he took a step which seems to have had the effect of bringing this tranquil period to an end: he married Gwen Salmond, one of the ablest Slade students of her time, whom he had met the previous year at a holiday painting class at Whitby. They moved

from place to place, living successively in Fontainebleau, Grez-sur-Loing (where he formed a lasting friendship with Delius), and finally London, in a flat at Grenville Place, Kensington.

When the First World War broke out Smith was rejected as unfit by the Artists' Rifles and the Honourable Artillery Company. In 1916 he was called up and joined the Inns of Court Officers' Training Corps, with which he spent a desolate winter training at Berkhamsted. The first morning, he arrived on parade with the evidence showing too clearly in his face and bearing of the party (attended by members of 19 Fitzroy Street) at which he had spent the previous night. When his commanding officer told him to 'fall out', he dropped his rifle. The misery of his situation kindled in the mind of this pacific and almost pathologically shy young man the determination to become an officer. He applied for a commission. When asked if he had any experience in the control of men he answered, 'Yes'. 'What sort of men?' the interviewing officer enquired. 'Yorkshiremen,' said Matthew Smith. He was promptly gazetted second lieutenant. Although harassed by his military duties – service at the battles of Arras and Ypres, where he was wounded – he managed to paint at irregular intervals. In 1913 he had taken a room in Percy Street, but he soon settled at 2 Fitzroy Street in an attic room that he retained, and occupied whenever he was able, until the end of the First World War.

In the least propitious circumstances he had ever known, Smith's art underwent an extraordinary transformation. This art, that had been as tentative and diffident as the painter himself, suddenly attained an aggressive maturity first noticeable in the fine *Lilies* (*c*. 1914), but which was resoundingly manifest in two big nudes, both seated in chairs, which he called after the room where they were painted – *Fitzroy Street I* and *Fitzroy Street II*. Both were painted in 1916 direct and from the same model in the same pose and both are painted with a startling violence of colour derived immediately from Fauvism. These two nudes, especially considering the hesitancy of the artist's long apprenticeship, are astonishing in their strident boldness and powerful draughtsmanship. They are among the most vivid and the strongest of all paintings, yet they are hardly, in the full sense of the term, paintings at all: they are powerful drawings, coloured with a harsh, disciplined violence. For a moment it seemed as though the artist were concerned primarily with problems of form. Both paintings were rejected by the London Group, at that time closely controlled by Fry. But work of such exceptional power could not remain unknown. They made an impression upon several artists who happened to see them. The girl who sat for these two pictures introduced the painter to Sickert, who called at the attic room. 'You paint', he said, 'like a painter and you draw like a draughtsman.' For

a time a close friendship subsisted between them. Sickert encouraged Smith, who found him wonderful company and 'full', he told me, 'of uncommon sense'.

In 1919 Smith was demobilized and his health collapsed. The immediate occasion of his breakdown may have been the sudden relaxation of the wartime tension that had given temporary cohesion to temperament, coalitions and organisms of many kinds. Whatever the immediate occasion, the cause was the unhappiness of his childhood, deepened in the years that followed it by the obstructions placed in his way to becoming an artist. It was as though the effort to become an artist was so exacting that, having achieved his purpose and having, with the two *Fitzroy Street* nudes, triumphantly proclaimed it, the tax upon his overstrained mind was greater than it could endure. He used to remain shut up for days at 2 Fitzroy Street, making copies from reproductions of paintings by Delacroix and Ingres, unable to face contacts with the world outside without apprehension. About this time he painted several still-lifes of fruit. One of these, *Apples on a Dish* (1919), is as fine, I think, as any of the numerous paintings of similar subjects that he made thereafter. It too often happens that contemporary artists represent 'simple' subjects because elaborate ones would be beyond their powers, but in this still-life Smith followed the injunction of the dying Crome to his son to dignify whatever he painted, and his apples have an almost breathtaking nobility of form, and, fused with it, colour that is both audacious and delicately astringent.

Early in 1920 Smith left London and spent half the year at St Columb Major in Cornwall. At first he could accomplish nothing; he remained there alone after his wife and sons had left, but eventually became absorbed by landscape. This was a fruitful time in which he produced a group of small landscapes, low and rich in tone, which express a sombre, sometimes even an almost anguished joy in the dour Cornish countryside. Although they are built upon a basis of firm drawing, which in certain cases the artist did not attempt to disguise, he showed, in his representation of atmosphere by the use of a wide range of colours and tones and by the close fusion of colour and form, that he had begun to see as a painter rather than as a draughtsman. I have called his stay in Cornwall a fruitful one because, for the first time, he made a group of pictures in which he painted, in fact, like a painter (for the first half of Sickert's compliment was simple flattery). These Cornish landscapes are still regarded as among Smith's best paintings. But, like certain paintings of Constable's later life, stormy canvases such as *Hadleigh Castle* or *Stonehenge*, whose sombre and troubled splendour reflected the artist's distressed spirit, the Cornish landscapes of Smith, with their black oppressive skies

and trance-livid fields, roads and trees, were the products of a darkening mind, a mind engaged in a losing struggle to maintain its equilibrium. He went to Brittany where he collapsed into a distracted melancholy in which he wandered from Grez to Paris, from Paris to Lausanne, from Lausanne to Lyons, in search of a doctor who could cure him. Whether his infirmity had run its mysterious course, or whether the specialist at Lyons was more skilful than those many others who had passed him, pessimistically, from one to another, at Lyons, in 1922, he began to emerge from the shadowy limbo in which he had lived for about two years. He was able to work: he made a copy of the El Greco in the Lyons Museum. The next year he was back in London, where he remained for about two years in a room at 115 Charlotte Street. The two following years he spent mostly in Paris, in a studio at 6 Bis Villa Brune.

Between 1922 and 1926, Smith evolved in all essentials both the way of seeing and the highly individual method appropriate to its expression that he developed consistently thereafter. For all their violence, the *Fitzroy Street* nudes seem to express a vision intellectual, constructive, and, as already noted, a draughtsman's. His later paintings, mostly still-lifes and nudes – that is to say, by far the larger and most important part of his life's work – expressed a vision in every respect the precise opposite of all this, an attitude in which passion and intuition play the dominant parts and in which the operations of the intellect count for little; the vision of an impassioned painter and an indifferent draughtsman.

Smith held his first one-man exhibition at the Mayor Gallery in Sackville Street in April 1926. During these four years his work had come to be regarded with respectful interest by his fellow artists and discerning critics, but this exhibition placed him in the front rank of the younger English painters. The most important sign of recognition was an article by Roger Fry that appeared on 1 May in *The Nation*. This article was the first attempt at a considered estimate of the work of Smith, and, slight though it is, it remains one of the best. How just a notion Fry had formed of what Smith was about is plain from the following passages:

> It is evident even from the first that his intention is neither to achieve dramatic expressiveness, although a certain almost melodramatic mood seems at times to result as an accidental by-product, nor to create decorative harmonies. He is clearly after some more intimate and significant interpretation of vision . . . And one sees that it is upon colour that he lays the task of situating his planes in the spatial and plastic construction. Upon colour, too, he relies to achieve the suggestions of chiaroscuro. In all this he is pushing to the furthest limits the essentially modern view of the functional as opposed to the ornamental role played by colour in pictorial design.

Although generous in his praise, Fry did not overlook one of the painter's besetting weaknesses: 'I mean', he observed in gentle admonition, 'his tendency to define his volumes with too uniformly rounded, too insensitive a contour.'

In December of the following year he held a second one-man exhibition at the Reid and Lefevre Gallery in King Street. On this occasion he was treated not as a promising beginner but as a painter with an established position. The position he had gained after so long and painful a struggle was reflected as clearly in the prices which his pictures commanded as in the respectful attitude of the critics. *The Girl with a Rose* (1925) – to my thinking one of those works in which his finest qualities are fully realized – priced in the 1926 catalogue at £30, reappeared as *Femme à la Rose* at £150. From 1926 his reputation grew steadily until, at the time when I write these words, there is probably no English painter so widely admired among those who care for the plastic arts. It is interesting to recall that Churchill once publicly reproached the Royal Academy in *The Daily Mail* for its failure to exhibit his work. But the highest tribute he has yet received came some six years earlier, from the pen of his admirer and close friend, Augustus John which appeared in the October 1928 issue of *Vogue*:

> With a cataract of emotional sensibility, he casts upon the canvas a pageant of grandiose and voluptuous form and sumptuous colour, which are none the less controlled by an ordered design and a thoroughly learned command of technique. This makes him one of the most brilliant and individual figures in modern English painting.

The decisive growth in self-knowledge during the early 1920s which allowed him to develop, at long last, so personal and so consistent a vision of things was in fact partly instinctive and partly deliberate.

Smith was very much aware that the *Fitzroy Street* nudes and the Cornish landscapes represented an immense stride forward, and even that they were, in their way, formidable productions, but the more he considered them the more he was convinced that, whatever their qualities, they were not true reflections of his own innermost intuitions. On the contrary, he became convinced that by his close study, his sedulous imitation even, of Post-Impressionists, Fauves and of Cézanne above all, he had built himself what he described to me as a spiritual prison. His dissatisfaction at last became unbearable. Certain that his earlier works were the products of this prison, and therefore false, he determined to cultivate a sensibility entirely his own and to search for the means of giving it appropriate expression, at no matter what cost. Under the stress of his dissatisfaction, he actually called upon himself aloud to be himself. The consequent

renunciation of the firm, constructive way of painting, the strident or
gloomy colouring Smith had evolved during the first five years or so
of his maturity, was no easy gesture. Until his middle thirties he had
struggled and groped, an unconsidered failure. Then, in four years,
he seemed to be justified, was sought out and praised by Sickert and
others, and, far more important, he had seemed at last to have earned
the right to be confident in himself. It was bitter to have to discount
all this as, at best, a false dawn. Deeply despondent, he started to roll
his stone uphill once again. But he was rewarded with a strange
promptitude. Having by a sustained effort of will expelled the fruits
of years of intensive study of other painters, Smith made the
exhilarating discovery that he was able to paint, whether from the
model or from flowers, with a fluency he had never known, and,
what was of greater consequence, that when he painted with his
mind, as it were, swept and garnished, he could express what he
exultingly recognized as uniquely his own.

His natural approach to things was not intellectual; he was not
deeply preoccupied with the problems of their structure, and, released
from the necessity of concern with what did not really interest him,
he became with extraordinary ease what he fundamentally must have
always been: a man moved by passion, guided by intuition rather
than by the intellect. By 1926 all this was fully apparent, and during
the next quarter of a century his work underwent extraordinary little
change. This gain in self-confidence, which brought with it the
release of his creative faculties, although it led with surprising
promptitude to the formation of a relatively unvarying style, was
never accompanied by a vestige of complacency. Smith's discontent
with his own work was acute and continuous. And not without
reason, for an art so reckless, pursued in an age that does not possess
a tradition, cannot be other than uneven. It distressed him that, after
painting a picture resonant and beautifully expressive in colour and
with a noble largeness of form, he was liable to find himself struggling
with what obstinately remained no more than so much paint; with
forms that no less obstinately remained insensitive, monotonous and
confused. Smith was well aware of the relative facility of his
orchestration of colour and the precariousness of his grasp of form
and composition. Upon these he lavished endless care, and suffered
depression that lifted only when, through some providential alchemy,
colour, form and composition fused into a masterpiece.

This exasperated discontent with his own work – not so much with
his drawings and preliminary studies as with the results of sustained
effort – is one by which the serious artist is peculiarly afflicted. Ethel
Walker is the only painter treated in these pages to have taken a frank
delight in her own work, and even her habit of self-praise may have

sprung from a determination that others should admire it. There are modest minor artists and Sunday painters, but they are, I think, more liable, if not to the sin of pride, at any rate to the disabling error of complacency. Of this last I recall an extreme yet not uncharacteristic example. When I was director, in the mid-1930s of the City Art Galleries in Sheffield, the members of the art club of a neighbouring city came to see, under the guidance of their president, an exhibition of contemporary painting. The President, a locally well-known Sunday painter of garish, rigid figures who fixed one with an epileptic stare, stopped in front of one of the most masterly of Steer's Cotswold landscapes. 'All I can say about this', he observed to his expectant disciples, 'is, it's not *my* method.'

Matthew Smith's prestige with critics and collectors and his hardly won fluency brought him personal difficulties and disillusions of a kind he had not earlier encountered. As a failure he had met much neglect, but also much kindness. As a success he inspired professional jealousy and interested friendship. The two men to whom, perhaps, he owed most – Sickert for his encouragement and Fry for his advocacy – were conspicuous among those whom he had to count among his enemies. The first time they met after the publication of Fry's article, Sickert was unable to conceal his resentment. The following year Smith said to Sickert: 'I've sent you a card for my show. But you needn't go; it's only complimentary.' 'You may be sure', answered Sickert, 'that my visit won't be complimentary.' After this encounter they rarely met again.

It was believed by some artists that one of the constant objects of Fry's continuous intrigues was the exaltation of Duncan Grant. In earlier days Smith had shared with other artists the impression that in the interests of Grant their reputations were 'played down' by Fry; then, to his surprise, the article in *The Nation* appeared. This was followed by an invitation by Fry to join the London Artists' Association. The gratitude that Smith felt for Fry did not eradicate his earlier impression that he was a crafty politician who issued, whenever he returned from Paris, new orders, fresh variants on the party line; and he therefore declined the invitation. Fry's response was to cut him in the street.

In the meantime Smith's restless habit of moving from place to place had become an established feature of his way of life. After his departure from Paris in 1926, he paid a long visit to Dieppe; in 1927 and 1928 he was in Fitzroy Street again. In 1929 – the year of his retrospective exhibition at Tooth's Gallery from 16 October to 16 November – he moved to the Grove End Road, St John's Wood, and spent some time at Arles. From 1930 until 1932 he was in Paris, living in the Passage Noirot. During 1931, 1932 and 1933 he also

lived partly in Cagnes. In 1934 he settled in Aix-en-Provence, where
he remained until 1940. At Aix he was happier, and as a consequence
less restless than at any other time in his life. He visited Paris in
1936, living at the Villa Seurat, and in 1939 he spent Christmas in
London, the first Christmas of the Second World War. He was finally
driven from Aix by the ominous events of the spring of the following
year that culminated at Dunkirk. He flew from Marseilles to Paris,
where he found himself for the time being trapped. In Paris no
telephones worked, but bad news travelled, it seemed, all the faster.
Eventually, on 8 June, the British Embassy was able to arrange for
him to be flown to London. In England he continued to move, with
accelerated speed, from place to place. The Cumberland and the Royal
Court Hotels, studios in Regent's Park and Maida Vale followed in
quick succession. It was during this, for him, more than usually
restless period that I first came to know him.

We used to meet, after the manner of bees who return to hover
about a ruined hive, in the hideously transformed brasserie of the
Café Royal, attracted by the prospect of seeing others who similarly
gathered in the ochre-and-scarlet room in the raw glare of the art
nouveau hanging lanterns. To me, as to most of them, the historic
and oddly beautiful earlier room – walled with mirrors set in slim gilt
pilasters, the painted ceiling supported by ornate gilt columns in
which everything but the glass was toned by generations of tobacco
smoke to the colour of a meerschaum pipe – was no more than a
boyhood memory, yet its ghost retained vestiges of magnetic power.

I was at first surprised to observe how often Smith dined alone,
and the more so when, after I had the privilege of dining with him,
I discovered that this illustrious and affectionately regarded man was
often lonely. But this caused me less wonder than the effect of his
society upon myself. After our first dinner together, as I walked home
exhilarated by the awareness of having spent one of the most
enjoyable of evenings, I tried to recollect precisely what it was that
had afforded me so much pleasure. But I scrutinized the evening's
impressions without reaching an adequate conclusion. The clearest
impression was of a melancholy man of about sixty, very pale,
wearing a grey check suit of rather formal cut, who read the menu
from very close up through thick-lensed spectacles, who spoke in an
even voice so quiet that it seemed to come from far away, who
repeated sentences to which he wished to give emphasis twice over,
in precisely similar tones. The principal subject of our conversation,
if my memory serves, was the problem – acute for everyone in those
bomb-ravaging times, but, as I was later to discover, a constant
preoccupation with Smith – of living and working accommodation.
'But there was a studio in Dieppe', he said with feeling, 'on which I

had an option, but I gave it up to somebody else, a friend, you know, who didn't really want it, but the owner wouldn't give me another chance. I was terribly disappointed over that studio. I could have worked there. I could see my future pictures stacked there in rows. Stacked there in rows, you know.' He at that time occupied a room in a large, dilapidated and not entirely reputable boarding-house in Piccadilly, and a studio with a leaking roof in Maida Vale, for both of which he had formed a gnawing aversion. I never visited the studio, but one day as we were leaving his room in the house in Piccadilly there emerged like a great bat from the murk of the corridor, into which she noiselessly disappeared again, the Countess Casati wear ing a triple cloak, leopard-skin gloves and a hat that framed a face in which I could discern no features but huge dark eyes. 'Oh, hullo, hullo,' whispered Smith mildly into the unresponding gloom.

Often the conversation ranged more widely, but whatever its subject, I never left Smith without the same sense of exhilaration as I experienced that first night, although later intensified with gratitude for the privilege of his friendship. The charm of his presence arose, I think, from the fact that almost any subject of conversation, or even silence, sufficed to reveal the qualities of the man, the courage of a nature constitutionally timid and without a vestige of aggressive impulse, and the active but masked benevolence, but a benevolence that did not compromise his candour. I never remember his saying a gratuitously cruel thing, nor failing to express himself with perfect frankness when the occasion required it. His conversation revealed, too, another of his qualities: an extreme but entirely unassertive love of independence. He avoided all commitments which would restrict his freedom to live and to paint in accordance with the dictates of his own nature, and he would have, I think, accepted no honours or distinctions liable to compromise this freedom. The conduct of life, he found, I fancy, sufficiently complicated in itself to make him wary of all needless entanglements.

Earlier on I referred to my surprise at finding how often, in spite of being liable to loneliness, he dined alone. Many men, as they advance in their professions, form the habit, whether from preference or a sense of obligation, to associate with successful confrères and suc-cessful or at least established persons in general. In this they are moved by a vague sense of the appropriateness of such associations, of their value, above all, to the consolidation of their positions. From all such considerations Smith was entirely free. But he had positive reasons for avoiding associations of this kind: for he took spontaneous delight in eccentric characters and persons of wit and talent – above all, perhaps, in beautiful women – whatever their position or oc-cupation. In consequence, he was bored as readily as a child by those

whose 'importance' was their chief recommendation, as well as by casual companions who did not arouse his interest. He had no ambition, I think, to be the focus of attention, but I saw him taking as much pleasure in a party at three in the morning, as he would if he were a very young man who had never been to one before. It is not surprising that he inspired the same degree of friendship as a man as he did admiration as a painter.

I have written nothing about his development from the time that he formed his highly personal language of painting in the early 1920s, because, in essentials, it varied extraordinarily little. In a detailed study there would be fluctuations of style to be recorded, and periods when nudes, faces, flowers, fruit or landscapes monopolized his interest. There was also discoverable an increasing emphasis upon bold and emphatic linear rhythms, but this emphasis was already pronounced by 1925, in, for instance, *La Femme du Cirque*. If we compare, for example, *Flowers* (c. 1920), the earliest example of his mature style known to me, with his *Blue Jug* (1937), or his *Peaches* (c. 1940), this change is evident, but it is by similarities rather than differences that we are impressed. Nor, since he evolved his mature style so slowly and in the face of so much difficulty, did he alter his technical procedure. Almost invariably he painted direct from his subject, only very rarely making use of preliminary studies. He would first draw in his composition on a blank canvas in thin paint (well diluted with oil) so that it might easily be washed off. Deeply imbued with the classical idea that design was more important than colour, and aware that he had a natural sense of colour, but a sense of design cultivated by the sweat of his brow, he laboured upon his composition until it satisfied him. Often he spent an anguished morning or, if need be, a whole day getting his composition right, but once he had succeeded he was able to work at great speed, and the picture was soon finished.

'A picture', he explained to me, 'should be "finished" from the start. In painting the gravest immorality is to try to finish what isn't well begun. But a picture that is well begun may be left off at any point. Look at Cézanne's watercolours . . .' Smith did not begin a picture until he saw it in his mind's eye in its completeness.

He did not have the advantage of working, like Poussin, for example, in an age in which the practice of painting was ordered by certain generally accepted rules. That nothing of importance can be achieved by the mere observance of rules, however sound, scarcely needs saying, but what is widely forgotten today is that by wise observance errors may be avoided. Every original work of art must be a perilous adventure, but in such anarchic times as our own it is a leap in the dark. Smith was a passionate and instinctive painter, naturally impatient with rules and suspicious of them as tending to

compromise individuality; and, as already noted, his grasp of structure was fluctuating. ('His linear drawings', Paul Nash once observed, 'hardly suggest the consummate painter he is.') It is not surprising, therefore, that he should have been the most uneven of living painters of his stature.

'He does not often hit the nail on the head', wrote an anonymous critic, 'but you should just see the wood all round' – but, I hastily add, he *did* sometimes hit it, and then you should have seen . . .!

These words were written many years ago, but, true though they are, the sum of the nails hit on the head with resounding blows is now considerable. The quality of Smith's painting had in fact received recognition ever since the late 1920s. Fry reviewed his first exhibition at the Mayor Gallery in 1926: 'Those who are bold and optimistic enough', he wrote, 'to believe in the future of an English school of painting will gain fresh confidence.' In 1944 Philip Hendy's *Matthew Smith* appeared. 'Among the English Painters of his generation', it begins, 'it is Matthew Smith alone who seems to me to have a place in the European tradition.' Yet praise, even from so notable a critic and from a director of the National Gallery, never won him, Smith's friends believed, the wide-ranging reputation which they and other ardent admirers were convinced he merited. Comprehensive exhibitions of his work had been held at Temple Newsam, Leeds in 1940 and at the Venice Biennale in 1950 – but none in London. It was decided accordingly to hold one at the Tate in 1953. As Dennis Proctor, chairman of the Gallery's board of trustees, noted in the catalogue foreword, 'the present exhibition may fairly be described as the first to cover all the main periods of Matthew Smith's work'. It consisted of eighty-one paintings from 1909 to 1952. Contributions to the catalogue included 'A Personal Tribute' by Henry Green, 'A Painter's Tribute' by Francis Bacon and 'An Appreciation' by A. J. L. MacDonnel.

Matthew arrived late to the private view. After looking carefully around the whole exhibition he said to me: 'Not so bad as I thought. Not so bad as I thought.' From him, in respect of his own work, almost complimentary. After working for so long with photographs of his paintings, I found the blaze of the originals superb. I earnestly hoped that he derived happiness from the exhibition, because I was so fond of him and because Henry Green told me that he thought he had not long to live. Although he looked ill, he lived on for six eventful years, travelling in France and visiting Venice and Tenerife. He received a Knighthood. With 1959, however, came the onset of his final illness, and he died on 29 September in his London house, 23 Acacia Road.

Some fifteen years later a notable event occurred: Mrs Mary Keene, his heir, presented Smith's collection of his own paintings to the

Corporation of London. The collection consists of more than a thousand oil paintings, drawings and sketchbooks. The gift was made subject to the condition that a major exhibition of the artist's work be held and there should be a subsequent display of a selection. The exhibition was held at the Barbican Art Gallery, 15 September to 3 October 1983, a memorable display of part of the bequest and many notable loans. The Corporation also undertook the continuous display of a selection from 1984.

WYNDHAM LEWIS
1882 – 1957

After spending some seventy years on this earth Wyndham Lewis did not assume in the slightest degree the colour of his surroundings. He remained unweathered in our terrestrial climate; he stood out as harsh and isolated as a new machine in a field. It should cause little surprise if research were to establish that this was in fact the guise in which he first appeared upon our planet: a defiant and heavily armoured mechanical man newly descended from Mars. There is a mystery about his beginnings. Nobody ever claimed kinship with Wyndham Lewis, nor to have been at Rugby with him, and no one seems to be certain where, or when, he was born. For instance in *The Art of Wyndham Lewis* (1951), a most careful survey undertaken with his help and approval, it is stated that he was born in 1884 in Nova Scotia. A few months later, in a letter to *The Times*, he gave the United States as his birthplace. Nor has the precise date of his birth been established. It may be that he had some reason for the strict secrecy about his origins and his personal life that was always so conspicuous a feature of his conduct; however this may be, such an attitude accorded very well with his general sense of his vocation. He believed, in the face of the prevailing adulation of the specialist mind of the scientist, and declared it throughout his writings, that the independent critical mind is still the supreme instrument of research. And he believed that the functions of a mind of this sort could best be exercised in relative isolation, and a posture of candid and aggressive challenge; free, above all, from any pretension to 'impartiality', that 'scientific impersonality' which he had always repudiated as treacherous and unreal. In the editorial to the first of the two issues of *The Enemy*, one of several hard-hitting but short-lived periodicals that he called into being to advertise his ideas, he dilated upon the advantages of isolation, with immediate reference to his own withdrawal from the art arena of London and Paris:

> My observations will have no social impurities whatever; there will be nobody with whom I shall be dining tomorrow night (of those who come within the scope of my criticism) whose susceptibilities, or whose wife's, I have to consider. If the public is not aware of the advantages it derives from such circumstances as these, it is time it awoke to its

true interest. Why does it not exact of its chosen servants some such social, or unsociable, guarantee?

Lewis's conduct of his life, in this respect, was led in general accord with his convictions, and today there is, among figures of comparable stature, no figure so isolated as he. Reputations are made, and to an extent far greater than the public appreciates, by members of gangs acting in close support of one another. I doubt, for instance, whether more than a few people are even now aware how closely knit 'Bloomsbury' was, how untiring its members were in advertising one another's work and personalities. Most people who came into casual contact with members of this gifted circle recall its charm, its candour, its high intelligence; few of those who were impressed by the openness of mind and the humane opinions proclaimed by *The Nation* (afterwards *The New Statesman and Nation*), their parish magazine, suspected how ruthless and businesslike were their methods. They would have been surprised if they had known of the lengths to which some of these people – so disarming with their gentle Cambridge voices, informal manners, casual unassuming clothes and civilized personal relations with one another – were prepared to go in order to ruin, utterly, not only the 'reactionary' figures whom they publicly denounced, but young painters and writers who showed themselves too independent to come to terms with the canons observed by 'Bloomsbury' or, more precisely, with the current 'party line', which varied from month to month in accordance with what their leader considered the most 'significant' trends of opinion prevailing in Paris. If such independence was allied to gifts of an order to provoke rivalry, then so much the worse for the artists. And bad for them it *was*, for there was nothing in the way of slander and intrigue to which certain of the 'Bloomsburys' were not willing to descend. I rarely knew hatreds pursued with so much malevolence over so many years; against them neither age nor misfortune offered the slightest protection. One of these days it will be possible to arrive at a clearer idea of 'Bloomsbury' art criticism by considering it in the light of the personal relations of certain of its leading members to the artists whose works came under the notice of *The Nation* and its successor; but this, for obvious reasons, is a question that cannot yet be publicly discussed.

Quite early in his career Lewis clashed sharply with Roger Fry in circumstances which I will presently relate. Thereafter he was to be traduced when he could not be ignored. In view of the pervasiveness of the Bloomsbury influence, his activities were therefore often ignored. 'There really is no occasion to apologize for a great insistence on this point', he wrote in an unsigned editorial comment, 'not in the Age of The Great Log-Rollers – for insisting upon the fact that *Mr*

Lewis has never yet been rolled by the hand of man. NO ONE HAS EVER ROLLED MR LEWIS – who, as well, is not a log, and so does not consort horizontally with logs and so physically cannot be rolled.' For years, 'by a sneer of hatred, or by a sly Bloomsbury *sniff'*, these people did their worst with the subject of this study; yet it would be unjust to attribute his isolation solely or even mainly to their activities, whose power to injure has in any case waned. There are two more radical sets of causes for it, psychological and intellectual. Lewis's radical suspicion of his fellow men, his habitual assumption that almost all men almost all of the time were moved solely by their own interests, and that they were scarcely capable of disinterested actions or even emotions, which caused him to be ever vigilantly on guard, did not seriously impair his quality as a private person as much as might be supposed: he could be an enjoyable companion, as willing to listen as to talk, considerate, and polite, sometimes to the point of courtliness, and a constant friend. But, although he happened to be a very interesting individual, Lewis always insisted that, as artist and thinker, he was a public not a private person. In this role he was certainly more candid, most *himself* in fact. His view of human nature declared itself, in particular in his writings, with utter candour and repellent power. I remember D. H. Lawrence, on the only occasion I met him, saying of Lewis's characters 'How they every one of them stink in his nostrils.' That his writings, both in intention and effect, have been beneficial to his fellow men I am firmly persuaded, but I doubt whether he regarded them with any positive affection.

However, want of affection, even when candidly declared, need not isolate a man. But Lewis adopted no such supine attitude: he was possessed by a satiric demon of extraordinary power and virulence. Most men delight in exercising their powers, and Lewis's satiric demon imperiously demanded exercise, both in and out of season. Consider a random instance from his *Art of Being Ruled*. This book constitutes the most ferocious and the most shrewdly directed attack I know upon the falsity and the drabness of the 'revolutionary' doctrines almost universally accepted today. 'Revolutionary politics, revolutionary art, and oh, the revolutionary mind, is the dullest thing on earth', he says . . . 'Everything is correctly, monotonously, dishearteningly "revolutionary". What a stupid word! What a stale fuss.' Immediately afterwards he refers to 'reactionary' journals as being like breaths of fresh air, worth their weight in gold, and Catholicism as essential to our health. Yet we turn the page to discover that he has switched the attack from the revolutionary, from '. . . the detestable crowd of quacks – *illuminés*, couéists and psychologists', to those who oppose them. This entertaining vignette of the 'Reactionary' represents him as a figure no wit more attractive than his scarlet

counterpart. 'The "Reactionary", a sort of highly respectable genteel quack, as well with military moustaches and an "aristocratic" bearing,' he writes, 'is even more stupid – if that were possible – than the "Revolutionary". We listen to him for a moment, and he unfolds his barren, childish scheme with the muddle-headed emphasis of a very ferocious sheep.' If any part of the theme of *The Art of Being Ruled* were the predicament of the common man between revolution and reaction, this impartial lampooning would of course be entirely consistent, but that 'revolution' is its target is obvious from the start.

Lewis was one of those rare beings, among whom Leonardo was incomparably the greatest, in whom the intellectual and artistic impulses are of equal intensity. Whenever Lewis wrote, however severely intellectual his subject (and however careless his writing), he was always the artist as well as the philosopher or critic. As an artist, as a literary artist especially, he was virulently satirical, liable, when dwelling upon almost any person, or class of persons – Englishmen, stockbrokers, women, the rich, as well as revolutionaries and reactionaries – to envisage them not as intellectual abstractions, but as artistic creations, that is to say, as satiric creations. As a private individual, Lewis nourished no more rancour, I believe, than the average man; but he satirized as naturally and as inevitably as G. F. Watts, for example, ennobled. It need scarcely be said that this propensity to satire did not endear him to his victims, more especially when these had reasons for counting themselves among his not very numerous friends and benefactors. An intractable independence of mind; a belief in the value of a detached, uncompromised status as best suited to the exercise of criticism; an innate or early acquired secretiveness; a clash with incomparably the most influential intellectual gang at the outset of his career, and an inveterate tendency to ferocious satire almost as readily directed at his intimates as at his enemies, were the principal causes for Lewis's isolation – an isolation for which I can recall no parallel among his contemporaries of comparable stature. With regard to his stature there is, as yet, no sign of an accepted opinion; instead the widest diversity of view. I have heard several of those few whose learning and judgment have won them the highest esteem refer to him, both as painter and writer, in terms of scarcely qualified contempt. There are circles who would regard the opinion that his contribution to art criticism was no less valuable than that of Fry not only as ludicrous but in some perhaps not readily definable way as unpleasant.

There also exists an opposing body of opinion, no doubt considerably smaller, but perhaps even more deeply convinced. Included in the company are Roy Campbell, H. G. Wells, W. B. Yeats, Rebecca West and J. W. N. Sullivan, while T. S. Eliot once wrote of him, in a

review of his novel *Tarr*, 'Mr Lewis is a magician who compels our interest in himself; he is the most fascinating personality of our time . . . In the work of Mr Lewis we recognize the thought of the modern and the energy of the caveman.'

Lewis's command of the written word freed the visual artist in this strange but remarkable prophet from the impulse to preach with his brush or his drawing pen, and made it possible to isolate his paintings and drawings from the productions of his typewriter. But to isolate too rigorously an art that represents only one of the activities of a being who was as closely integrated as he was versatile would serve no serious purpose. With Lewis the eye and the intellect were intimately related, and he himself never regarded himself as a pure 'visual', or indeed shown much respect for the artist with pretensions to being a pure visual, with no preoccupations except form and colour. 'The best artist,' he has written 'is the imperfect artist. The PERFECT artist, in the sense of "artist" *par excellence*, and nothing else, is the dilettante or taster.' The art of Lewis needs to be considered in a larger context, and above all, it seems to me, in that of his ideas. The art of painting was probably his first preoccupation, but the predicament of the artist in the modern world drove him, as it has driven other artists of intellect, to a close analysis of the elements of his situation. There is an obvious parallel in this respect between Lewis and Ruskin: both, originally concerned almost exclusively with the arts, ended by taking vast areas of speculation as their province. At the very outset of his career as a writer Lewis dealt with the predicament of the serious painters of his generation, and showed powers of analysis and exposition of a rare order. His words are as enjoyable and as relevant as they were the day when they were written. Of how pitiably little art criticism can this be said! Briefly his argument is that Impressionism involves a disabling subservience to nature's 'empiric proportions' and 'usually insignificant arrangements', and is conducive to a new and shallow academism.

The alternatives he considered are: *Cubism*, which he showed to be as closely concerned as Impressionism with naturalism, no less 'scientific' in its methods, and which 'tempts the artist to slip back into facile and sententious formulas, and escape invention'. *Futurism*, which was always 'too tyrannically literary, . . . too democratic and subjugated by natural objects, such as Marinetti's moustache'. *Expressionism* – in which he included abstraction – which was disabled by its ambivalent attitude towards the natural world. 'If you do not use shapes and colours characteristic of your environment, you will only use some other characteristic of somebody else's environment, and certainly no better. And if you wish to escape from this, or from any

environment at all you soar into the clouds, merely', is how he states his basic criticism.

Lewis's art and thinking provide his answer. The first thing to notice about him was the decisive and consistent externality of his approach. 'Give me the *outside* of all things,' he wrote. 'I am a fanatic for the externality of things.' And, more explicitly, '. . . what made me, to begin with, a painter, was some propensity for the exactly defined and also, fanatically it may be, the physical and the concrete'. Precisely what he was *not* is defined in some notes on Kandinsky, which appeared in *Blast II*, whom, at the time when he wrote, he regarded as the only purely abstract painter in Europe:

> Kandinsky, docile to the intuitive fluctuations of his soul, and anxious to render his hand and mind elastic and receptive, follows this unreal entry into its cloud-world out of the material and solid universe. He allows the Bach-like will that resides in each good artist to be made war on by the slovenly and wandering spirit. He allows the rigid chambers of his Brain to become a mystic house haunted by an automatic and puerile spook, that leaves a delicate trail like a snail.

Lewis was always much preoccupied by the distinction between the fashionable subjective method used by Kandinsky and Klee, and by Henry James and James Joyce, and the 'external' method of which, in our day, he was one of the few exponents. Early in 1939, discussing *The Apes of God* with Lewis, I pointed out the traits in his victims that he had most precisely caught and most grotesquely parodied. To keep the record straight, he occasionally issued a little formal denial that my identifications were well-founded (as of course they were), and growing tired, or even perhaps apprehensive of the turn the conversation had taken (for the air was heavy with threats of libel actions), he abruptly turned the conversation to the philosophy behind the book. No sooner had he begun to expound than it was time for me to leave. A few days later there arrived through the post *Satire and Fiction*, an inscribed copy of the pamphlet he composed and published concerning the rejection by *The New Statesman and Nation* of Roy Campbell's review of *The Apes of God*. The author had marked several passages that served to complete the exposition which my departure had cut short. As these define something fundamental in Lewis's outlook, and as the pamphlet is difficult to come by, I will transcribe a few sentences from it:

> In another book [by Lewis], the outlook, or the philosophy, from which it derived, was described by me as a 'philosophy of the EYE'. But in the case of 'The Apes of God' it would be far easier to demonstrate . . . how *the eye* has been the organ in the ascendent here.
> For 'The Apes of God' it could, I think, quite safely be claimed that no book has ever been written that has paid more attention to *the outside*

of people. In it their shells, or pelts, or the language of their bodily movements, comes first, not last.

In my criticism of 'Ulysses' I laid particular stress on the limitations of the *internal* method. As developed in 'Ulysses', it robbed it . . . of all linear properties whatever, considered as a plastic thing – of contour and definition in fact. In contrast to the jelly-fish that floats in the centre of the subterranean stream of the 'dark' Unconscious, I much prefer, for my part, the shield of the tortoise, or the rigid stylistic articulations of the grasshopper . . . The ossature is my favourite part of a living organism, not its intestines.

In the last marked passage he speaks of 'the polished and resistant surfaces of a great externalist art'.

Near the beginning of the first volume of this work I contrasted the arguments employed by R. H. Wilenski and others to make us believe that the modern movement in the arts is synonymous with a revival of classicism, with the scarcely deniable absence of any classical characteristics from the art that it actually produced. In a world which, however classical its patter, had in action so unmistakably 'declared for Dido against Aeneas and Rome', Lewis was one of the few artists who made a serious attempt to carry fashionable classical theory into practice. That his sympathies were fanatically classical he repeatedly stated, as in *Men Without Art*:

I always think of something very *solid*, and I believe it is a sensation I share with many people when the term 'classic' is employed, and of something very dishevelled, ethereal, misty, when the term 'romantic' is made use of. All compact of common sense, built squarely upon Aristotelian premises that make for permanence – something of such a public nature that all eyes may see it equally – something of such a universal nature that to all times would it appear equal and the same- such is what the word *classic* conjures up. But at *romantic* all that drops to pieces. There is nothing but a drifting dust . . . which no logical pattern holds together . . .

The 'classical' is liable to incline to be objective rather than subjec- tive . . . to action rather than to dream . . . to the sensuous side rather than the ascetic: to be redolent of common sense rather than meta- physic . . . to lean upon the intellect rather than the bowels and nerves.

I have quoted at some length from the contrast Lewis has drawn between the classical and romantic attitudes not as a lucid and forceful restatement of a rather threadbare theme, but as a concise declaration of his own convictions as an artist.

Lewis regarded himself as a classical artist, but this implied no special degree of discipleship of Raphael, Poussin or Ingres. No slightest suspicion of revivalism is attached to the classicism of Lewis; he was, for good and ill, to a degree rare in a man of high intelligence, uninterested in the past. But his claim to classicism is very relative, and made with a strict qualification. He recognized that

an art that is impersonal and public can exist in its fullness only when it has an audience which shares common values, and that no 'highbrow' set in a great metropolis like London or Paris, still less such enormous, sprawling proletarianized societies as ours, can for a moment supply the same order of framework that was forthcoming for the artist of the Augustan age, or the homogeneous, compact society behind Dryden, Pope and Swift.

On account of this and other conditions which characterize our civilization he declared that 'It would be mere buffoonery, in an artist of any power among us . . . to say "as an artist I am a classicist".' But however unfavourable the circumstances, Lewis consistently tried 'to be impersonal rather than personal; universal than provincial; rational rather than a mere creature of feeling; to act as the rational animal, man, *against* the forces of nature', for such, he concluded, 'is the dramatic role of the classical consciousness'. I have said enough to give an indication of the character of the strange, tough, heavily armed and heavily armoured being who seemed to have dropped from nowhere.

I have already referred to an uncertainty about the place where Lewis first appeared. It seems reasonably certain that this was on the other side of the Atlantic, and the date somewhere about 1882. It is worth mentioning that in 1951, in the course of a conversation about other matters, I asked him a question about his early life, and he refused an answer saying, 'now that I'm blind and unable to paint, writing is my only means of support, and my recollections of my own life are my chief material, and I don't see why I should give away a single fact; and I don't intend to, to anybody'. Lewis went to Rugby School, and, according to Handley-Read's book, spent the years 1897 and 1898 there. In 1898 he went to the Slade School, where he remained for three years. No work of his student years seems to have survived, but three drawings are preserved at the Slade, one signed and dated 1902 and two others of similar character. These proclaim him a draughtsman of no ordinary gifts, content, for the time being, to accept academic discipline. They are precise, elegant studies, marked by a reticent yet unmistakable masculine strength and hardness. The next six years he spent abroad, visiting France, Germany, Holland and Spain. In his autobiographical writings these wander-years are treated with characteristic reserve. He spent six months at the Heimann Academy in Munich, and occupied a studio in Paris in the Rue Delambre. At the Slade, in spite of the hostility of Tonks, he acquired a firm grasp of drawing; to this invaluable accomplishment he had added, by the time he returned to England in 1909, a formidable education, both intellectual and artistic. It is reasonable to

assume that the austere hardness of Spain strengthened those qualities in him; how closely he observed certain aspects of the German character was brilliantly manifest in his novel *Tarr*. It was his desire to pierce behind the enigmatic façades of the Russian students he met in Paris, he told me, that first led him to search, in a long course of reading Russian novels, for the sources of their arrogant and mystical confidence in their country and themselves. Little as is known about his years abroad, from the many and significant allusions to them in his conversation, I believe that it was largely in the course of his travels that he developed his highly personal attitude to life.

No example of the considerable quantity of work that Lewis is believed to have done abroad has apparently survived, but there is sufficient evidence to show that by 1909 he was also beginning to evolve a correspondingly personal style as a draughtsman. Whether because he produced little – which is unlikely – or because he destroyed much, and most of what survived has been lost, examples of the work of the years immediately following his return to England appear to be rare. There are, however, several in the Victoria and Albert Museum. His association with the Camden Town Group, of which he was a founder member, must have been due to his friendship with Gilman and personal ties with other members, and perhaps to his apprehension that the Group was the most serious and active nucleus of painters in England. Certainly there was no community of aim between Lewis and his fellow members, and he played no part in the Group's brief but influential history. But from 1911, the year of its foundation, dates the earliest of a fairly extensive group of drawings in which Lewis, for the first time, consistently strikes a note that we recognize as unmistakably his own. For the most part they represent rock-like men and women standing or seated in landscapes of lunar aridity and harshness. These massive, primitive persons are depicted sometimes making gestures of incoherent protest against some malign fate, sometimes in attitudes of hopeless passivity. The drawings are carried out in varied combinations of mediums, which include pen and ink, watercolour washes (often mushroom pink, brown and grey), pencil and chalk.

The artist's preoccupation with these massive incoherent primitives was intense but not lasting and during the following year he began to make drawings of a character afterwards recognized as Vorticist. The term 'vorticist' was first used by Ezra Pound in 1913. Lewis was, inveterately, a theorist, but it was, I think, the sensational impact of Filippo Marinetti, preaching his gospel of Futurism, that first provoked Lewis to formulate his own counter-gospel and brought out the inveterate pamphleteer in him. Unlike Surrealism, Vorticism

was not a clearly formulated canon, but an expression of Lewis's own convictions – temporarily adopted by a small group of associates – promulgated with a violence and pungency which he had learnt from the Futurists. The movement has often been treated as an English version of Futurism. Apart from their propaganda techniques and the fact that they were both extreme and noisy manifestations by truculent young men contemptuous of the near past, above all of an Impressionism that had become a pervasive and boneless academism, Vorticism had little in common with Futurism; in fact the English movement rejected the principal tenets of the Italian. In *Notes and Vortices: II*, Lewis has given his reasons for his inability to accept Futurism in some detail. While applauding the 'vivacity and high spirits' of the Italian Futurists, he condemns them as too much theorists and propagandists, as too mechanically reactive, too impressionistic, and unable to master and keep their ideas in place. What most repelled him was their hysterical insistence upon ACTION. 'The effervescent Action-Man, of the Futurist imagination, would never be a first-rate artist', for, he says, 'to produce the best pictures or books it is possible to make, a man requires all the peace and continuity that can be obtained in this troubled world, and nothing short of this will serve'. Finally, he was impatient with the attempt to represent figures or machines in violent motion, which was to represent a blurr. ' "Je hais le movement qui déplace les lignes" ' (' "I hate movement that disrupts the outlines." ') he quoted at Marinetti, when they found themselves over adjacent washbasins in a London restaurant. There were clashes between Futurists and Vorticists during Marinetti's visit to London: Lewis, Gaudier-Brzeska, T. E. Hulme, Edward Wadsworth and others barracked the Futurist leader as he delivered a lecture at the Doré Gallery in New Bond Street. Lewis used to claim that he owed his equanimity when subjected to heavy gunfire in Flanders to having been 'battle trained' by hearing Marinetti imitating the noise of a bombardment on the lecture platform, with the aid of Richard Nevinson with a drum.

One characteristic a number of Lewis's Vorticist drawings do share with the work of the Futurists is violent action. Among the earliest of them are the *Centauress* drawings of 1912, in pen and ink and watercolour. The centauress herself bears some resemblance to the primitive figures of Lewis's preceding phase, but the later drawings bear the stamp of a very different character. The earlier are spontaneous, and, if the adjective would not be inappropriate to forms so massive, even sketchy. The later are emphatically deliberate, and their most conspicuous feature is their angular, rectilinear character. They clearly have an intimate affinity with the international Cubist movement. But Lewis was a Cubist with a difference. 'The Cubists,

especially Picasso,' he wrote, 'Found their invention upon the posed model, or the posed Nature-Morte, using these models almost to the same extent as the Impressionists.' He repudiated this practice as an absurdity and a sign of relaxed initiative. According to Lewis, the Cubists either took apples or mandolins as the basis of their designs, or if, on the other hand, they 'departed from what was under their eyes, they went back to the academic foundations of their vision, and reproduced (in however paradoxical a form) an El Greco, a Buonarotti'. In either case they avoided invention: that was his contention. This is not the place for an analysis of Cubism, but the rapid collapse of a movement so brilliantly staffed and which promised to fulfil the highest hopes of the most adventurous painters of the age for the establishment of a new classical art suggests that there may have been radical defects in the ideas upon which it was based. It is characteristic of Lewis that, a self-confessed, indeed an aggressive revolutionary, he should have subjected the great revolutionary movements of his time to the most searching criticism. When most of his contemporaries had climbed on to the bandwagon, and most of his seniors were throwing brickbats (and how wide of the mark!), Lewis analysed the revolutionary tendencies that he most respected with exemplary independence.

Lewis's Vorticist drawings were either totally abstract inventions, such as *Planners* (1913), a pen and ink, crayon and watercolour drawing, or the designs for *Timon of Athens* (1913–14), in which he made use of a modified Cubist technique, with a frankness rare, if not unknown, among Continental Cubists, in order to enhance the intensity of the representation of an invented scene. For Lewis the years immediately preceding the war were times of intense and many-sided activity. During 1913 he carried out four decorative paintings in oil, in The Cave of the Golden Calf, an intellectual nightclub run by Mrs Strindberg, in the Eiffel Tower restaurant, in the house of Lady Drogheda, and in South Lodge, the house of Violet Hunt, all of which have been destroyed. This last, according to my own imprecise recollection, was inferior to most of his Vorticist drawings known to me. On the very eve of the war Lewis created two agencies for the propagation of his ideas and the advertisement of his activities. These were the Rebel Art Centre, the seat of what he called 'The Great London Vortex', and the periodical *Blast*.

The Rebel Art Centre was brought into existence as a result of his stormy departure from the Omega Workshops, the centre established in July 1913 at 33 Fitzroy Square by Roger Fry, where a group of his friends undertook, in Fry's words (from an undated prospectus of Omega Workshops),

almost all kinds of decorative design, more particularly those in which
the artist can engage without specialized training in craftsmanship . . .
Actuated by the same idea of substituting wherever possible the
directly expressive quality of the artist's handling for the deadness of
mechanical reproduction, they have turned their attention to hand
dyeing and have produced a number of dyed curtains, bedspreads,
cushion covers, etc., in all of which they employ their power of
invention with the utmost freedom and spontaneity of which they are
capable.

In furniture they have not attempted and will probably not attempt
actual execution, but they believe that the sense of proportion and
fitness and the invention, which are the essential qualities of such
design, can be utilized to create forms expressive of the needs of
modern life with a new simplicity and directness.

When Lewis came in one day he was told by Fry that the Omega had
been given 'a wonderful commission' by *The Daily Mail* to design and
carry out the furnishing and decoration of a Post-Impressionist room
at the Ideal Home Exhibition, and that the principal tasks were
already allocated. 'But you, Lewis,' Fry said after a moment's
reflection, 'might carve an overmantel.' Carving in the round was not
one of Lewis's many talents, and he addressed himself gloomily to
his task. A few days later he happened to meet P. G. Konody, art
critic of *The Daily Mail* and art adviser to Lord Rothermere, its
proprietor. Konody asked him how the Post-Impressionist room was
shaping up, and Lewis told him that, apart from his languishing
overmantel, he knew little about it. 'As the designer I think you *ought*
to know,' Konody complained. 'The *designer?*' Lewis asked. Then
Konody told him that he had called to see him at the Omega
Workshops, been told he was out, that Fry had offered to take a
message, and he had asked him to convey to Lewis and Spencer Gore
an invitation from *The Daily Mail* to design the Post-Impressionist
room.

Talking with me years later about the episode, Lewis said that if he
had known what protest would have cost him he would have kept
silent. But he did not know: so there was an angry interview, followed
by the trailing of a coat, in the form of a letter that may one day find
place in the anthologies of invective. 'The Round Robin', as Lewis
called it, not only charged that 'the Direction of the Omega Workshops
secured the decoration of the Post-Impressionist room at the Ideal
Home Exhibition by means of a shabby trick', and that it had
suppressed 'information in order to prevent a member from exhibit-
ing in an exhibition *not* organized by the Direction of the Omega',
but it attacked the policy of the Omega and the character of its
director.

As to its tendencies in Art, they alone would be sufficient to make it

very difficult for any vigorous art-instinct to long remain under that roof. The Idol is still Prettiness, with its mid-Victorian languish of the neck, and its kin of 'greenery-yallery', despite the Post-What-Not fashionableness of its draperies. This family party of strayed and dissenting Aesthetes, however, were compelled to call in as much modern talent as they could find, to do the rough and masculine work without which they knew their efforts would not rise above the level of a pleasant tea-party, or command more attention.

The reiterated assurances of generosity of dealing and care for art, cleverly used to stimulate outside interest, have then, we think, been conspicuously absent from the interior working of the Omega Workshops. This enterprise seemed to promise, in the opportunities afforded it by support from the most intellectual quarters, emancipation from the middleman-shark. But a new form of fish in the troubled waters of Art has been revealed in the meantime, the Pecksniff-shark, a timid but voracious journalistic monster, unscrupulous, smooth-tongued and, owing chiefly to its weakness, mischievous.

No longer willing to form part of this unfortunate institution, we the undersigned have given up our work there.

The circular, which bore the signatures of Frederick Etchells, C. J. Hamilton, Wyndham Lewis and E. Wadsworth, was widely distributed, especially among patrons of the Omega, and also sent to the press. According to his biographer, Virginia Woolf, Fry decided not to take up the challenge. 'No legal verdict,' as he observed, 'would clear his character or vindicate the Omega.' But he had other means of visiting his rancour on the principal challenger. Of these he did not neglect to make unremitting use.

Brief and unhappy though his experience at the Omega was, it would seem to have impressed Lewis with the advantages to be drawn from such a centre. A friendship that he had formed not long before with Kate Lechmere gave him the opportunity of realizing his ambition to control such a centre himself.

He had met Miss Lechmere at the house of Mrs R. P. Bevan, probably in 1912. At a chance meeting a few days later he gruffly invited her to dinner. Throughout dinner he spoke not a single word. Over coffee he apologized and explained that he was upset and distracted by some hysterical letters that he had been getting lately. But soon he was able to revert to his normal interests. Had she read Gorky? he inquired; he talked at length about the *Tales of Edgar Allan Poe* which he was reading in Baudelaire's translation. They often met thereafter.

When Lewis was in the grip of the resentful mood that followed his departure from the Omega, Miss Lechmere wrote to him from Paris to propose the formation of an atelier, like a French one. So the Rebel Art Centre was established in the spring of 1914, where it was intended that classes, lectures and exhibitions should be held.

Premises were taken in a fine Georgian house, 38 Great Ormond Street, of which the first floor provided the rooms for the Centre's own operations. The Rebel Art Centre stirred the politician in Lewis into full activity. He refused to allow 'membership', in any formal sense, to any of those who were, for all practical purposes, its members. Of these the chief were Etchells, Gaudier-Brzeska, Wadsworth, Epstein, Nevinson, Roberts, Bomberg, T. E. Hulme and Ezra Pound. At the opening meeting Nevinson said, 'Let's not have any of these damned women,' and Lewis confessed with embarrassment that the Centre was entirely financed by Miss Lechmere. Nevinson's aversion to women's participation in public affairs was shared by Lewis, who was invariably reluctant to admit that the Rebel Art Centre owed its existence to a woman. Another instance of Lewis's prejudice against women was his refusal to allow the artists who, in imitation of the procedure followed at 19 Fitzroy Street, brought their work to be seen by friends, to hand round tea. At 19 Fitzroy Street the artists waited upon their guests; at the Rebel Art Centre this menial task was strictly reserved to women.

Unlike many other projects undertaken in 1914, the Rebel Art Centre was not extinguished by the war; after an existence of some four months it came to an end, principally because it was unable to withstand the stresses imposed upon it by Lewis's possessiveness and suspiciousness. His conduct of its affairs was audacious and enterprising, but his suspicion of his associates, his fondness for intrigue, his uncertain temper, his jealousies and the strains that inevitably ensued within the Centre, quickly overwhelmed an institution that had been prevented from acquiring necessary support due to his conduct. Its activities, effectively publicized, gave it and Lewis much prominence, but it accomplished little. Ford Madox Ford and Marinetti lectured there, but its teaching activities were restricted, for only two students presented themselves for instruction: a man who wished to improve the design of gas-brackets and a lady pornographer. The day came when Miss Lechmere declined to bear further expense and Lewis moved out.

The most fruitful consequence for Lewis of his connection with the Rebel Art Centre was his association with Hulme. Scattered references to Hulme occur in Lewis's writings: in *Blasting and Bombardiering* he is the subject of a chapter in which it is conceded that he was a remarkable man, with a sensitive and original mind. But the entertaining and condescending account of this man gives no hint of the extent to which Lewis was in his debt. 'All the best things Hulme said about the theory of art,' he claimed, 'were said about my art'; he refers, too, to the influence of his own pronouncements upon Hulme, and sums up in the words, 'what he said should be done, I *did*. Or it

would be more exact to say that I did it, and he said it.' That Lewis possessed an intellect of immeasurably greater range and penetration than Hulme is not open to question, yet there are reasons for thinking that in the association between the two it was not Lewis but Hulme who played the dominant part. If Hulme had spoken and written earlier he would have been one crying in the wilderness; if later, one uttering commonplaces; but his coming was providentially timed and the ideas he propounded proved salutary, energizing and influential. He was neither an original thinker – there can be scarcely an idea in his writings that he had not come upon in his reading of Pascal, Sorel, Bergson, Worringer, Lasserre or Husserl – nor an accomplished writer, although there is something attractive about his forthright, muscular style.

At the heart of Hulme's system of ideas was his disbelief in the perfectibility of man. There are, he held, two prevailing views about man's nature, as expressed in *Speculations, Essays on Humanism and the Philosophy of Art* (1936):

> One, that man is intrinsically good, spoilt by circumstance, and the other that he is intrinsically limited, but disciplined by order and tradition into something fairly decent. To the one party man's nature is like a well, to the other like a bucket. The view which regards man as a well, a reservoir full of possibilities, I call the romantic; the one which regards him as a very finite and fixed creature, I call the classical.

I do not propose to follow in any detail the arguments by which Hulme associates the romanticism of the generations immediately preceding his own with the progressive supersession of classical by romantic principles in the political, and every other, sphere of activity following the triumph of Rousseauism in the French Revolution. The root of all romanticism was for him the notion that man the individual is an infinite reservoir of potentialities, and that the destruction of order, which is oppressive by its very nature, will release these potentialities and 'progress' will inevitably follow. Against the naturalistic, 'vital' art produced by the romanticism of the modern world he sets up the classical ideal of the archaic Greeks, the Egyptians, Indians and Byzantines 'where everything tends to be angular, where curves tend to be hard and geometrical, where the presentation of the human body, for example, is often entirely nonvital, and distorted to fit into stiff lines and cubical shapes of various kinds'. He insisted upon the impulse towards abstraction discernible in the later works of Cézanne which makes them 'much more akin to the composition you find in the Byzantine mosaic (of the Empress Theodora) in Ravenna, than it is to anything which can be found in the art of the Renaissance'. Abstract art, to quote Hulme:

exhibits no delight in nature and no striving after vitality. Its forms are always what can be described as stiff and lifeless. The dead form of a pyramid and the suppression of life in a Byzantine mosaic show that behind these arts there must have been an impulse, the direct opposite of that which finds satisfaction in the naturalism of Greek and Renaissance art.

Hulme regarded by far the greater part of the art of his own and the immediately preceding centuries as sharing the same naturalistic and vital impulses as those of Greece and the Renaissance, from which it derived. Hulme was not a diehard concerned to defend or revive any existing or past social order. Nor was he an enemy of progress, but he believed, on the contrary, that the prevailing trust in an inevitable process called Progress vitiated the creative efforts of the individual and sacrificed the right of moral judgment. In the words of his informed and fair-minded biographer, Hulme believed that 'the liberal and romantic outlook coloured nearly all political and philosophic thought in England; and he claimed that this outlook was mistaken and could be abandoned without any sacrifice of generosity and intellectual intregrity'. Hulme – who was born on 16 September 1883 at Gratton Hall, Endon, Staffordshire, and educated at the High School, Newcastle-under-Lyme and St John's College, Cambridge – seems to have begun his brief career as a writer in 1911 with a series of articles on Bergson in *The New Age*. The following year there appeared in the same journal five 'Imagist' poems under the heading 'The Complete Poetical Works of T. E. Hulme'. It was not so much by his writings, however, as by his talk that Hulme disseminated his ideas, not from the lecture platform – where both he and Lewis were conspicuously ineffective – but in cafés, college common-rooms and at the Rebel Art Centre.

The fact that Hulme expressed himself most persuasively in conversation, and that Lewis published nothing on the philosophy or criticism of art before the appearance of *Blast* makes it extremely difficult to assess with any degree of precision the intellectual relationship between the two. We know that it was shortly after the influence of the ideas propounded by Hulme began to be felt in London that Lewis's own drawing assumed a geometrical, nonvital character. On the other hand, we know that on his own long sojourn on the Continent Lewis observed and read much, and Hulme's biographer has told us that 'he had become interested in the new geometrical art of Picasso, Wyndham Lewis, David Bomberg, William Roberts and Jacob Epstein'.

What is most likely, I think, to have occurred is that Lewis had acquired some familiarity with the ideas Hulme propounded – it is most improbable that a man of his curiosity should have known

nothing of Continental philosophical ideas, and he had listened to Bergson lecturing at the Collége de France – but that they were sensibly clarified, vivified and expanded by contact with Hulme's more impressive personality. How splendid a head he had is apparent from the portrait of him modelled by Epstein. A combination of knowledge, conviction, critical sensibility, charm, brilliance, humour and a sense of fantasy enabled him to dominate any conversation. 'To hear Hulme develop general ideas and abstractions was like studying an elaborate pattern whose inner lines and texture emerge gradually as you gaze.' I myself had the good fortune to hear second-hand Hulme's description of a free fight that broke out in the Ethical Section at the Philosophical Congress held at Bologna in 1911. In addition, Hulme was courageous and extremely tough. On one occasion when Lewis showed reluctance to continue a discussion, Hulme lifted him up and held him upsidedown against the railings of Soho Square continuing to develop some intricate theme at leisure. The extreme jealousy that Lewis showed where Hulme was concerned suggests that he was conscious of his debt to a man whose greatest capacity was for the stimulation and direction of the creative faculty in others, whom he regarded somewhat in the light of mediums. It was certainly in such a light that he regarded Epstein, who ought, he considered, to carve instead of model and whose carving *The Rock Drill* may well owe something to Hulme. Epstein told me that Hulme, tireless in his efforts to inspire others, was apt to be lazy where his own work was concerned, assuming that he had a long life before him. In this he erred: he joined the Honourable Artillery Company shortly after the First World War began and was killed on 28 September 1917.

For Lewis 1914 was a year more productive and eventful than any he had known. Through a loan of £100 and an order for fifty copies on behalf of the Rebel Art Centre, Miss Lechmere enabled Lewis to publish *Blast*, the spectacular periodical which brought Lewis an ephemeral notoriety. This outsized periodical with the raspberry cover, and the combative introductory manifesto in huge black type, was read with eager curiosity, mixed with derision at what was taken to be the irresponsible extremism of the robust 'blasts' and 'blesses'. Like so much of Lewis's writing – except for signed contributions by Ford Madox Ford and Rebecca West; some poems and a manifesto by Ezra Pound and another by Gaudier-Brzeska; and a review by Wadsworth, almost the whole text was his work – it not only withstood the assaults of time but flourished upon the ordeal. *Timon of Athens*, a folio of drawings, rectilinear in character, of figures in energetic movement, also appeared that year. Beyond comparison Lewis's most important achievement of 1914 was the composition of

Tarr, his first novel and in certain respects his best. It is a work of extraordinary energy, which uncompromisingly manifests his 'externalist' convictions. It was not published in book form until four years later. It was in 1914 that he completed his first *Portrait of Ezra Pound*. Towards the end of the year he was ill, and on his recovery in 1915 he joined the army. The Vorticists held their only exhibition in June, at the Doré Gallery, organized by Lewis, who wrote a 'note' for the catalogue, in which he thus defines the movement:

> By Vorticism we mean (a) ACTIVITY as opposed to the tasteful PASSIVITY of Picasso; (b) SIGNIFICANCE as opposed to the dull or anecdotal character to which the Naturalist is condemned; (c) ESSENTIAL MOVEMENT and ACTIVITY (such as the energy of a mind) as opposed to the imitative cinematography, the fuss and hysterics of the Futurists.

In that year appeared the second, and final, number of *Blast*.

Army training entirely arrested Lewis's activities as draughtsman and painter during 1916, but he found time to revise *Tarr*, which appeared month by month in *The Egoist* – then under the editorship of Harriet Weaver, Richard Aldington and Dora Marsden – from April until November the following year. A barren period was ended by his secondment as a war artist to the Canadian Corps. This appointment not only released, but stimulated, a flood of creativity. Besides giving a constantly industrious artist the leisure to draw and paint, it provided Lewis with a subject to which he responded ardently. Although vividly conscious of the calamitous character of war, and of the shallowness of the machine-worship of his Futurist associates, Lewis was enraptured by the physical splendour of mechanized warfare. Big guns in particular – he served in the artillery – possessed the characteristics of hardness, bareness, purposefulness, power and unqualified masculinity that marked his own temperament. In the presence of big guns the place of satire is usurped by romance. In *Blasting and Bombardiering* he wrote,

> Out of their throats had sprung a dramatic flame, they had roared, they had moved back. You could see them, lighted from their mouths as they hurled into the air their great projectiles, and sank back as they did it. In the middle of the monotonous percussion, which had never slackened for a moment, the tom-toming of interminable artillery, for miles around, going on in the darkness . . .

The sense of romance that this description conveys is present in an intenser degree, although in a less obvious form, in his gun paintings. In these, he who had for so long observed, theorized and experimented, now emerged as an assured, weighty and highly individual artist. The most considerable are *A Battery Position in a Wood* (1918), a drawing, *A Battery Shelled* (1919), *A Canadian Gunpit*, (1918). These

and a number of subsidiary studies well illustrate an aim which took an increasing hold upon Lewis, that of reducing the flux of nature to something simpler, more rigid, more tense and angular. Impersonal figures move like automata at the compulsion of some irresistible force.

Lewis may be said to have belonged to the international Cubist movement, but like much else he wore his Cubism with a difference. His criticism of the Cubists for avoiding creation by organizing their compositions upon a natural, posed model I have already noticed. He also criticized them for the triviality of their subjects, for their failure to attempt the grandness that Cubism almost postulated.

'HOWEVER MUSICAL OR VEGETARIAN A MAN MAY BE, HIS LIFE IS NOT SPENT EXCLUSIVELY AMONGST APPLES AND MANDOLINES. Therefore there is something requiring explanation when he foregathers, in his paintings, exclusively with these two objects.'

Neither reproach is applicable to Lewis's own Cubist works. His abstractions, such as the *Planner* drawings, are inventions, not based upon nature, and the *Timon of Athens* designs and the paintings and drawings of the First World War represent an attempt to apply Cubism to subjects of wider scope and deeper human concern. The chief effect of his service as a war artist was to sharpen a discontent with the restrictions imposed by pure Cubism. The effect of his confrontation with a subject so overwhelmingly compelling as the theatre of war, which, as already noted, had a special appeal for him, was to sharpen his sense of the inadequacy of pure Cubism to express the full content of his vision.

The geometrics which had interested me so exclusively before I now felt were bleak and empty. *They wanted filling.* They were still as much present to my mind as ever, but submerged in the coloured vegetation, the flesh and blood, that is life . . .

There was his programme, and one which he shared with the best of his contemporaries. No work by Lewis shows the wonderfully subtle perception of the use of Cubism in defining form, of, for instance, Picasso's *Femme á la Mandoline*, or *Femme Assise*, Duchamp's *Nude Descending a Staircase*, or certain Braques, but he put it at the service of a wider purpose. Pure Cubism constituted a position which others, unable to see their way ahead, tacitly abandoned, but from which Lewis marched out with colours flying.

Lewis's suggestion that he was filling his geometrics gives an inadequate notion of the extraordinary power of expressing natural forms which he acquired during the latter part of the war. *Red Nude* (1919), for instance, is equally powerful whether it is considered as a design or as a representation – in which contempt is curiously fused

with something near to veneration – of a massive standing woman. What a splendid drawing this is! During these years his powers as a draughtsman came to maturity, and although he was able to draw well throughout his life, at no other time did his drawings exhibit such abounding vitality controlled by so classical a discipline. He drew finely and with ease, and admirable drawings done in about 1920 are not uncommon – drawings of the quality, for example, of *Girl in a Windsor Chair* (1920), or the *Portrait of Ezra Pound* of the same year. After the early 1920s his drawing done from life lost something of its quality as the extraordinary tense equilibrium between powerful thrusts – between the force of gravity and that of muscular effort, between horizontals and verticals – gradually relaxed. It inclined to become decorative, and lines, although they charmed by the distinction of their fancy, lost their former suggestion of stark inevitability. They were no longer lines of force.

The extent of the process of relaxation can be judged by comparing the two drawings just mentioned – which hold their own, in my opinion, with any drawings made anywhere within a similar range of years – with, say, *Portrait of Artist's Wife* (1936), or with *Lynette* (1948), in which the forms are loosely defined. Now and again something of the old energy seems to revive, but the revival is more apparent than real, as may be seen by a comparison of the Pound portrait with *Head of Ezra Pound* (1938), in which, in spite of the aggressively forceful character of the lines, the forms are not defined with anything approaching the precision of the earlier drawing. No such relaxation is discernible in Lewis's imaginative drawings, which are powerfully evocative, and, in spite of the obvious debts to African, Oceanian and other primitive arts, highly personal works. From their black, bristling forms a species of primitive magic emanates. In the 1940s, however, their forms became more open and relaxed, but, however weakened, they still convey something of the same potent magic. A characteristic example is *What the Sea is like at Night*, which was made as late as 1949, when Lewis's sight was seriously impaired.

I have made it clear that I regard Lewis as one of the first draughtsmen of his time, and a word on his methods of drawing would not be superfluous. Although I visited several of his successive studios, I never saw him at work; with the exceptions of his wife and those who sat for their portraits I doubt whether more than a very few, at the most, were accorded this interesting privilege. It is possible, nevertheless, to form some notion of his procedure. In *The Art of Wyndham Lewis*, Handley-Read has pondered the available evidence and given so clear and workmanlike an account of his findings that I cannot do better than quote from it:

There are no sketches, if a drawing goes wrong it will be done again, or the faulty area will be cut out, the paper replaced, and the passage redrawn. There is no scaffolding in pencil . . . there is no attempt to hide preliminary lines. He draws first of all the horizontal and vertical lines, which give a firm basis to the structure . . . the weight of the arm rests on the last joint of the little finger which acts as a kind of ball-bearing runner when the long straight lines are being drawn, and as a pivot or compass-point for the curves . . . With the addition of heavier shading the essentials of the drawing are before us . . . and then comes the detail. A little shower of pen strokes, like sun-flower seeds, is stabbed and scattered . . .

If Lewis was unable to retain intact the extraordinary powers of drawing that he possessed around 1920, his powers as a painter were maintained, if not increased, for the better part of two decades. As his paintings are rare in comparison with his drawings, it is hardly possible to trace his development precisely, but a few of the best were painted on the eve of the Second World War. There is nothing inconsistent in this divergence: drawing is apt to reflect, with an immediacy that cannot be disguised, the personality and condition of the artist; painting, a more calculated procedure, reflects it at several removes. If ill-health, for instance, affected the delicate adjustment between Lewis's hand and eye, any deleterious effect it might have had upon his drawing could have been offset by greater concentration in his painting.

Lewis's reputation as a painter in oils will depend upon a small group of works. The chief of these I take to be, in addition to *A Battery Shelled* (1919) and *Bagdad: a panel* (1927), *Portrait of Edith Sitwell* (painted between 1923 and 1935). *The Surrender of Barcelona* (1936), *Portrait of T. S. Eliot* (1938) and *Portrait of Ezra Pound* (1938), and, ranking somewhat below these, *The Red Portrait* (1937), of which the subject is the artist's wife. These works form a group remarkably consistent in quality and style; all are conspicuously original. Apart from *Bagdad* – a near-abstract by a more adult, more masculine but less lyrical and less sensitive Klee – all represent persons and events belonging wholly to the real world, although the *Barcelona* deals with a subject from history. In each case the artist's aim would seem to have been to evolve forms, colours, compositions, gestures and expressions, all calculated to represent the essence of each subject with the utmost force and clarity. Someone – I cannot remember who – once aptly described his forms as 'vaulted and buttressed, fretted and smoothed'. These metallic forms – hard, reinforced, smooth-curling and polished – are animated by abrupt, dynamic rhythms. The *Portrait of Edith Sitwell* is probably the work in which Lewis most nearly approached achieving the breadth, clarity and solidity of classical art. The *Pound*, although less noble in conception and less

complex in form, is free from the laboured quality that is just apparent in certain details of the long-worked earlier portrait. Compare, for instance, the conventional sheet of paper at her knee with the watch-spring energy of the papers at his elbow. Both portraits manifest Lewis's prophetic faculty with the same certainty as the best of his writing: he seems to have discerned in Edith Sitwell the great poet she became, and in Ezra Pound the victim of some horrible destiny. The *Eliot* is a less communicative affair than either of the others; not a sensitive likeness, for there is no trace of his strained conscience-hauntedness or of his humour, and none of a yet more obvious characteristic, his grave distinction. As an interpretation of character it is of little interest, but it is a likeness of a seated man at once tense and solid, and every part of its tightly integrated complex of forms, sculptured as if out of some hard material, holds the attention. In one respect the artist has registered a success of a specifically contemporary order.

During the past century artists have combed the surface of the world – some have even dredged its depths – for objects in themselves unattractive from which they might distil some element of beauty. Barely two centuries ago beauty was held to be restricted to a narrow range of subjects, and only since then have the whole contents of the world (including man's dreams and the uncensored contents of his unconscious mind) been regarded as proper subjects for a work of art. This inclusiveness was an inevitable consequence of the growth of the belief that beauty resides not in any subject but in the eye of the beholder. It has long seemed to me – and the notion is strengthened by every visit to an exhibition of contemporary portraits – that of all the vast variety of products of our industrial civilization the most refractory to treatment by painter or sculptor is the *business suit*. I know of no business suit, certainly no new, smart suit, that has been transformed – without loss of verisimilitude – into a seemlier, indeed a nobler, object than the one worn by Mr Eliot in Lewis's portrait of him. Such a transformation called for the exercise of exceptional artistic power and deep insight into the character of our shabby civilization.

Lewis often spoke as though the relative fewness of the paintings he produced was due to the particular circumstances of the age, which compel the original artist to dissipate his energies in defending and justifying his creations by articles, pamphlets and the like, and in painting 'pot-boilers' to enable him to afford to undertake his serious projects. The circumstances he had in mind are certainly not the products of his fancy. They are real enough, but I think he exaggerated their special relevance to himself. Most of the original painters of his time wrote little or nothing in justification of their

work; when they wrote at all, it was more often than not in response to pressure from an enterprising publisher. Contemporary painting, with its repudiation of traditions and of the reality perceptible to the average eye, has indeed brought into being a vast expository literature, but this is pre-eminently the work of professional art critics and art historians. Had Lewis not been so apt to show himself mistrustful towards those who wrote about his work, and on occasion dictatorial, it would have found effective advocates, and relieved him of any obligation to take up the pen in his own defence. In one sense such advocates might well have been more effective than he: effective in the sense of winning sympathy and patronage for his painting. But in another sense he was his own most effective advocate.

Upon appropriate provocation, armed and armoured like some massive tank, he would roll into action, and the opponents would be crushed beneath the vehicle's steel tracks, withered by blasts of heavy dialectical gunfire and suffer final agonies from his secondary armament of satiric invective. I have met no polemical engine more deadly in all English literature; it seems to me to have surpassed even that of Swift. Magnificent, but it enabled him to win only Pyrrhic victories. A society with higher literary than pictorial traditions was quick to accord him recognition – although in my opinion not adequate recognition – as a writer; but this recognition was astutely used to disparage his painting. Nobody that I know of has suffered death from invective; every one of Lewis's mangled enemies lived to fight – mostly from secure ambush – in other days. The modicum of respect and the harvest of resentment his polemical writings reaped won him few friends and fewer patrons.

Of 'pot-boiling' Lewis never made any success. Considering that a formidable, even a menacing, character marks his best painting and drawing, a deliberate attempt to ingratiate involved a filleting process which could result only in the elimination of the very qualities for which his work is most to be valued.

In the preceding pages there has been afforded some explanation of why, in an age in general so ready to recognize merit, there was so little disposition to concur in T. S. Eliot's opinion that Lewis was 'the most fascinating personality of our time'. For myself, I am convinced that the 'mists of winter', which in 1951 thickened into an impenetrable fog before Lewis's eyes, ended the career of a painter and draughtsman whose best work will stand beside the best done in his time. It is in the best sense masculine and positive, the product of one who acts, not, like most contemporary art, of one to whom things merely happen, of one who looks arrogantly forward without nostalgic glances backward, one who – if humanity by a miracle escapes

a Third World War – may be looked back upon as a great primitive of a nobler, clearer and more rational way of seeing.

Lewis lived a continuously industrious life and produced a phenomenal volume of work of a variety unsurpassed by any Englishman of his time. In addition to his paintings and drawings he produced volumes of satire, philosophy, art and literary criticism, contemporary history and autobiography.

Lewis was among the most articulate men of his generation and, with the full realization of the difficulties opposed by the traditionless character of his age to such a programme, it was his constant endeavour to address himself, in all his work, to a public as wide as was consistent with a fair measure of responsibility. Although in this respect he has nothing in common with such 'iceberg' men as Acton, who published no more than a small fraction of his speculations and researches, or the philosopher Wittgenstein; none the less, there is a private Lewis not readily perceptible in his work.

In the Introduction which prefaces this first volume of these studies I stated my belief that there is a sense in which the artist transcends his work, and that it is difficult to think of any fact about an artist, or of any circumstances of his life, that might not have an effect upon his work. From this belief I was led to the conclusion that an obligation falls upon those who have had the privilege of knowing artists to place something about their personalities and their opinions on record.

I would suppose Lewis's seriously held opinions to be fully elaborated in his writings, and less explicitly in his painting and drawing. But his works, designed to express his opinions with the utmost clarity and the utmost pungency, also act as masks for his private personality. Consequently, in the course of this study I have treated the public personality almost exclusively. By way of discharging the obligation to which I just now referred I propose to conclude with a few comments on the man not easily discernible in the work of the artist.

Lewis was an eccentric, whose attitude towards the surrounding world was political and, to an extraordinary degree, defensive. He was actuated, I believe, by an overmastering impulse to record, in all its aggressive sharpness, the vision of his outward and inward eye, his prophet's apprehension of the real and the false. It is the case that the antagonism of 'Bloomsbury' and the British aversion for what is stark, uncompromising and truculently stated exposed him to hostility and criticism; but both did so in far smaller measure than he habitually assumed. Suspicion and 'trigger happiness' with his armament of satire did more to isolate him than the nature of his opinions, or even the manner in which they were proclaimed.

However that may be, his habitual attitude was one of militant resistance to impending martyrdom. At restaurants he insisted upon sitting with his back to a wall. At Adam and Eve Mews, where he lived when I knew him first in the early 1920s, his back was secured by a high wall; at 29A Kensington Gardens Studios, Notting Hill Gate, where he mostly lived before his death, the narrow many-cornered approach, leading eventually to an inner fastness, might have been constructed with a professional eye to defence. To the sequestered and fortress-like character of the places where he lived was added an extraordinary secretiveness, as an elaborate security measure. Not for years after his marriage, for instance, did he admit to the existence of his wife. It was probably during 1938 or 1939 that I had dinner with him at Kensington Gardens Studios – an elaborate affair in an impeccably tidy studio. I was reminded of the earlier occasion, when I had been entertained by my host. Then we had sat on packing-cases in front of a red-hot iron stove, from whose angry rays we must have suffered painfully had we not been shielded by a yard-high range of cinders encircling the fearful source of heat. Only a feminine hand, I reflected, and a feminine hand of more than usual authority could have so transformed the environment of so formidable a man. Suddenly I knew that Mrs Lewis – of whose existence I had vaguely heard – was somewhere present, concealed somewhere in the tiny studio flat. Not long afterwards, during the winter of 1939, on a visit to the United States, I met Lewis in New York and Buffalo. In the latter city he introduced me to his wife, and proposed that they should spend Christmas at the house of my wife's parents in Lexington, Kentucky. My wife wrote gently reproaching Lewis for having neglected to bring his wife to our house in London, where he had been a visitor from time to time. In a long and regrettably lost reply he wrote that the Romans were never accompanied by their wives on their campaigns, but that the Gauls and other barbarians sometimes were, and that he varied his own practice in accordance with the exigencies of the campaign upon which he was engaged. In Europe, therefore he, followed the Roman fashion; in America, the Gallic, sometimes even, he concluded, actually riding into battle with his wife. To our regret, the exigencies of a campaign of wider scope impeded our reunion in Kentucky.

I recall a characteristic circumstance of his last visit, just before the war, to our London house. Lewis had accepted an invitation to dinner at short notice, and my wife then telephoned Margaret Nash to ask her and Paul to dine with us also. 'We should love to come,' Margaret Nash said, 'love to.' 'By the way,' said my wife, 'Wyndham Lewis is coming.' 'Oh, Wyndham Lewis? Just a moment, I must speak to Paul.' And then, a few moments later, 'I'm sorry, but Paul's asthma is bad

tonight, and besides – Wyndham Lewis – Paul doesn't feel inclined.
There were some letters, and Paul has not been very well since.' That
night my wife asked Lewis what he had done to offend Nash.
'Nothing at all,' Lewis answered. 'Paul is a real pro. One of the few
we've got in England. I'd not dream of doing anything to Paul.
Besides, I've not seen him for months.' 'Nor written to him?' 'Not
that I can remember.'

'Margaret Nash seemed to think you had.'

'Now I do remember writing him a letter – Paul and I had a trifling
difference as a matter of fact.'

'And you wrote him a letter? Surely you did more than that?'

'It comes back to me now. After this difference I wrote to Paul. He
didn't answer. I wrote again, and again no answer, so I wrote to him
every day.'

'How long did your difference last?'

'Nearly three weeks.'

'And how did the matter end?'

'With a letter from Paul's solicitor explaining that his doctor wished
our correspondence to cease.'

While I was reading through this chapter prior to its re-publication
in the present edition it became evident that somehow the concluding
pages had been lost – and that their loss had remained unnoticed. I
will not now make any attempt to replace them, but can hardly allow
the chapter to conclude so abruptly, in effect, leaving entirely
unnoticed the concluding twenty years or so of Lewis's life, although
blindness made painting or drawing impossible during the last six.
I will accordingly borrow freely from *Time's Thievish Progress*, the
long-extinct third volume of my autobiography.

Lewis remained in the United States and Canada until August
1945 when he returned to London. From across the Atlantic he wrote
me occasional though longish letters, of which he was evidently
anxious to ensure the safe arrival, so he always sent them in duplicate.
Owing to my visit to the United States in the early days of the war,
I was among the last of his English friends to see him, and he seemed
to regard me as a point of contact with London. The first, of 15 July,
1942 begins:

> As you notice, I have landed up here – New York as you probably
> foresaw it would, has ended in disaster. My dream of American dollars
> (which would help me pay my London debts) was beginning to fade
> already at the time we met. – You, with your good practical sense,
> should have warned me! . . . You did not find the Tate in ruins I hope
> upon your return; or did you get back before the blitzes started? Any
> way, is that mausoleum intact? I hope the Blake drawings you had in

your office are safe: the Whistlers and Pre-Raphaelites, and several moderns which I shall not name, though your father would be on the list . . .

The next letter, of 17 November, was pathetic and very long, relating almost entirely, with irony or seriousness, to the possibilities of his finding work in England:

> . . . would the King appoint me Keeper of his ceramics . . . To be serious – for of course the above is merely my way of trying to be funny. Since life for a free-lance painter-novelist-journalist would be impossible at such a time as this is there any *post* you know that I could occupy? Is there such a thing as an art-professor at Oxford or Cambridge?

I was haunted by the indignities and frustrations suffered by one of the most powerful intellects and, at moments, one of the finest draughtsman-painters I knew, and by the failure of my efforts to alleviate them; I was saddened by our first meeting. I called on him on 2 July 1946 at his old studio at 29 Kensington Gardens Studios, and found him engaged upon a series of portraits which were weak in drawing and pallid in colour, and which seemed designed merely to flatter. He correctly interpreted my silence as expressive of disapproval, and launched into a justification of flattery, contending that an intelligent painter must aim first of all to please his sitters. His arguments were as flimsy as the portraits and as unworthy of his powerful intellect and incisive hand.

In the studio was *A Canadian War Factory* (1943), a good work, although not among his best. It was presented to the Tate by the War Artists' Committee, but Lewis, far from excusing its defects asked to retain it in order to put them right. Although a letter of 17 August began 'Well, the picture representing *Canada's War Effort* is finished' he never succeeded in finishing it to his own satisfaction, and the Gallery was unable to obtain possession of it until after his death, when it was handed over to us by his widow.

I visited him from time to time and my impression was that although his intellect retained its vigour, as painter and draughtsman his work had become nerveless. This falling-off was no doubt precipitated by the progressive failure of his sight, for in May 1951 in a tragic article entitled 'The Sea – Mists of the Winter', published in *The Listener*, he announced his blindness. About this calamity I wrote to him, and received this touching reply:

> *June 9th 1951*
> I have been over in Ireland which is why I have been so long in answering your letter. I received many letters about my approaching blindness but hardly any which I found affected me so much, in its simple sincerity – your word about 'Rude Assignment' gave me great

pleasure: you are au courant in the matter of its subjects, which makes your opinion doubly valuable.

Yours,

W.L.

He continued to write with characteristic courage, contributing articles regularly to *The Listener*, among many others, on 'Contemporary Art at the Tate'.

I well recall the difficulties I faced in the course of a long visit to his studio in July 1951 in the hope of eliciting information for the chapter of which this is a long-belated conclusion. He looked seriously ill: very pale, his features puffy. His mood was aggressive, but he said he did not value belated politeness inspired by his blindness. He had been treated badly, indeed persecuted, and grudgingly excepted me on account of 'the half-dozen of my pictures at the Tate', but then, his ill-temper mounting, he complained that we never invited him to evening receptions at the Gallery, and he was unimpressed when I explained that these functions were all but invariably held by independent societies to raise funds for some art charity.

At first he declined to give me any biographical information, even the date of his birth – about which, however, he was consistently evasive – saying that, as he could no longer paint or draw, writing was his only source of livelihood, and his own 'vast store of biographical information', his principal asset, and that he intended to write another, and this time fuller and much more factual autobiography. Forgetful of his negative response to my request for help, Lewis became suddenly genial and forthcoming, talking about his own art. I did not risk breaking the spell by asking questions about his reference to the 'uncontrolled skill, and therefore the vulgar skill' of certain of his early drawings, or his assertions that he showed no real mastery as a draughtsman until he seriously applied himself to more or less naturalistic drawing just after the First World War. He denied he was ever a Cubist, and recalled his prompt indictment of Cubism as entirely dependent on the natural appearance that it ostensibly rejected. Lewis lamented the shortcomings of his own work, due mostly to illness and economic stress. The affliction of the eyes, he explained, now prevented him from seeing clearly at the centre of his field of vision. The 'economic stress' from which he seemed pretty constantly to suffer used to surprise his friends, for he was extremely industrious both as a painter and a writer and he always lived very simply.

At the private view of an exhibition of his work held in the spring of 1949, I found him expounding to a small group, which included T. S. Eliot, the contrast between the Cubists, 'whose art was firmly rooted in the nature they affected to exclude', and a 'genuine inventor of

abstract forms', such as he himself had been before the First World War. As I walked in he momentarily directed his discourse at me, as I had incautiously described one of his *Timon of Athens* drawings, made in 1913 and recently acquired by the Tate, as Cubist. I left the exhibition in the company of Eliot, who spoke with admiration of Lewis, but observed that one of the reasons why certain people so disliked him was that he was a 'pro', both as writer and painter.

I had had an ardent admiration for Lewis ever since I first came to know him, and his near-blindness and the poor state of his health, both of which perhaps aggravated his morbid obsession about the hostility of his fellow men (the more influential, the more hostile), made me determined to propose to the trustees that we should arrange a retrospective exhibition of his work at the Tate. They readily agreed.

When I went to see Lewis on 10 April 1955 to discuss the exhibition I was shocked to find him aged and ill, obsessed by a painful operation on his hands which he described in detail; his sight was almost gone. It was a sad experience to see the powerful, militant personage I so clearly remembered on earlier visits to this same studio in Notting Hill Gate so utterly reduced, his features white and without form, his energy ebbed away. Apprehending how changed I found him, he spoke with envy of Augustus John's health, and, in sudden irrelevant disparagement, of Matthew Smith's painting as 'the taste of the stupid'.

We discussed the catalogue of the projected exhibition, and I asked him whether he thought that T. S. Eliot would write a brief foreword. 'Tom's always been timid, and afraid of what "people" will say,' Lewis answered, ' "people" these days for him being "bishops", but I'll sound him out.'

In view of his state of health we assembled the exhibition with minimum recourse to Lewis himself, who did, however, write a brief foreword to the catalogue. At the private view, on 5 July 1956, Lewis, very feeble and nearly blind, was present, and to Elizabeth my wife expressed his pleasure without reserve and spoke of the consideration with which he had been treated by the Tate; he was deeply touched, he added, by all that I had done on his behalf. His words moved me, not only because of my admiration for this formidable artist-prophet, but because it is singularly difficult to give help to people in distress, and so easy to give help to the successful to whom it counts for little.

The private view was a remarkable assembly of Lewis's old friends: T. S. Eliot, the Sitwells, Kate Lechmere, Mrs Nevinson, and many others: the last occasion, I fancy, when the survivors and associates of the movement in which Lewis played so splendid a part would be gathered together. When I quoted to Eliot his own opinion of Lewis as 'the most fascinating personality of our time', he replied vaguely,

'but that was so many years ago'. It was not, I think, that he was implying the least denigration of the later Lewis, but that at that particular moment he himself was also occupied with thought of happenings of 'many years ago'.

Lewis was so exhausted by the ordeal that it was only with difficulty that Mrs Lewis, Elizabeth and I could get him into a taxi. I remember him being exhausted, but touchingly happy. Wyndham Lewis died on 7 March 1957.

DUNCAN GRANT
1885 – 1978

An anonymous reviewer of the first volume of these studies took me to task for referring to my own relationship with their subjects. Writers who treat contemporary subjects work under manifest disadvantages: they are likely to be ignorant of relevant documents, documents of the kind which come to light only after a lapse of time, and they find the utmost difficulty in seeing persons and events in their just proportion, which for those who write later is relatively easy. In fact, it may justly be objected that the contemporary historian 'cannot see the wood for the trees'. But he does have opportunities of observing the trees, and since these studies are, so to speak, about trees rather than about woods, I regard it as useful on occasion to make clear in what circumstances I have made my own observations. Biographies of artists are apt to contain accounts of events and alleged sayings which are of little value simply because nothing is known of their origin: whether they come from friends or enemies, or whether they are hearsay or fabrications. Therefore the writer who is able to say, 'I heard the artist say this', or 'I saw that', may be making a contribution, however modest, to the sum of facts out of which history is made. It also follows that the possible value of a fact will be enhanced if something is known of the relation of the observer to the observed. The anonymous reviewer, in any case, took a narive view of the question of detachment. He chose to forget that there exists no such quality as perfect detachment. All writers worth reading have an attitude towards their subject, and the more plainly this attitude is manifest the less likely they are to deceive. If the reader knows where a writer stands, he will be able to make the necessary allowance for his bias. The deceiver is he who claims, explicitly or by his manner, a detachment that he cannot possess. What malevolence, on the other hand, may be masked from the casual reader of certain learned journals by a bland manner, numerous footnotes and meticulous citation of authorities!

I have chosen to preface my study of Duncan Grant with these general observations because I do in fact stand in a particular relation to the society of which this artist was a central figure. It is a relation that I, quite simply, inherited. Following the resounding success of

'Manet and the Post-Impressionists', that is to say the so-called 'first' Post-Impressionist exhibition organized by Roger Fry at the Grafton Galleries in November 1910, the directors offered him the control of their galleries during the autumn months. Fry hoped to use this opportunity to bring together all the serious tendencies in English painting and to show them side by side with French, which, if successful, might, in the words of his biographer, Virginia Woolf, 'unite groups; destroy coteries and bring the English into touch with European art'. In pursuance of this aim he wrote several letters to my father giving at some length his reasons for his belief in the fruitfulness of the projected exhibition and appealing urgently to my father to participate. In spite of his admiration for Fry's wide knowledge, the perennial freshness of his outlook and his gifts of lucid and persuasive exposition, my father decided, for reasons already briefly noted, to refuse. Fry regarded this refusal as a betrayal of the progressive forces in English painting by a friend whose place was in their ranks. He never forgave my father, and he communicated his rancour to a wide circle of the Bloomsbury group. Not only were the most venomous attacks made on any artist of the time made on my father in the columns of *The New Statesman and Nation*, but I myself, years later, was in one way and another made aware of Bloomsbury hostility.

If there should be an arm's-length character or any lack of fairness in my treatment of any member of the Bloomsbury group, it will be due to a constraint in my relations with them of which I shall have given a summary indication of the cause. Let me, however, make unequivocally clear that, so far as I am aware, Grant never associated himself with the vendettas and intrigues so ruthlessly pursued by certain of his friends, nor indeed was he actively concerned with art politics of any kind.

Fear has stamped my first meeting with Grant vividly upon my memory. One hot afternoon in the summer of 1922 I found myself with two companions, also Oxford undergraduates, in a house where none of us had been before, pausing at an open french window that gave out upon a lawn, at the farther end of which a tea party was in progress. We paused because the lawn was not so large that we could not discern among the tea-drinkers the figures of Lytton Strachey, Aldous Huxley and Duncan Grant, as well as that, so awe-inspiring upon a first encounter, of our hostess Lady Ottoline Morrell. At that moment this modest patch of grass seemed to us an alarmingly large area to cross beneath the gaze of so many august eyes. So it is that I can still picture the group: Lytton Strachey inert in a low chair, red-bearded, head drooped forward, long hands drooping, fingertips touching the grass; Aldous Huxley talking, with his face turned up

towards the sun; Duncan Grant, pale-faced, with fine, untidy black hair, light eyes ready to be coaxed from their melancholy; and Lady Ottoline wearing a dress more suitable, one would have thought, for some splendid Victorian occasion, and an immense straw hat. In the course of the afternoon I heard Grant speak, but one had to be alert to catch his scarcely more than whispered words which, towards the close of his sentences, became almost soundless. The friendliness he showed did not, however, disguise even from my inexperience his membership to some society with a means of communication very special to itself. After listening to the discourse of Strachey and several others, I vaguely apprehended that in this Oxfordshire village were assembled luminaries of a then to me almost unknown Cambridge world.

At the time Grant was thirty-seven years old, having been born at Rothiemurchus, Invernesshire, on 21 January 1885; the only child of Major Bartle Grant, and his wife Ethel, born MacNeil, from Kircudbrightshire. The Grants had been lairds of Rothiemurchus for centuries, but as both Duncan Grant's grandmothers were English his ancestry was as much English as Scottish. Between the ages of two and eight he lived in India, where his father's regiment was serving, with home leave every second year. Even in this early period of his life his responsiveness to what he saw was sufficiently developed for him to experience a conscious joy, he told me, in the colour and movement of Indian life, especially in the life of the bazaars, of which he even made childish drawings. Back in England he attended a private school at Rugby, and at the age of fifteen entered St Paul's as a day boy. Being destined for a military career he was placed in the army class, where mathematics was the principal object of his study. But of mathematics he understood nothing and during his unhappy years at both schools a long-cherished ambition to spend his life in drawing and painting took an ever firmer hold. (At Rugby he prayed that God would make him paint like Burne-Jones.)

However little such an ambition would have recommended itself to Grant's father, his London home was with a family whose outlook was radically different. His father's sister was married to Sir Richard Strachey, at whose house in Lancaster Gate Grant lived during his parents' continuing absence abroad. It soon became evident to Lady Strachey that Grant was without either the qualifications or the disposition for an army career, and she persuaded his parents to allow him to go to the Westminster School of Art, in 1902. Neither here, however, where he spent upwards of two years, nor at the Slade, which he briefly attended later on, did he make any particular mark; nor did he derive much benefit from the instruction he received. The somewhat negative response to his art schools of this

young man who, during a youth shadowed by the prospect of an
army career, had longed to be an artist was due to the character of his
second home. From it he received the heightened consciousness and
intellectual stimulus that many other students owe to the art schools
they attend. As well, indeed, he might have for it must have been one
of the most intelligent houses in England. The five Strachey brothers
and their five sisters all shared a passion for learning, a bracing
scepticism and a wit which made membership to their circle an
adventurous and exacting education. One of the brothers, Lytton,
became a lifelong intimate of his cousin Duncan.

On leaving Westminster, after having failed to gain admission to
the Royal Academy Schools, Grant visited Italy where he made copies
of the Masaccios in the Carmine and studied the Piero della Francescas
at Arezzo with wondering awe: works now invariably acclaimed as
masterpieces but which attracted comparatively little notice at that
time.

A French painter, Simon Bussy, who was engaged to Dorothy
Strachey, was a visitor at Grant's second home, and it was he who
suggested that Grant would profit by study in Paris. To Paris he
accordingly went to spend a fruitful year as a pupil of Jacques-Emile
Blanche, who taught at La Palette. I once asked him what paintings
most impressed him in those days and he said that at the Westminster
School he knew comparatively little about the work of his older
contemporaries. An occasional reproduction of a Degas or a Whistler
was passed from hand to hand. Paris, he said, did not enlarge his
knowledge as much as might be supposed. It was less easy than it
became a few years later to see the work of contemporaries at the
dealers' galleries, but it was from the Caillbotte Collection of Impres-
sionists, then hung at the Luxembourg, that Grant first received the
full impact of modern painting. He also studied the older masters,
especially Chardin, at the Louvre. Living at an hotel with English
students, his contacts with the French were few. Upon his return to
London he spent a few weeks at the Slade before settling into a studio
in Fitzroy Square.

It was during these years that the group which became known as
'Bloomsbury' was in the process of formation. Bloomsbury came into
being as a consequence of the establishment in London of a group of
several generations of Cambridge men drawn together by friendship
– one of the most attractive characteristics of the group was the high
value which its members put upon friendship – and a community of
ideas. The intellectual climate of the group at Cambridge was analysed
with penetration and candour in the first of *Two Memoirs* by Maynard
Keynes, an original lifelong member of it, in the essay entitled 'My
Early Beliefs'. Among the places where members of the group

gathered was the house of Duncan Grant's cousins, the Stracheys. On account of the friendship between him and them it was natural that he should enter the Bloomsbury circle. Although, even perhaps because, one of its least publicly articulate members, he became one of those most generally liked and respected: for he was highly intelligent, full of a high-spirited enjoyment of life, and of a pale, dark handsomeness, yet unassertive and free from the rancour and virulent partisanship that marred the characters of some of his friends. A still more important meeting place of the group was the house of Sir Leslie Stephen whose daughters Virginia and Vanessa, with their husbands Leonard Woolf and Clive Bell, constituted the centre of the circle of friends. Grant was introduced into this house by Lytton Strachey, and with the Bells in particular formed an intimate and lasting friendship. Other notable members of this circle of friends were Roger Fry, Maynard Keynes, Desmond MacCarthy, E. M. Forster and Lowes Dickinson. Grant had first met Fry at the age of sixteen or seventeen at the Strachey's, and had been strongly impressed by his intellectual powers, but it was not until 1909, when he again met him through the Bells, who already knew him well, that the two men became intimate friends.

In the Bloomsbury circle Grant quickly became 'the painter' (with Vanessa Bell an admired second), just as Fry became 'the art critic and expert' (with Vanessa Bell's husband Clive his truculent suffragan), and Maynard Keynes 'the economist and man of affairs'. The effect upon the artist of the somewhat uncritical admiration and powerful advocacy of so highly organized and so influential a body of friends is a matter which I shall examine briefly later on. Grant's establishment at the centre of this self-conscious, esoteric and highly intellectual society placed him in an environment which exercised a strong and continuing effect upon his art. It was, in fact, the decisive event of his life.

There has been a disposition among some of those who have written about Duncan Grant to represent him, in quite early days, as an apostle of the revolution made by Cézanne and even of Picasso and Matisse. He could have known little about them, however, before the Post-Impressionist Exhibition of 1910. Even Fry confessed, as late as 1906, 'to having been hitherto sceptical about Cézanne's genius'. It was not until two years later that Grant for the first time saw works by Picasso and Matisse in the collection of Gertrude and Leo Stein in Paris. The experience had no immediate effect upon his own work, for in 1910 he painted the *Portrait of James Strachey*, a characteristic 'New English' picture, if better composed than most, but surely the work of an eye innocent, for all practical purposes, of Cézanne; a work in close accord with that of the soberest spirits of the

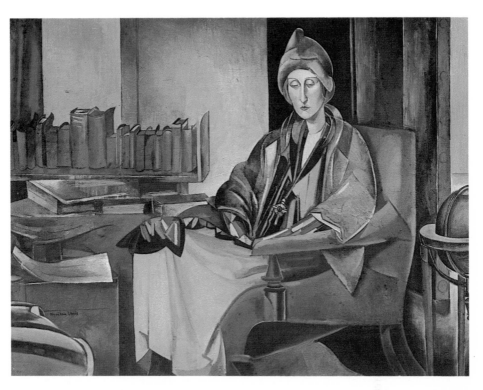

13. WYNDHAM LEWIS: *Portrait of Edith Sitwell* (1923–35).
Oil, 34 × 44 in (86·3 × 111·7 cm). The Tate Gallery, London.
(© Estate of Mrs G. A. Wyndham Lewis. By permission.)

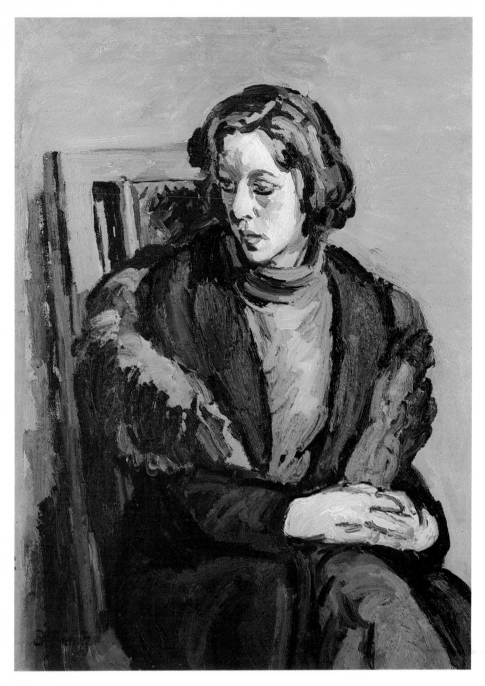

14. DUNCAN GRANT: *Portrait of Miss Holland* (1937).
Oil 30 × 22 in (76·2 × 55·8 cm). Private collection.
(Photo courtesy of Christie's, London.)

15. JAMES DICKSON INNES: *Bala Lake* (1912).
Oil, 12½ × 15½ in (31·7 × 39·3 cm). City of Manchester Art Galleries.

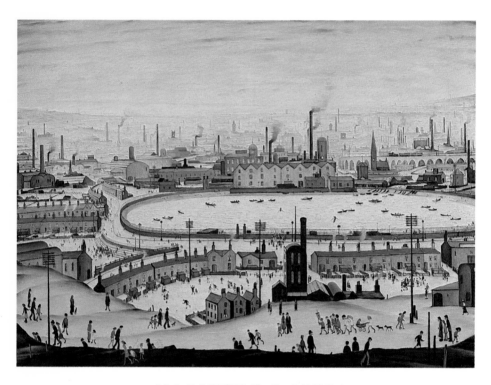

16. L. S. LOWRY: *The Pond* (1950).
Oil, 45 × 60 in (114·3 × 152·4 cm). The Tate Gallery, London.

New English Art Club and as remote from that of Picasso and Matisse as anything painted anywhere that year. This portrait, like the early *Still Life*, of three years earlier, show him as an intelligent and serious traditional painter, with an eye for construction and the texture of things.

The events which changed the direction of Grant's art were the Post-Impressionist Exhibitions of 1910 and 1912. An account of these two exhibitions – their effect upon individual painters and the direction of painting in England and the resounding sensation they provoked – could make an illuminating and entertaining book. Grant once told me that he was not shocked by these exhibitions, even though they introduced him to some painters whose work he had not seen previously. The change in his own work suggests that when he saw Picassos, Matisses and other contemporaries at the Stein's he saw them with the eyes of an intelligent sightseer, but that the impact he received from them at the Post-Impressionist Exhibitions was so violent as to make it an intimate part of his own experience.

The ensuing change in Grant's outlook declared itself at once. Even in such a picture as *The Lemon Gatherers* (1911), painted, Mortimer tells us in Penguin Modern Painters, from Sicilian memories (from memories, he might have added, of Florence and Arezzo as well); even in a picture in which he aimed at frankly monumental form in the manner of the Italian masters, a certain audacity and freedom testify to the pervasive influence of Post-Impressionism. The difference between this and the other pictures referred to, painted before Grant felt the impact of Post-Impressionism, and those painted under its spell is conspicuous. After 1910 he painted for a time with the fervour, but also at times with something of the subservience, of a convert. Mortimer describes Grant's early Post-Impressionist paintings as 'without parallel in the history of the British School'. The possibility of being able to catch in them 'references to . . . Matisse, to African sculpture . . .' he does concede. 'References' is too ladylike a word, however, to meet the occasion. *Still Life* (apples) (*c.* 1912), is almost pure Cézanne. *Head of Eve* (1913), is Picasso of the *Demoiselles d'Avignon* period; *The Tub* of the same year, would be unimaginable without Matisse, and *Background for a Venetian Ballet* (1922), is a belated essay in Fauvism in the manner of Derain.

What are difficult to catch in these are references to Duncan Grant; and it cannot even be said that they are distinguished. In the *Head of Eve*, for instance, Picasso's energetic hatching technique has been closely imitated, but Picasso's austere adaptation of the grim, impersonal masks from the Congo or the Ivory Coast has been softened into a baby face with oversize eyes and a little pouting mouth. Lest it should be supposed that I have drawn these examples from the

penumbra of admitted failures, it should be stated that all were selected for reproduction in either one or the other of the first two books devoted to the artist.

It was not until Grant's elation at the discovery of the direct and audacious language of the Parisian Post-Impressionists had somewhat subsided that he began to find his own distinctive way of seeing and the means to give it form. In 1913 there came an opportunity for a wide extension of his range, and the process helped him towards the discovery of what he was best suited to do. This opportunity he owed, as so much else, to his friend Fry. In my study of Wyndham Lewis I had occasion to refer to the organization by Fry of the Omega Workshops, inspired by the dual purpose of enabling artists to live, without having to teach, by making designs for furniture, pottery, textiles and the like, and making a constructive protest against the timid design and mechanical finish of current factory products. A precursor of the Omega venture was the assembling of the artists who collaborated in 1911 in the decoration of a room at the Borough Polytechnic. Before this time the Bloomsbury circle was an academic group composed chiefly of Cambridge men of a philosophic inclination; subsequently Bloomsbury possessed a wing concerned with the visual arts. For Grant, participation in the Omega project was as fruitful as it was embittering for Lewis. The opportunity of designing and decorating a wide variety of objects revealed both to him and to others that he possessed a richly inventive faculty hitherto hardly suspected. He quickly showed himself to be a designer with a fresh and lyrical touch – with a touch, too, of fantasy – and a designer of resource, so that he quickly came to set the tone of the Omega products. The 'handwriting' of their decoration was essentially the 'handwriting' of Duncan Grant. There was one conspicuous feature, however, which they derived from Fry.

One of Fry's marked characteristics was an innate hatred of what was smooth, facile or mechanical. The suave facility of Sargent, for instance, provoked a particular antipathy in Fry, exacerbated by the esteem in which these qualities were held. (It is my belief that Sargent was a far more considerable artist than Fry allowed, but his paintings certainly possess the character for which Fry had so consistent a distaste.) Another object of this innate antipathy was the smooth, regular finish of machine products, which led Fry to persuade his artist friends to exaggerate the irregularities which characterize the handmade object. Exaggerated irregularity, a touch, even, of wilful clumsiness, suggestive of the intelligent and sensitive amateur beloved by Fry, and subtly reproachful of the smoothly mechanical professional whom Fry detested, remained, as a consequence of Duncan Grant's months at the Omega, a permanent characteristic of

his work. If this is a defect it is a small and rather engaging one to set against the gains in confidence, versatility and self-knowledge which Grant owed to the experience.

It was not long before Grant's enhanced resourcefulness found varied use: Jacques Copeau invited him, in 1914, to design the costumes for his production of 'Twelfth Night' at the Vieux Colombier Theatre in Paris. Occasional designs for the theatre became a feature of Duncan Grant's activity. 'The making of designs for the theatre is a sheer pleasure,' he told me, 'and a necessary rest from painting, but I dislike the incidental work it involves, especially the visits to the dressmaker.' Among the other theatrical productions for which he designed costumes, scenery, or both, were 'The Pleasure Garden' by Beatrice Mayor, at the Stage Society; 'The Postman', a short ballet in which Lopokova danced, at the London Coliseum; Aristophanes' 'The Birds', at Cambridge, and 'The Son of Heaven' by Lytton Strachey, at the Scala. Before the First World War Grant began to decorate rooms in the houses of his friends, and in the course of his life many different kinds of rooms were enlivened by his fantasy, as well as the room at the Borough Polytechnic, which, with a group of other artists, he decorated in 1911.

It was before the war that Grant enjoyed the first of his rare meetings with Matisse, the living painter whom he most admired and whose example counted for much in his own growth as an artist. With a letter from Simon Bussy he called on Matisse at his house on the route de Clamart, near Issy-les-Moulineaux. He was unable to recall any words spoken by the master, but he did remember that he was engaged upon a still-life with goldfish and that the celebrated *La Danse* was in the studio, although he slightly distrusted this latter memory. But as Matisse moved to this suburban house in 1910, where *The Dancers* was painted in the same year, Grant may well have seen it there. The first of Matisse's six goldfish subjects was painted in this or the previous year, and the last in 1915.

For Duncan Grant, as for thousands of others, the outbreak of the First World War interrupted a way of life in which much had been fulfilled, but much more promised. Denied by his convictions, the harsh satisfaction of fighting for his country and, in consequence, the opportunity of serving as a War Artist, these years were for him relatively barren. For a time he worked on a farm in Suffolk. In 1916 Keynes bought the farmhouse named Charleston, near the village of Firle in Sussex, 'to provide', he said, 'a country house where Duncan Grant and David Garnett . . . could discharge their obligations under the National Service Act by doing agricultural labour,' but he referred to it with characteristic generosity as 'Duncan's new country house.'

As a young man Grant showed extraordinary high spirits. The most

striking manifestation was his participation in the 'Dreadnought' hoax of 1910. With Horace Cole, the instigator, Adrian Stephen and his sister, Virginia, he spent two or three hours in the first great battleship, then shrouded in highly publicized secrecy, disguised as an Abyssinian notable, after a telegram, purporting to come from the Admiralty, advised the captain of the visitors' arrival. They were shown the wireless, then regarded as a species of 'secret weapon', but, owing to their makeup, did not dare accept an invitation to luncheon. The exploit startled the whole country and echoed round the world. Grant apologized to the First Lord of the Admiralty, Reginald MacKenna. King Edward was greatly distressed but expressed the hope that none of the culprits would ever come to court.

In spite of such high spirits and the respect that was widely accorded to him because of his detachment and intelligence, his wide interests and the combination of an eager flow of spirits with a dignified reserve, Grant rarely played any part in public affairs. On one occasion he did, however, use his influence with Keynes – who from about 1908 had been perhaps his closest friend – to propose that the National Gallery should make some purchases from the Degas sale of 1918. Keynes persuaded the Chancellor of the Exchequer, Bonar Law, of the wisdom of such a course, and the sale was attended by Keynes himself, representatives of the Treasury and members of the staff of the National Gallery. 'Do buy Ingres portrait of self Cézanne Corot even at cost of losing others', Grant urged Keynes by cable. In consequence of his timely intervention the National and Tate Galleries were enriched by the purchase of works by Ingres, Corot, Delacroix, Forain, Gauguin, Manet – including his *Firing Party* – and others.

With the coming of peace Grant was able to settle down, without serious interruption, to doing the greater part of his life's work, taking a studio at first in Hampstead, then one that had been occupied by Whistler, Sickert and John at No. 8 Fitzroy Street; later dividing his time between Charleston, occasional visits to London, where he usually took an annual holiday, and, between 1927 and 1938, spending some months each year at Cassis near Marseilles.

Free, by the early 1920s, from the spell of Post-Impressionism, he began to find a way of seeing very much his own, or, to be more precise, two complementary ways: the way of a decorator and the way of a realist. The former was the first to reach maturity. The comprehendingly affectionate essay by Fry published in 1923 makes it clear that his friend and tutor was of the opinion that Grant's true talent was for decoration:

He pleases because the personality his work reveals is so spontaneous,

so unconstrained, so entirely natural and unaffected, . . . he has . . . a great deal of invention . . . the peculiar playful, fantastic elements in it which remind one occasionally of the conceits of Elizabethan poetry . . . Gifted as he is with a particularly delightful rhythmic sense and an exquisite taste in colour, he is particularly fitted to apply his talents to decoration.

Fry emphasized this opinion by noting regretfully that 'at a time when the movement of creative artists was in favour of insisting almost exclusively upon the formal elements of design, he should have tended to suppress his natural inclination to fantastic and poetic invention . . . The effort to create complete and solidly realized constructions in a logically coherent space, which he succeeded of late to the more decorative conception that derived from Gauguin, has, I think, hampered rather than helped his expression. Duncan Grant co-ordinates form more fully on the flat surface than in three dimensions.' In considering this opinion it should be remembered that it was formed in 1923, when Grant had enjoyed numerous opportunities – at the Omega, in the theatre and on the walls of friends and patrons – to exercise his talents as a decorator, but that he had as yet paid little attention to the creation of 'complete and solidly realized constructions in space', and his most serious attempts in this direction were made after the publication of Fry's essay.

Long before 1923 Fry had become the impassioned apostle of the idea that everything of value in a work of art resides in its formal harmony, and had become a victim of a mystique of pure form. Content was of no consequence except in as much as it favoured formal harmony. 'I want to find out what the function of content is,' he wrote to Lowes Dickinson in 1913, 'and am developing a theory which you will hate very much, *viz.* that it is merely directive of form, and that all the essential aesthetic quality has to do with pure form.'

Grant was by far the most gifted artist in the closely knit Bloomsbury circle – the court painter and designer, so to speak – so that an admission that in his own work he was so far from exemplifying the cherished doctrine of pure form as even to 'remind one occasionally of the conceits of Elizabethan poetry' must have been one that Fry made with reluctance. It is evident that he made it with the utmost conviction. An anonymous critic once wrote to Fry that he seems to have felt that '. . . in cases of maladjustment between artist and critic the fault was almost always on the artist's side'. Brueghel, Hogarth and Turner lay in their graves, all their manifold shortcomings beyond the critic's correction. But Grant lived, so to speak, within point-blank range. Fry had a passion for acting the mentor and Grant was the continuously praised 'star turn'. I do not know how insistently the critic played the mentor in this case, and there must be two or

three informed upon the matter. I once discussed with Grant to what extent he regarded himself as affected by aesthetic theories. 'I've had to pay attention to many theories,' he answered, speaking with deliberation, 'but I don't believe I've adopted any. With me it's been rather a question of picking one's way *through* theories. I could hardly help being interested in theories, but my interest doesn't go very deep.'

Standing open to correction, I would hazard the guess that Duncan Grant did 'pay attention' to the prevailing insistence upon the exclusive value of the formal elements of design, especially when supported by Fry's extraordinarily persuasive argument, with the result that the preoccupation of this born decorator was largely diverted from decoration to the creation of 'complete and solidly realized constructions in a logically coherent space'. Just as, in the age of Reynolds, the painter who was not a painter of 'history' was inferior to him who was, so, in the Bloomsbury circle, the painter who did not realize such constructions was inferior to him who did.

Because it would have given Fry such satisfaction to praise the purely formal qualities in Grant's art, his praise of him as a decorator should be received with particular respect. Fry extols his decorative qualities, the elegance of his handling, the singular charm of his manner, his lyrical joyousness and his enjoyment of what is beautiful – in the ordinary sense – in nature. None the less he seems to me to lack one of the essential qualities of a great decorator, namely the power to enhance the act of living by exhilarating those who see his works with a vision of a humanity and its environment idealized, either by the creation of an Olympus, Parnassus or an Arcadia, or even – to descend to a commonplace level – a humanity 'glamourized'. Unless, in fact, by its exuberance, wit, gaiety, and style, a decoration affords us a glimpse of a world of greater nobility, delight or amenity than that with which we are familiar, it cannot be said to have realized its principal purpose.

It is easy to recognize in Grant's decorations the engaging qualities which delighted Fry, and others besides. Take, for instance, *Decoration on a Cupboard* (1921), or *Long Decoration – Dancers* (1934). The earlier shows fantasy, wit and a feeling for the poetry of homely objects, and the later is rhythmic in movement, clear and gay in colour, the whole being lyrical in feeling. Yet in spite of their manifold beauties, neither is really intended to enhance life; the heavy boneless limbs of the dancers, their flabby hands, their thick humourless feet suggest that the painter was not quite in earnest about this all-important purpose. Sir Kenneth Clark once wrote of Grant's concern with 'the earthly adventures of amorous gods'. But for the sake of which of his dancers would Jupiter have given himself the trouble of changing into a bull?

It may be that beneath his gay lyricism lurked a melancholy that made him sceptical about the prospects of enhancing man's condition. It does not seem to me, as it seemed to Fry in 1923, that the artist coordinated form less fully in three dimensions than he did on a flat surface.

Whatever forces persuaded Grant to attempt to 'create complete and logically realized constructions' – whether Fry himself or the consensus of opinion among the artists of his acquaintance – it appears difficult to deny Grant a substantial measure of success, especially in his portraits of women. Of a longish series there are at least two which take their places with the fine portraits of our time: *Miss Holland* (1930), and *Vanessa Bell* (1942). In the earlier a design which beautifully combines great breadth with great subtlety, animated by sweeping movement, is carried out with a masterly ease and precision. Nothing is omitted or scamped, but the detail takes a subordinate, although enriching, place in the largely seen scheme of things, and the portrait is evidently a penetrating likeness. The later portrait is remarkable for a combination of all Grant's decorative resources – figure, draped curtain, high chair, screen, cloak and patterned carpet are related in a harmony at once opulent and of great dignity – with the creation of a wholly convincing presence. Such a combination is rare in contemporary portraiture. *Vanessa Bell* is a modest descendant, as it were, on a scale appropriate to our time, of the great portraits of the past in which stateliness and insight into character marched naturally together. How appropriate that so admirable a portrait should have for its subject the artist with whom he had been most constantly associated: who so often worked simultaneously from the same models and from whose talent, at once distinguished and robust, his own has derived nourishment. These two portraits and a handful of others will outlast, I think, any of Grant's purely decorative paintings.

There is another theme which on many occasions brought his highest faculties into play: the nude. To my thinking Duncan Grant made nothing more beautiful than his pastels from the nude model and a few are among the most lyrical drawings of the time. I have particularly in mind a *Nude* (1934), and a *Nude Study* (1935). The owner of these two lovely drawings accurately described the artist's vision as 'so instinctively and unhesitatingly chromatic that he can build up a passage of modelling with strokes of pure colour'. The words were written before these two drawings were made, but this ability was never more perfectly exemplified than in the second.

During the 1940s Grant put his hand to an undertaking of a character different from anything he had done previously. When I received an invitation from the artist in the summer of 1943 to go

down to Sussex to see a series of wall paintings which Vanessa Bell,
her son Quentin and Grant had carried out in the parish church at
Berwick, a village not far from Firle, I made the journey with interest
tempered by misgiving. It did not seem to me that he was well-
equipped, either in mind or hand, for such an enterprise. Neither the
sceptical, or rather the in general positive hostility of the Bloomsbury
circle to Christianity (hostility, let it be said at once, not so much to
the Christian ethic as to the Christian Church, more particularly in its
supernatural aspects) nor the decorative method of wall painting
Grant had evolved for the evocation of the philandering of nymphs
and satyrs, seemed to promise anything but failure. It was apparent
when I entered the church that my apprehensions were groundless.
The Nativity and *The Annunciation* were represented by Vanessa Bell,
The Parable of the Wise and Foolish Virgins, by Quentin Bell, and *Christ
in Glory* by Grant himself. There was no mistaking that the series was
the work of three different hands, but they all radiated the same mood
of noble gravity. The figures were solid, clearly defined, yet not
without a becoming touch of mystery. The one defect that I noticed
was that the solidity of certain of the figures was insisted upon to a
degree which caused them to project from the walls and thereby to
break the unity of surface of the series as a whole. Even if the Berwick
paintings bear no comparison with those at Burghclere they must, I
think, be accounted among the best paintings to be made in any
church or chapel in England during the present century.

With characteristic delicacy of feeling the artists arranged that I
should visit the church alone. My visit ended, I joined them and
Clive Bell for lunch at Charleston. It was a curious experience for
several reasons, chiefly because it was the first occasion since I had
stayed with Fry as a schoolfriend of his son Julian that I had been in
the house of a member of the inner circle of Bloomsbury. Grant was
not a good hater, and he took no part, that I know of, in the
Bloomsbury vendetta against my father, who was, I believe, one of
the first artists to give him encouragement. In any case the cohesion
of the group had loosened and its influence waned, and I sensed,
mainly from the conversation of Clive Bell, that certain younger
artists now provoked greater antipathy than a son of my father.
Certain sharp comments he made about younger contemporaries
made me suddenly realize the extent to which the survivors of this
circle, regarded when I was young as aggressive advocates of
'significant form' and other 'advanced' ideas, had become 'Old
Bolsheviks' who showed less sympathy towards younger artists
considered 'advanced' than my older painter friends, such as Matthew
Smith and Charles Ginner, who were their seniors. In fact, having
vaguely expected to be made delicately to feel reactionary, I found

myself in an environment fascinating for its 'period' interest, although for other reasons, of course, as well. There were the pieces of Omega furniture and carpets and the textiles designed by my hosts, their slightly clumsy yet distinguished pottery embellished by swirls and hooks in their deliberately irregular, unmistakable calligraphy; also the iron stove, the mustard-coloured wallpaper and other objects made familiar by their pictures. All this mingled with the gentle voices, often dying away, of the artists and the booming voice of the critic expressing opinions in which an urbane liberalism blended oddly with unexpected rigidities, strong prejudices more easily sensed than defined. Here I was, in the only corner of this vanishing society to have survived intact: people and environment, everything, even out of the windows, could be glimpsed as the subjects of so many of the two artists' landscapes.

At the conclusion of this brief study of Duncan Grant's painting it might be useful if I were to put together and set down what I remember his saying about his method of painting. He did landscapes and still-lifes direct from life, beginning with very summary indications in charcoal on the canvas but generally without preliminary studies:

> . . . but I begin to paint as soon as I possibly can. It's not only that painting is such a delight, but as I paint with difficulty I want to come to grips with it with the least delay. When I first came to know him at the Stracheys Simon Bussy urgently impressed on me the value of making copies and I've always followed his advice. I don't try to make exact copies but interpretations. I agree with Bussy that there is a great deal to be learnt from this practice. It isn't the painting that one does before another painting that teaches one. The real idea behind copying is to induce one to look at a picture for a long time. Even if you're a painter and deeply interested, it is difficult to look for very long and it is much easier if one is doing something.
>
> I usually have several pictures going at the same time – too many I'm inclined to think – sometimes compositions, at others realistic works. I don't often work on pictures of both kinds at the same time: my interest in imaginative works and in realistic ones runs in phases . . .

I am very conscious that these brief studies of mine, although perhaps not wholly without value as eyewitness reports, or of a witness at one remove, omit much of importance, and that they will all of them be quickly superseded. But none, I fancy, so quickly as this study of Duncan Grant. The circle to which he belonged included some of the most articulate persons of their generation: they have left innumerable letters and other records which will vastly amplify our knowledge of the lives and works of its members and possibly lead to radical reappraisals. There is a classic waiting to be written on this

circle so full of interest, indeed unique in its time, although in certain respects so malign in its influence.

For the moment, however, although there clings to the name of Duncan Grant an aura of respect, interest in his work declines. From one generation to another the focus of interest inevitably shifts, but this alone does not account for the neglect of an artist of gifts so considerable and so various. There is another, a more readily perceptible cause. When Bloomsbury was a power in the intellectual and artistic life of England, and its nominees held or dominated most strategic critical positions, praise of Bloomsbury's court painter became the rule. Most people have by now forgotten to what lengths these routine paeons went. Take, for instance, these words by an ordinarily sensible critic, William Gaunt in *Drawing and Design*, May 1929:

> Duncan Grant is an artist in the full sense of the word – as opposed to the typical English artist who never grows up – in the Constable tradition . . . I do not think, however, it is too much to say that he combines some of the masculine English quality with a wider and more imaginative outlook than the men of Suffolk.

More significant still are some sentences in an article by an extremely conservative critic, Adrian Bury, who, in the course of what is plainly intended as a severely critical notice, described Grant as 'a sort of nephew of Cézanne, but with more discipline than his uncle, a painter who has made Post-Impressionism logical'. Sporadic praise of this kind, however lacking in discimination, did little harm. Entirely different was the praise that issued forth, almost week by week, in the vastly influential Bloomsbury 'parish magazine' *The Nation*, after 1931 *The New Statesman and Nation*. Its most regular art critic was Clive Bell who contributed to the first and was the art critic of the second from 1933 to 1943. This critic's praise of his wife and of his intimate friend Grant was as continous as it was excessive. Take a characteristic passage in an article in which allusion is made to Grant's 'genius': 'Here is the most important exhibition yet given,' wrote Mr Bell, 'by the living artist whom many good judges consider the best . . . after seeing these pictures none will be at pains to contradict.' In the course of the article Picasso, Bronzino, Constable, Piero della Francesca and Gainsborough are mentioned by way of comparison. The harm caused by this routine spate of such injudicious praise – more especially when it contrasted so sharply with the treatment accorded to other artists – involved twofold, and, as I am persuaded, threefold injury to Grant. It wearied a whole generation with his name; worse still, it sowed the suspicion in the minds of other artists that they were belittled in order that his reputation might

be enhanced, and thereby bred dislike of a man of integrity and charm of character; and, as I believe, it had a deleterious effect upon the artist himself. With all his qualities as an artist Grant had one insufficiency: an insufficiency of passion. Compare one of his landscapes with one by Gainsborough, Constable, Courbet or Corot or any great landscape painter, and what is usually at once apparent is that his subject mattered less to him than theirs to them: where they had manifest passion he had a tasteful intelligence. Usually, not always, there are conspicuous exceptions to this generalization, such as *Green Tree with Dark Pool* (1926). But for a man with an insufficiency of passion, few things can be more enervating than the lifelong echo of 'genius, genius, genius' in his ears. But the effects of overpraise, however reckless, eventually passed and Grant is today recognized as a painter with a sense of beauty matched by a sense of actuality, and as a decorator of extraordinary resource. He died at the age of ninety-three on 8 May 1978.

JAMES DICKSON INNES
1887 – 1914

Few, if any, more painters are able to maintain themselves by the practice of their art than were able to do so before the Second World War. But if they cannot live as artists, their existence – the existence of a fortunate few among them – is at least recognized. The exhibition of their work abroad is believed to make a modest contribution to British prestige, and it is officially sponsored. It is also believed that some good may come of its exhibition within the shores of these islands, and this, too, receives official support.

Before the last war, however, a painter, unless spectacularly successful or else notable for something besides his work, was ignored. In the Introduction to these studies, which prefaces this volume, I referred to an acquaintance's having told me that she was engaged upon a study of James Innes, and I made the comment that, although this painter had been dead only thirty-eight years, at the time, the materials for this undertaking would be assembled only with infinite labour. Some time passed, and I heard nothing further, but I fancy the undertaking was abandoned, and I doubt whether material adequate for anything more than a sketch any longer exists. A sketch has indeed been written, and well written, by a friend who was a fellow student of Innes's and whose intimacy ended only four years before his death. But except for John Fothergill's few illuminating pages (*James Dickson Innes* [1948]), Innes the man, so to speak, has sunk into his grave almost without trace. His death passed virtually unmentioned in the press, although it has been said that his friend and patron Horace Cole managed to secure the insertion of a few lines about him in one of the weeklies. Nor has Innes been judged sufficiently important for mention in *The Dictionary of National Biography*.

James Dickson Innes was born on 27 February 1887 at Llanelly, where his father, a Scot, had an interest in a brass and copper works. His grandfather and great-grandfather both served in HM Customs and Excise. Both his brothers distinguished themselves, Alfred as a biological chemist, and Jack, who died in 1931, as a naval architect. 'It was a well-bred family at Llanelly,' Fothergill tells us, 'four serious and almost silent males, and Mrs Innes the life of it.' Innes attended Christ's College, Brecon, and the art school at Carmarthen from 1904

until 1905, winning a scholarship which took him to the Slade, where he remained until 1908. He spent his vacation in 1906 at Oxford and Plymouth, and in 1907 at Chepstow, a painting ground favoured by Steer, his favourite teacher at the Slade. In the same year, while still a student, he first exhibited at the New English Art Club. In the year following his death-knell sounded: he was ill, and his illness was diagnosed as tuberculosis by Dr Tebb, who was for a time our own family doctor. I clearly recall Innes's thin, pale face and his reddish hair, but still more clearly how much more interest he showed in discussing painting and literature than medicine.

It is difficult to make out how much talent Innes's work showed before he went to the Slade. It was without character, Fothergill declares, 'all save the grandiose conception, *The Quarry, Llanelly*'. But in the volume to which he contributed the essay already cited, this picture is dated as 1906, that is, when Innes was already a student at the Slade. To judge by a reproduction – I have not seen the original – it is a 'New English' landscape of what Sickert used to call 'an august site', but it showed aspirations after monumentality based upon hard structure not commonly met with at the Club's exhibitions.

In spite of his originality Innes was easily led, and what I take to be the principal painting he made during his Slade years, *The Wye near Chepstow* (*c.* 1907) was an elaborate – and highly successful – essay in the manner of Steer of one of his master's favourite motives; in which, however, the luminosity of grass and foliage does not disguise his greater delight in the rocky elements in nature nor his concern with design.

Innes found figure drawing both difficult and distasteful, and it was an exercise which he often avoided. Oddly enough, he was awarded a prize for a figure competition with *Death of the Firstborn*, but according to Fothergill this was an imaginative landscape in which 'the first born themselves, a muddled little group of three figures, were relegated to a shadow in the middle distance'. Either towards the end of his term at the Slade or shortly afterwards he painted a small group of figure pieces, of which the two most successful are *Moonlight and Lamplight* and *Resting*. The first represents a subject which offered many difficulties, in particular the harmonizing of the genial but prosaic lamplight which fills the room and the blue and silver moonlight seen outside the window. The figure seated beside the window is Innes's friend and follower, the Australian-born painter Derwent Lees. If this figure is featureless, that in *Resting* is inept, with her huge head and tiny face and supporting arm too feeble for its function. More interested in inanimate nature than in his fellow men, in these similar interiors, still-life takes precedence over figures. In the first picture the landscape outside the window

gives occasion for a muted expression of Innes's most passionate love, but the furniture, and even the clear-cut shadows, were the objects of a more affectionate scrutiny than of the artist's friend. In the second the most vividly realized features are the curling prints hanging on the wall, framed with black bands along two edges.

But Innes's short painting life began, Fothergill has told us, when in 1908 he and Lees went to France together, first to Caudebec, then to Bozouls, near Rodez, and last to Collioure, near Perpignan. At the second place he painted *Bozouls, near Rodez*, a 'New English' picture with an added crispness and sparkle, and a group of watercolours, of which *Bozouls, near Rodez*, the only one of them known to me, is somewhat summary and empty. It was, Fothergill wrote, at Collioure with its 'Saracenic church . . . and gem-like with fishing boats of antique build and scarlet sails', and its heat and light, that Innes's sense of colour was awakened, but not until he was back in England did this transforming experience become apparent in his painting. 'But for this visit,' concludes Fothergill, 'we might have had in Innes just one more exponent of pale English sunshine and veiled charm.' Within the next two years he had evolved a way of expressing what he saw and felt, and in about 1910, working consciously against time, he began to paint his finest pictures.

The art of Innes was a singular art. Mountains were his theme, yet his representation of them was not grandiose or monumental. A critic's jibe that he made molehills out of mountains is justified to that extent, but his eminences were spacious, rhythmical, often noble and sometimes menacing. If there was nothing vast about them, there was equally nothing small nor mean: perhaps because of his disinterest in man they are oddly scaleless. According to Fothergill Innes was an unsophisticated lover of nature, who even pretended to know all about trees and butterflies, yet the reflection of his knowledge in his pictures is faint. We learn from the same authoritative source that he was an impassioned student of Turner, Constable and Cotman, but that he owed nothing to French painters. To his English predecessors, Cotman in particular, his debts are evident, but his approach to his subjects, especially as manifest in his pure, vivid colour, his sparing use of neutral tones, his hard, clearcut forms, associates him with Gauguin and other Post-Impressionists. Had Innes consciously admired these French masters, Fothergill would hardly have given so explicit a denial that he owed them nothing. There was a channel, however, through which their influence might have reached him and taken hold upon his unconscious mind. Like Augustus John, Innes was associated with the Camden Town Group. The differences between these two and the members of this group of painters of urban landscape were conspicuous, yet close personal

relations existed between them; indeed, John and Innes were titular members of it. It is likely that the passion for strong, pure colours and the contempt for neutral tones which animated Gilman (a disciple of Van Gogh) and to an only slightly lesser degree Bevan (who knew Gauguin) and Ginner (who had long been familiar with the painting of the Post-Impressionists working in France) should have communicated itself to Innes in some degree.

That French influence, if it played any part in the formation of Innes's painting, played a part of which the painter was unaware, receives some corroboration from Matthew Smith. The two painters went together, he told me, in 1908 or the following year, to the house of Leo Stein, where Innes showed himself not only entirely unresponsive to the works of Matisse and other Post-Impressionists so finely represented there, but even to those of Cézanne. (There was another occasion when Smith, regretting Innes's apathy, if not dislike, took him to Vollard's gallery, but the dealer, less sympathetic towards students than dealers in general are today, unceremoniously turned them out.) The exotic character of Innes's art, and in particular his rosy mountain-peaks, may owe something to the study of Japanese prints, too, which were commonly met with in his day: the British Museum, which he often visited, housed, then as now, a splendid collection of them. International art movements are notoriously pervasive, their slightest manifestations, only unconsciously received or half understood, are often sufficient to serve their inscrutable although imperative purposes, for they may be seed falling upon soil ready to receive them. Whether on account of some elusive interplay of influences or through spontaneous generation, the art of Innes is in fact closely related to that of the Post-Impressionists, and has little in common with that of Steer or of the others whom he regarded as his masters. In spite of his talk about botany, his art was not primarily descriptive. The contemplation of mountains induced a mood of exaltation in him, which he expressed most eloquently in terms of conscious design, sometimes, as in his celebrated *Waterfall* (1910), of a very elaborate character, and of pure, strong, even violent, colour.

If Innes was unaware of the effects of Post-Impressionism upon himself, he was certainly aware of a strain within himself recalcitrant to Ruskin's injunction 'to go to nature with all singleness of heart, selecting nothing, rejecting nothing'. At Bozouls, on his momentous first journey to France, he expressed misgiving to Fothergill at his impulse 'to try for something more or better than nature'. 'I'll go and be moral,' he said, and spent the next three afternoons making a precise study of a green boulder in a stream. Later he showed him a big canvas, which in the course of three laborious but fruitless weeks

he had covered with thousands of representations of leaves, but he quickly came to understand that for him this kind of exercise was immoral. From St Ives, where he went the following year, he wrote to Fothergill, 'An artist came to see some of my latest pictures. "That's a good slap at nature," said the man wishing to be encouraging. "I think, rather, it's a good slap in the face," I replied.'

It was to St Ives that his mother took him for a longish stay at The Retreat in order that he should fight, in the healthiest circumstances, the disease that had fastened upon his lungs, but he knew that he did not stand a chance. 'Really I am entirely happy now here . . . my mind is, I think, fairly disconnected from the body which is not so strong as might be but the mind seems all right, so don't say, "You flatter yourself".' And late that year, or early the next, he wrote for Fothergill a parody of Blake's poem to Flaxman, of which he gives these lines in his essay:

> . . . Pneumonia and drink appeared to me and terror appeared in heaven above
> And Hell beneath and a mighty and awful change threatened my earth
> And the germicidal war began, all its dark horror passed before my face,
> And my angels told me that seeing such visions I could not subsist upon earth

Innes's first love was always his painting, but he was also a romantic lover of life, and the knowledge that he had only a little time left, a few years at most, led him not only to intensify his efforts as a painter but disposed him to live, after his easy, casual fashion, still more fully. From quite early days he had shown some disposition to depend upon alcohol, forgetting what he wished to forget and heightening his pleasures with a rosy aura. The nearer prospect of death increased this dependence.

About this time the friendship between Innes and Fothergill came to an end, and they never met again. One consequence is that with it ends the slight record which, nevertheless, remains the chief source of information about the artist and the man. The narrative suddenly breaks off and little is added about either the painting or the life of Innes during the four final years. About the former he offers only one comment of substance, namely that he was in a hurry. 'Earlier he had worked,' he writes, 'with the same charming leisure with which he had walked and talked, but latterly, I was told, he angrily regretted all that work as wasted and began to work at top speed.'

It does not seem to me that this stricture is justified by Innes's work. Both his earlier and his later life had their failures, but it was during the years 1910 to 1913 – after the breach with Fothergill – that he painted the pictures by which he is likely to be remembered. There

was a time, certainly, around 1912, when his touch became swifter
and more fluent, but his best paintings of that time, in which speed
and fluency are apparent, cannot be said to show signs of haste. Such,
for instance – to name only a few – are *Tan-y-Grisiau, Mediterranean,
Ranunculus*, and *In the Welsh Mountains*.

It is unfortunate that Innes should have foregone the company of
his close friend and brief chronicler at the very moment when he was
entering the most fruitful period of his short life. In 1910 and the two
years following he visited Wales, where, applying his now fully
awakened sense of colour to the interpretation of the splendid
landscape of his native country, he painted the greater number of his
finest pictures. The innate understanding he had of the mountains of
Wales gave a reassuring credibility to his most exotic conceptions:
Mount Arenig and Bala Lake, however unearthly from a momentary
effect of sunlight their colouring may be, are always of the earth.
Some of his Mediterranean landscapes, although by no means all,
have by comparison the look of pure fantasies.

The most remarkable picture he made during the first year of full
maturity was *The Waterfall*, a watercolour. There are other pictures by
his hand which glow with a richer or more scintillating light, but in
none known to me does he show such mastery of intricate design. It
is a picture that maintains a delicate balance – and it is chiefly this
which gives it an unearthly air – between abstraction and represen-
tation. At one moment it presents itself to our gaze as a complex of
forms and movements which, from whatever angle one may regard
them, hold us under their spell. (I know of few small modern pictures
which invite – or repay – such prolonged scrutiny.) At another, it
represents, and most convincingly, a wide stream which flows out of
the far distance towards the spectator between strangely formed rocks
and beneath a menacing sky, descending here and there over shallow
falls until, in the foreground, it abruptly precipitates over black rocks
into two big falls; and it is full-face and from midstream that one
witnesses this fascinating culmination of a quiet journey. *The Waterfall*
is an exercise in design, more especially in the silhouetting of one
form against another derived from Cotman, of a complexity which
gives it a place apart among Innes's works. There is another particular
in which it differs from his most characteristic works, in which the
focus of interest is the far distance: the point where a mountain-peak
stands up black against an opal sky or else emerges sharp and clear
above a fleecy wreath of cloud, and the foreground is summarily
handled, or even, on occasion, dispensed with altogether. In *The
Waterfall* the spectator is compelled to share the artist's fascination
with a foreground which, however, is intimately linked, both formally
and dramatically, with the farthest background. Preoccupation with

the distant – in this picture the meeting-point of sombre peak and menacing sky – marks another but less splendid work of this year, *The Dark Mountains: Brecon Beacons*. In one respect the best of his landscapes of the following year make a new departure. The outlines of *The Dark Mountains* are lacking in the character of rock: they are a little soft in modelling and texture; but those which so nobly rise in the two of the *Bala Lake* (*c.* 1911), have all rock's density and hardness. These, more especially that with the high central peak, are beautifully classical in their lucid harmony. Fine, too, is an *Arenig* in its combination of radiance with weight, but a *Tan-y-Grisiau* of about the same time, is a fluffy pastiche of Constable's *Weymouth Bay*.

Round about 1911, too, the increased swiftness and fluency of handling to which I alluded just now became a marked although intermittent feature of Innes's work, and more conspicuously in the Mediterranean landscapes than in the Welsh. It would seem that the heat and the brilliance of the south of France, which first excited his audacious sense of colour, also stimulated him to the use of this rapid and summary way of painting, and that the Welsh mountains favoured a serener although a still more exalted mood. It was particularly in his interpretations of these that Innes seemed to be haunted by a highly personal conception of the ideal landscape which also haunted the imaginings of Puvis de Chavannes and Gauguin. The ideal landscape of Innes, unlike that of these two, was not an idyllic setting for man, but a wild landscape generally austere in form although glowing with a romantic radiance in colour, and peopled, only latterly and then with reluctance, by a lone figure or couple.

One of the marks of Innes as a colourist was the audacity with which he used purple. The Slade professor Randolph Schwabe told me that Innes reproved him for speaking disrespectfully of the representation of purple heather, and was unimpressed when reminded of Ruskin's warning against the free use of that colour. This was a colour generally avoided in English painting until the Pre-Raphaelites used it and, indeed, regarded it almost as an emblem of their emancipation from subserviency to outworn, but still tyrannically enforced, conventions. 'And then about colour,' Holman Hunt reports his young self saying to Millais in criticism of prevailing methods,

> why should the gradation go from the principal white, through yellow, to pink and red, and so on to stronger colours? With all this subserviency to early examples, when the turn of violet comes, why does the courage of the modern imitator fail? If you notice, a clean purple is scarcely ever given in these days . . .

Innes could easily have seen – indeed so regular a visitor to art

galleries could not well have avoided seeing – work by the Pre-Raphaelites, but I have found no evidence that they were objects of his particular study, and it is no more possible to say whether Innes was affected by the deep evocative purple of Hunt and Hughes – 'the colour of Amethysts, Pageantry, Royalty and Death' – and by the jewel-like colours of the Pre-Raphaelites than whether he was by the forthright, audacious colours of the Post-Impressionists. Some day perhaps the discovery of letters written by Innes – more informative than those at present known – will enable us to form a clearer notion of the external influences that contributed to the formation of his art.

Innes's most successful works were in watercolour, although he painted from the first in oil as well, and towards the end he came to prefer the heavier medium. Ill-health and awareness of how little time was left to him brought a feverish quality to his work. The large *Arenig* (1913), which at a distance seems to be a kind of summing up of Innes's achievement, on closer inspection reveals loose and unfelt forms, and colours, like the colours of a poster, designed to make an immediate impression rather than to give prolonged delight.

The work of his last years was marked by an innovation: the introduction of figures into his landscape. Interiors with figures had long been a subject of occasional interest to him, but an interest conspicuously less intense than that inspired in him by landscape. As a consequence, however, of the ripening of his friendship with Augustus John – which probably began about 1910 – with whom he spent much of the spring and summer of 1911 and 1912 in North Wales, during the latter year the presence of a female figure or two, of somewhat Johannine aspect, became a feature of his landscape. *Mountain Pool* (1911), *Tan-y-Grisiau: The Green Dress, The Van Pool* (both 1912), and the splendid *Mountain Lake* (1913), all contain figures. When John introduced a figure into a landscape it was apt to become a focus of interest, but, unlike his friend, Innes was not a humanist, and his figures, as Fothergill observed, are blended with or growing out of his rocks and mountains. If Innes – who revered John – owed the presence of figures in his own landscape to his example, he imparted his own vision of landscape to his friend.

During the last two or three years of his life Innes was haunted by the knowledge of how near the end must be, and that, in consequence, he would have almost no time to realize in its fulness the vision of landscape which he must have known, modest as he was, to be both original and poetic; and, moreover, that his avid sense of experience must be largely unsatisfied. The twofold urge to create and to experience was sharpened by the stimulating nature of his illness, and because he spent his time among companions who, however devoted in other respects, had little or no concern for his health, his

thirst for alcohol encountered no restraint. Unable to live and work in quiet he spent his evenings at the Café Royal, music-hall and theatre, and his expedition on the way home from the Pyrenees to Marseilles for an assignation with so unusually robustly constituted a companion as Augustus John was bad for his health. John, who took him to the Hotel Bozio at Ste. Chamas on the Etang de Berre, seeing how ill he was, advised Innes, he tells us, to return to England, which he did.

Innes's admirers could wish that John had given a fuller account of him in *Chiaroscuro*, but the few pages he devotes to his friend are excellent. He begins with a description of him:

> He himself cut an arresting figure, a Quaker hat, a coloured silk scarf, and a long overcoat set off features of a slightly cadaverous cast, with glittering black eyes, a wide sardonic mouth, a prominent nose and a large bony forehead, invaded by streaks of thin black hair. He carried an ebony cane with a gold top, and spoke with a heavy English accent, which had been imposed on an agreeable Welsh substratum.

This description is amplified by Schwabe in *The Burlington Magazine*, January 1943:

> He was of middle height, black haired and thin featured, handsome to many people, though others must have regarded him differently, since, when I was away from London for a while, and lent him my rooms in Howley Place, my charwoman, on my return, assured me that he was, literally, 'the devil', and she was undoubtedly terrified of him.

Fothergill calls his voice 'low and melodious', and himself 'affectionate and easily led as one who wanted help to get through life's effort'.

John proceeds to a revealing account of an expedition he made in the spring of 1911 at Innes's invitation to the Arenig valley north of Bala:

> Our meeting at Arenig was cordial, yet I seemed to detect a certain reserve on his part: he was experiencing, I fancy, the scruples of a lover on introducing a friend to his best girl—in this case, the mountain before us, which he regarded, with good reason, as his spiritual property . . . At this time Innes' activity was prodigious; he rarely returned of an evening without a couple of panels completed. These were, it is true, rapidly done, but they usually meant long rambles over the moors in search of the magical moment. Perhaps he felt he must hasten while there was time to make these votive offerings to the mountains he loved with religious fervour.

They left the inn, Rhyd-y-fen, and took a cottage a few miles away by the brook called Nant-ddu, which looked out on Arenig. Here they returned the following year and yet again.

Innes's extreme susceptibility to beauty made him hardly less responsive to women than to mountains, although to no woman, I think, was he as constant as to Mount Arenig. Of his romantic

attachments John has several stories to tell. He describes Innes's enchantment, in a bar at Corwen, with Udina, a lovely young gypsy of the rare tribe of Florence, and how the next day he rose early to rejoin the Florences and, finding them gone, followed on foot until, on the outskirts of Ruthin, he was discovered collapsed by the roadside. More characteristic still is the account he gives of Innes's relations with a singer known as 'Billy', a girl who 'had some beauty, much good nature, and an American accent contracted in Soho'. Innes became very much attached to her, although his feelings, in John's opinion, were more chivalrous than passionate.

> At this time he had acquired a caravan from a gypsy, and this was resting in the yard of an inn in the remote village of Penmachno. Burning with romantic zeal, he resolved to extricate Billy from a life in which the Café Royal played too great a part, and at last gained her consent to accompany him to North Wales, where they would take to the open road, and travel the world together in healing contact with Nature and the beneficent influences of his beloved mountains. They were approaching their destination: Dick, greatly moved, pointed through the carriage window, crying 'Billy, look, the mountains of Wales!' but Billy, immersed in 'Comic Cuts', was not to be disturbed. They reached Penmachno and spent several days at the inn. From time to time Dick would suggest a visit to the yard to inspect their future wheeled home, but Billy, refusing to budge, only called for another whisky and soda.
>
> They soon returned to London and the Café Royal. Some years later, being at Penmachno, I saw Innes's van or what was left of it. It had never been moved: some fragments of its wheels still protruded from the ground.

But Innes's last and deepest attachment was to Euphemia Lamb. They met in a Paris café, and Innes at once responded to the beauty of her pale oval face, classical in feature yet animated by a spirit passionate, reckless and witty, and the heavy, honey-hued hair: a beauty preserved in many paintings and drawings by her artist friends, most notably, perhaps, in a tiny drawing in pen and ink by John. Together Innes and Euphemia made their way, largely on foot, to his favourite resorts in the foothills of the Pyrenees, and back to London, he contributing to their support by making drawings in cafés and she by dancing. Their attachment lasted until his death. He used to write verse in her honour and design and make jewellery for her adornment.

Innes was alternately depressed and exhilarated, idle and industrious, and as soon as he emerged from a period of sterile melancholy he was prone to recklessness. One day when Horace Cole – noted as a friend of painters and the great practical joker of the age – was on his way abroad, he was accompanied to Victoria Station by Innes

and, according to Schwabe's published account, 'one or two inti-mates':

> In the taxi-cab they bethought themselves of the rite of 'blood brotherhood', and at once put it into practice. They mingled their blood freely enough. Innes drove a knife right through his left hand. One of the others stabbed himself in the leg and was laid up for some time afterwards. Cole made a prudent incision, sufficient to satisfy the needs of the case. The driver was indignant when he saw the state of his cab and its occupants, but the rite had been performed and no lasting damage was done.

The 'one or two inmates' of the published account of the incident, and he who stabbed himself in the leg, according to Schwabe's verbal account earlier referred to, were the same person, namely Augustus John, who was also the instigator of this revival of the rite. An impulsive quixotism used to involve Innes in brawls. A mutual friend told me that he once accompanied him to some Parisian night-haunt, out of which he was thrown a few moments afterwards and presently arrested, and that he had gone to the magistrate and managed to secure his friend's release. Parted from every franc with which they had set out, and ravaged by the night's adventures, the two friends sat morosely together – feet to head – on a divan in the friend's studio. 'Well, I shall simply lie here,' said Innes, 'until funds arrive from London.'

During his last years 'his teeth suffered', wrote Schwabe, 'and I doubt if he could masticate properly'. In Fitzroy Street, where he lived for a time, he was so low that he seemed incapable of getting out of bed in the morning without a stiff dose of brandy which a friend would fetch from The Yorkshire Grey. His paintings and drawings, according to Schwabe's account, were neglected no less than his health: he left them about in improbable places, and they were bought only by a few friends and admirers.

Even within hailing distance of death, at Mogador in North Africa, where he had been taken by his friend Trelawney Dayrell Reed in a last desperate attempt to arrest the progress of his malady, Innes occupied himself in experimenting with various combinations of tobacco.

In 1914 he went to Brighton where he was nursed devotedly by his mother. Horace Cole and John visited him there; the war had broken out, and John recalls the general excitement over it, and the indiffer-ence of Innes, who took no interest in anything except his medicine. At last he was moved to a nursing home at Swanley in Kent. The two friends went to see him here as well, this time in company with Euphemia Lamb, as described in *Chiaroscuro*:

> The meeting of these two was painful, we left them alone together: it

was the last time I saw him. Under the cairn on the summit of Arenig Dick Innes had buried a silver casket containing certain correspondence: I think he always associated Euphemia with this mountain, and would have liked at the last to lie beside the cairn.

When he died on 22 August 1914 at the age of twenty-seven Innes was buried instead at Whitechurch, Tavistock, along, now, with both his parents.

Innes died too early to infuse his own poetic spirit into English painting. He had one disciple, the Australian-born and Slade-trained painter Derwent Lees, whom he took with him to Collioure. Lees left at least one work of great beauty in the Innes tradition, *Pear Tree in Blossom* (1913), but he was desirous of quick success and to this end adapted himself to the styles of John and McEvoy as well as Innes, and before he could form a personal style he became deranged.

L. S. LOWRY
1887 – 1976

I have introduced the artists considered in these pages in the order
of their birth, as I explained in the Preface, so as to avoid groupings,
which are more apt to obscure than to clarify. But had I decided to
consider them instead as members of groups, and had associated
Steer and Sickert as 'English Impressionists', say, and Lewis, Roberts
and Wadsworth as 'Vorticists', there would be no group in which
Lowry could appropriately be placed. He occupied, in most respects,
a position as remote from any contemporary as Gwen John; in fact,
farther, for however personal her treatment, there is nothing novel
about her subjects, whereas Lowry's constituted a modest landmark
in the history of the concept of the beautiful. Lowry's remoteness
from his English contemporaries does not arise from any want of
harmony with his surroundings. When Sickert wrote, 'The artist is
he who can take a flint and wring out attar of roses', he had Spencer
Gore in mind, but his words apply more forcibly to Lowry. One of the
most persistent characteristics of the whole modern movement in
painting, traceable as far back as Rembrandt's *Slaughtered Ox* and
Anatomy Lesson and beyond, has been a continuous extension of those
aspects of life deemed to constitute permissible subjects for art, in
short, of the conception of 'the beautiful'. Step by step, the idea that
beauty resided in the artist's vision asserted itself against the classical
view that beauty was an attribute, sometimes a measurable attribute,
of things themselves. The classical ideal, supported by the authority
of Greek and Renaissance art, did not die. It remains, coherent and
comprehensive, and it still retains a hold, obscurely recognized, over
the hearts and minds of civilized men. It would be foolish to dismiss
the possibility that a day may come when that appeal will once again
be imperative, but for the present the tide still runs in the opposite
direction, and artists are more preoccupied with the discovery of
beauty in subjects previously regarded as ugly – with wringing attar
of roses from flint – than in the representation of subjects beautiful-
in-themselves. Sickert's description applies to Lowry with peculiar
aptitude because Lowry did not, like Gore, simply subscribe to the
widely held view expressed by Sir Winston Churchill that 'once you
begin to study it, all Nature is equally interesting and equally charged

with beauty', but, with an audacity that would have appealed to Sir Winston, he annexed to the kingdom of beauty what are probably the ugliest regions that ever disfigured the surface of the earth – the industrial suburbs of Manchester and Salford.

It was in the North of England that the Industrial Revolution began. As the dark satanic mills sprang up in dense clusters along the valleys of South Lancashire and South and West Yorkshire, the traditional life of the surrounding country underwent a rapid process of disintegration and whole populations were drawn into the industrial vortex. The problem of their housing was mostly left to the uncontrolled activities of the speculative builder. The kind of building that these circumstances brought into being in Manchester in the 1840s is thus described in a contemporary official report:

> An immense number of small houses . . . of the most superficial character . . . are erected with a rapidity that astonishes people unacquainted with their flimsy structure. They have certainly avoided the objectionable mode of forming underground dwellings but have . . . neither cellar nor foundation. The walls are only half a brick thick . . . and the whole of the materials are slight and unfit for the purpose . . . They are built back to back; without ventilation or drainage; and, like a honeycomb, every particle of space is occupied.

In order to accommodate the rapidly growing population, whole great areas of the industrial north were densely covered by rows of such houses, divided from one another by what a contemporary called 'that mass of filth that constitutes the street'.

As the nineteenth century drew towards its close successful efforts were made to ameliorate conditions in this densely packed mass of rotting, rat-infested houses. Typhus and cholera were gone and the old houses replaced, and efficient drainage and innumerable other amenities had been introduced. Yet those areas which felt the first horrifying impact of industrialization to this day bear the seared imprint of it, and they will in all probability continue to bear it for generations. This imprint, which reveals itself in an architecture bleak, meagre and disorderly, in an atmosphere sombre and grimy, in a humanity that serves the forges, looms and glowing furnaces of the great mills: this imprint was the subject of Lowry's art. His distillation of beauty from the shabbiest and meanest of subjects that the world has to offer was in harmony with the spirit of his age, but his choice of the locality in which he performed this remarkable operation was an anachronism.

The prevailing tendency towards centralization is faithfully reflected in the world of art. Most artists who regard themselves as 'avant-garde', whether they belong to Salford or Sioux City, are affiliated (if only on a 'country-member' or even a correspondence-

course basis) to the huge and brilliantly advertised School of Paris. This school has no accepted style. The principal requirement for membership is today little more than the ability to imitate the superficial elements in the style of one or other of its original masters – Picasso or Braque, Matisse or Gris. It is desirable that the imitation should be carried out, at any rate for a time, *in Paris itself*. Should this prove impossible, then it should be done in London or New York but *on no account* in Salford or Sioux City. Centralization is now so complete that even members of lesser, more traditional schools no longer practise their art in the places where they happened to be born. As soon as they can afford to do so they take the journey to London (or Paris or New York) from which few of them ever return. When they have established their reputation they may safely, and even profitably, settle in some picturesque rural dependency of the capital.

So compelling are the attractions of a few great cities for artists, and so pitifully meagre the patronage of provincial cities that it is in these few major centres that the fine arts today are exclusively produced, and for the most part, it need scarcely be added, in the closest conformity with the styles and sentiments that prevail there. Regional art – except as practised by those who, in these bitterly competitive days, have been unable to 'get away' and who had been compelled to stay disconsolately where they are – no longer exists in England, except in persons such as Lowry. He was born in Manchester. He never went to Paris, or anywhere abroad, went only occasionally to London which, although he regarded it with affection, left him, as an artist, entirely untouched. Let me place on record the basic facts of his quiet life.

Laurence Stephen Lowry was born at Old Trafford, Manchester, on 1 November 1887, the only child of Robert Stephen Lowry, an estate agent and a native of the same city, and his wife Elizabeth, born Hobson. He attended the Victoria Park School, and at about the age of sixteen, not long before he left, he began to draw and presently realized that he had no wish to do anything else. Aware of his shyness and his love of home (and knowing nothing of the hardships of a painter's career) and sympathizing with his serious quiet pursuits, his parents raised no objections to his attending the Manchester School of Art. Here he had the good fortune to meet a painter named Adolphe Valette, who had come to Lancashire as a designer to a textile firm and who used to attend the School, where he was eventually invited to take the life class. 'I can't overestimate the effect on me at that time,' Lowry once said to me, 'of the coming into this drab city of Adolphe Valette, full of the French Impression-

ists, aware of everything that was going on in Paris. He had a freshness and a breadth of experience that exhilarated his students.'

In 1909, three or four years after he began to attend the School, Lowry's parents moved out and he with them (for so long as either of them lived he remained at home) to 117 Station Road, Pendlebury, an industrial suburb. The move was made to enable them to be near friends, but the friends died. None of them liked the place and so planned to move away, but they never did, and Lowry continued to live in the house until 1948. Presently he transferred to the nearer although inferior art school at Salford. Speaking of the effect upon artists of the pictures they see in early life, he said to me: 'As a student I admired D. G. Rossetti and, after him, Madox Brown. The queer thing is, I've never wavered; they're my two favourite artists still.' 'Yet your admiration for neither of them is even faintly reflected in your work,' I said. 'No. I don't believe it shows; nor if you were to ask me, could I tell you why these two artists are constantly in my mind.'

I am unable to form a clear notion of what Lowry's work was like during his earliest years. Fragments I came upon in his studio suggest that it was characterized by the scrupulous notation of low, rather muddy tones. It must, I think, have been the painting of a serious student, but lacking in purpose. In 1916 he had an experience – on the surface of it a characteristically commonplace experience – that gave him, in the winking of an eyelid, a sense of vocation that never left him. After his parents' removal to Pendlebury, his dislike for the place took the form of a half-conscious determination to ignore it, and he ignored it for seven years. One day he missed a train from Pendlebury, and as he left the station he saw the Acme Spinning Company's mill. The huge black framework of rows of yellow-lit windows stood up against the sad, damp-charged afternoon sky. The mill was turning out and hundreds of little pinched, black figures, heads bent down (as though to offer the smallest surface to the whirling particles of sodden grit) were hurrying across the asphalt square, along the mean streets with the inexplicable derelict gaps in the rows of houses, past the telegraph poles, homewards to high tea or pubwards, away from the mill without a backward glance. Lowry watched this scene (which he had looked at many times without seeing) with rapture: he experienced an earthly equivalent of some transcendental revelation. Recalling the experience more than thirty years later he exclaimed to me with wonder, 'And to think that it had never occurred to me to do Manchester subjects.'

Those moments of illumination at the station in 1916 formed him. From that time he made it the purpose of his life to represent the grimmest regions of industrial Manchester and Salford with the same clarity with which he was privileged to see the Acme Mill. It was

characteristic of his patient and laborious spirit that certainty about his vocation did not lead him to leave the Salford Art School; there he remained for a further ten years, assiduously drawing from the antique and life in order the better to pursue it. 'I always enjoyed the antique: there's a nobility about it,' he said to me, 'but the life: I never was so stirred by that.' This lack of interest is reflected in his work. When he represented human figures as distant marionettes he was able to endow them with a bleak but highly expressive animation, as they loiter in the neighbourhood of a street accident or at the door of a surgery or chapel or as they mill around a playground, but when he represented them 'close-up', because of his lack of interest in the living human body, as well as his uncertain grasp of form, he invariably failed. But his was also a radically lonely spirit; as he once said, he felt cut off from normal human communication.

During all these years at art schools Lowry worked only at what seemed to him to be of value – equipping himself as a painter – but he never completed a set course. Immediately after his eyes had been opened to the esoteric yet touching beauties of the industrial suburbs of Manchester, he began to make paintings. Although his dedication to these subjects remained almost constant – indeed his occasional aberrations served to emphasize his constancy – his way of treating his subject changed. Writing about a Lowry exhibition in 1945 the art critic of *The Times* expressed the opinion that in other circumstances the artist might have been 'a Wiganish kind of Corot'. This telling phrase precisely describes not his potentialities, but what, in fact, he had already been. His early landscapes, instinct with a kind of gloomy lyricism, put one very much in mind of Corot. Lowry's colours are smoky instead of limpid or silvery like Corot's, but there is the same reticent candour, the extraordinarily precise perception of values, the refinement in colour, and something, too, of the same humility of spirit. In these early canvasses he shows one characteristic which has become very uncommon: a way of handling paint as though it were precious.

Contemporary painters are apt to be suspicious of 'quality' that is sought too deliberately and made an end of, instead of accepted as a happy but almost accidental consequence of, the successful pursuit of larger aims, in the same way as contemporary writers are of 'fine writing'. No painter was ever less 'precious' in his outlook than Lowry, freer from preoccupation with 'finish'; or with pigment for its own sake, with the 'cookery' of painting. He handled paint as though it were precious because respect – respect for the rights, talents, convictions, and privacy of his fellow men, for nature and for the objects of daily use – was a sentiment that deeply coloured his outlook. No painter whom I have known was more consciously aware

of a sense of privilege, amounting almost to a sense of wonder, at being a painter, and any attitude but one of respect for his medium would have been out of harmony with his thinking and feeling.

During his years as a 'Wiganish Corot' Lowry painted Manchester and Salford subjects very tenderly, showing, as already noted, an extraordinarily sensitive perception of values, and a power of exquisite modulation within a narrow range of colours and tones: a few drab greens, burnt sienna, umber, all seen, as it were, through a light screen of industrial smoke. His subjects were often taken from the less ugly aspects of these cities; he showed a preference for those areas where a few trees might belatedly put forth a little frostbitten foliage, or a few blades of grass push hopefully upwards through the smooth-trodden black earth. Good examples of the 'Wiganish Corot' period are the *Salford Art Gallery* and *Peel Park, Salford* (both 1924). But as the vision he had at Pendlebury eventually permeated every part of his being, the search for foliage and blades of grass seemed to him a little absurd. If he wanted to paint foliage and grass, he reflected, he could take a tram out to where they grew unstunted; if he wanted to paint Manchester and Salford, why should he take for subjects what, of all things, was least characteristic of them? So he looked these two appalling places full in the face, and concerned himself more and more exclusively with their most characteristic features: the massive mills and the contrastingly flimsy dwellings of those who worked in the mills; the grim twilight areas of disorderly dereliction; the chapels, the pubs, the sweetshops, where they tried to forget their work. It is significant that he rarely painted the most modern mills, and never, I think, the new housing estates, for his real subjects were the bleak, pervasive vestiges of the Industrial Revolution. Lowry never represented what he had not seen, yet what he shows us is not a portrait of our own age of equality and planning, when the impact of relievable misfortune is pillowed by social security, when a drab uniformity is replacing squalid disorder. Squalid disorder is what he constantly depicted, and the poverty that accompanied the production of wealth on a scale incomparably greater than any previous age had known – a poverty measured not only in terms of wages but in terms of life itself. There were no splendid church services or civic spectacles – no symbolic marriage of the Mayor of Manchester to the Ship Canal; no civic games, no complex of beautiful public buildings such as ameliorated the harshness of life in earlier civilizations.

The traditional belief that emotions are best expressed by colour and ideas by line does roughly correspond to the truth. So long as he was impelled by a vague desire to represent the seemliest fragments of a hideous environment – a corner of a park, or the classical portico

of a public building – Lowry could rely upon his delicate sense of colour and tone. But once he came to see Manchester and Salford as creations of *man*, huge complex industrial organisms, his subject became not scenes sought out because they were pleasant, but man in his environment. It was a subject that called, inevitably and imperatively, for the expression of ideas. For such a purpose even the most delicate perceptions of colour and tone are of little help. What he required was a more expressive and, above all, a more exact language of paint, and, first and foremost, the ability to draw.

When I began to meditate upon the work of Lowry with the view to writing these pages about him, I looked forward to doing justice to a man who was dedicated to a forbidding subject and personally lonely and obscure. To a man for whom I felt affection; to painting which I believe has a unique place in the art of its time. However, I find that, in the case of Lowry, doing justice initially involves a degree of depreciation. Singularly enough, in the course of the little that has been written or broadcast about him, he was unwisely praised. Eric Newton, for example, said of him, 'He is not an artist of the first rank; that is to say, he is not a Titian, a Rembrandt or a Velazquez . . . but he is among the first of the artists of the second rank,' and he proceeded to link him with Constable and Brueghel. On another occasion, in *The Sunday Times*, he wrote that 'Lowry's Pendleton [as Newton here and elsewhere calls Pendlebury] is as positive and convincing as Constable's East Bergholt'. Such excessive praise is a consequence of a generous impulse, but I know of no standard of values in which Lowry could be placed among the first in a class which would include Goya, Degas, Botticelli, Poussin, Dürer, Brueghel or Constable. Or of any in which he would stand in relation to such masters other than as a domestic cat to tigers. He had the misfortune to be born into an era of decline, when great traditions had been lost. It is, I think, doubtful whether there is a single painter now alive to whom we could assign, without misgiving, a foremost place in the second rank. It is possible to do justice to Lowry only if such indefensible claims are taken not as criticism, but as gestures of encouragement.

In his search for a means of expression adequate to his enlarged and intensified vision of surrounding life, Lowry made two discoveries: that his drawing and his composition were elementary. He was unable to make his forms solid or exact, and his arrangement of them was often marred, for example, by intrusive horizontals, sometimes along both foreground and horizon, that were clumsy and destructive of any illusion of space. His paintings often looked like backdrops.

There was no second revelation: Lowry's highly personal style was the product of his unceasing struggle with two radical shortcomings.

He never acquired the full power of creating solid form, but he did overcome his inability to compose, except with the simplest forms, to enable him, in happy moments, to represent even panoramic subjects spaciously and variously.

Art is a mysterious pursuit, without laws (except, perhaps, for a few bye-laws), and I cannot explain how it came about that, in the heat of his encounter with what ought to have been crippling disabilities, Lowry was able to forge the means of giving the most convincing form to what he divined that afternoon at Pendlebury station. 'The essence of poetry with us in this age of stark and unlovely actualities,' wrote D. H. Lawrence in 1916 to a friend, 'is a stark directness, without a shadow of a lie. Everything can go, but this stark, bare, rocky directness of statement, this alone makes poetry today.' I think there could be no better description of the fundamental virtue which makes the best of Lowry's work memorable. As memorable, in its way, as that of Utrillo, one of the very few of his contemporaries with whom he is at all closely comparable. The colour of Utrillo (in his earlier days) was far richer and various than Lowry's ever was, his sense of form subtler, larger; but Lowry, with his narrower means, evoked the life of a city even more pungently and completely, and with a richer humanity – a city, it must be remembered, almost formless, almost colourless, and, so far, more refractory than Paris as a painter's subject. The more abysmal the ugliness, it might be said, the greater the beauty that may be distilled from it. From time to time Lowry has been classed as a 'Sunday painter', that is to say a species of amateur. An amateur may achieve something in constantly depicted cities like Paris or London, Venice or New York, but to transmute a huge featureless tract of industrial dereliction into art, and without the guidance of predecessors, is a feat beyond amateur powers.

On account of the stony directness of his statements about what Lawrence called 'stark and unlovely actualities', Lowry is sometimes regarded as a satirist moved by indignation, or a social reformer moved by pity. In fact he was neither. 'People in Manchester,' he said to me more than once, 'are as happy as people anywhere else.' He stood in singular relationship to his subject; a relationship which he could not, I think, put into words, and which I confess I do not fully make out. I never heard him express any particular opinion about Manchester or Salford. On one occasion we were speaking of an article which attributed to him pity and other sentiments towards his subjects. He turned towards me in emphatic protest: 'I don't feel anything. Anything at all. I simply paint. Of course,' he continued, 'I must have unconscious feeling.' With characteristic modesty he disclaimed the intellectual power to analyse his feelings, much more

to expound them. He was a man who felt and meditated, but who formed few decided general ideas. He reached, for instance, no conclusions about religion or politics, 'though I spend a lot of time,' he said, 'thinking about them'. 'Occasionally I like to see pictures,' he said in answer to some question of mine, 'but only occasionally.' But I have never known a painter quicker to discern the good qualities in any pictures in which they are to be found.

What he lacked in the way of intellectual penetration was made up by the most intense and affectionate observation of his subject. In a general sense Lowry's subject was the industrial area of South Lancashire, and by extension poor industrial regions anywhere, but it existed for him in its most compelling form in a particular, strictly local sense, namely an area immediately adjacent to the Oldham Road, formed by Rockford Road, Apollo Street, Livesey Street, Mozart Square, Butler Street, Elizabeth Street, Woodward Street, Kemp Street (late Prussia Street) and Redhill Street (late Union Street) beside the canal. To this district he went every day except Saturday and Sunday, and spent the middle hours walking the streets, making pencil notes on the backs of envelopes, occasionally a careful drawing, but mostly just observing. 'I don't know a soul in this district, but I love it more than any place I can imagine,' he said, 'especially this street' (it was along Union Street that we were walking at the time), 'and Woodward Street and the footbridge over the canal. And when the idea for painting has come to me, I hurry home and put it down.' He usually spent few hours painting; a short time early in the morning, longer at night. Sometimes he worked through the night 'without getting tired,' he said; 'at night I lay in my design and put down my colour in a general way, but I never work on detail or *finish* anything by artificial light.' His method was to paint straight on to a white canvas without an undersketch. Sometimes he improvised out of his vast detailed repertory of observations, 'without the slightest idea of what I'm going to do'. More often he worked from drawings made in the street. Some of his paintings are transpositions, others faithful renderings. *Dwellings, Ordsall Lane, Salford* (1927), for instance, was made from a fairly detailed chalk drawing. How faithful a rendering the painting is I was able to see one midsummer afternoon in 1951 when I stood, with Lowry, lashed by rain from a slaty sky, on the place where the drawing was made.

Lowry was usually occupied with about twenty subjects at the same time. A big painting, worked on intermittently, took him about eighteen months to complete. Only rarely did he paint directly from his subject. After the main lines of the composition were drawn in black paint, he put in the colour, mixed with a little medium,

gradually building up to the required quality and pitch, always keeping on the light side.

Newton once said that 'Lancashire is to him what a crippled child is to a devoted mother . . .' This is a matter about which it would be unwise to be dogmatic, but, so far from sharing Newton's opinion, I believe that far from regarding his subject with pity, Lowry was to an extraordinary degree dependent upon it. He was entirely aware of the ugliness of this region, but I never heard him allude to it in terms of pity. (A few pages back I noted his insistence that Manchester people were as happy as people anywhere else.) His attitude appears to me to have been one simply of fascination and love, that grew year by year until it had him almost enslaved. Not only was he drawn into the Oldham Road district every day there was a bus service from Mottram in Longendale, the nearby village where he has lived since 1948, but in times of despondency he was able to regain his tranquillity only by walking its streets. He told me that:

> There's one street, Juno Street, that I couldn't paint, as it has no distinctive feature at all. Yet in my studio my mind turns to it constantly. I don't know why, but I am grateful to that street that I shan't ever paint. In fact, it's not too much to say that in bad times it's this district that keeps me going.

For many years he was aware of his singular dependence.

In the mid-1930s Pendlebury, where he had spent almost all his working life, ceased to have any interest for him, but he found the attraction of Oldham Road undiminished. 'After a little time in the country or by the sea,' he said, 'I have to go back.' One of his attempts to break the spell of Oldham Road added to the range of his art. In 1944 he went to Anglesey. 'I was bored almost to death. I couldn't work. I could hardly even look at anything. A month after I had got home I started to paint the sea that I'd seen, nothing but the sea. But a sea with no shore and no boat sailing on it – only the sea.' Just as he went in times of depression to the Oldham Road, so in times of loneliness, away from home, he found comfort in the poor quarters of any industrial town. 'I go round quite a bit, and I know the poor quarters of many English cities and of Glasgow, but it's only round the Oldham Road that I am entirely alive. I wish,' he said, looking round the sitting-room of The Elms, his little stone house in Stalybridge Road, Mottram, 'there was a weekend bus service into Manchester. Mottram's a nice place, but I'm lost in the country.'

Lowry's sea-pieces – featureless stretches of smooth water – reveal as none others the exceptional directness and intensity of his perceptions. The work of so many painters is marked by a false simplicity, a simplicity that results not from an authentic breadth of

vision, nor from a tension between the desire to include and the necessity to exclude, but simply from emptiness of mind, from an unjustifiable esteem of simplicity as an end in itself. Lowry's sea-pieces are models of simplification; not only ships and shores and clouds, but even big waves are excluded so that the artist may press nearer to expressing the essential nature of the sea. With this subject he was troubled neither by his uncertain draughtsmanship nor his difficulty in composing: his exact perception of tone and colour was enough, and the little canvasses, half sky, half sea, with neat lines of blackish ripples, exert a mesmeric effect.

In the spring of 1951 I spent an afternoon visiting dealers' galleries with Graham Greene. In one of these we were shown paintings by Tintoretto, Degas and other illustrous masters, but his attention remained upon a tiny canvas, divided almost exactly in two by a horizontal line, the upper half stained with a faint grey and the lower with a dusky green – an early seascape by Lowry which he bought and insisted on carrying promptly away.

In Manchester Lowry had a few close friends, and in the Salford Art Gallery he found intelligent and loyal support, for assembled here is the best collection of his work in public possession. Nevertheless he led a lonely life, 'with fourteen clocks for company'. Departure from the neighbourhood, however, would have been impossible, so dependent was he on the Oldham Road, not only for his subjects but as a point of contact with the world. This was the world, and the only one, in which he had roots. I have already commented that Lowry's was an essentially lonely spirit and intimated that it may be this personal characteristic which, more than a simple lack of interest in the living human body, accounted for his failure in the depiction of the figure. He felt himself unable to communicate in the normal ways with other human beings, and confessed himself correspondingly unhappy; it may be that here is a clue to the explanation of the bleakness of the human elements in his pictures. The industrial north is, or was, no less bleak and grim and chilling in all its nonhuman environment than it is in his pictures. Among the people who live there, however, these qualities are conspicuously lacking; instead there is warmth and easy gregariousness and an abundance of community feeling. But in Lowry's work, as a writer in *The Observer* commented in August 1955, there is a wistful and melancholic quality.

> His figures are often pathetic – not because they are poor or stunted or shabby but because they are lost souls, unable to communicate. The Lowry landscape, though it has a pale sad beauty of its own, is a lost landscape . . . Places are transmuted in his mind and come out strange and far away.

Lowry had no other world; he could never leave it. In his earlier years, even had he had the wish, departure would have been difficult: outside the Manchester region he was unknown, and even within it, in spite of the encouragement of the *Manchester Guardian*, he remained little known until the early 1930s when the circle of his admirers widened. It was not until 1939 when McNeill Reid, of the Reid and Lefevre Gallery, happened to see some of Lowry's pictures at a framer's, and was so impressed by their originality that he arranged an exhibition of his work, that his name came to be known outside his own locality. I well remember the impression that Lowry's pictures made on myself, for whom a six-year sojourn in a region that had much in common with his Salford had ended only the year before. Six years in the West Riding were long enough to get to know it and not long enough for the sharpness of the impression to blur. I stood in the gallery marvelling at the accuracy of the mirror that this, to me unknown, painter had held up to the bleakness, the obsolete shabbiness, the grimy fogboundness and the grimness of northern industrial England. It was as a connoisseur of all this that his pictures held me fascinated; only when the fascination of the subject had subsided a little were the beauties of these scenes as paintings borne in upon me. I chose for submission to the Tate trustees the picture that summed up remorselessly, yet with tenderness, the industrial north I knew so well. This was *Dwellings, Ordsall Lane, Salford*.

The exhibition, and the Tate's acquisition, brought Lowry a modest national reputation, which increased consistently for the rest of his life. Success, however, meant little to him: it had come too late. He was fifty-two, but very few people knew much about the distresses and the failures of his earlier years, in particular of his parents' lack of interest in his promise as an artist and his accordingly having to work as a clerk for insurance concerns from 1907 until his retirement in 1952 at the age of sixty-five. (I met him not long after we bought *Dwellings, Ordsall Lane, Salford*, and several times on subsequent occasions when I was assembling information for this chapter. At that time he was still serving as a rent-collector. He talked with friendliness and apparent candour, but never referred to his having followed any profession except painting. And no account of his having done so was published until after his death.)

About 1961 Lowry ceased to paint industrial subjects. In a talk with his friend Professor Hugh Maitland, Lowry explained his reason for adopting industrial landscapes for his subject. 'I couldn't see anybody . . . who had done it . . . I didn't just go off and do it. I researched it properly. I found that nobody had done it seriously . . . I wanted to put the industrial scene on the map because nobody had done it . . . And I thought a great shame. But I did not expect to keep

on working at it all my life as I have done.' By the early 1960s he had impressively succeeded, and he accordingly ceased to represent industrial subjects. 'I could do it now,' he said to a friend, 'but I have no desire to do it now – and that would show.'

Lowry's fascination with industrial subjects was succeeded by others: the sea and landscape, although this was sometimes marked by the inclusion of a number of buildings as in *The Rhonda Valley* (1962) and *Bargoed* (1965), but he also painted pure landscapes, such as *A Winding Road* (1961). His many seascapes include *People Walking towards the Sea*, *Seascape* (both 1965), *Stormy Sea* (1968) and a number done of the coasts of Durham and Northumberland.

Lowry's abandonment of industrial subjects was marked by a bizarre event: the reception of his seventh one-man exhibition in the autumn of 1961. The work of the man who for decades had painted industrial subjects which scarcely anyone wanted was suddenly received with acclamation. Being at the time in New York, I was unable to see it, but later learnt with astonishment of the scenes which it evoked, of 'the cheque-waving admirers of the artist', of the demands of the would-be buyers being such that, in order to keep works for sale, they were rationed to one painting each. At Lowry's first one-man exhibition in Manchester, held ten years before, not a single work was sold, but within the hour of its opening at the Lefevre more than a dozen had sold, each for around £1000 – in those days a formidable price.

It is hardly necessary to note that upon a man of Lowry's integrity the exhibition had no affect – except to evoke his amusement. He felt that to continue to paint and draw Lancashire industrial landscapes when he was convinced that he had said his say was unthinkable. He had not lost his impulse to portray what he saw around him, but he focused his attention elsewhere: not, as he so often had, on the urban scene as a whole, often, indeed, uninhabited, but on figures that were usually anonymous. 'Now,' wrote Shelley Rhodes, in her highly informative book, *A Private View of L. S. Lowry*, 'he had a new obsession, his single figures, his grotesques. The struggling, surging, misshapen homienculas who used to live for so long in the shadow of the mills emerging at last from their background to stand alone, as he stood alone . . . if he saw them rejected, it was because, despite all his current acclaim, he still saw himself rejected . . . He had a story to tell about each one of them'. She quotes from the film *Mr Lowry* 'the *Man Drinking Water*, like a thief in the night in a public lavatory; the tramp sleeping in splendid isolation on a bench in the National Gallery; the *Man Fallen Down a Hole*; the *Lady in a Straw Hat without a Dog*; the businessman lying full length on a wall, his bowler on his stomach, his briefcase by his side (when he painted the businessman he put the

initials LSL on the briefcase) . . . And, of course, the *Woman with a Beard* whom some call *The Working Man's Mona Lisa*, seen on a train from Cardiff to Paddington: 'She had a very nice face, and quite a big beard'.

Lowry's painting was treated with ridicule, condescension or neglect for so long that when recognition – even though on a grand scale – came, it came too late.

During the last twenty years of his life his works were bought by a member of the Royal Family, national and regional collectors and notable private collectors, and for high prices. Moreover, he was offered honours, including a Knighthood, an OBE and a CH, all of which he declined, besides an invitation to dine with a Prime Minister at 10 Downing Street. The only honours he did accept were membership to the Royal Academy, the Freedom of the City of Salford and the doctorates of three universities. Too late to give him satisfaction; too late to atone for the dreary, demeaning years of neglect. Yet it would, I believe, be a mistake to impute resentment to him; his attitude was rather one of disillusionment.

On the two rare occasions when we met, the benevolent, often amused detachment with which he spoke was alluded to in our conversation. I am now well aware of the secrecy with which he preserved several events in his life, most notably his years of work with insurance concerns and his relations – of a rare innocence – with certain women friends. One incident, recalled by Shelley Rhodes, seems to me to exemplify beautifully a characteristic attitude. In 1955, when at the age of sixty-seven Lowry was elected an Associate Member of the Royal Academy, the telegram announcing his elevation – '. . . hope you will attend Academy Dinner. Evening Dress with decorations' – lay on his hall table at Mottram while Lowry, in London, went to the ballet with two young friends. When the press reproached him with this lapse, he explained the situation, adding: 'I could not have put my young friends off; youth sets such store by such things.'

Lowry would, I believe, have derived immense satisfaction from admiration by other artists, which was accorded to him, but only late and in moderation. Satisfaction by 'popular acclaim' never appealed to him. And when success did come he found its demands excessive, and more and more frequently for paintings of subjects about which he had depicted all that he desired – portraits, industrial landscapes – then the melancholy figures who emerged from the shadow of the mills. He found the art world too demanding and there came a time in the early 1960s when he found little which inspired him; moreover, he was exhausted, and he gradually abandoned painting, declaring on several occasions his intention of doing so.

His exhibitions were increasingly successful, culminating in the

Arts Council retrospective at the Tate in 1966. This covered the entire range of his work, from a still-life made as a student in 1906, to a Northumberland seascape of 1965. It was acclaimed in the press and brought over forty thousand visitors. But increasing success brought ever increasing stress. Lowry's creative urge, although reasserting itself briefly from time to time, had in effect expired. For years he had been calmly resigned to dying: his creativity had ended and many of his closest friends, and almost all of his family, were dead.

'What are you hoping for?' he was asked in an interview by the writer John Heilpern. 'What would you imagine?' he replied, and, seeing the answer in his desolate look, the writer did not want to answer him. 'I want the truth from you,' the artist snapped. 'You're hoping for death.' 'Correct,' said Lowry. 'Death, comfortably. What is there left?' Presently, his precarious condition worsened; he was taken to the Woods Hospital at nearby Glossop.

On 23 February 1973 Lowry died in his sleep of pneumonia following a stroke. 'Such was the humour of the invalid,' wrote Shelley Rhodes, 'that though they' – she refers to a group of his 'true friends' – 'came in tears, they left in smiles.'

The day of the funeral was dark, and attended by two hundred friends, fellow artists, neighbours, the press and gate-crashers. Lowry was buried in the Southern Cemetery, Manchester.

Nine months later a major retrospective exhibition of his work was held at The Royal Academy. The attendance was rivalled only by that at the Turner exhibition two years before. This brought full recognition, which has steadily increased ever since. Surely it is recognition which is merited.

BIBLIOGRAPHY

Harold Gilman:
Harold Gilman: An Appreciation, Wyndham Lewis and
 Louis J. Ferguson, 1919.

Frances Hodgkins:
Frances Hodgkins, Myfanwy Evans, 1948.
Frances Hodgkins, Four Vital Years, Arthur R. Howell, 1951.
The Works of Frances Hodgkins in New Zealand and *The Expatriate*,
 E. H. McCormick, 1954.
The Origins of Frances Hodgkins, Hocken Library, University of Otago, 1969.

Augustus John:
Chiaroscuro, Fragments of an Autobiography, Augustus John, 1952.
Finishing Touches, Augustus John, Daniel George, ed., 1964.
Augustus John, A. Bertram, 1923.
Augustus John, T. W. Earp, c. 1931.
Augustus John: Drawings, Lillian Browse, ed., 1941.
Augustus John, John Rothenstein, 1944.
Portraits of the Artist's Family, Malcolm Easton, 1970.
Augustus John I: Years of Innocence, 1974; *Augustus John II: Years of Experience*,
 Michael Holroyd, 1975.
The Art of Augustus John, Malcolm Easton and Michael Holroyd, 1974.

Gwen John:
Gwen John, Susan Chitty, 1982.

Ambrose McEvoy:
The Works of Ambrose McEvoy from 1900 to May 1919, Claude Johnson,
 ed., 1919.
Ambrose McEvoy, Reginald Gleadowe, 1924.

William Nicholson:
William Nicholson, S. K. North, 1923.
William Nicholson, Marguerite Steen, 1943.
William Nicholson, Robert Nichols, 1948.

William Orpen:
Sir William Orpen, R. Pickle, 1923.
Sir William Orpen Artist and Man, P. G. Konody and Sidney Dark, 1952.

Lucien Pissarro:
Lucien Pissarro, un coeur simple, W. S. Meadmore, 1962.

James Pryde:
James Pryde, Derek Hudson, 1949.

279

William Rothenstein:
Men and Memories, 1931–32, William Rothenstein.
Since Fifty, William Rothenstein, 1939.
Imperfect Encounter: Letters of William Rothenstein and Rabindranath Tagore, 1911–1941, 1972.
Max and Will: Max Beerbohm and William Rothenstein, Mary M. Lago and Karl Beckson, 1975.

W. R. Sickert:
Sickert, Lillian Browse, 1943 and 1960.
The Life and Opinions of Walter Richard Sickert, Robert Emmons, 1941.
A Free House, Osbert Sitwell, ed., 1947.
Sickert, Wendy Baron, 1973.

Matthew Smith:
Matthew Smith, Philip Hendy, 1944.
Matthew Smith, Philip Hendy, Francis Halliday, John Russell, 1962.
Matthew Smith, John Rothenstein, 1962.

Philip Wilson Steer:
Wilson Steer, Robin Ironside, 1943.
Philip Wilson Steer: Life, Work and Setting, D. S. MacColl, 1945.
Philip Wilson Steer 1860–1942, Bruce Laughton, 1971.

Henry Tonks:
The Life of Henry Tonks, Joseph Hone, 1939.

Duncan Grant:
Duncan Grant, Roger Fry, 1923.
Duncan Grant, Raymond Mortimer, 1944.
Bloomsbury Portraits: Duncan Grant, Vanessa Bell and their Circle, Richard Shone.

James Innes:
James Dickson Innes, Lillian Browse, ed. 1946.

Wyndham Lewis:
Blasting and Bombardiering, Wyndham Lewis, 1937.
Rude Assignment, Wyndham Lewis, 1950.
The Art of Wyndham Lewis, Charles Handley-Read, ed., 1951.
Wyndham Lewis, Geoffrey Wagner, 1957.
Wyndham Lewis: Paintings and Drawings, Walter Michel, 1971.
The Letters of Wyndham Lewis, W. K. Rose, ed., 1963.
Vorticism and Abstract Art in the First Machine Age, Vol. 1: Origins and Development, Richard Cork, 1976.

L. S. Lowry:
L. S. Lowry, intro. by Mervyn Levy, 1961.
Drawings of L. S. Lowry, Mervyn Levy, 1963.

LOCATIONS OF WORKS MENTIONED IN THIS VOLUME
(public galleries only)

Walter Richard Sickert
The Statue of Duquesne, Dieppe, The City of
 Manchester Art Galleries
Rue Notre-Dame, Dieppe, The National
 Gallery of Canada, Ottawa
The Lady in a Gondola, The Ashmolean
 Museum, Oxford
The Juvenile Lead, Southampton Art
 Gallery
The Camden Town Murder, Graves Art
 Gallery, Sheffield
Ennui, The Tate Gallery, London
The Soldiers of Albert the Ready, The
 Graves Art Gallery, Sheffield

Philip Wilson Steer
Mrs Raynes, The Tate Gallery, London
Richmond Castle, The Tate Gallery,
 London
Chepstow Castle, The Tate Gallery,
 London
A Procession of Yachts, The Tate Gallery,
 London
Mrs Cyprian-Williams and Children, The
 Tate Gallery, London
The Horseshoe Bend of the Severn, The City
 Art Galleries, Manchester and
 Aberdeen

Ethel Walker
Hard Times, The Walker Art Gallery,
 Liverpool
Music Room, The Tate Gallery, London
Nausicaa, The Tate Gallery, London
The Zone of Love, The Tate Gallery,
 London

Henry Tonks
Spring Days, The Tate Gallery, London
An Advanced Clearing Station in France,
 The Imperial War Museum, London
*Steer at Home on Christmas Day with
 Nurse*, The Slade School, University
 College, London
An Evening at the Vale, The Tate Gallery,
 London
Sodales: Mr Steer and Mr Sickert, The Tate
 Gallery, London

Frances Hodgkins
Two Women with a Basket of Flowers, The
 Tate Gallery, London

William Rothenstein
L'homme qui sort, Toledo Museum of Art,
 Ohio
Conder, Musée d'Art Moderne, Paris
The Quarry, The City Art Gallery,
 Bradford
Aliens at Prayer, The National Gallery,
 Melbourne
St Seine L'Abbaye, The City of Manchester
 Art Galleries
Cliffs at Vaucottes, The Tate Gallery,
 London
Morning at Benares, The City of
 Manchester Art Galleries
St Martin's Summer, The City of
 Manchester Art Galleries
Portrait of Barnett Freedman, The Tate
 Gallery, London
Portrait of Augustus John, The Walker Art
 Gallery, Liverpool

William Nicholson
Carlina, The Kelvingrove Art Gallery,
 Glasgow
Hundred Jugs, The Walker Art Gallery,
 Liverpool
The Lowestoft Bowl, The Tate Gallery,
 London
Glass Jug and Fruit, The National Gallery
 of Canada, Ottawa
Miss Jekyll, The National Portrait Gallery,
 London
Walter Greaves, The City of Manchester
 Art Galleries
Mr and Mrs Sidney Webb, The London
 School of Economics

Harold Gilman
The Artist's Mother, The Tate Gallery,
 London
The Little French Girl, The Tate Gallery,
 London
Halifax Harbour after the Explosion, The
 National Gallery of Canada, Ottawa

Gwen John
Self-Portrait, The Tate Gallery, London
Dorelia in a Black Dress, The Tate Gallery, London
A Lady Reading, The Tate Gallery, London
Nude Girl, The Tate Gallery, London
Portrait of a Nun, The Tate Gallery, London

Augustus John
Rachel, The Tate Gallery, London
Portrait of an Old Lady, The Tate Gallery, London
Portrait of Estella Dolores Cerutti, The City of Manchester Art Galleries
Lyric Fantasy, The Tate Gallery, London
Joseph Hone, The Tate Gallery, London
Robin, The Tate Gallery, London

Charles Ginner
The Café Royal, The Tate Gallery, London

Spencer Gore
North London Girl, The Tate Gallery, London
Inez and Taki, The Tate Gallery, London

Ambrose McEvoy
The Ear-ring, The Tate Gallery, London
La Reprise, The City of Manchester Art Galleries
The Rt. Hon. Augustine Birrell, The National Gallery of Canada, Ottawa

William Orpen
The Browning Readers, The City Art Gallery, Bradford
The Mirror, The Tate Gallery, London
Myself and Venus, The Carnegie Institute, Pittsburgh
On the Irish Shore: Fairy Ring, The Johannesburg Art Gallery
Leading the Life in the West, The Metropolitan Museum, New York
Hommage à Manet, The City Art Gallery, Manchester
Adam and Eve at Pérrone, The Imperial War Museum, London

Matthew Smith
Lilies, The City Art Gallery, Leeds
Fitzroy Street I, The Tate Gallery, London
Fitzroy Street II, The British Council
Apples on a Dish, The Tate Gallery, London
Peaches, The Tate Gallery, London

Wyndham Lewis
Planners, The Tate Gallery, London
Portrait of Wyndham Lewis, The National Gallery of Canada, Ottawa
A Battery Position in a Wood, The Imperial War Museum, London
A Battery Shelled, The Imperial War Museum, London
A Canadian Gunpit, The National Gallery of Canada, Ottawa
Femme Assise, The Tate Gallery, London
Red Nude, The British Council
Girl in a Windsor Chair, The City of Manchester Art Galleries
Portrait of the Artist's Wife, Cornell University, New York
Bagdad: a panel, The Tate Gallery, London
Portrait of Edith Sitwell, The Tate Gallery, London
Portrait of T. S. Eliot, The Municipal Art Gallery, Durban

Duncan Grant
Portrait of James Strachey, The Tate Gallery, London
Still Life, The Courtauld Institute, London
The Tub, The Tate Gallery, London
La Danse, Museum of Western Art, Moscow
Long Decoration – Dancers, The City Art Gallery, Birmingham
Vanessa Bell, The Tate Gallery, London

James Dickson Innes
The Quarry, Llanelly, The Parc Howard Museum, Llanelly
Bozouls, near Rodez, The Tate Gallery, London
Waterfall, The Tate Gallery, London
Ranunculus, Walker Art Gallery, Liverpool
In the Welsh Mountains, The City Art Gallery, Manchester
The Dark Mountains: Brecon Beacons, Temple Newsam, Leeds
Arenig, The National Gallery of Canada, Ottawa
Tan-y-Grisiau, National Gallery of Canada, Ottawa
Pear Tree in Blossom, The Tate Gallery, London

L. S. Lowry
Peel Park, Salford, The City Art Gallery, Salford
Dwellings, Ordsall Lane, Salford, The Tate Gallery, London

INDEX

Page references in **bold type** refer to the section of the book which deals specifically with that particular artist.

INDEX